THE \$12 MILLION STUFFED SHARK

THE \$12 MILLION STUFFED SHARK

THE CURIOUS ECONOMICS OF CONTEMPORARY ART AND AUCTION HOUSES

Don Thompson

First published in Great Britain 2008 by Aurum Press Ltd 7 Greenland Street London NW1 OND

Copyright © 2008 Donald N. Thompson

The moral right of Donald N. Thompson to be identified as the author of this work has been asserted by him in accordance with the Copyright, Designs and Patents Act 1988.

All rights reserved. No part of this book may be reproduced or utilized in any form or by any means, electronic or mechanical, including photocopying, recording or by any information storage and retrieval system, without permission in writing from Aurum Press Ltd.

A catalogue record for this book is available from the British Library.

ISBN: 978 1 84513 302 3

1 3 5 7 9 10 8 6 4 2 2008 20010 2012 2011 2009

Designed in Trade Gothic by Roger Hammond
Typeset by Saxon Graphics, Derby
Printer and bound in Great Britain by MPG Books, Bodmin, Cornwall

Contents

Green and wrinkled and twelve million 1 Branding and insecurity 9 Branded auctions 19 Branded dealers 29 The art of the dealer 45 Art and artists 57 Damien Hirst and the shark 67 Warhol, Koons and Emin 79 Charles Saatchi: Branded collector 93 Christie's and Sotheby's 103 Choosing an auction hammer 113 Auction psychology 129 The secret world of auctions 145 Francis Bacon's perfect portrait 161 Auction houses versus dealers 173 Art fairs: The final frontier 185 Art and money 195 Pricing contemporary art 207 Fakes 219 Art critics 227 Museums 233 End game 245 Contemporary art as an investment 257

Postscript 271 References 275 Art websites 279 Photo credits 281 Index 283

Green and wrinkled and twelve million

13 JANUARY 2005, NEW YORK

million asking price for this work of contemporary art.* Another was that it weighed just over 2 tons, and was not going to be easy to carry home. The taxidermy 15-foot tiger shark 'sculpture' was mounted in a giant glass vitrine and creatively named *The Physical Impossibility of Death in the Mind of Someone Living*. It is illustrated in the centre portion of the book. The shark had been caught in 1991 in Australia, and prepared and mounted in England by technicians working under the direction of British artist Damien Hirst.

Another concern was that while the shark was certainly a novel artistic concept, many in the art world were uncertain as to whether it qualified as art. The question was important because \$12 million represented more money than had ever been paid for a work by a living artist, other than Jasper Johns – more than for a Gerhard Richter, a Robert Rauschenberg or a Lucian Freud.

Why would anyone even consider paying this much money for the shark? Part of the answer is that in the world of contemporary art, branding can substitute for critical judgement, and lots of branding was involved here. The seller was Charles Saatchi, an advertising magnate and famous art collector,

^{*}This and prices that follow in the book are quoted in the currency of the original transaction. As a rough average over the periods involved, assume that \$1.80 or €1.38 equals £1.

who fourteen years earlier had commissioned Hirst to produce the work for £50,000. At the time that sum was considered so ridiculous that the Sun heralded the transaction with the headline '50,000 For Fish Without Chips'. Hirst intended the figure to be an 'outrageous' price, set as much for the publicity it would attract as for the monetary return.

The agent selling the shark was New York-based Larry Gagosian, the world's most famous art dealer. One buyer known to be actively pursuing the shark was Sir Nicholas Serota, director of London's Tate Modern museum, who had a very constrained budget to work with. Four collectors with much greater financial means had shown moderate interest. The most promising was American Steve Cohen, a very rich Connecticut hedge-fund executive. Hirst, Saatchi, Gagosian, Tate, Serota and Cohen represented more art world branding than is almost ever found in one place. Saatchi's ownership and display of the shark had become a symbol for newspaper writers of the shock art being produced by the group known as the Young British Artists, the yBas. Put the branding and the publicity together and the shark must be art, and the price must not be unreasonable.

There was another concern, serious enough that with any other purchase it might have deterred buyers. The shark had deteriorated dramatically since it was first unveiled at Saatchi's private gallery in London in 1992. Because the techniques used to preserve it had been inadequate, the original had decomposed until its skin became heavily wrinkled and turned a pale green, a fin had fallen off, and the formaldehyde solution in the tank had turned murky. The intended illusion had been of a tiger shark swimming towards the viewer through the white space of the gallery, hunting for dinner. The illusion now was described as entering Norman Bates' fruit cellar and finding Mother embalmed in her chair. Curators at the Saatchi Gallery tried adding bleach to the formaldehyde, but this only hastened the decay. In 1993 the curators gave up and had the shark skinned. The skin was then stretched over a weighted fibreglass mould. The shark was still greenish, still wrinkled.

Damien Hirst had not actually caught the now-decaying shark. Instead he made 'Shark Wanted' telephone calls to post offices on the Australian coast, which put up posters giving his London number. He paid £6,000 for the

shark: £4,000 to catch it and £2,000 to pack it in ice and ship it to London. There was the question of whether Hirst could replace this rotting shark simply by purchasing and stuffing a new one. Many art historians would argue that if refurbished or replaced, the shark became a different artwork. If you overpainted a Renoir, it would not be the same work. But if the shark was a conceptual piece, would catching an equally fierce shark and replacing the original using the same name be acceptable? Dealer Larry Gagosian drew a weak analogy to American installation artist Dan Flavin, who works with fluorescent light tubes. If a tube on a Flavin sculpture burns out, you replace it. Charles Saatchi, when asked if refurbishing the shark would rob it of its meaning as art, responded 'Completely.' So what is more important – the original artwork or the artist's intention?

Nicholas Serota offered Gagosian \$2 million on behalf of Tate Modern, but it was turned down. Gagosian continued his sales calls. When alerted that Saatchi intended to sell soon, Cohen agreed to buy.

Hirst, Saatchi and Gagosian are profiled later in the book. But who is Steve Cohen? Who pays \$12 million for a decaying shark? Cohen is an example of the financial-sector buyer who drives the market in high-end contemporary art. He is the owner of SAC Capital Advisors in Greenwich, Connecticut, and is considered a genius. He manages \$11 billion in assets and is said to earn \$500 million a year. He displays his trophy art in a 32,000sq ft mansion in Greenwich, a 6,000sq ft pied-à-terre in Manhattan, and a 19,000sq ft bungalow in Delray Beach, Florida. In 2007 he purchased a ten-bedroom, 2-acre estate in East Hampton, New York.

To put the \$12 million price tag in context it is necessary to understand how rich really rich is. Assume Mr Cohen has a net worth of \$4 billion to go with an annual income of \$500 million before tax. Even at a 10 per cent rate of return – far less than he actually earns on the assets he manages – his total income is just over \$16 million a week, or \$90,000 an hour. The shark cost him five days' income.

Some journalists later expressed doubt as to whether the selling price for Physical Impossibility actually was \$12 million. Several New York media reported that the only other firm offer aside from that made by Tate Modern came from Cohen, and the actual selling price was \$8 million. *New York Magazine* reported \$13 million. But the \$12 million figure was the most widely cited, it produced extensive publicity, and the parties agreed not to discuss the amount. At any of these numbers, the sale greatly increased the value of the other Hirst works in the Saatchi collection.

Cohen was not sure what to do with the shark; it remained stored in England. He said he might donate it to the Museum of Modern Art (MoMA) in New York – which might have led to his being offered a position on the MoMA board. The art world heralded the purchase as a victory for MoMA over London's Tate Modern. The *Guardian* bemoaned the sale to an American, saying 'The acquisition will confirm MoMA's dominance as the leading gallery of modern art in the world.'

I began the journey of discovery that became this book at the Royal Academy of Arts in London where on 5 October 2006, along with 600 others, I attended a private preview of *USA Today*, an exhibition curated by the same Charles Saatchi. This was billed as an exhibition of art by thirty-seven talented young American artists. Many were not in fact American-born, though they were working in New York – an illustration of how hard it is to label an artist.

The Royal Academy (RA) is a major British public gallery. Founded in 1768, it promotes its exhibitions as comparable to those at the National Gallery, the two Tate galleries, and leading museums outside the UK. The *USA Today* show was not a commercial art fair, because nothing was listed as for sale. Nor was it a traditional museum show, because one man, Charles Saatchi, owned all the work. He chose what was shown. The work would appreciate in value from being shown in such a prestigious public space, and all profit from future sales would accrue to Saatchi.

Saatchi is neither professional curator nor museum official. Over a four-decade career he has been both the most talked-about advertising executive of his generation, and later the most talked-about art collector. He is wildly successful in reselling art he has collected at a profit, Damien Hirst's shark being but one example.

There was criticism of Saatchi both for using the RA to advance the value of his own art, and because some considered the work decadent or pornographic. The artists present at the opening had no illusions about the nature of the event. One called the Royal Academy the 'temporary home of the Saatchi Gallery'. Another said it was good to see his art on the wall because it might not be displayed again until it was offered at auction.

Extensive promotion of the show produced huge press coverage. It was hyped before its opening by every major newspaper in London, the *New York Times*, the *Wall Street Journal* and a dozen other major US papers. Billed as an exhibition of shocking work, the show included a battle scene involving rats, and an image of a girl performing a sex act on a man.

The theme of *USA Today* was billed as disillusionment with contemporary America. Critics and curators at the private opening had diverging opinions of the theme and the work. Some questioned whether the artists could properly be described as disillusioned, or even talented. Norman Rosenthal, the Royal Academy's exhibitions secretary, said the work 'introduces a sense of political edge and anger mixed with nostalgia; this is an exhibition for our times'. Critic Brian Sewell said 'At least *Sensation* [Saatchi's previous exhibition] made me feel nauseous. This made me feel nothing.' Ivor Abrahams, a sculptor who sits on the RA exhibitions committee, added 'It's schoolboy smut and a cynical ploy to get Saatchi even more noticed.' Such is the range of opinion common to contemporary art. Saatchi's own contribution was: 'Please be my guest at *USA Today*, and leave me a note if you think that anything there is truly more tasteless than so much we see around us every day.'

The next day the show opened to the general public. Ticket holders shuffled through the galleries in near silence, emotions muted. The crowd looked as if it was queuing to sign the condolence book before Princess Diana's funeral. As is true with much contemporary art, no one seemed anxious to admit they neither understood nor liked what was being shown. At the end people filed out, talking softly, absorbing the experience, neither pleased nor shocked.

What kind of contemporary art did Charles Saatchi choose for the show? Jonathan Pylpchuk from Winnipeg, Canada showed a miniature army camp containing black American GIs with amputated legs – some writhing, others dead. The title is *Hopefully, I Will Live Through This With a Little Bit of Dignity.* Beijing-born and Vancouver-raised Terence Koh's *CRACKHEAD* is a death fantasy of 222 glass vitrines with distorted black heads in plaster, paint and wax, for which Saatchi said he had paid \$200,000. Koh also offered a neon rooster titled *Big White Cock*.

French artist Jules de Balincourt's *US World Studies II* is a map showing the USA upside down, with the Mississippi River dividing Democratic states on the left from Republican states on the right. The rest of the world, in small scale, is at the bottom of the map. An artist actually born in New York, and improbably named Dash Snow, offered a work called *F*** the Police*, which consists of a collage of forty-five newspaper clippings discussing police misdeeds, over which the artist had sprayed semen – his own presumably. Twenty-five-year-old Snow already had achieved notoriety in the New York City art community for running a graffiti gang called Irak, and for performance art called *The Hamster's Nest*, which involved naked girls and hundreds of shredded phone books.

By consensus, the most offensive work was Pakistani artist Huma Bhabha's wire figure with a primitive tail, dressed in a black garbage bag with outstretched arms and positioned in what seemed to be the Islamic prayer position (illustrated). Bhabha, forty-five, makes sculptures of found materials which are, she says, about the human condition. Her work at *USA Today* seemed at first glance to be half-man, half-rat. However, critic Waldemar Januszczak said in the *Sunday Times*, 'There's only one likely reading of this work ... as a religious specimen in which evolution has gone into reverse. Hence the tail.'

Judging art is supposed to have less to do with the content of a work and more to do with an instinctive sense for what the artist has to say. My wife Kirsten Ward, who is a physician and psychologist, says that art has the greatest impact when it makes the thinking part of the brain talk to the feeling part. Great work speaks clearly, while more trivial work does what critics call 'going dead'. The experienced art collector will take a work home before buying it, to look at it several times a day. The question is whether a week or a month hence, after the novelty disappears, the message and painter's skill will still be apparent.

Dealer prices for the work shown by Saatchi ranged from \$30,000 to \$600,000. For the 105 pieces the total was about \$7.8 million. Saatchi probably paid half that, because he is a high-profile collector, and because the work was to be shown in a prestigious museum. Display at the Royal Academy would likely double the original retail value of each work, in which case the paper profit to Saatchi from the show was about \$11.7 million. Saatchi is thought to have contributed about £2 million to pay for mounting the show.

So what was the significance of *USA Today?* Did the show reflect the reality of twenty-first-century contemporary art, or just Charles Saatchi's preference for shock art? Did these works deserve to be shown in a major museum, in some cases only weeks after they were created? Jerry Saltz of the *Village Voice* offers a rule of thumb: 85 per cent of new contemporary art is bad. Most of the art world agree with the percentage, but disagree on how any particular work should be ranked.

As an economist and contemporary art collector, I have long been puzzled by what makes a particular work of art valuable, and by what alchemy it is seen as worth \$12 million or \$100 million rather than, say, \$250,000. Works sometimes sell for a hundred times what seems a reasonable sum, but why? Dealers and auction house specialists do not claim to be able to identify or define what will become million-dollar contemporary art. They say publicly that prices are whatever someone will pay, and privately that art buying at the most expensive end is often a game played by the super-rich, with publicity and cultural distinction as the prize. That may be a good description of motivation, but it does not explain the process.

What follows is my year-long journey of discovery through the workings of the contemporary art market, in London and New York, spending time with dealers, auction houses, former executives of each, and artists and art collectors. During that year, record prices were achieved at auction for 131 contemporary artists; four paintings sold during a six-month period for more than \$100 million each. The book looks at the economics and psychology of art, dealers and auctions. It explores money, lust and the self-aggrandizement of possession, all important elements of the world of contemporary art.

Branding and insecurity

What is Christie's? 'A brand of painting!'
Answer by Jacobe, age seven, quoted in Judith Benhamou-Huet, *The Worth of Art*

Modern art is merely the means by which we terrorize ourselves. Tracey Emin, artist

Rutkowski, formerly a specialist at Sotheby's, now a director of Bonhams auctioneers in London. 'Never underestimate how insecure buyers are about contemporary art, and how much they always need reassurance.' This is a truth that everyone in the art trade seems to understand, but no one talks about. The insecurity does not mean art buyers lack ability. It simply means that for the wealthy, time is their scarcest resource. They are not willing to spend the time required to educate themselves to the point of overcoming insecurity. So, very often, the way the purchase decision for contemporary art is made is not just about art, but about minimizing that insecurity.

The insecurity is understandable; it is a world where even the most basic concepts can be slippery. Whenever I discussed the idea of this book, one of the first questions was always, 'Tell me what defines contemporary art.' There are really two questions there; what is contemporary, and what is art. The first question is much simpler, but even that lacks general agreement.

One of the best books in the field, Brandon Taylor's *Contemporary Art*, is subtitled *Art Since 1970*. That is also the definition used by Christie's, who place work from the 1950s and 60s in a '20th Century Sale'. Sotheby's defines

as 'early contemporary' art produced between 1945 and 1970, and post-1970 art as 'late contemporary'. 'Old Masters' is art of the nineteenth century and earlier. 'Modern art' encompasses the twentieth century up to 1970, and includes Abstract Expressionism and Pop Art. Impressionist art overlaps the nineteenth and twentieth centuries and is auctioned as a separate category, or as 'Impressionist and modern'.

Another definition of contemporary art is 'art by artists who are still living', but that excludes many deceased artists whose work is sold as contemporary: Andy Warhol, Joseph Beuys, Martin Kippenberger, Roy Lichtenstein, Donald Judd, Yves Klein, Jean-Michel Basquiat. Yet another definition includes artists born after the Second World War, but that eliminates everyone above except Kippenberger and Basquiat.

The easiest definition is that contemporary art is what is sold by major auction houses in contemporary art sales. Even this is tricky: Sotheby's calls its sales 'Contemporary Art', while Christie's uses the broader title 'Post-War and Contemporary Art', without indicating which work is in which category. Christie's does this because its categorization depends on the work rather than the date. Gerhard Richter's more abstract work is contemporary and his later photorealist pieces are modern and Impressionist. This mirrors the idea that contemporary art is more cutting-edge than that produced by traditional artists.

My working definition is that contemporary art is non-traditional and was created after 1970, or that a major auction house has offered it or a similar work by the same artist as 'contemporary'. The descriptions and illustrations in the book provide a sense of what is included.

I only discuss two-dimensional works on canvas or paper, and sculpture. I do not include video installations, performance art, film or photography, industrial art (clocks, fans, bus shelters) or the draping of buildings. If you can smell it or taste it, or it is still moving or breathing, it may be art – but it is not included here. Such works are excluded because I don't understand them, and because with the exception of the photography of Cindy Sherman and a couple of others, major auction houses do not sell them under the heading of contemporary art.

Even saying that much contemporary art is two-dimensional work called painting is not straightforward. Painting should be easy to define; it is the product of paint-like materials being applied to a flat surface. But what about a painting produced as a video, or a painting that is a collage, a cartoon or graffiti? Cy Twombly has done a painting with a pencil; Andy Warhol has done paintings with urine; Robert Rauschenberg with dirt; and Chris Ofili with elephant dung. Ellsworth Kelly does paintings in which the image is a colour, and Damien Hirst pours paint onto a spinning wheel and produces spin paintings. Christopher Wool's letter paintings contain a word; in the case of one auctioned at Christie's, New York in November 2005 for \$1.24 million, the fifteen stencilled alkyd and enamel letters on aluminium spelled *Rundogrundogrun* (illustrated).

Some of the stories and illustrations in this book refer to art of a period earlier than contemporary, usually modern or Impressionist. They are included as examples of economics and process, at auction houses and with dealers.

The themes of contemporary art and design often overlap. Is a Louis Vuitton handbag a work of design or art? There are a great many connections. Bernard Arnault, owner of Louis Vuitton Moet Hennessy (LVMH), the world's largest luxury goods group, is also the owner of Christie's auction house. LVMH has an art gallery in its flagship store on the Champs Elysées in Paris. One of the first exhibits in the 'Espace Culturel Louis Vuitton' involved large photographs of naked black and white women forming the LV of Louis Vuitton. Another exhibit was a video of women posing as handbags on the shelves of the shop. The idea is to 'use art to rejuvenate Vuitton designs and to relate the LV brand to art'. Both the Victoria and Albert Museum in London and the Guggenheim Museum in New York have shown Vuitton handbags – the V&A as design, the Guggenheim as art.

Contemporary art overlaps with everyday objects, particularly when the ability to draw or sculpt is rendered superfluous by conceptual art. In 2003 a twenty-five-year-old student named Clinton Boisvert at the School of Visual Arts in New York was asked to produce a sculpture project showing how the emotion elicited by art could impact on life. Boisvert created three dozen black boxes each stencilled with the word 'Fear'. He had just finished hiding the last of these in New York City subway stations when he was arrested. A dozen stations were shut down for several hours while police squads retrieved

the sculptures. Boisvert was convicted of reckless endangerment, but received an 'A' for the project. *New York Times* art critic Michael Kimmelman commented, 'Art this bad should be a crime.' When art schools and critics can't agree on the merit of a work, it is not surprising that collectors might lack confidence in their own judgement.

Collectors' insecurities are reinforced by the way that contemporary art is described. Art professionals talk about Impressionist art in terms of boldness, depth, use of light, transparency and colour. They talk about contemporary art like Damien Hirst's shark or Terence Koh's *CRACKHEAD* in terms of innovation, investment value and the artist being 'hot', meaning a relative unknown made suddenly sought-after by word-of-mouth reports. Since art collectors cannot always fathom the value code, they understandably do not trust their own judgement. Their recourse is often to rely on branding. Collectors patronize branded dealers, bid at branded auction houses, visit branded art fairs, and seek out branded artists. You are nobody in contemporary art until you have been branded.

The concept of branding is usually thought of in relation to consumer products like Coke or Nike. Branding adds personality, distinctiveness and value to a product or service. It also offers risk avoidance and trust. A Mercedes car offers the reassurance of prestige. Prada offers the reassurance of elegant contemporary fashion. Branded art operates the same way. Friends may go bug-eyed when you say 'I paid \$5.6 million for that ceramic statue.' No one is dismissive when you say 'I bought this at Sotheby's', or 'I found this at Gagosian', or 'This is my new Jeff Koons'. Branding is the end result of the experiences a company creates with its customers and the media over a long period of time — and of the clever marketing and public relations that go into creating and reinforcing those experiences.

Successful branding produces brand equity, the price premium you are willing to pay for a branded item over a similar generic product. Brand equity is obvious when you purchase Coca-Cola rather than a supermarket housebrand cola. Brand equity also has a huge effect on art pricing.

The high return made on successful brands exists in all creative industries. As this book was being researched, two of the highest-grossing movies

were Dan Brown's *The Da Vinci Code*, and *Mission: Impossible III*. What those movies had in common were reviews that ridiculed both the story lines and actors Tom Hanks and Tom Cruise. A year earlier, Mel Gibson's *The Passion of the Christ* received 'don't go' reviews, then went on to break box-office records. The reason moviegoers ignored these reviews was the involvement in each movie of at least one brand name: Brown, Hanks, Da Vinci, Cruise, *Mission: Impossible*, or Christ. All are brands that audiences respond to.

In contemporary art, the greatest value-adding component comes from the branded auction houses, Christie's and Sotheby's. They connote status, quality and celebrity bidders with impressive wealth. Their branded identities distinguish them, and the art they sell, from their competitors. What do you hope to acquire when you bid at a prestigious evening auction at Sotheby's? A bundle of things: a painting of course, but also, you hope, a new dimension to how people see you. As Robert Lacey described it in his book about Sotheby's, you are bidding for class, for a validation of your taste.

The Museum of Modern Art, the Guggenheim and the Tate are museum brands. These have very different status from museums in Portsmouth or Cincinnati. When MoMA displays an artist's work, it conveys a shared branding, adding to the work of the artist a lustre that the art world calls 'provenance'. The MoMA brand offers buyers reassurance. A work of art that was once shown at MoMA or was part of the MoMA collection, commands a higher price because of its provenance.

Contemporary art dealerships like Gagosian or Jay Jopling's White Cube in London are respected brands, which differentiate their art and artists from hundreds of other galleries, as *Da Vinci* or *Mission: Impossible* are differentiated from other movies. A few collectors, such as Charles Saatchi, and artists such as Damien Hirst, Jeff Koons and Andy Warhol have also achieved the status of recognized and respected brands.

The motivation that drives the consumer to bid at a branded auction house, or to purchase from a branded dealer, or to prefer art that has been certified by having a show at a branded museum, is the same as that which drives the purchase of other luxury consumer goods. Women purchase a Louis Vuitton handbag for all the things it may say about them. The handbag

is easily recognized by others, distinguished by its brown colour, gold leather trim and snowflake design. A woman uncertain as to whether her friends will recognize this symbolism can choose a bag with 'Louis Vuitton' spelled out in block capital letters. Men buy an Audemars Piguet watch with its four inset dials and lizard-skin band even though their friends may not recognize the brand name, and will not ask. But experience and intuition tells them it is an expensive brand, and they see the wearer as a person of wealth and independent taste. The same message is delivered by a Warhol silkscreen on the wall or a Brancusi sculpture in the entrance hall.

Art world practices change when a branded player is involved. The price a dealer charges for work by a new artist is based on the reputation of the gallery and the size of the work rather than any measure of its quality. No artist is actually ever referred to as new; they are called 'emerging', which describes where the artist is coming from, not where she is going. Emerging is an art world term that means unknown and, in a relative sense, not expensive.

An emerging artist's work that sells for £4,000 at one gallery might be offered at £12,000 at a branded gallery. Strange as it may seem, it is the dealer branding, and substitution of the dealer's choice and judgement for the collector's, that add value. Larry Gagosian's clients can simply substitute his judgement or that of his gallery for their own, and purchase whatever is being shown – to the point of purchasing over the phone or via the internet, without first seeing the actual painting. The dealer brand often becomes a substitute for, and certainly is a reinforcement of, aesthetic judgement.

When an artist becomes branded, the market tends to accept as legitimate whatever the artist submits. Consider the attraction of a work by Japanese conceptual artist On Kawara, whose *Today* series involves painting a date on canvas. Thus the work *Nov. 8, 1989* (just those letters and numerals, in block white against a black background) in liquitex on canvas, 26×36 in $(66 \times 91$ cm), sold for £310,000 in February 2006 at Christie's auction house in London. Kawara paints freehand, and limits himself to the hours of one day to complete a work. A painting unfinished by midnight is discarded as it would no longer be a day painting. The paintings are all made on Sundays. If Kawara is in the USA, the date begins with the name of the month in English, followed

by the day and year. If he is painting in Europe, the day precedes the month. If he is in a country that does not use Roman script, he writes the month in Esperanto. Each sale includes the front page of a newspaper from that date. Christie's catalogue described the Kawara work as 'an existential statement, a proof of life'.

There is no rarity factor; Kawara has been making these paintings since 1966. There are 2,000 Kawara day paintings in existence. But Kawara is a brand, and his branding stands as a beacon for every contemporary dealer and every aspiring conceptual artist. One dealer told me that so long as collectors will pay high auction prices for Kawara's day paintings, there is hope for everyone.

Even art lovers prepared to accept as legitimate whatever an artist might submit were bemused by a 1991 work by Felix Gonzalez-Torres, offered at a Sotheby's auction in New York in November 2000. Gonzalez-Torres is on several lists of great artists of the 1980s and 90s; he is very branded. He died of AIDS in 1996 at the age of thirty-eight. Untitled, but referred to as *Lover Boys*, the work consists of 355 lb of individually wrapped blue and white candies. Intended to be piled in a triangular shape in one corner of a room to be eaten by guests, the candy represents his lover's body wasting away from AIDS. The work was listed as a sculpture, described in the catalogue entry as 'dimensions variable'. The estimate was \$300–400,000; it sold for \$456,000.

In May 2003 Christie's followed up with *Untitled (Fortune Cookie Corner)* by the same artist. This consisted of 10,000 fortune cookies, described as an endless supply, also intended to be piled in a corner and with variable dimensions, but approximately $36 \times 100 \times 60$ in $(91 \times 254 \times 154$ cm). The estimate was \$600–800,000, double the value of the blue and white candies. It went unsold, but received a high bid of \$520,000.

There was concern about how easily a collector might fake a 355 lb Gonzalez-Torres sculpture with a visit to the local store. To deal with this problem, a note in the auction sales catalogue read: 'It is the artist's intention that a new certificate of authenticity and ownership is issued stating the new owner's name, in addition to the current certificate of authenticity which accompanies this work.'

Sotheby's full-page, three-column explanation of the significance of the sculpture invoked its legitimacy by citing Nancy Spector, who had said in a Guggenheim catalogue on Gonzales-Torres: 'The simple elegance of the work invites contemplation, even reverie. The work's provocation lies in its seeming open-endedness, its refusal to assert a closure of meaning.' It is this reverie and provocation that the buyer hopes will prevent his friends from staring open-mouthed and gasping: 'You paid what for the candy?'

Spector, who is curator of contemporary art at the Guggenheim in New York, controversially nominated Gonzales-Torres to represent the USA at the 2007 Venice Biennale exhibition of contemporary art, but escaped with less criticism than had she nominated an unbranded artist. One of several Gonzales-Torres pieces shown at the Biennale was *Untitled (America)*, a large, flat, room-filling sculpture composed of pieces of liquorice.

A work offered in a prestigious evening auction at Christie's or Sotheby's will bring on average 20 per cent more than the same work auctioned the following day in a less prestigious day sale. It is 'Evening Sale' that adds value. Branding of the artist is also important, in that a branded artist such as Jeff Koons seems able to sell almost anything, and his collectors can have almost any work accepted for resale at an evening auction.

Contract terms change when a branded player is involved. Normally a dealer or auction house offers a standard contract to the artist or consignor, with most terms favouring the institution. Consignment is a term that refers to the legal transfer of a property to the auction house for sale on the owner's behalf. Consignors at auction normally pay a percentage of the selling price as commission, and are also asked to cover the costs of insurance or photography. A consignor of a valuable Picasso can negotiate the seller's commission – sometimes to zero; the promotional package; even the identity of the auctioneer. Artists who have achieved branded status, such as Damien Hirst or Jeff Koons, can negotiate lower commissions, the frequency of shows, advances, even payment of a 'signing-on bonus' with the dealer.

Money itself has little meaning in the upper echelons of the art world – everyone has it. What impresses is ownership of a rare and treasured work such as Jasper Johns' 1958 White Flag. The person who owns it (currently

Michael Ovitz in Los Angeles) is above the art crowd, untouchable. What the rich seem to want to acquire is what economists call positional goods; things that prove to the rest of the world that they really are rich.

Even if you are only moderately rich, there is almost nothing you can buy for £1 million that will generate as much status and recognition as a branded work of contemporary art – at that price maybe a medium-sized Hirst work. Flaunting a Lamborghini might be viewed as vulgar. A country house in the south of France is better, but it should have a small vineyard and a sea view. A great many people can afford a small yacht. But art distinguishes you. A large and recognizable Damien Hirst dot painting on the living room wall produces: 'Wow, isn't that a Hirst?'

New York and London are the two nerve centres of the world market for high-end contemporary art – and they are where branding is most evident and most important. New York is more important than London for most categories of art, but in contemporary art, London has been gaining for a decade and deserves to be considered as equal. The most important artists work in or around these centres, or visit frequently.

These cities are where the major dealers are, and where the art magazines are published. Every major collector tries to visit New York, London or both, once or twice a year to attend auctions and art fairs, talk to others in the trade and see new work. New York and London are themselves brands. Having a painting on your wall acquired in New York has a lot more cachet than having one purchased in Milwaukee.

One of the ultimate forms of branding in the art world, and certainly the most newsworthy, comes in the form of the prestigious evening auctions at the great auction houses, Christie's and Sotheby's. The world of art auctions, from an economist's point of view, is a fascinating and complex one, and is discussed at length later in the book. But first we visit an evening auction to look at what this adds to the branding process.

Branded auctions

Works of art, which represent the highest level of spiritual production, will find favour in the eyes of the bourgeois only if they are presented as being liable to directly generate material wealth.

Karl Marx, philosopher

ALF AN HOUR before an evening auction at Christie's or Sotheby's, in London or New York, black limousines sit two deep by the kerb outside the auction house, engines idling like getaway cars in a modern Mafia movie. Many who arrive by car will not register for a paddle – a numbered object the bidder shows to register a bid. They are there because evening art auctions are a place to be seen, and a chance to observe seven-figure sums of money being offered for objects many of the crowd would not want to have on display in their homes.

Inside the auction house's entrance is a hall packed with high-profile dealers, rich collectors and their advisors. The space is full of 'wish I could remember the name' celebrities, with lots of real or faked greeting and air-kissing. Acquaintances smile and extend their arms and mouth 'What work are you here for?'

The protocol in the entry hall before an auction is to air-kiss, right cheek then left cheek; if male to male, shake hands, grasp just above the other's elbow with the free hand and respond 'It's good to see you looking so well' and 'I'm here for the Rothko' (or whatever work is on the catalogue cover, or is most expensive – no one will enquire further). Then look over the other party's shoulder as if searching out an old friend. This is the other's cue to do the

same, and move on. Nobody asks names; very often they are relieved to escape without admitting they do not remember.

Some of those attending amuse themselves, or impress their friends, by doing the greet-kiss-shake-shoulder routine with anyone they recognize from a newspaper photo. Dealer Larry Gagosian is most recognizable, thus a favourite. Like good politicians, dealers will never admit to not recognizing someone who recognizes them.

A sign of high status as an auction client is to bid without the plebeian necessity of possessing a bidding paddle. The idea that it is necessary to register and have a paddle before bidding is a myth. The auctioneer will have pre-assigned numbers for bidders who are known not to bother registering, or an attendant will offer a paddle once they are seated.

The auctioneer will ask anyone unknown who bids without a paddle, 'Are you really bidding?' If the individual confirms that he is, the bid is accepted. If a paddleless and previously unknown bidder is successful, an arbitrary paddle number is assigned, and an auction house clerk materializes to gather personal identification.

At the front of the auction room is a large television screen which projects each bid simultaneously in pounds, US dollars, euros, Swiss francs, Hong Kong dollars and Japanese yen. In May 2007, Sotheby's added Russian roubles to the conversion for the first time. Every bidder is perfectly competent to calculate their bidding position in the auction currency; the conversion is there to remind everyone what an international event this is.

The auctioneer tries to start precisely on time, whether people are in their seats or not. He spends the first three minutes greeting the audience, listing withdrawn items, and recounting how the house will bid on behalf of consignors. All this permits last-minute greet-kiss-shakers to make it to their seats.

If USA Today offered a glimpse of the newest art, evening auction house sales represent contemporary art that is a few years older but much more expensive. In May 2007, Christie's and Sotheby's in New York achieved the two highest auction totals in history for their prestigious evening contemporary art sales – the previous record for the most expensive post-war work was

broken four times within twenty-four hours. The most sought-after contemporary pieces now rival the most expensive works of Impressionist and Modern art, or Old Masters.

Christie's and Sotheby's contemporary sales take place on successive evenings, the auction houses alternating which goes first. This is nominally for the convenience of foreign bidders, since it doubles the number of works available on one visit to London or New York. There is also psychology involved. An uncertain bidder is doubly persuaded; two auction houses and two different sets of specialists say that contemporary art is desirable, prestigious and a good investment. The unsuccessful bidder at the first auction may be an even more determined bidder at the second.

In May 2007 the auction at Sotheby's came first, on a Tuesday evening, with sales of sixty-five works totalling \$255 million (including the premium paid to the auction house by purchasers). Forty-one of the works sold for over \$1 million each. The high point of the sale was Mark Rothko's painting *White Center (Yellow, Pink and Lavender on Rose)* (illustrated), which brought a world record price for the artist and for any post-war or contemporary work at auction.

The painting is spectacular. It is almost 7ft tall, with three dominant broad bands of yellow, white and lavender, divided by thin green stripes. The background is red, pink and orange. It is a museum-quality work that had been shown in the 1998 Rothko retrospective at the National Gallery in Washington, after which it travelled to the Musée d'Art Moderne in Paris. Painted in 1950 by an artist who committed suicide in 1970, it is not a contemporary work by age, but was offered as contemporary because of its composition.

The Rothko was owned by David Rockefeller, the ninety-one-year-old retired chairman of the Chase Manhattan Bank, chairman emeritus of the Museum of Modern Art, and a well-known philanthropist. His mother, Abby Aldrich Rockefeller, was one of the founders of MoMA in 1929. His brother, Nelson Rockefeller, was a three-term governor of New York from 1959 to 1973, and the forty-first Vice-President of the United States under Gerald Ford.

David Rockefeller had owned the painting since 1960. He purchased it for \$8,500 from Eliza Bliss Parkinson, the niece of Lillie Bliss, one of the three

founders of MoMA. Mrs Parkinson had bought the work a few months earlier from Rothko's dealer, Sidney Janis. Chase had its own corporate art collection, but a Rothko was far too abstract to be considered, so Rockefeller, then a vice-president of the bank, bought it himself and it hung in his various outer offices over a period of forty-seven years.

Rockefeller initially negotiated the consignment exclusively with Sotheby's because they had advised him in the past, and had embarked upon discussions about a possible sale. Sotheby's needed a feature work for their spring 2007 New York contemporary auction and feared Christie's would jump in with a pre-emptive offer. Auctioneer Tobias Meyer, famous for offering huge guaranteed prices for art he thinks will be successful, was reported by Carol Vogel in the New York Times to have guaranteed Mr Rockefeller a price of \$46 million even if the painting sold for less. That amount was calculated as the estimated \$40 million selling price, plus a rebate of the premium to be paid by the buyer on a \$40 million sale. Several dealers grumbled that the guarantee amount was leaked by a Sotheby's employee to Ms Vogel only to gain media attention - and it certainly did. Christie's, learning of the pending consignment, made a quick offer including a guarantee price thought to be in the \$30-32 million range. This did not warrant serious consideration. Christie's said a higher guarantee would have been foolhardy; they also had two Rothkos consigned for their next-day sale, and were less in need of the work

To put Sotheby's guarantee price of \$46 million in perspective, it was twice the previous auction record for a Rothko – the \$22.4 million achieved at Christie's in 2005. Any price above \$27 million would have made the Rothko the most expensive post-war work of art ever sold at auction. Sotheby's claimed that a comparable Rothko had sold privately at the \$30 million level, implying that the previous ownership record – Rockefeller, Chase Manhattan, Parkinson, Janis (but mostly Rockefeller) – might add \$10 million to the final value. Instead of listing an estimate for the work, the catalogue stated 'Refer Department', which means 'call us and we'll tell you what we think'. The amount quoted to those who called Sotheby's started at \$40 million, and had crept up to \$48 million by the day of the auction.

On the assumption that Mr Rockefeller's seller's commission was waived and that Sotheby's incurred \$600,000 in promotion costs, the auction house could make a profit only if the painting sold for over \$47 million. It would lose money if it sold for less than that: a \$1.4 million loss at the \$40 million auction estimate; \$7.5 million at a selling price of \$35 million; \$13 million at \$30 million; and an \$18.5 million loss at a selling price of \$25 million, which would still have been an auction record for a Rothko painting.

Sotheby's marketing campaign included heavy advertising, and the painting was flown to London for a private showing. The painting was taken for three individual visits to particularly promising collectors. It was emphasized (and stated in the catalogue) that the painting had come from 'this most illustrious of collectors'. Clients were sent special white hardback catalogues, and those attending private viewings in New York and London were given gift bags that included a catalog from the Rothko retrospective held in 1998–9 at the National Gallery and the Musée d'Art Moderne.

During the auction, Tobias Meyer introduced Lot 31, *White Center*, with the words 'And now ...' This was followed by a long pause. The audience chuckled. Meyer spelled out the painting's full title and moneyed history, 'From the collection of David and Peggy Rockefeller', a lengthy introduction virtually never heard in evening auctions, where lots are normally introduced only by their number and the artist's name. David Rockefeller observed the proceedings from a private box.

The opening bid was \$28 million, \$6 million above the auction record for a Rothko. Six bidders pursued it in \$1 million bidding increments. Two and a half minutes later, Meyer hammered down *White Center* for \$72.8 million. Who bought it? One dealer identified a bearded Russian collector in a box adjacent to that occupied by Rockefeller. Sotheby's said it was sold over the phone to a client of Roberta Louckx, a Russian-speaking auction house specialist – perhaps the same bearded gentleman, speaking on a house phone. Another rumour was that two of the final four bidders were Russian. Rothko was born in Russia; his birth name was Marcus Rothkowitz.

The selling price vindicated Meyer's judgement and his aggressive guarantee. Consignment of the painting produced a profit of just over \$16 million

for Sotheby's, including their share of the amount achieved above the guarantee price. Angela Westwater of New York gallery Sperone Westwater said of the sale price, 'Money has no meaning ... it's a good work, but the whole marketplace is crazy.' Nicholas Maclean, another New York dealer, said someone 'had just bought a Rockefeller'.

The price was thought outrageous in part because it violated Tobias Meyer's own rule about art pricing. Meyer's rule is that what people outside the art world see as obscene prices for art must be judged against an anchor price like that for a great New York apartment. If the great apartment costs \$30 million, then a Rothko that hangs in the featured spot in the living room can also be worth \$30 million – as much as the value of the apartment. But no one could envision a \$72.8 million apartment to use for comparison.

Sotheby's specialists had high hopes that, driven by the price paid for the Rothko, the total of \$255 million attained at their New York spring contemporary sale would be higher than that achieved at Christie's the next day. It was not to be. Twenty-four hours later, having auctioned an Andy Warhol silkscreen for \$71.7 million and set auction records for twenty-six artists, Christie's totalled a record \$385 million in sales. This obliterated Sotheby's short-lived record, and brought the total for the two evening sales to \$640 million.

What sort of work was included in two auctions totalling almost two-thirds of a billion dollars? The Rothko is museum-class. A less traditional work was Jim Hodges' *No-One Ever Leaves*, a leather jacket tossed in a corner. The title reflects the meaning of the work. The catalogue illustration looks a lot like an advertisement for a leather jacket – except for a spider's web of thin silver chains joining the hem to the wall, which transformed it into a work of contemporary art. It sold for \$690,000, more than double the artist's previous auction record, and almost certainly a world record for any leather jacket. The next artist record went to Jack Pierson, for a set of plastic and metal letters nailed to the wall and reading *Almost*. Each letter differed from the next in size, colour and design. It sold for \$180,000.

Among other offerings from branded artists at Sotheby's was a Jeff Koons vacuum cleaner mounted in a Plexiglas case, with fluorescent tubes on either side. Titled *New Hoover, Deluxe Shampoo Polisher* (illustrated), it was

described in the catalogue as 'executed' by the artist. It sold for \$2.16 million. Is the polisher a utilitarian object, or one transformed into minimalist art by being presented in an aesthetic setting? The auction catalogue entry described it as 'addressing social class and gender roles as well as consumerism'. Koons produced it as art, and Sotheby's offered and sold it as art.

At the more extreme end, a Jean-Michel Basquiat picture was titled *Untitled* (illustrated), perhaps because choosing an appropriate title would have been a challenge. It was described by Basquiat himself as a self-portrait, by a critic as a one-eyed dwarf raising both hands in fury, and by Sotheby's as a Christ-like figure representing the struggles of the black man in a white society. It would take considerable creativity on the part of a viewer to see any one of these in the mix of acrylic, oilstick and spray paint that make up the work. It was estimated at \$6–8 million and sold for \$14.6 million, an auction record for the artist.

Superior to the Basquiat in artistic merit and a wonderful example of contemporary portraiture – but like the Basquiat, a work that is difficult to imagine living with – was Francis Bacon's *Study from Innocent X* (illustrated). One of a series inspired by Velazquez' *Portrait of Pope Innocent X* painted in 1650, it shows the shadow of death on an emaciated head. An unidentified buyer set an auction record for Bacon at \$52.7 million, double the previous record of \$27.6 million.

A few lots later came a large 1991 oil by Peter Doig entitled *The Architect's Home in the Ravine*. It is not clear whether this painting is intended to celebrate or satirize modern architecture; the building is shown as being overtaken by encroaching foliage. Every critic agreed as to its artistic merit. It is a work that would be easy to live with. It was hammered down at \$3.6 million.

More records were set at Christie's, one with Donald Judd's *Untitled*, 1977 (77.41) Bernstein, a set of ten rectangular stacks with iron sides and Plexiglas tops manufactured – as are all Judd's sculptures – by artisans. The sculpture, if that is the correct categorization, sold for \$9.8 million.

Remarkable as that price seemed, it was nothing compared with what happened two lots later. Andy Warhol's *Green Car Crash (Burning Car 1)* is a commercially produced silkscreen showing multiple images of a car accident

victim impaled on a metal step on an electricity pole, and copied from a photo of the accident scene published in *Newsweek* in 1963. It sold for \$71.7 million, four times the previous record for a Warhol, and one bid away from topping the previous evening's Rothko as the most expensive contemporary work at auction. It was bought by the Chinese bidder who had been the underbidder on the Rothko the night before.

Several lots after the Warhol came Damien Hirst's *Lullaby Winter* (illustrated). A sculpture constructed as a medicine cabinet filled with pills and intended to contrast the ability of medication to prolong life with the inevitability of death, this sold for \$7.4 million, a price announced as a record for an 'assembled item'. All these works were offered as contemporary art, and each – the leather jacket, Pierson's letters, Koons' shampoo polisher, and the Rothko and Doig oils – represent one segment of the contemporary art world.

When thinking about the potential prices for the works shown at *USA Today* and those offered at the two auctions, one should remember that the key part of the word contemporary is 'temporary'. Look at a listing of major galleries from a ten-year-old art magazine like *Frieze*, and you will note that half no longer exist. Inspect ten-year-old evening sale catalogues from Christie's or Sotheby's and you will find that half the artists are no longer being offered in evening auction sales. Ten years from now, will there be collectors around willing to pay even more for Terence Koh's black heads or Jim Hodges' leather jacket – the 'richer and more lustful fool' assumption? If not – and everyone I have talked to thinks 'not' is the likely outcome – and if these are not decorative objects that you might want to display in your home, then why is the work shown in *USA Today* collectively worth \$15 million? Why is some of the individual work in the evening auctions worth so much?

As you read about different works of art in this book and the prices involved, ask whether each purchase seems to you a decent investment. Not just 'Will this art be important twenty-five years from now?' but 'Will this art double in value in ten years as would a moderate-risk bond portfolio?' For almost all art, the answer is no. Of the thousand artists who had serious gallery shows in New York and London during the 1980s, no more than twenty were offered in evening auctions at Christie's or Sotheby's in 2007. Eight of ten

works purchased directly from an artist and half the works purchased at auction will never again resell at their purchase price.

In the end, the question 'What is judged to be valuable contemporary art?' is determined first by major dealers, later by branded auction houses, a bit by museum curators who stage special shows, very little by art critics, and hardly at all by buyers. High prices are created by branded dealers promoting particular artists, by a few artists successfully promoting themselves, and by brilliant marketing on the part of branded auction houses.

The chapters that follow tell the story of how great marketing and successful branding by artists, dealers and auction houses produce huge prices for the stuffed shark and other contemporary work. The journey includes the story of Christie's sale of a portrait triptych by branded post-war British artist Francis Bacon that was expected to produce a world record auction price for the artist. We explore the world of branded artist Damien Hirst and branded collector Charles Saatchi. We look at other players who influence ever-rising art prices: branded artists Andy Warhol and Jeff Koons, auction houses, dealers, art fairs, critics and museums.

Branded dealers

I had reservations about making art a business, but I got over it. Mary Boone, New York dealer

Art dealers are like surfboard riders. You can't make a wave. If there aren't waves out there, you're dead. But the good surfboard rider can sense which of the waves coming in will be the good one, the one that will last. Successful art dealers have a feeling for hitting the right wave. Andre Emmerich, New York dealer

F CHRISTIE'S AND Sotheby's are where the theatre of branding plays out most visibly, the branded art dealerships are where artist brands are born and incubated.

The branded art gallery is interesting. It is often designed to be a not-very-friendly place for those who are 'just looking', and visitors are not comfortable. Part of the psychology of the contemporary gallery is its décor. It is often windowless, and composed of rooms with flat-white walls. The architecture is referred to as 'white cube'. This featureless environment is meant to reinforce the idea that what is being viewed is 'art', and that galleries are elitist. One example of white cube design is Larry Gagosian's gallery in London, a renovated vehicle repair garage. The space is so modernistic that when Gagosian opened, critics said he faced little financial risk; should the gallery location fail, the space would make a fine nightclub.

Observe people looking at art through a gallery window; frequently they pause before pushing the buzzer, then walk away. The quick escape has

nothing to do with the art being shown. It is that the elitist gallery imposes a psychological threshold as well as a physical one. It is the fear that the dealer will treat you as an unwelcome intruder or, worse, as an idiot, and will patronize you. It is the experience one collector described as 'Ringing the doorbell of a windowless gallery just to have an aloof dealer talking down to me in a barely decipherable language.'

Another fear is that if you look somewhat affluent and interested, the dealer may follow you around, speaking a form of dealer-code where cutting-edge means radical, challenging means don't even try to understand it, and museum quality means if you have to ask, you can't afford it. The dealer may tell you what you should like and why. 'Isn't it great? You can see how talented this artist is.' Or they volunteer, 'Charles Saatchi liked this.' Did he like it enough to take it home? Few collectors think they have the self-confidence to respond, 'Actually, your artist does disturbing work and I, like Mr Saatchi, would never want that painting anywhere near me.'

The psychological barrier is more common to the branded, superstar gallery, of the kind described in this chapter. Mainstream galleries and others lower on the dealer pyramid tend to be less psychologically daunting. Those galleries are described in the chapter that follows.

A fascinating part of my journey of discovery was the chance to spend time with dealers in the very top echelon. Some – Tim Marlow of White Cube, or Harry Blain of Haunch of Venison – were fun to talk to, smart, customer-aware and marketing-savvy. Others, such as Larry Gagosian, are unquestionably great marketers, but had a whole lot less interest in spending time with a noncustomer like me.

The world of dealers includes men and women of the highest integrity, many of whom are experts on the work of the artists they sell, on the same level as museum curators or university professors. Examples include Julian Agnew and Anthony d'Offay with the Camden Town Group; Zurich dealer Thomas Ammann and New York dealer Ron Feldman on the work of Andy Warhol; Otto and Jane Kallir on Egon Schiele; and Tim Marlow and Harry Blain, mentioned above.

When it comes to marketing the work of their artists, some dealers described their programmes in a way that remind me of how fashion houses

like Hermès, Chanel or Prada stimulate customer needs and then satisfy demand. Some mainstream dealers are more like mass-market brands such as Ralph Lauren or Tommy Hilfiger. A few others, at the mainstream level and below, evoke images of used-car dealing.

Use of the term 'dealer' elicits complaints from – well, from dealers. Some dealers insist on being called a 'gallerist', because 'dealer' implies they practise a form of trade, or are in the business for money. Others, like Harry Blain, say 'Of course I'm a dealer, what else would I call myself?' I have throughout the book referred to those who run galleries, or operate privately, as dealers. No offence to gallerists is intended.

The art trade is the least transparent and least regulated major commercial activity in the world. Anyone can purchase a business license and become a dealer. There is no required background, no test, no certification. Superstar art dealers achieve that status by coming to the table not with graduate business or art degrees, although some have them. Rather they have lots of operating capital, sometimes good contacts, judgement in choosing marketable artists, aggression in approaching collectors, and savvy in promoting their brand. And they have charm, although charm takes many forms. In many cases, luck plays a role. Long-term power in the art-dealing world is measured by the names on your speed-dial, and whether major collectors, dealers and artists return your calls. Below the top level, dealers have less money, fewer phone numbers, less charm and probably less luck.

Dealers have different operating models. Some, such as PaceWildenstein in New York, carry a huge inventory of artworks, while L&M, another New York dealer, holds little inventory but assembles work for artist shows. Gagosian represents a stable of branded artists, while Mitchell Innes & Nash specializes in representing artists' estates.

If a collector wants to purchase serious contemporary art, the best strategy may be to buy directly from the dealer who represents that artist in the primary market, rather than in the secondary market or at auction. The primary art market is art directly from the artist, offered for sale for the first time. The secondary market is resale: buying, selling and trading among collectors,

dealers and museums. Work purchased directly from the dealer will usually be cheaper than that bought at auction because the dealer tries to keep primary-market art prices below auction prices. The collector also gets access to fresh art. But buying from the primary dealer is harder than it may seem. He may refuse to sell to you, or he may put you at the end of a long waiting list – more about that later.

It is the branded dealer who manages the long-term career of a mature artist, placing work with collectors, taking it to art fairs, placing it with dealers in other countries, and working with museums. These dealers are the gate-keepers who permit artists access to serious collectors. They represent the established artist whose work brings newsworthy prices at auction. Being with a branded dealer allows the artist to hang out with other artists at the top of the food chain. Like other professionals, artists are very status conscious. Until artists get such representation, they don't often get to hang out.

The branded dealer undertakes a range of marketing activities that include public relations, advertising, exhibitions and loans. Most marketing is not intended to produce immediate sales, but rather to build the dealer brand and obtain coverage for the artist in art publications. Marketing starts with public relations: private dinners to introduce customers and art critics to new artists; brunches and cocktail parties at the opening of shows. That dealers sell art is implied in these roles, but never openly. The higher the dealer's status, the less the gallery acts like a commercial enterprise, and the less it looks like a commercial space. The superstar, branded dealer's space resembles a museum, and never displays prices.

One or two dealers define each era in art. The history of the branded dealer started at the end of the nineteenth century with the legendary Joseph Henry Duveen, born in Hull in 1869. Duveen dominated the trade in Old Master paintings. On occasion Duveen sold extravagantly priced paintings that he did not own. He sold Thomas Gainsborough's *Blue Boy* to Americans Henry and Arabella Huntingdon for £182,000 (\$750,000 at the time, about £2.2 million or \$4 million in 2007 currency), at a time when the painting was owned by the Duke of Westminster, whom Duveen had never met. No problem. Duveen negotiated a purchase about two months after he had sold the work.

Duveen was the prototype for today's branded dealer. He targeted John D. Rockefeller, J.P. Morgan, Henry Clay Frick and Andrew Mellon. These gentlemen had great wealth but little art background. Duveen charged high prices, and defended them by saying: 'When you pay high for the priceless, you acquire it cheaply.'

Distinguished trustees from the Metropolitan Museum of Art or the National Gallery accompanied Duveen on many of his client visits. They came on his promise that as a condition of being allowed to buy the art, the client would agree to later contribute it to their institution. Duveen introduced preferred clients to museum trustees and to nobility, arranged invitations to great country homes and, in at least two cases, selected brides.

Duveen understood the desire of his clients, whom he referred to as pupils, for social acceptance. He was the first to sell social status in the guise of selling art. His motto was 'Europe has plenty of art while America has plenty of money and large empty mansions, and I bring them together.' Today's superstar dealer might say 'Russia and China have plenty of money and desire the reassurance of western status symbols, and I can provide it.' Modern dealers emulate Duveen in choosing a narrow, upscale target market and selling status as art – although no modern dealer offers sale-without-ownership, or mate selection.

Ambroise Vollard was a French law student who carried the Duveen tradition into Impressionist art. In 1894, Vollard gave up law to concentrate on dealing. He bought a collection of drawings from Edouard Manet's widow, and swapped them with Degas, Gauguin, Renoir and Pissarro for their own work. He sold two Degas works and a few months later attended the Hotel Drouot auction of Parisian merchant Julien Tanguy's pictures. With 838 francs from the two Degas and little competition from an uninterested audience, he purchased four Cézannes, one Gauguin, a van Gogh and a Pissarro.

Vollard gave Pablo Picasso, Paul Cézanne, Paul Gauguin and, posthumously, Vincent van Gogh their first one-man shows, accepting paintings in lieu of commission. He sought out foreign collectors, providing most of the work acquired by Russians Sergei Shukin and Ivan Morosov – art that was confiscated after the Russian Revolution and today forms the basis of the

Pushkin Museum's collection in Moscow. During his career Vollard originated many of today's dealer practices. He purchased multiple paintings from unknown artists, branded the work he offered as 'The Vollard Collection', sent exhibitions to the USA, Russia and Japan, and published catalogues on his artists' work.

In 1939, Vollard died in rather mysterious circumstances. According to the official, romantic version, he was struck on the head by a Maillol bronze that tumbled from the ledge behind the passenger seat when his car braked suddenly. Another version holds that his driver clubbed him to death with the bronze at the behest of a rival Corsican dealer. Whichever is true, at his death his estate was worth \$15 million, much of it the result of the single best art purchase in history: finding Paul Cézanne depressed over the extent of his debts, Vollard agreed to purchase 250 canvases for 50 francs each. Some were later sold at 40,000 francs. Today those 250 works would be worth between \$3 and \$4 billion.

The mid-twentieth century heir to Duveen and Vollard was Leo Castelli, an Italian banker who opened a New York gallery in 1957. Castelli tried to predict art movements and to pick the best practitioner within each. He chose artists on his gut feeling, based on personality – if there was not much personality, there would not be much depth to the art. Two of his early discoveries were Jasper Johns and Robert Rauschenberg. These were followed by Cy Twombly, Claus Oldenburg and Jim Dine. Castelli's early choice of artists, notably of Johns, established the gallery brand.

Castelli was one of the first dealers to pay his artists a stipend so they would not have the insecurity of waiting for sales. In 1960, Frank Stella was working as a house painter in Brooklyn, creating paintings in the evening using colours left over from work. Castelli admired a chartreuse painting and offered Stella \$300 a month for three years to devote all his time to painting. He supported his artists through periods when they were not painting, and he was willing to show 'unsaleable' work.

Early in the life of his gallery, Castelli invited Alfred Barr, then director of the Museum of Modern Art, to a private viewing of Jasper Johns' work. Barr bought several of Johns' works for MoMA, and showed them simultaneously with a

Johns show at Castelli's gallery. Barr wanted to buy the acknowledged best work in the show, a picture called *Target With Plaster Casts*. The work included nine wooden boxes on top of the canvas, in one of which was a green plaster cast of a penis. Thinking his museum board might be troubled by that part of the work, Barr called Johns to ask: 'Could we keep this box closed?'

'All the time or part of the time?'

'I'm afraid, Mr Johns, all of the time.'

To which Johns replied, 'I'm afraid, Mr Barr, that would be unacceptable.' Barr purchased his second choice, and Leo Castelli agreed to purchase Target With Plaster Casts himself, for \$1,200. In 1993 Castelli sold Target to American film and theatrical producer David Geffen for \$13 million. Today it is worth eight times that amount.

Johns was in awe of Castelli's ability to market art. In 1960 Willem de Kooning said of Castelli, 'That son of a bitch, you could give him two beer cans and he could sell them.' Johns laughed and created a sculpture of two Ballantine Ale empties. Castelli immediately sold the work to collectors Robert and Ethel Scull. The cans are now in a German museum.

In 1959, Castelli had the first showing of British artist Francis Bacon in the USA, selling out at prices from \$900 to \$1,300 – about one-fortieth of 1 per cent of what the pictures would sell for forty-five years later. Castelli did not keep any of the Bacon work for his own collection – he later called this his major mistake in a lifetime of art dealing.

Early on Castelli had rejected Andy Warhol's work. Later he agreed to represent him, but Warhol thought Castelli ignored him in favour of his major artists, Johns and Roy Lichtenstein. Warhol took a little revenge by bypassing Castelli and selling work directly from his studio, through his business manager Fred Hughes. On one occasion he swapped one of his paintings for one by Lichtenstein, then had Hughes sell the Lichtenstein work.

Castelli reasoned that artists' work had to be seen, not stored, so he set about franchising his artists. When he wasn't showing Warhol, Stella or Lichtenstein in New York, he had Irving Blum show them in Los Angeles, or Joseph Helman in St Louis. He extended the artist franchise overseas, first to western Europe and then to Japan. By the 1970s, Leo Castelli was the most

influential contemporary art dealer in the world. Collectors talked about acquiring 'a Castelli', rather than a Johns or one of his other gallery artists.

Though early success may come from knowledge, charm, contacts and luck, later success comes because the dealer is branded and trusted. The key to the success of both Duveen and Castelli was the implicit trust that accompanied their brand. The brand gave clients the confidence that neither the artwork nor its price need ever be questioned. Only a few art dealers in each generation ever manage to build a brand that adds both trust and value to what they sell.

The twenty-first-century heir to Duveen and Castelli in modern and contemporary art is Larry Gagosian, agent for Charles Saatchi in the sale of Damien Hirst's shark. Born in Los Angeles and seemingly known to everyone in the art world either as 'Larry Gaga' or just as 'Go-Go', he is famous for his silver hair, beautiful companions and lovely homes. He manages more gallery space than any other dealer in the world. He is also known as one of the few dealers to get away with breaking the unwritten rule that you should not be seen to live better than your artists.

Gagosian achieved his current status in contemporary and modern art through determination and audacity. He began his career as a poster and print dealer in the Westwood Village area of LA, and opened his first New York gallery with Annina Nosei in 1979 – in a first-floor location across the street from Leo Castelli. He gave American contemporary artist David Salle his first show. He opened his own gallery in 1985, in a West 23rd Street building owned by artist Sandro Chia. His first show there involved work he had secured for resale from the famed American contemporary art collectors Burton and Emily Tremaine.

Gagosian obtained the Tremaines' number from directory enquiries in Connecticut, called and made an offer for a painting by Brice Marden – essentially asking Emily Tremaine to bypass her dealer, Leo Castelli. He was turned down, but kept calling Mrs Tremaine, making her feel important – which he said Castelli had not done. She decided she liked him, and let him have the Marden and two other paintings. His first major client was S.I. Newhouse, owner of Condé Nast, to whom he sold Piet Mondrian's *Victory Boogie Woogie*

for \$10 million. He then convinced Newhouse to attend auctions – which he had rarely done before – and to bid publicly through Gagosian. The art world was impressed, and other clients followed.

Gagosian deals in both primary and secondary markets. Where does he make the most money? On paper, from secondary art, because there are few overhead or staff costs involved in reselling. What does he prefer? Most dealers prefer the secondary market, because it comes without any need to reassure and appease insecure artists. But it is not quite that simple, because one of the inducements offered to consignors and secondary-market collectors is the opportunity to purchase over-subscribed work from primary artists. Selling work from those primary artists produces many of the collector contacts that result in secondary-market sales.

Gagosian has an A-list roster of clients that includes Newhouse, Geffen and Saatchi. He represents a long list of branded artists: in the USA Richard Serra, Chris Burden, Jeff Koons, Mike Kelley, and the estates of Andy Warhol and Willem de Kooning. He also represents British artists Rachel Whiteread, Jenny Saville and, for the US market, Damien Hirst.

Gagosian has two galleries in New York, one in Beverly Hills, two in London and one in Rome. In 2008 he will open a gallery in China. His move to London confirmed that city's status as the centre of Europe's contemporary art market. When Gagosian chose to participate in the prestigious Maastricht art fair for the first time in 2006, it was seen as confirmation that the fair had become the most important in the world. The Gagosian galleries do a lot of advertising in art magazines, not so much to attract customers as to reinforce the Gagosian brand, keep gallery artists in the public eye and reassure previous buyers that 'their' artist is being promoted.

Gagosian's major London gallery opened in May 2004 with a show of paintings by Cy Twombly. The show was a stunning example of the power of dealer branding. Gagosian and his staff called collectors and pre-sold the show on the basis of transparencies and computer images, at prices from £300,000 to £1 million.

Equally impressive, Gagosian pre-sold a Tom Friedman show in January 2007 with no phone calls at all, by placing digital images of Friedman's work

on a section of the Gagosian gallery website that could be accessed only by password. Gagosian emailed the password to his select clients. The show sold in less than a day, based only on the on-line images. Friedman's work is conceptual, for example a large Excedrin (a popular pain reliever) box constructed from dozens of cut-up real Excedrin boxes; or papier-mâché balloons, with strings held together by a pair of men's underpants suspended in mid-air. The list prices were as high as \$500,000.

Gagosian also pre-sold £4 million of a Damien Hirst show which opened in London in June 2006, in conjunction with a showing of works by Francis Bacon. Gagosian does not represent the Bacon estate; Faggionato Fine Arts does. But his extensive network of contacts allowed him to assemble an amazing collection of Bacon's work.

Other shows at Gagosian sell out because a gallery employee phones clients and says 'Larry said you need this for your collection.' One former Gagosian employee claims that in about a quarter of the cases, clients say 'I'll take it' without ever asking 'What does it look like?, or 'How much?'

What kind of collector pays \$100,000 or more (sometimes a lot more) for a work of art they may have seen only as an image on a computer screen, or heard of on the phone, or know is from an artist with a limited reputation? The answer is, collectors who trust their dealer in the same way they trust their investment advisor. It's the idea of buying art with the ears rather than the eyes, of buying the artist's expected future value. Selling this way is one of the defining characteristics of the superstar dealer.

With the exception of the late Jean-Michel Basquiat, the Brooklyn-born son of Haitian and Puerto Rican parents, a high-school dropout with no formal art training, Gagosian has neither nurtured nor represented new artists. Basquiat made himself that exception, going to Los Angeles in 1983 where he talked his way into living and working for six months in one room of Gagosian's beach house in Venice. The great trivia aspect of that story is the identity of Basquiat's girlfriend, who lived with them; the then unknown singer Madonna.

Gagosian never followed Castelli's practice of searching out new artists and new 'isms'. His artists came to him from other dealers because he offered more money, association with other branded artists, and better access to

collectors. John Currin moved to Gagosian from his first dealer, Andrea Rosen, after Gagosian brokered the sale of his *Fishermen* to S.I. Newhouse for \$1.4 million, three times Currin's auction record at the time. The work was consigned by New York hedge-fund manager Adam Sender, who had paid \$100,000 for it eighteen months earlier.

A very different dealer model is represented by White Cube in London, a gallery synonymous with its owner, Jay Jopling. Jopling is an Old Etonian and son of Michael Jopling, Baron of Ainderby Quernhow, who was Chief Whip and Minister of Agriculture in Margaret Thatcher's government. In 1991 Jopling began a friendship with Damien Hirst. Hirst has a classic working-class background, but the two became neighbours in Brixton, and both were avid supporters of Leeds United. Hirst was trying to finance production of new work, and Jopling offered the money. It was Jopling who came up with the idea of telephoning post offices in Australia asking them to put up a sign saying 'Wanted, 15-foot tiger shark'.

Jopling opened the first White Cube in May 1993, in Duke Street, St James's, a traditional and expensive gallery area. He gave solo shows to many of the young British artists, including Tracey Emin, and the gallery became associated with the yBas.

Emin appeared on a BBC television show in 1999, doodling pencil sketches of herself masturbating. On one she wrote 'it can just be one big massive cum' in mirror writing. Jopling jumped on camera to announce 'One can buy a unique drawing of Tracey's [at my gallery] for £1,500 to £3,000; she has just had a hugely successful show in New York with her work selling up to £30,000.' The incident was widely reported, and Jopling produced as much publicity for himself and White Cube as for Emin.

In April 2000, Jopling moved White Cube to the gallery's present location in Hoxton Square, an area far from West End London galleries but popular with yBas. The building had housed a publishing company and before that a piano factory. In 2002 two extra floors were added by hoisting a prefabricated unit to the top of the existing structure. Neighbours thought the new addition was a Damien Hirst installation. In 2006 Jopling opened a second 5,000sq ft gallery in a former electricity station in London's West End.

White Cube's approach differs from that of Gagosian or most major galleries. While Jopling represents about twenty artists including Hirst and Emin, Lucian Freud, Jake and Dinos Chapman, and Ellsworth Kelly, he does not show them at regular intervals, nor does he have a contract with any artist. Each is a free agent for whom White Cube is accepted as their principal UK dealer. Jopling helps arrange exhibitions for his artists worldwide.

Seventy per cent of White Cube's shows are for overseas artists who are being considered for representation, the art world version of a football trial, with collectors as talent evaluators. Other galleries give artists trial shows, but usually these represent only between 5 and 10 per cent of gallery presentations. For most of the White Cube triallists, they will be one-off shows. Because White Cube shows are so unique, each attracts extensive press coverage. Jopling says he does not choose artists from any standard profile but responds to work that is brought to him. He looks for art that will be relevant in forty years.

For a hot artist, the dealer's waiting list for their work is never first come, first to purchase. Gagosian or White Cube do not sell a painting by a really hot artist; they 'place' it. They then circulate information on which museum or collector has demonstrated faith in the artist by acquiring. Both formal and informal agreements between dealers and artists allow the dealer to discount 'where it is worthwhile to place the art in an important collection'. Museums demand and get even larger discounts, arguing 'You can ask even higher prices for this artist's work once it is represented in the museum's collection.'

First in line for placement are museums, then branded private collectors such as Steve Cohen or Charles Saatchi. Next in line are collectors with whom the dealer has a long-standing relationship, where part of the quid pro quo is future business, or 'young collectors' who are being encouraged. A new buyer with no track record at the dealer has little chance of being high on the list to purchase a hot artist. Actually this new buyer has little chance of even seeing the hot paintings, which will be kept in a small private room. What is hung in public areas is available for purchase but of lesser significance.

When an artist is hot, the economist's concept of supply and demand does not apply. If the artist can create enough work to show simultaneously at several galleries and art fairs, the greater buzz produces higher prices. Each show, each fair, each mention in an art magazine, each critical appraisal produces more talk, more visitors and more jumping on the bandwagon. The reassurance given by the dealer's brand is reinforced by the behaviour of the crowd. As critic Robert Hughes says of New York collectors: 'Most of the time they buy what other people buy. They move in great schools, like bluefish, all identical. There is safety in numbers. If one wants Schnabel, they all want Schnabel, if one buys a Keith Haring, two hundred Keith Harings will be sold.'

White Cube has not expanded to other cities and has no plans to do so. Its reasoning is that branded artists do not want the same gallery representing them in several countries, because that gallery loses some of the incentive to promote their work. Better to have galleries in different countries competing for the artist's work, each bringing the work to art fairs, and each wanting to show the work through foreign partner galleries.

Gagosian exemplifies the opposite approach – dealers who open galleries in many cities and spend part of each week in first-class airline seats. Opening galleries internationally used to be limited to a very few dealers with large financial resources and branded artists. Now both new and established galleries want an international presence, which offers the ability to make better use of their investment in art and artists across markets. Most expansion is by European galleries wanting to get closer to American collectors, curators and artists, for example FA Projects (London and Los Angeles) and Yvon Lambert (Paris and New York). Other galleries, such as Lothar Albrecht (Frankfurt and Beijing) or Patrick Painter (Los Angeles and Hong Kong), want to take their artists to locations where new fortunes are chasing contemporary art. Some expansion, such as Gagosian's to Los Angeles and London, is undertaken to avoid the problems inherent in sharing an artist with foreign galleries - the timing of a show, and who gets the best work. For a branded dealer in a strong market, there is little financial risk in opening additional galleries. When paintings sell for \$50,000-100,000, three sold-out shows pay for leasing and renovating the new gallery.

Opening a foreign gallery allows the dealer to approach new artists. In September 2007, Harry Blain opened a branch of Haunch of Venison in

Berlin. His intention was not particularly to sell art – many cities offer a much larger collector community than Berlin. However, the city has a vibrant art scene and Blain wanted some of these artists to be represented in his galleries in London and Zurich. Steve Sacks opened his gallery Bitforms in Seoul, South Korea, to attract new Asian artists. New galleries also offer a place to preview art and artists before presenting them in New York or London.

The disadvantage of expansion is that the dealer spends so little time at the home gallery that important artists and collectors become annoyed. For most superstar galleries, the director is the gallery. Marc Glimcher, president of PaceWildenstein in New York, opened galleries in Los Angeles and London in the mid-1990s and closed both a few years later because they languished without his presence. He says that the foreign gallery model works for Gagosian only because 'Larry has a special talent; clients don't expect to see him, they are happy just getting the aura of Larry.' That may be the ultimate defining characteristic of the branded dealer.

Other than Gagosian and White Cube, who are today's superstar dealers? The table that follows is a consensus top ten list of contemporary art dealers in London and New York, with sample artists for each. What about all those dealers below the branded few? That is the subject of the next chapter.

THE SUPERSTAR DEALERS

LONDON

Larry Gagosian (Jeff Koons, John Currin)
Haunch of Venison (Bill Viola, Wim Wenders)
White Cube (Damien Hirst, Tracey Emin)
Lisson Gallery (Anish Kapoor, John Baldessari)
Sadie Coles (Sarah Lucas, Richard Prince)
Victoria Miro (Peter Doig, Chris Ofili)
Hauser and Wirth (David Hammons, Tony Smith)
Maureen Paley (Wolfgang Tillmans, Gillian Wearing)
The Approach (John Stezaker, Gary Webb)
Stephen Friedman Gallery (Tom Friedman, David Shrigley)

NEW YORK

Larry Gagosian (Damien Hirst, Takashi Murakami)

PaceWildenstein (Robert Rauschenberg, Chuck Close)

Marian Goodman (Gerhard Richter, Jeff Wall)

Paula Cooper (Carl Andre, Robert Wilson)

Gladstone (Matthew Barney, Richard Prince)

David Zwirner (Luc Tuymans, Lisa Yuskavage)

Matthew Marks (Andreas Gursky, Ellsworth Kelly)

Sonnabend (Jeff Koons, Clifford Ross)

Luhring Augustine (Christopher Wool, Janine Antonini)

Gavin Brown (Peter Doig, Franz Ackermann)

The art of the dealer

Bernard Berenson [the critic] said to Bauer the antique dealer: 'A man as scholarly as yourself shouldn't be a dealer, it's horrible to be a dealer.' To which Bauer replied, 'Between you and me there's no difference; I'm an intellectual dealer and you're a dealing intellectual.' Berenson never forgave him that.

René Gimpel, Diary of an Art Dealer

We act as a sort of midwife trying to represent the desires of our artists and the needs of private collectors and museums.

Brent Sikkema, New York dealer

AGOSIAN AND WHITE Cube and maybe twenty others are the branded galleries at the peak of the dealer pyramid. They represent artists who have achieved great success – but these are far less than 1 per cent of all contemporary artists. The majority of artists seek and settle for representation with less well-branded dealers.

There is a traditional series of steps that new artists typically follow in trying to gain gallery representation. An artist's first show is usually held at the studio where the art was made, or in a small artist-run space visited by collectors and dealers. There the artist waits to be discovered by a mainstream dealer whose instinct is that the work will be well received. The mainstream dealer is one level below the branded dealer, and serves as gatekeeper to the world of contemporary art, determining who will be shown and who will not. Each mainstream dealer typically represents between fifteen and twenty-five artists, who

might each get a one- or two-person gallery show every eighteen months. The dealer organizes the show and promotes the artist with collectors, art writers and museum curators.

The first show with a mainstream dealer is the artist's springboard to joining the serious art community. It is at the mainstream gallery that the art is first seen and purchased by most serious collectors. The gallery expects to lose money on the first two or three shows of the artist's work, but is prepared to absorb a loss in return for the promise of profit on later shows and on resales in the secondary market.

If the art is successful at the gallery level it will be shown at minor art fairs and, later, by mainstream galleries in other cities. The work will then be described and discussed in art magazines. Artists who do not find mainstream gallery representation within a year or two of graduation are unlikely ever to achieve high prices, or see their work appear at fairs or auctions or in art magazines.

The high cost of opening a mainstream gallery, and the extended period of negative cash flow that follows the opening, usually means a wealthy backer is required. The financier is sometimes simply buying first place in line to acquire new artwork, without paying the dealer's markup. When Castelli's manager Ivan Karp left the gallery to set up his own, he claimed to have received a dozen calls the first day, offering financial support. Every caller wanted first right of refusal on new work. This sort of financing creates an obvious conflict of interest between clients, the artist and the gallery.

Without a wealthy patron, a new gallery has a precarious future. Conventional wisdom in the art world is that four out of five new contemporary art galleries will fail within five years. Ten per cent of galleries established for more than five years also close each year.

Few dealers survive the first few years on primary-market sales alone. The dealer may have previously made a living on secondary-market sales and will continue to do so. Harry Blain spent five years dealing in the secondary market as Blain Fine Arts, before venturing into primary artist representation as Haunch of Venison. Even then, he entered the business with a group of first-rate artists inherited from the Anthony d'Offay Gallery when D'Offay retired.

Mainstream dealers are found in the same cities as branded dealers, especially New York and London. These cities offer a concentration of wealth, high salaries, artists and galleries to shape tastes, and convenience for collectors who want to gallery-shop. Can you establish a strong mainstream gallery in a secondary location? Some exist in Zurich, Frankfurt, Chicago, Toronto and other large cities, but it is more difficult. A dealer and his artists are better off as the fiftieth gallery in New York or London than as the first in Baltimore or Bristol.

The need to be represented by a mainstream gallery explains why so many successful contemporary artists choose to work in New York, London, Los Angeles or Berlin, or at the margin, in Paris, Rome or Zurich. Artists living anywhere else need to be represented by a gallery that takes their work to international art fairs, leading to exchange representation with a mainstream gallery in one of these cities.

Below the mainstream dealer are the 'High Street' galleries, which represents artists rejected by or not yet ready for a mainstream gallery, and the artists' cooperative, where artists share display space and share costs. At the bottom is the vanity gallery, where artists pay a fee to have their work shown. High Street galleries, artists' cooperatives and vanity galleries attract no reviews and sell very little. What they do sell will generally have very little resale value. The combination of artists seeking dealers and money seeking art provides an umbrella under which these dealers can open. Some will evolve to handling better art; most will survive a few years and disappear.

The profit model for a mainstream dealer entails the dealer taking most work on consignment. The dealer tries to lose as little money as possible on new artists, making money by selling the new work of established gallery artists and achieving profitable secondary-market sales. New artists are inherently unprofitable: gallery maintenance expenses will be the same as for any show and promotion costs are high, but selling prices will be stuck in the low to middle four-figure zone – and worse, the work may not sell.

Two out of five new artists will no longer be showing in a mainstream gallery five years after their first show, two will have been marginally successful, and one will be quite profitable for the gallery. If the fifth, profitable

artist becomes very successful, she may try to move to a branded gallery or may be lured away with a signing bonus and monthly stipends. Only one artist in 200 – and that is 200 established artists – will reach a point where her work is ever offered at Christie's or Sotheby's auctions.

The mainstream galleries that survive this culling are the ones that have replacement artists available – or are able to attract them. When gallerist Mary Boone lost Julian Schnabel to Pace, she was able to promote David Salle and Eric Fischl. When Salle moved to Gagosian, Boone featured Ross Bleckner.

Sometimes the dealer has a long, formal contract with artists to cover their mutual obligations. Galleries such as New York's Luhring Augustine use a letter of understanding, setting out what each side has undertaken to do. But very often, as with White Cube, there is no written document; the two parties operate on a handshake.

Formal contract or not, all but the most established artists have very little input in the agreement with the dealer. Artists are eager to have their work shown, may be insecure about their own talent, and are excited that a mainstream gallery might show their work. They have little bargaining power and no experience in commercial negotiation. Some contracts even require the artist to share the dealer's costs of promotional outlays like announcements and catalogues. There have been cases where the artist ends up owing the dealer money after a show where only a couple of pieces sold.

Dealer markups in the primary art market are pretty straightforward; the dealer takes 50 per cent of the selling price as a commission. That is an industry standard for both branded and mainstream galleries, and dealers try to stick to it. If the dealer shows an artist who is under contract to another dealer, at least 10 per cent of each sale is returned to the primary dealer. The figure can be as high as 25 per cent if the artist is hot.

The exception to the standard 50 per cent commission is a branded artist showing with a superstar dealer; for these shows, rules and commission rates are often dictated by the artist. By the end of their relationship, Jasper Johns' split with Leo Castelli gave 90 per cent to Johns, 10 per cent to Castelli. Gagosian and White Cube take a 30 per cent commission on Damien Hirst's sales. For many branded artists the rule is 50 per cent to the dealer on sales at

a show or to new collectors, and 30 per cent for sales between shows or to established collectors of the artist's work. Markups in the secondary market can be as low as 5 per cent on an expensive work acquired specifically for a favoured client, and up to 300 per cent on works purchased for inventory.

The markup is the most common area of disagreement between dealer and artist. To the artist 50 per cent seems outrageously high: 'After all, I created the work.' Dealers are seen as undervaluing the artist's training and creative input, and artists are viewed as undervaluing the contribution of the dealer's brand, customer base and promotional activity.

Beyond markups, relationships between dealer and artist are always being reassessed because they involve so many roles: financier, agent, advisor and friend. Often the gallery is developing at the same time as the artist. The gallery may feel the need to upgrade its artists, the artist to upgrade his dealer.

The other major source of mistrust arises when a dealer encourages the artist to channel his creativity into what the market wants, 'more of what sold last month' or 'work that can be featured at a coming art fair'. The artist, on the other hand, naturally wants the dealer to find collectors willing to buy what he wants to create.

Mainstream dealers do not add as much value to art as the branded dealer, but they add some by helping overcome the uncertainty of the contemporary buyer. This was wonderfully illustrated in 2005 at a show held by New York dealer Jack Tilton, owner of Jack Tilton Gallery. Tilton is well respected; the gallery ranks in the upper third of 'mainstream'.

In December 2005 Tilton and his gallery director Janine Cirincione toured the studios of students in Master of Fine Arts (MFA) programmes at Hunter College, Yale and Columbia. They chose thirty works by nineteen student artists for an exhibition called, appropriately, *School Days*. The work included paintings (one entitled *Yale, Bad Idea*), sculpture and video works.

The show was mounted at the gallery on East 76th Street in New York, an historic townhouse where Franklin and Eleanor Roosevelt were married. The opening was attended by Tilton's collectors, *New York Times* reporter Carol Vogel, and every hungry and thirsty art student who could wangle an invitation or stride in posing as a real collector (and thus not be asked to

produce an invitation). Vogel's article the next day quoted Tobias Meyer of Sotheby's as saying that searching for student work had become the art world version of *American Idol*. She also quoted a warning from Robert Storr, dean of Yale's art school: 'These anointed stars are much less likely to mature ... they get sidetracked and confused and are not giving themselves time to grow and develop.'

Tilton priced each student's work at about five times the cost if purchased directly from the artist or at the school thesis show a few months later. He sold out the show. Ashley Hope, an MFA student at Hunter College, sold a painting for \$6,000, an amazing price for a first-time exhibitor. Columbia student Natalie Frank, who had previously exhibited in Chelsea with work at a third the price, sold one for \$16,000. Yale student Logan Grider, whose previous sales record was \$800, sold the painting *My New Home* for \$5,000 to Los Angeles collector Michael Ovitz. Tilton's sales, and the prices achieved, reinforce Howard Rutkowski's wisdom, 'Never underestimate how insecure buyers are about contemporary art, and how much they always need reassurance.'

Like most branded galleries, a few mainstream galleries will advance money to the artist against future sales, or pay a monthly stipend. Both types of galleries offer emergency loans, legal and accounting services, help with book publishing and, as one dealer added, 'alcohol rehab and nanny services'. Neither dealer nor artist really likes the system of advances and loans – the dealer ends up with a mortgage on the artist's future work and the artist feels indebted and resentful.

The advances paid to a successful artist can be substantial. When Peter Halley switched galleries in New York in 2002, a lawsuit resulted and the legal documents stated that he had been receiving a stipend of \$40,000 a month. Several dealers told me that they believe White Cube pays £1.1 million per month in artist stipends, and Gagosian considerably more.

Stipends have another disadvantage. Dealers who offer a high signing fee or monthly stipend to a young artist demand that the artist produce. Artist David Hammonds put this nicely: 'What happens in that situation is that you are tempted by the devil. You are shown everything you could have. All you have to do is part with your soul. I found myself in agony.' Gallerist Mary Boone said, only partly in jest, that her strategy with non-productive artists was to pay

large advances to encourage them to develop expensive tastes. 'Get the artist to buy expensive houses and have expensive girlfriends and expensive wives. That is what drives them.'

Superstar dealers and a few mainstream dealers may also publish a catalogue of the artist's work to accompany an exhibition. This contains high-quality reproductions and commissioned essays by respected critics. The catalogue is intended to document the artist's progress, and has become so important that artists have switched dealers to protest at the failure to produce a catalogue (or in one case that the catalogue produced was not lavish enough).

At some point in the relationship, the developing artist will want to know why his work is not being discussed in the *New York Times* or *ARTnews*, or being shown at the Frieze Art Fair, like that of artists represented by branded galleries. All developing artists want three things apart from money: write-ups in art magazines; placement of their work in art museums; and a retrospective in a highly branded museum. The mainstream dealer has a different concern; heavy promotion may bring sales but may also result in abandonment, if the artist moves up to a superstar gallery. And most artists are uncomfortable discussing relationships with their dealers, even when talking with other artists. This is sometimes explained as embarrassment; if only they were more successful, their clout with their dealer would be greater.

With or without a contract, the artist almost always has an exclusive relationship with a single dealer in each country. Artists may think there is an incentive to sell through multiple dealers, because competition would improve the terms offered by each. They quickly realize that without exclusive representation, a dealer's promotional efforts would also benefit any other dealers handling the same artist – and so no dealer would do any promotion.

Dealers can affect an artist's prices through their activities in the secondary market. When a work appears at auction, some dealers bid up to what it would sell for at the dealership, to protect the gallery market. Some buy back the work to protect the artist from going unsold. Opinion differs as to whether such price support is necessary. Some claim that it an absolute obligation for dealers; others, such as Matthew Panter of Panter and Hall in London, say they have no obligation and won't do it.

Dealers offer discounts in order to move work. It is a common misconception that dealer prices are not negotiable. They are almost always negotiable, even for a hot artist, because dealers need to maintain a sense of gratitude in their collectors. Even with sold-out shows comes the dealer's whispered, 'For you, my valued customer, a ten per cent discount.' And the valued customer responds, 'Might twenty per cent be possible, my friend?' The discount is justified as the equivalent of an art advisor's commission. For art displayed between an artist's shows, a standard ploy among collectors is to say to the dealer, 'I like the work a lot, make me an offer I can't refuse.' It works, sometimes even at Gagosian and White Cube.

A painting can be sold with or without reproduction and exhibition rights – these can be retained by the artist, or by a subsequent buyer. When a branded dealer sells a work, rights are usually retained for the artist. A mainstream or High Street dealer who sells a work may pass all rights to reproduce or exhibit to the buyer. This is risky, because subsidiary rights can be worth far more than the painting itself.

In the mid-1990s an investor paid \$8 million for American realist painter Andrew Wyeth's paintings of model Helga Testorf, together with the associated subsidiary rights. The existence of the Helga paintings was unknown for many years; their discovery made the covers of both *Newsweek* and *Time* magazines because of a rumoured relationship between artist and model. The investor received \$1.2 million for three subsequent museum shows, \$2.8 million in royalties for a book-length museum catalogue that sold 400,000 copies, and \$40 million on reselling the paintings to a private Japanese collector. He retained reproduction rights for posters and lithographs, valued at \$9–12 million.

An artist who has achieved success in one country would like to gain representation in others. Sometimes this comes with a gallery such as Gagosian showing the work in other cities, or with White Cube arranging for a show through partner galleries. Sometimes the artist just signs different contracts in different cities. When an artist has different representations a problem is created. Each gallery wants enough work to present a solo show every two to three years, and still more to show at each art fair they attend.

Creativity and quality can both suffer. The artist may end up being shown on four different stands at, say, Art Basel, with different price levels and discounting policies. Four different galleries will then contact collectors and museum curators, saying 'Come and see this artist at my stand.' Buyers may play galleries against each other, claiming they receive a 20 per cent discount on the artist from one gallery and demanding the same from others.

There is one more type of dealer. Usually also located in a major city, a private dealer or art advisor is just that. She typically works from an apartment, as an agent in the secondary market or as an advisor to a collector. Most private dealers were once public dealers or auction-house specialists, curators or academics. The agent will contact anyone she knows who has purchased a significant painting at auction, saying 'You paid twenty million, would you flip it [make a quick resale] right now for thirty?' She then adds the work to her 'sell' list, offering it at \$35–40 million, hoping to negotiate no lower than \$33 million to provide a good commission. She emails or calls dealers attending a major art fair, asking for descriptions and images of the work to be shown, so at the opening she and her client can sprint directly to works of interest and try to reserve them.

On a more routine level, advisors scout sales rooms, attend Maastricht, Art Basel and a raft of lesser art fairs, and review student shows for clients who do not have the time or interest. They try to stay current on insider information and art trends so they can advise on what Charles Saatchi is buying, and what show might be pending at the Guggenheim.

Private dealing developed in the nineteenth and early twentieth centuries when the new class of industrialists and merchants thought they had inadequate art background to commission work directly from artists, and chose instead to go through informed intermediaries. Some dealers became very wealthy. In 1879, at the age of thirty-one, Paul Gauguin earned 30,000 francs a year (about \$125,000 today) as a stockbroker, and as much again from selling the art of his teacher, Camille Pissarro, to other brokers. After the stockmarket crash of 1882 Gauguin lost his job as a stockbroker and the art market collapsed. He was forced to become a full-time artist.

Advisors have been described as 'part broker, part tastemaker, part tour guide and part shrink'. They are also described as weasels, parasites, and

worse. They are tolerated by most dealers because they occasionally deliver new collectors, but in private, dealers have as little good to say about advisors as they do about auction houses.

Their advantage is a wide network of connections, expertise and focus; their disadvantage an almost total lack of visibility. They are not offered much art, and their lack of financing means that they cannot afford to buy. Many private dealers simply rely on public dealers or private collectors to find pictures to offer on a commission basis.

Private dealers sell their services as consultants, using the argument that collectors need to be wary. Dealers and auction houses, like estate agents, represent sellers, not buyers. Their business interest is in securing the highest price and commission, not in looking after the buyer. Nowhere on an estate agent's listing do you find information about the local crime rate, or the incinerator located a mile upwind. Nowhere on a dealer's wall or in an auction catalogue does the collector find information on the painting's condition, or the validity of the price estimate, or whether it has recently been bought-in (retained by the auction house), or on any concern about authenticity.

Advisors are useful in gaining access for a collector to primary-market art from artists with a long waiting list. Along with extolling the virtues of the artist to the collector, they sell the merits of the collector to the gallery – and are listened to if the dealer wants to cultivate their future business. Advisors also serve on the selling side, aggregating market information, trying to predict when an artist's price curve has levelled or started to decline, and recommending when to divest.

As an advisor, the private dealer is neither dealer nor agent, but receives an annual retainer, or a commission of between 2 and 10 per cent of the value of the art involved, or some combination of these. The advisor may simultaneously ask for a 1 or 2 per cent 'finders or consignors' fee from an auction house or dealer. Taking money from both sides is not considered unethical so long as the client knows and agrees.

The dealer-client relationship can deteriorate, leading to distrust and expensive litigation. Lawsuits involving collectors, consignors, artists and dealers are not uncommon. Manhattan attorney Peter Stern, whose practice

involves the art market, describes four cases. In the first, a collector who consigned work to a gallery discovered the picture had been sold only when a family member saw it hanging in a museum. The gallery had neither notified nor paid the consignor. In the second case the consignor saw his painting at a friend's cocktail party and asked the sale price. This turned out to be 50 per cent higher than the gallery had declared. A third case involved a gallery assistant creating invoices with two different prices and accidentally switching them when posted, thus revealing the true selling price to the consignor. A fourth case involved a gallery that had pledged or sold rights to almost twice as many of an artist's paintings as it had access to.

If you just want some background on the art in a branded or mainstream gallery without being patronized or pressured, never start by talking to the carefully turned-out young lady behind the reception desk, known in the art world as a gallery girl. She is last spring's art history graduate from a local university who got the job through her father's clout. Unlike her counterpart working at an auction house, she is allowed hennaed hair and body piercings. She spends her day reading *The Art Newspaper*, answering the phone, and saying 'Can I help you?' in a tone of voice intended to cause window-shoppers to flee. She has been instructed as to which classes of people to be explicitly rude to: artists wanting to have their slides reviewed, student groups, and women with large hats, cheap handbags or who arrive in groups larger than two. She is told not to say anything meaningful to anyone who carries an authentic designer handbag or might be an actual collector, but to call the manager immediately. If you insist, she will offer you a guest book to sign, but the gallery will never mail anything to you. Snub her as she snubs you.

Instead look for a gallery guard, usually positioned in the room furthest from the entrance. Talk to the guard. No one else does, so he has never been told not to talk. Ask him what he likes. The guard swaps gossip with the receptionist, knows what has sold, what is overpriced, and what the gallery owner and artist fight about – he overhears everything, but at work he is invisible.

Art and artists

Art tells you things you don't know you need to know until you know them.

Peter Schjeldahl, art critic

Art is sexy! Art is money-sexy! Art is money-sexy-social-climbing-fantastic!

Thomas Hoving, former director, Metropolitan Museum of Art

ONTEMPORARY ART HAS achieved its current importance in resale markets in part because the best examples of other schools of art are disappearing from the market, and are never again likely to appear for sale. For centuries, the best of the work of the past appeared regularly at private sales or at auction. Today, when an important non-contemporary work appears at auction there is a price explosion. A 1918 Modigliani portrait, Le Fils du concierge, which sold at auction for \$5.5 million in 1997, resold in 2006 for \$31 million. A wonderful Cezanne watercolour, Nature morte au melon vert (1902-6), was sold at Sotheby's London for £2.5 million in 1989 and resold at Sotheby's New York in May 2007 for \$25.6 million. A minor Gauguin, Cavalier devant la case (1902), which sold at Christie's London in June 1998 for £969,000, was resold at Sotheby's New York in May 2007 for \$4.9 million. Examples of modern and Impressionist art that would never have been included in prestigious evening auctions a decade ago now both appear and bring seven-figure prices.

Two things contribute to the shrinking supply of traditional art. The first is the worldwide expansion of museums as donors seek immortality and cities seek respectability and increased tourism. Art is donated to museums, a few of these works will someday be deaccessioned but most – and the best – to be hung or stored, never to return to the market. The past twenty-five years have seen a hundred new museums around the world, each intent on acquiring, on average, 2,000 works of art.

Second is the parallel expansion of private collections. Over the past fifteen years the number of wealthy collectors has multiplied twenty times – and many of those collections will end up in museums rather than be resold. There will always be a few Impressionist and twentieth-century works offered, but the quality declines as more of the best art resides in museums and long-term collections.

As awareness of scarcity grows, both museums and private collectors face a 'last chance' situation every time a major work comes up for sale. Fearing they may never have another opportunity to add a certain artist or period to their collection, they purchase without consideration of past prices. Logically the shortage of earlier work should not influence the price level for contemporary art by living artists, as there is always more being produced. But it does. Contemporary art has evolved to be the hottest segment of the art market.

Another result of scarcity of branded work is that the role of aesthetics in judging art decreases. Paintings are described in terms of the mystique of the artist, who else collects the work, and recent prices achieved by the artist at auction. Yves Klein, who died in 1962 at the age of thirty-four, painted a series of eleven monochromatic works that were probably intended for meditation. At Christie's London in June 2006, a Klein work called *IKB 234*, a canvas painted a unique solid blue, sold for £994,000 (\$1.8 million). IKB stands for International Klein Blue. Klein's work is as far as one can go from the requirement that the artist be able to draw, or balance colour.

What did Christie's catalogue say about this solid blue canvas? 'These works allowed the viewers to bathe in the infinite, in the luminous spiritual realm of the Blue. Influenced by his experiences of Judo, his interest in Rosicrucianism, his fascination with the age of the atomic, Klein had created paintings that have no

frames and therefore no edges, and are thus windows into the eternal and endless spiritual realm.' Imagine being offered a window to the eternal for just $\pounds 994,000$. That is an example of creative catalogue marketing, and the strange facts that art marketers think collectors find persuasive.

Sometimes a dealer or auction house will claim that a work of contemporary art has meaning, that an artist such as Andy Warhol is a social commentator. Critics and curators may debate what a work means; most collectors just want to hang a work that touches their soul. Experienced collectors do not spend much time worrying about meaning. If the work is expensive enough that the dealer or collector is asked, they will probably just invent an elaborate legend.

So who are the great contemporary artists? Again, it depends whom you ask. Philippe Segalot, a New York art consultant and former manager of Christie's contemporary art department, says there are no more than ten great artists in any one generation. These ten will see their prices grow, while other artists disappear.

Segalot's twelve artists of the 1980s and 90s (he had trouble narrowing it to ten) are Jeff Koons, Jean-Michel Basquiat (creator of *Untitled*), Cindy Sherman (a photographer), Richard Prince, Felix Gonzalez-Torres (of candy-sculpture fame), Charles Ray, Mike Kelley, Martin Kippenberger, David Hammons, Andreas Gursky, Damien Hirst and Maurizio Cattelan. For the first half-decade of the twenty-first century, Segalot chose Takashi Murakami, Luc Tuymans, Matthew Barney and Robert Gober. Segalot claims that you can pick great artists early; there is no longer a van Gogh syndrome, where it takes years to recognize a genius. Today there are so many dealers, curators, advisors and critics checking new art that artists whose work merits attention are quickly recognized.

I asked this 'Who are the great contemporary artists' question of dealers, auction specialists and other experts. No two offered the same list. What follows is a consensus ranking of twenty-five major contemporary artists – and this list excludes five who are on Segalot's list! Inclusion is partly based on the opinion of experts, partly on auction records, but also on Walter Sickert's oftquoted 1910 comment that the importance to be attached to an artist is found

in the question: 'Have they so wrought that it will be impossible henceforth, for those who follow, ever again to act as if they had not existed?' The reader might notice that there are no women on the list, nor were there any on those of the experts except for Segalot's inclusion of photographer Cindy Sherman. Almost every survey ranks Sherman as the most popular woman artist of the twentieth century, well above Georgia O'Keeffe or Frida Kahlo.

TWENTY-FIVE MAJOR CONTEMPORARY ARTISTS

- 1. Jasper Johns (American, 1930-)
- 2. Andy Warhol (American, 1928-87)
- 3. Gerhard Richter (German, 1932-)
- 4. Bruce Nauman (American, 1941-)
- 5. Roy Lichtenstein (American, 1923-97)
- 6. Robert Rauschenberg (American, 1925-)
- 7. Joseph Beuys (German, 1921–86)
- 8. Ed Ruscha (American, 1937-)
- 9. Francis Bacon (Irish/English, 1909-92)
- 10. Lucian Freud (English, 1922-)
- 11. Cy Twombly (American, 1928–)
- 12. Damien Hirst (English, 1965-)
- 13. Jeff Koons (American, 1955-)
- 14. Martin Kippenberger (German, 1953–97)
- 15. Donald Judd (American, 1928-94)
- 16. Willem de Kooning (American, 1904–97)
- 17. Takashi Murakami (Japan, 1963-)
- 18. Peter Fischli/David Weiss (Swiss, 1952/54-)
- 19. Richard Serra (American, 1939-)
- 20. Antoni Tapies (Spanish, 1923-)
- 21. Maurizio Cattelan (Italian, 1960-)
- 22. Andreas Gursky (German, 1955-)
- 23. David Hockney (English, 1937-)
- 24. Richard Diebenkorn (American, 1922-93)
- 25. Jean-Michel Basquiat (American, 1960-88)

There is no close relationship between the ranking of artists and the prices their works bring. A great work by a contemporary artist can be valued six times as highly as an ordinary work by the same artist. A painting with previous celebrity owners, or one that comes from a major museum, may be worth considerably more than one without that history. Divergent evaluations, together with the mixture of ego, competitiveness and greed in the auction room, is what creates price records. Many records come at auction, and a great many were set in 2006 and 2007. Most records are set by modern and Impressionist artists, but contemporary records are closing in. The contemporary artists on the list of record prices that follows are Andy Warhol, David Smith, Willem de Kooning and Jasper Johns. By the time you read this, new records will undoubtedly have been added.

The highest price paid for a modern work went for Jackson Pollock's *No. 5, 1948*, a 4 × 8ft drip painting. It sold in 2006 for \$140 million in a private transaction negotiated by Tobias Meyer of Sotheby's. Pollock, who died at the age of forty-four, was not a prolific artist, and his best work seldom comes up for sale. The second most expensive work was a 2006 private purchase by Steve Cohen, of Willem de Kooning's 1952–3 *Women III*, for \$137.5 million. Third on the list is Gustav Klimt's *Portrait of Adele Bloch-Bauer I*, negotiated by Mark Porter of Christie's New York but sold privately. At a reported \$135 million, the price was four and a half times the previous high for a Klimt. Until this sale, most art critics and historians would have ranked Klimt as a second-tier modern painter, and that is what his previous auction records suggested. The price illustrates the ease with which art history is now rewritten with a chequebook.

ART PRICE RECORDS

THE MOST EXPENSIVE PAINTINGS SOLD AT AUCTION

Garçon à la pipe (1905), Pablo Picasso, \$104 million, Sotheby's New York, 2004

Dora Maar au chat (1941), Pablo Picasso, \$95.2 million, Sotheby's New York, 2006

Portrait of Dr Gachet (1890), Vincent van Gogh, \$82.5 million, Christie's New York, 1990 (resold privately through a Sotheby's private placement in August 1997 for \$90 million)

Portrait of Adele Bloch-Bauer II (1907), Gustav Klimt, \$87.9 million, Christie's New York, 2006

THE MOST EXPENSIVE POST-WAR WORK SOLD AT AUCTION

White Center (Yellow, Pink and Lavender on Rose) (1950), Mark Rothko,

\$72.8 million, Sotheby's New York, 2007

From Car Crock (Purping Car I) (1964). And the Workel. \$71.7 million. Obviolated.

Green Car Crash (Burning Car I) (1964), Andy Warhol, \$71.7 million, Christie's New York, 2007

THE MOST EXPENSIVE BRITISH PAINTING SOLD AT AUCTION Giudecca, La Donna della Salute and San Giorgio (1840), J.M.W. Turner, \$35.8 million, Christie's New York, 2006

THE MOST EXPENSIVE SCULPTURES SOLD AT AUCTION Bird in Space (1923), Constantin Brancusi, \$27.5 million, Christie's New York, 2005 Cubi XXVIII (1965), David Smith, \$23.8 million, Sotheby's New York, 2005

THE MOST EXPENSIVE PAINTINGS SOLD PRIVATELY

No. 5, 1948 (1948), Jackson Pollock, \$140 million, negotiated sale by Sotheby's New York in 2006 to Mexican financier David Martinez

Women III (1952–3), Willem de Kooning, \$137.5m, private sale in 2006 to Steve Cohen **Portrait of Adele Bloch-Bauer I** (1907), Gustav Klimt, \$135 million, negotiated sale by Christie's New York in 2006, to New York cosmetics heir Ron Lauder's Neue Galerie **False Start** (1959), Jasper Johns, \$80 million, private sale in 2006, David Geffen to Anne and Kenneth Griffin

Peasant Woman Against a Backdrop of Wheat (1890), Vincent van Gogh, \$80 million, private sale by Steve Wynn, 2005

Turquoise Marilyn (1962), Andy Warhol, \$80 million, private sale by Stefan Edlis to Steven A. Cohen, 2007

THE MOST EXPENSIVE SCULPTURE SOLD PRIVATELY

Bird in Space (1923), Constantin Brancusi, \$38.5 million, private sale brokered by New York dealer Vivian Horan to a Seattle collector, 2000 (this is a different version

of the sculpture from the one listed under 'The Most Expensive Sculptures Sold at Auction', above)

THE MOST EXPENSIVE PAINTING PER SQUARE INCH

Madonna of the Pinks (1506–07 and 11×14 in), Raphael, sold by Ralph Percy, 12th Duke of Northumberland to the National Gallery for tax-free equivalent of a taxable £35 million offer from the Getty Museum

For all the publicity it receives, particularly about its high prices, the world of contemporary art is not that big. There are about 10,000 museums, art institutions and public collections worldwide, 1,500 auction houses and about 250 annual art fairs and shows. There are 17,000 commercial galleries worldwide, 70 per cent of which are in North America and western Europe. Average turnover per gallery is about \$650,000, implying gross sales for the primary market and part of the secondary market of about \$11 billion – of which \$7 billion could be considered contemporary art.

The major auction houses sell contemporary art to a value of about \$5.5 billion; private and institutional trading (including private sales by auction houses) and sales through art fairs might amount to another \$5.5 billion. So the estimated value of world contemporary art sales is around \$18 billion per year. That sounds like a lot, but it is only equal to the worldwide sales of Nike or Apple Computer, and half the annual worldwide sales of the Walt Disney Corporation. It equals the gross national product of Iceland.

Contemporary art shows present a good illustration of economists' concept of a negative price. Everyone who visits commercial galleries has played some version of the following game. Walk around the gallery with your partner and ask, 'If we won the raffle and could take home any piece to hang, which would it be?' It is a great way to find out whether you share the same taste in art!

So then, how much would you pay *not* to have to take the raffle prize home and hang it? That is the idea of the negative price – it is like saying 'How much would you pay to have your teenage son not get that dragon tattoo on his forehead?'

The same 'What would I pay not to have to look at that every day?' observation might be made for work in the USA Today exhibition, or for some of the

work at any Christie's or Sotheby's evening auction, or at any high-end gallery. Most people respond to only about one in a hundred contemporary works, and seriously dislike a lot of the rest. But taste and lust are subjective, and rejection should never be construed as disrespectful of art or artist. The work on which you have placed the highest negative price will be purchased by someone, who will then confidently exhibit it to their closest friends.

The art market looks pretty healthy from the standpoint of a branded artist represented by a branded dealer, and OK from that of an artist represented by a mainstream gallery. What does the market look like from the standpoint of all the non-represented artists, or those selling through local or suburban galleries? Most of those artists see the high-priced art market only through art magazines or gallery openings, and in auction catalogues. There are approximately 40,000 artists resident in London, and about the same number in New York. Of the total of 80,000, seventy-five are superstar artists with a seven-figure income. Below those are 300 mature, successful artists, who show with major galleries and earn a six-figure income from art. On the next level down are about 5,000 artists who have some representation, most in a mainstream gallery, and who supplement their income through teaching, writing, or supportive partners.

There are thought to be 15,000 artists walking the streets of London at any one time looking for gallery representation, and the same number in New York. This number actually increases each year as publicity given to the high prices paid for contemporary art attracts more young artists to the profession, and those already seeking gallery representation spend longer before dropping out. Greater perceived demand for art results in greater supply of art producers. Whatever the number looking for representation, the superstar gallery ignores them all and bids artists away from other galleries. Mainstream dealers generally pay little attention to those who knock on their door. Instead they search for new artists by visiting artists' studios and art school graduate shows, or by following recommendations from current gallery artists, collectors or friends. From these sources and from cold calls, a gallery may see slides or completed work from a dozen new artists a week, but take on only one or two a year.

Dealers say they pay attention to tips from their own artists and from museum curators, but pay little attention to critics. London dealer Victoria

Miro says she follows up recommendations from her artists because she respects their opinions – but seldom takes on a new artist this way. Another dealer said she sees a thousand slides a year, visits fifty studios, includes five to ten new artists in her group shows, and from that group adds one each year to the list of regular artists represented by the gallery.

The net result of this process is that there are about 45,000 artists in London and New York who are trying to sell privately or through artist cooperatives or suburban galleries, or who have given up. Many will leave the professional art world by the age of thirty, to be replaced by that year's cohort of art school graduates.

What such artists aspire to is the status and recognition of the branded artist, those few associated with the world of high-end contemporary art. What combination of talent, luck and particularly marketing and branding gets an artist to the very top? The following chapters tell the stories of Damien Hirst, creator of the shark; Andy Warhol; Jeff Koons; and Tracey Emin. None provides an easy template for the aspiring artist.

Damien Hirst and the shark

Becoming a brand name is an important part of life. It's the world we live in.

Damien Hirst, artist

It takes a certain amount of nerve to act as though one knows what is good or, more important, what will be deemed good in the future. It's an article of faith in the art world that some people have an eye for it and some people don't; the disagreement arises over which do or don't.

Nick Paumgarten, 'Days and Nights in Leo Koenig's Gallery', The New Yorker

RITISH ARTIST DAMIEN Hirst, creator of the \$12 million stuffed shark, is one of a very few artists who can claim to have altered our concept of what art and an art career can be. Hirst claimed to be worth £100 million at the age of forty. This means that he was worth more than Picasso, Andy Warhol and Salvador Dali combined at the same age – and these three are at the top of any list of artists who measured their success in money. Francis Bacon, who briefly held the auction record for contemporary British artists, had an estate valued at £11 million when he died in 1992 at the age of eighty-two. It is hard to imagine a greater contrast than the artistic lives of Francis Bacon and Damien Hirst.

Do these amounts mean that Hirst deserves to be discussed in the same breath as Picasso or Warhol? The story of Damien Hirst – his art, his prices, his shark and his client Charles Saatchi – is a good introduction to some of the

objects now accepted as conceptual art and to the role of the artist in marketing and achieving high prices for this art.

Hirst was born in Bristol and grew up in Leeds. His father was a motor mechanic and car salesman, his mother an amateur artist. He first went to art school in Leeds, then worked for two years on London building sites before applying to and being turned down by St Martins in London and a college in Wales. He was accepted by Goldsmiths College in London.

Many art schools in the UK serve the function of absorbing students who cannot get into a real college. Goldsmiths in the 1980s was different; it attracted some bright students and creative tutors. Goldsmiths had an innovative curriculum, one which did not require the ability to draw or paint. The model has been widely adopted.

As a student at Goldsmiths, Hirst had a placement in a mortuary, which he has said influenced his later themes in art. In 1988 he curated the acclaimed *Freeze* exhibition in an empty Port of London Authority building in Docklands, showcasing the work of seventeen fellow students plus his own contribution, a cluster of cardboard boxes painted with household latex. *Freeze* was Hirst's personal creation. He chose the art, commissioned a catalogue and planned an opening party. He raised money for the show from a Canadian company, Olympia & York, which was building the Canary Wharf business complex. When Norman Rosenthal of the Royal Academy said he did not know his way to Docklands, Hirst picked him up and drove him to the exhibition. The *Freeze* exhibition both launched the careers of several yBas and brought Hirst to the attention of art collector and patron Charles Saatchi. The Goldsmiths class which took part in *Freeze* – Hirst, Matt Collishaw, Gary Hume, Michael Landy, Sarah Lucas and Fiona Rae – was perhaps the most successful of all time in the UK in terms of later careers in art.

Hirst graduated in 1989. In 1990 he and a friend, Carl Freedman, curated another warehouse show called *Gambler*, in an empty Bermondsey factory. Charles Saatchi visited the show; Freedman describes him as standing openmouthed in front of Hirst's installation *A Thousand Years*, a representation of life and death in which flies were hatched inside a vitrine to migrate over a glass partition towards a cow's rotting head. The flies were electrocuted en

route by a bug zapper. A visitor could see *A Thousand Years*, and then visit it again a few days later and see the cow's head becoming smaller and the pile of dead flies larger. Saatchi purchased the installation, and offered to fund Hirst's future work.

In 1991, Saatchi funded and Hirst created *The Physical Impossibility of Death in the Mind of Someone Living*. Hirst had described the idea of the shark in an interview in the first-ever edition of *Frieze* magazine. 'I like the idea of a thing to describe a feeling. A shark is frightening, bigger than you are, in an environment unknown to you. It looks alive when it's dead and dead when it's alive.'

Hirst's titles are an integral part of marketing his work, and much of the meaning flows from the title. If the shark were just called *Shark*, the viewer might well say, 'Yes, it certainly is a shark,' and move on. Calling it *The Physical Impossibility of Death in the Mind of Someone Living* forces viewers to create a meaning. The title produced as much discussion as the work.

In January 2005, amid a great deal of art world hype about the sculpture, *Physical Impossibility* was purchased by Steve Cohen. Later in 2005 Hirst agreed to replace the now decrepit shark. He called Vic Hislop, the fisherman from whom he had purchased the first shark in 1991, and requested three more tiger sharks and a great white shark of the same size and ferocity as the original. Hislop actually sent five sharks, one of which he threw in for free. These were refrigerated and shipped to a former aircraft hangar in Gloucestershire. The shark chosen to replace the original was injected with 224 gallons of formaldehyde, ten times the amount used on the first shark and in a stronger concentration. The replacement shark was exhibited at the Kunsthaus Museum in Bregenz, Austria, in *Re-Object*, an exhibition of readymades and pop culture that also included work by Marcel Duchamp and Jeff Koons. In September 2007, the new shark was shipped to the Metropolitan Museum in New York, where it will be shown for a three-year loan period.

Hirst's shark was not the first. A man named Eddie Saunders displayed a golden hammerhead shark in his JD electrical shop in Shoreditch in 1989, two years before Hirst. In 2003 Saunders' shark was put on display in the Stuckism International Gallery in East London under the title *A Dead Shark*

Isn't Art. Stuckists are an international movement encompassing forty countries; they are against conceptual art like sharks, and say they are also against the anti-art art trend.

Saunders emphasized that not only had he caught his shark himself, but it was much more handsome than Hirst's. Saunders offered his shark for sale at £1 million, with an ad that said 'New Year Sale: Shark for only £1,000,000; save £5,000,000 on the Damien Hirst copy'. He received a great deal of media coverage but no offers.

One of the things that give value to a work of art is scarcity, the assumption that it is one of a kind and will never be duplicated. Prints or sculptures can be produced in multiples, but the size of the series is known. To protect the value of Cohen's shark, it might be expected that Hirst would never produce a competing version. But he did. In early 2006, Hirst opened *The Death of God*, his first exhibition in Latin America, at the Galeria Hilario Galguera in Mexico City. Front and centre, there was *The Wrath of God*, another tiger shark in formaldehyde. This was a 5ft shark, the one Vic Hislop had thrown in for free, stuffed and mounted by assistants in Germany working under the artist's supervision. The new shark sold before the show opened, for \$4 million to the Leeum Samsung Museum in Seoul, Korea. There was no public comment from Steve Cohen on the sudden expansion of the shark family, or on the threat posed by the three sharks remaining in Hirst's freezer.

So what does one of the world's richest artists create, besides sharks? Hirst's work falls into six categories. The first group are the 'tank pieces' which he calls his *Natural History* series, and which incorporate dead and sometimes dissected creatures – cows and sheep as well as sharks – preserved in formaldehyde. Hirst describes these as 'suspended in death' and as the 'joy of life and inevitability of death'. A pickled sheep, said to have sold for £2.1 million, followed the first shark.

The second category is Hirst's long-running 'cabinet series', where he displays collections of surgical tools or pill bottles in pharmacy medicine cabinets. In the Mexico City show, Jorge Vergara, president of a Mexican vitamin company, paid \$3 million for *The Blood of Christ*, a medicine cabinet installation of paracetamol tablets. In June 2007 Hirst's *Lullaby Spring*, a

cabinet containing 6,136 handcrafted pills mounted on razor blades, set a record at Sotheby's London for the highest price paid at auction for a work by any living artist, £9.6 million (\$19.1 million), topping the previous record of \$17 million, paid for a work by Jasper Johns, and Hirst's own record, set when the companion piece, *Lullaby Winter*, was auctioned a month earlier in New York for \$7.4 million.

Hirst's third long-running production series consists of spot paintings. These consist of fifty or more multicoloured circles on a white background, in a grid of rows and columns and usually named after pharmaceutical compounds. The allusion to drugs refers to the interaction between different elements to create a powerful outcome.

The spot paintings are produced by assistants. Hirst tells them what colours to use and where to paint the spots, but he does not touch the final art. Which assistant does the painting apparently matters a lot. Hirst once said that 'the best person who ever painted spots for me was Rachel. She's brilliant. Absolutely fucking brilliant. The best spot painting you can have by me is one by Rachel.' Hirst claims ownership of the concept of spot paintings, and once sued British Airways subsidiary Go for breach of copyright after it used an advertisement containing coloured spots. Every UK paper reported the case. In May 2007 at Sotheby's New York, a 76×60 in $(194 \times 154$ cm) spot painting sold for \$1.5 million.

The fourth category, spin paintings, are 'painted' on a spinning potter's wheel. One account of the painting process has Hirst wearing a protective suit and goggles, standing on a stepladder, throwing paint at a revolving canvas or wood base and shouting 'more red' or 'turpentine' to an assistant. Hirst said that the great advantage of spin paintings is that 'It's impossible to make a bad one.' He claims to have tried, using a broom, to smear the colours as the wheel spun, but the painting still looked good. Each spin painting represents the energy of the random. The Mexico City spin paintings differed from previous versions in having a skull in the centre and darker colours.

The fifth category is butterfly paintings. In one version, collages are made from thousands of dismembered wings. Another version has tropical butterflies mounted on canvas which has been painted with monochrome

household gloss paint. The mounted butterflies are intended as another comment on the theme of life and death. These works are constructed by technicians working in a separate studio in Hackney. One of the first butterfly paintings was purchased by footballer David Beckham for £250,000.

Hirst's London dealer, White Cube, has sold 400 butterfly and spin paintings and 600 spot paintings, at up to £300,000 each. The smallest 8×8 in (20 \times 20cm) spot paintings sell in the gallery for £20,000. Signed photographic reproductions of a spot painting entitled *Valium*, in an edition of 500, were sold for \$2,500 each. That begins to explain how Damien Hirst came to be worth £100 million at the age of forty, and why a comparison with Picasso's earnings might be misleading.

Some of Hirst's art incorporates several categories. A cabinet of individual fish in a formaldehyde solution combines stuffed creatures with the cabinet series, but has the same intention as the spot paintings, to arrange colour, shape and form. These too have publicity-producing titles, like Isolated Elements Swimming in the Same Direction for the Purposes of Understanding.

The final category was first shown at the Gagosian Gallery in New York in March 2004. This was a collection of thirty-one photorealist paintings, which caused some art writers to comment, 'Yes, he really can draw!' The show was entitled *Damien Hirst: The Elusive Truth*, and the large canvases filled six rooms of the gallery. Most of the canvases depicted violent death. One was titled *A Crack Addict, Abandoned by Society*; another, set in a morgue, was *Autopsy with Sliced Human Brain*.

In an interview at Gagosian, Hirst pointed out that the artworks were, like the shark and the spot and butterfly paintings, produced by a team of assistants. Each painting is done by several people, so no one is ever responsible for a whole work of art. Hirst added a few brush strokes and his signature. In another interview he said that he cannot paint, that a buyer would get an inferior painting if it was done by him. On the artistic ethics of using four studios and forty assistants to produce 'Hirsts' which he then signs, he has said: 'I like the idea of a factory to produce work, which separates the work from the ideas, but I wouldn't like a factory to produce the ideas.'

Those who praised the show said Hirst was engaged in a meditation upon death in the tradition of Marcel Duchamp and Andy Warhol. *Village Voice* art critic Jerry Saltz commented: 'The best that can be said about these canvases is that Hirst is working in the interstice between painting and the name of the painter: Damien Hirst is making Damien Hirsts. The paintings themselves are labels – carriers of the Hirst brand. They're like Prada or Gucci. You pay more but get the buzz of a brand. For between \$250,000 and \$2 million, rubes and speculators can buy a work that is only a name.'

Every work was sold on the first day of the Gagosian show, the top price of \$2.2 million almost equalling Hirst's record at the time, achieved for a medicine chest sculpture. Hirst emulates fashion designers in also selling a diffusion line. Visitors unable to afford the paintings or the signed prints at Gagosian could purchase T-shirts.

Because branding raises the value of the ordinary, the public activities of a branded artist like Hirst often end up being about money and publicity. On New Year's Eve 1997, Hirst and friends Jonathan Kennedy and Matthew Freud (related to painter Lucian Freud and, distantly, to Sigmund Freud) opened a bar and restaurant called Pharmacy in Notting Hill. Prada designed the uniforms and Jasper Morrison the furniture, while Hirst filled the restaurant with medicine cabinet sculptures and butterfly paintings. There were cabinets containing latex gloves and suppositories in the lavatories. The cocktails were named 'Detox' and 'Voltarol Retarding Agent'. Hirst installed a lime-green neon cross out front, just like a real pharmacy.

The restaurant attracted an art crowd and celebrity diners Hugh Grant, Madonna and Kate Moss. Pharmacy made headlines when the Royal Pharmaceutical Society sued, claiming the Pharmacy name was confusing the sick. Hirst went along with the publicity by agreeing to change the name every few weeks to a different anagram of 'Pharmacy': 'Achy Ramp' or 'Army Chap'. The challenge was dropped when newspaper coverage waned. The words 'Bar and Restaurant' were added to the Pharmacy name, and the green cross was removed.

Pharmacy closed in 2003. Sotheby's contemporary art specialist Oliver Barker was on a bus when he spotted the fittings being removed for storage, and

suggested an auction. One hundred and fifty items from the restaurant were offered in what Barker described as the first auction in Sotheby's 259-year history made up completely of consigned work by a single living artist. Hirst designed the cover for the catalogue, which itself became a collector's item.

The pieces from Pharmacy, estimated at £3 million, sold at auction for a staggering £11.1 million. Five hundred people attended the auction and thirty-five assistants took absentee bids on phones. The butterfly canvas Full of Love sold for £364,000 to London dealer Timothy Taylor; the underbidder was Harry Blain of Haunch of Venison, representing Christie's owner François Pinault. Blain then outbid Taylor at £1.2 million for a medicine cabinet, $The\ Fragile\ Truth$, one of a pair of six-vitrine medicine cabinets from Pharmacy's bar.

Six Pharmacy ashtrays, expected to sell for a total of £100, brought £1,600. Two martini glasses, estimated at £50–70, sold for £4,800. London dealer Anne Faggionato paid £1,440 for a pair of birthday party invitations. A pair of salt and pepper shakers went for £1,920. Forty rolls of the restaurant's Hirst-designed gold wallpaper brought £9,600. Bidding on a set of six Jasper Morrison dining chairs had reached £2,500 when a standing-room bidder called out '£10,000', a textbook illustration of the 'must have it' culture in which money is no object.

Hirst had negotiated an agreement that allowed him to repurchase his art from the bankruptcy receivers for £5,000. This turned out to be a good investment, given the £11.1 million realized at auction. The Hirst-branded contents of Pharmacy, as auctioned art, produced more profit in one evening than the restaurant had made in six years.

Does Hirst's contemporary art have an intrinsic meaning, or does the meaning just flow from the brilliant titles? Virginia Button, a curator at Tate Modern, says there is meaning. She called *The Physical Impossibility of Death in the Eyes of Someone Living* 'brutally honest and confrontational, he draws attention to the paranoiac denial of death that permeates our culture'.

Many others share Button's thinking about the importance of Hirst's work. Consider the awards he has received over a ten-year period. In 1995 there was the Turner Prize, awarded each year to a British artist under fifty. His prize-winning sculpture involved two glass cases with a narrow passageway

between them. Each case contained one half of a cow which had been split lengthways from nose to tail. This and a calf similarly split were called *Mother and Child, Divided*, illustrating again the marketing value of the title in forcing the viewer to interpret the object. Why a cow? A horse was too noble, and viewers share no affinity with goats.

In May 2003 Hirst became the first artist to have his work sent into space. A spot painting was used as an instrument calibration chart on the British Beagle lander, launched that month as part of the European Space Agency's Mars Express mission (illustrated). The painting was accompanied by a track by the British rock band Blur, to be played from the probe as a signal that the Beagle had landed. On Christmas Eve 2003, Beagle landed on the Martian surface at 225kmph, and lander and spot painting were reduced to rubble. Another spot painting appeared in the Meg Ryan movie Kate and Leopold as representing the art and culture of the twentieth century.

The most incredible Hirst-branding story involved A.A. Gill, feature writer and restaurant critic for the *Sunday Times*. Gill owned an old painting of Joseph Stalin by an unknown hand, which he said 'used to hang over my desk as an aid to hard work' and for which he had paid £200. In February 2007, Gill offered it to Christie's for sale in a midweek auction. The auction house rejected it, saying it did not deal in Hitler or Stalin.

'How about if it were Stalin by Hirst or Warhol?'

'Well then, of course we would love to have it.'

Gill called Damien Hirst and asked if he would paint a red nose on Stalin. Hirst did so, adding his signature below the nose. With the signature, Christie's accepted it and offered an estimate of £8–12,000. Seventeen bidders later, the hammer fell at £140,000. It was, after all, a signed Hirst.

Hirst's most recent and much-publicized project is a life-size cast of a human skull in platinum, with human teeth, from an eighteenth-century skull of a European aged about thirty-five who died between 1720 and 1810. Hirst purchased the skull from an Islington taxidermy shop. Encrusted with 8,601 pave-set industrial diamonds with a total weight of 1,100 carats, the cast is titled *For the Love of God* (illustrated), the words supposedly uttered by Hirst's mother on hearing the subject of the project. Hirst says that *For the Love of God*

is presented in the tradition of *memento mori*, the skulls depicted in classical paintings to remind us of death and mortality. It is also presented in homage to the Aztecs, as he now spends four months each year at his second home in Mexico. He emphasizes it is the context that a buyer will acquire – along with, I would think, a major security problem – and not just the jewelled skull.

At the centre of the forehead is a large pink 52.4 carat, light pink brilliant-cut diamond said to be valued at £4 million – the number changes with the telling. Hirst once said the skull cost £12 million to fabricate; his business manager Frank Dunphy said it cost £15 million. The work was constructed by artisans from the Bond Street jeweller Bentley and Skinner, with Hirst maintaining creative control. Claimed to be the largest diamond commission to a British jeweller since the Crown Jewels, it contains three times as many diamonds as the Imperial State Crown. It went on display in June 2007 in a show called *Beyond Belief* at White Cube's Mayfair gallery in London, in a darkened upstairs room lit only by spotlights directed upon the diamond-encrusted skull. Entrance was by timed ticket, for groups of ten each allowed in for no more than five minutes.

The skull was offered for sale at £50 million, which Frank Dunphy described as being 'on the cheap side'. Cheap or not, the price was certain to produce headlines. White Cube also offered limited edition silkscreen prints of the work, priced at £900 and £10,000; the highest priced is sprinkled with diamond dust.

In September 2007, ten weeks after it went on display, the skull was purchased by a group of investors for what Frank Dunphy said was 'full price, and in cash'. Hirst retained a 24 per cent interest, so the investors put up £38 million for their share. The £50 million total price made the skull by far the most expensive work by a living artist. As part of the deal the buyers are required to display the skull for two years in museums. The buyers said it was their intention to resell the work at a later date.

It will come as no surprise that White Cube considers Hirst the most marketing-savvy artist in the world. No artwork other than *For the Love of God* was ever written about in a hundred publications, a year before it was created. Artist Dinos Chapman called the skull a work of genius – not the art, the marketing.

What does all this tell us? First, that it may today be unimportant whether work is created by the actual hand of a famous artist, as long as the branded artist has conceptual input and the work is associated with his name. Damien Hirst's success rests on a strong brand and a quality-controlled manufacturing operation. A spot painting signed by Hirst has great value, one by his artisan Rachel does not. Also, uniqueness in art may not be as important as has been thought. The second version of the shark produced a very high price.

At the age of forty-two, Damien Hirst is richer, more famous and maybe more powerful than any other living artist. He lives on a country estate, Toddington Manor in Gloucestershire, with his wife, Maia Norman, and their three children. Andy Warhol and Salvador Dali each lost some of their creative spark as money became more central to their existence. Will this happen to Hirst? He says he will stop producing spot, spin and butterfly paintings because while they produce income, they do not develop him creatively. He will continue to do photorealist paintings, and will do at least one more shark.

Does Hirst command power and high prices because he is good, or because he is branded? Is he famous because of his work, because the shock value of his work holds public attention, because Charles Saatchi first made him famous with the high price reported for *Physical Impossibility*, or is he famous for being famous? Is he a social commentator who offers a profound meditation on death and decay? No two critics would likely agree on the answers to these questions. What is clear is that Hirst's work and his flair for marketing and branding cannot be ignored. His brand creates publicity, and his art brings in people who would never otherwise view contemporary art. It also produces a great many bad headline puns in newspapers, the worst being 'Dismembered cows are absolutely tearabull'.

Jerry Saltz says: 'We sneer at Hirst, his dealers and his collectors for having bad taste and bad values; they scoff at us for being old-fashioned, out-of-themoney sourpusses. We all tell ourselves what we already know. The only thing at stake is gamesmanship.' One Christie's auctioneer shrugged when asked about values and said: 'Would I buy a Hirst? No. But we don't dictate taste, the market creates it – we just auction the art.'

Warhol, Koons and Emin

It is a great paradox of our times that visual culture should be vanishing even as the art market soars. Abstract concepts take precedence over what the eye sees. Artists' names matter ever more, and the art to which they are attached ever less.

Souren Melikian, art journalist

Jeff Koons made banality blue chip, pornography avant-garde, and tchotchkes into trophy art, with the support of a small circle of dealers and collectors.

Kelly Devine Thomas, art journalist

AMIEN HIRST HAS generated publicity and high prices for the nature of his art, and for his brilliant titles. Other artists generate high prices for being innovative, for being great draughtspeople, for being celebrities, for being controversial, and for being sexy and controversial. Each can help establish a successful brand. The artist as celebrity is exemplified by Andy Warhol. The artist as controversial figure could be Jeff Koons. Sexy and controversial is Tracey Emin. In becoming branded, each artist has established a role in popular culture, which has translated into high prices in galleries and at auctions.

The idea of artist-as-celebrity may seem strange, but it is just an extension of the superstar concept in music, movies or sport. Every cultural activity has celebrities who become superstars. Celebrity status can be achieved through marketing and resulting well-knownness as well as through professional skill: think of Paris Hilton or Anna Kournikova.

The modern phenomenon of the artist-as-celebrity began in early 1960s New York, when Jasper Johns, James Rosenquist and Roy Lichtenstein were promoted by dealers Leo Castelli, Betty Parsons and Charles Egan. Andy Warhol is a later and hugely more successful example. Twenty years after his death, Warhol is the second most actively traded artist in the world after Pablo Picasso. In 2006, 1,010 Warhol works with a total value of \$199 million were sold at auction – five a day, every working day of the year. Forty-three of those works sold for over \$1 million each – four more than Picasso. As with Hirst, most of Warhol's art was produced by technicians.

His work is known for reflecting the culture of late-twentieth century America, but his principal product was 'Andy'. He created a brand that the press still loves and young artists still revere.

Andrew Warhola was born in 1928 in Pittsburgh, Pennsylvania, the youngest of three sons of Czech immigrant, working-class parents. He dropped the final 'a' from his name when he graduated from the Carnegie Institute of Technology in 1949 and moved to New York for a career as an illustrator and graphic designer. In the early 1960s he began painting what was later called Pop Art, but no one would take him seriously. His early marketing efforts included presenting his work to Leo Castelli, who rejected it as unoriginal. He then tried to donate a *Shoe* drawing to MoMA; the museum returned it.

In 1962 Warhol completed thirty-two hand-painted images of Campbell's soup cans, offered for sale at \$100 each by Irving Blum, legendary director of the Ferus Gallery in Los Angeles. The *Campbell's Soup Cans* exhibition got Warhol his first media publicity, mostly due to Blum's influence. The paintings were displayed on white shelves that ran along the perimeter of the gallery, suggesting the layout of a grocery store. A rival gallery across the street helped by stacking actual soup cans in their display window with a sign 'We have the real thing, only 29 cents'.

There are varying accounts of what happened next. One version of the story is that after just six paintings were sold at \$100 each, one to actor Dennis Hopper, Blum had the sudden inspiration that the set should be kept intact, called the purchasers and bought them back. He then offered Warhol \$1,000 for all thirty-two, payable at \$100 a month for ten months. In a second version

none of the paintings actually sold, and Blum, who had committed to Warhol that he would sell the whole set, negotiated the \$1,000 price.

In 1985 a Japanese agent offered \$16 million for the thirty-two can set. Blum countered with a request for \$18 million and the sale fell through. In 1995 Blum sold the set to the Museum of Modern Art for \$14.5 million.

There have been many theories as to why Warhol painted soup cans. Warhol said that packaged food was a legitimate subject for a generation fixated on business. He added that the real question was whether his own preference was tomato or chicken noodle, thus which was the more valuable silkscreen.

Many of Warhol's critics have said the soup cans were his most important contribution to contemporary art, that once the concept of the can went from the shelf to the gallery wall 'You would never see an ad in the same way, ever again.' The soup cans were the beginning of the artistic concept of commodification.

Warhol later made individual examples such as *Small Torn Campbell's Soup Can (Pepper Pot)* (illustrated), tracing the images directly from photographs and hand-painting within his pencilled marks. On *Pepper Pot* the pencil marks are still visible; this is thought to be intentional. The soup can series helped Warhol to focus on what the media would publicize. *Pepper Pot* was purchased by Los Angeles collector Eli Broad – an industrialist ranked by *Forbes* magazine as the forty-second richest American – at Christie's New York in May 2006, for \$11.8 million. His wife, Edythe, sitting beside him but unaware that he was bidding, is said to have grumbled 'What dumb idiot bought that?', to the huge amusement of those within earshot.

Later in 1962 Warhol began making silkscreen prints of celebrities: Marilyn Monroe, Elizabeth Taylor, Elvis Presley and Jackie Kennedy. The images were based on studio publicity photos. Production involved the transfer of the blown-up photos onto canvas, in multiple images and different colour combinations. Each frame was modified with brush strokes or blurring to create a sequence of slightly different images. Many of Warhol's silkscreen celebrities were portrayed as tragic: Monroe after her death, Elizabeth Taylor involved in battles with substance abuse, and Jackie Kennedy before and after the death of her president-husband.

As these images produced publicity for Warhol, he began to tackle more difficult subjects by reproducing actual disasters. *Five Deaths* from 1963

shows a car of teenage crash victims in party dresses. *Tunafish Disaster* portrays the housewife victims of tainted tuna. His most reproduced disaster silkscreen is *1947 White*, a news photograph of a fashion model who jumped from the Empire State Building and landed on the roof of a diplomatic limousine. By the end of the 1960s, Warhol's subject matter and personality were more newsworthy than his art.

Having achieved celebrity, Warhol switched back to silkscreen portrayals of consumer goods: Coca-Cola, Brillo Pads and more Campbell's soup cans. In 1963 he moved his studio to a larger space and called it The Factory, implying that art could be produced on an assembly line, like commercial products. Paul Morrissey, a film-maker at The Factory, called it The Andy Warhol Industrial Complex.

For a while in the 1970s, his work was out of fashion. Two consecutive shows, *Dollar Sign* and *Hammer and Sickle*, each sold nothing. Warhol supported The Factory by doing portrait commissions. For a fee of \$25,000 he would produce an original portrait, dedicated to making the sitter look glamorous. Warhol's friend Chris Makos described the portraits as involving facelifts and nose jobs. 'I don't know if Mrs Dusseldorf knew she was getting Liza Minnelli's lips but they sure made her look better.' His commercial portraits were derided by other artists, but gave his clients idealized images of themselves.

Warhol signed the work when the client picked it up in the studio, beside celebrity portraits of Mick Jagger, Liza Minnelli and Rudolph Nureyev. The word-of-mouth promotion that resulted produced more commissions. Warhol completed a thousand portraits in his career, more than the lifetime output of many artists. Each work took about a day to complete. His portrait fee rose to \$40,000 in the 1980s.

Warhol initially employed assistants to turn commercial photos into silkscreen multiples, but later contracted out the work to local printers. As he explained, 'Paintings are too hard; the things I want to show are mechanical.' Warhol understood the authentication problems caused by his contracting-out: 'I think it would be great if more people took up silkscreens so that no one would know whether my picture was mine or somebody else's.'

In the first decade of the twenty-first century, long after his death, the Andy Warhol Authentication Board has exactly that problem – judging which works are authentic Warhols. The question is not whether a work is fake or original, nor whether his hand ever touched the work. It is the 'presence of the artist', whether Warhol at least saw the work and approved it on its way to his dealer. Scholars disagree on even that criterion; they make the point that it was exactly the practice of blurring authorship and using mass production that produced his place in art history. This has resulted in chaos for collectors and dealers trying to understand what is authentic. Some pictures received directly from Warhol have been rejected by the Board. It has also rejected works previously authenticated by representatives of the Warhol Foundation, and in some cases it has reversed its own previous opinions.

The Board never officially explains why it denies authenticity, which has led to claims of a conflict of interest. The Authentication Board is paid by, and reports to, the Andy Warhol Foundation, which on the artist's death acquired 4,100 paintings and sculptures. The Foundation releases work to auction and to a few selected dealers such as Gagosian. Warhol's highest-quality work, and early work like the 'disaster series', is in short supply. Other works exist in quantity. It will take thirty years for the market to absorb the work currently held by the Foundation. There are at least fifty *Little Electric Chair* paintings and silkscreens in existence, and more than a hundred electric chair works in total.

In July 2007, Joe Simon-Whelan, the owner of a 1964 Warhol self-portrait, filed a class action antitrust lawsuit in the federal district court in New York City against the Warhol estate, the Andy Warhol Foundation for the Visual Arts and the Authentication Board. The Board had rejected the portrait on two occasions, even though Simon-Whelan claimed it had earlier been authenticated by Warhol's business manager, Frederick Hughes. The suit alleges that the defendants monopolize the market for Warhol works, and was filed as a class action so that the owners of Warhols could join in a single lawsuit. If the Foundation and Authentication Board lose, damages could be in the hundreds of millions of dollars, and the judgement might lead to hundreds or thousands of other Warhols being brought forward for authentication and offered at auction.

The number of Warhols has not detracted from his importance in the contemporary art market, nor from his high prices. The work produced between 1962 and 1967 – the soup cans, celebrities, disasters and self-portraits – is widely regarded as genius and as responsible for altering the course of modern art. These works fetch the highest prices.

For almost a decade, Warhol's auction record was the 1964 silkscreen *Orange Marilyn*, sold by Sotheby's in 1998 for \$17.3 million. Three works had sold privately for between \$25 and \$28 million: the 1961 *Dick Tracy and Sam Ketchum* was bought by New York financier Henry Kravis from David Geffen, and the 1960 *Superman* by Steve Cohen, both sales brokered by Larry Gagosian. *Four Race Riots* was sold through New York's Acquavella Gallery.

Then in May 2007 his auction price record exploded. As described earlier, *Green Car Crash (Burning Car I)* was offered at Christie's New York with an estimate of \$25–35 million, and sold for \$71.7 million – four times the previous record for a Warhol. *Green Car* shows repeated images of an overturned burning car. Part of its value came from collectors' concern about 'last chance'. Warhol created five car-crash silkscreens between 1962 and 1964 for his disaster series. Three are in museums, and the fourth is much smaller.

The 1964 Marilyn silkscreens included a series called *Shot*, another example of Warhol marketing. Shortly after a set of Marilyn silkscreens was produced, a friend of Andy's named Dorothy Podber showed up and asked if she could shoot one. Andy said yes, and was stunned when she drew a gun and drilled a hole through the forehead of the first in the pile – and two others stacked behind. Rather than discarding the three and starting again, Warhol publicized the story, had the works restored, renamed the series *Shot Red Marilyn* and raised prices. In later auctions the *Shot Red* works brought double the price of other *Marilyn* silkscreens.

Warhol denied that there was any social criticism intended in his work. The question focused on the *Electric Chair* series of paintings and silkscreens. Although not identified in the work, the electric chair in the photograph Warhol used is the one in which Julius and Ethel Rosenberg were executed in 1953 for passing nuclear secrets to the Soviet Union. There were debates over whether the three doors shown represented the goals of criminal justice – retribution,

imprisonment and deterrence – or whether they represented heaven, purgatory and hell. Warhol insisted 'No meaning, no meaning', a denial likely intended as another form of marketing.

All his life, Warhol worked on perfecting an androgynous look. In 1981, at the age of fifty-three, he started to do fashion modelling, first for the Zoli Agency and then for the Ford Modelling Agency. In 1986 he appeared in commercials for a financial services company, sitting in front of his own 1986 Fright Wig Self-Portrait, with the caption 'I thought I was too small for Drexel Burnham' (illustrated). Drexel claimed that the Warhol ads were not run to attract business, but to add an element of cool to their image, and to make employees feel better about where they worked. Warhol tried unsuccessfully to convince the company to adopt his dollar sign silkscreen as the Drexel Burnham symbol.

Just before the Drexel Burnham commercial, one branded collector rediscovered Warhol and began to quietly buy up his work – and then went public in purchasing a *Triple Elvis* at Sotheby's for \$125,000. The buying was noticed, and when Larry Gagosian showed the *Oxidation Paintings*, made by urinating on canvases covered with ferrous oxide, other branded collectors – Thomas Ammann and Asher Edelman – bought, and others followed. The original branded buyer? Charles Saatchi.

Warhol died on 22 February 1987 of post-operative complications following routine gall bladder surgery. One of his last public statements was: 'Death means a lot of money; death makes you a star.' It did. During his lifetime he never received more than \$50,000 for a work, although several of his earlier works had sold for more at auction. This was at a time when Roy Lichtenstein and Robert Rauschenberg were getting five times as much. Warhol's fame grew after his death and with it, the prices paid for his art.

Awareness of the Warhol brand was such that three years after his death, Andy's brother Paul Warhola mounted an exhibition of posters of a can of Heinz vegetarian beans, priced at \$550 and signed 'Andy Warhol's brother Paul'. Warhola had spent his working life as a scrap-metal dealer and chicken farmer and had no particular talent for art. Instead he used Andy's technique of silkscreening from a photograph. The bean cans sold. Paul next created his

own signature works of art, made by dipping chicken feet in acrylic paint and walking them over a canvas. That edition sold out at \$5,500. He then offered a line of Warhola T-shirts.

Warhol's legacy has continued to grow in parallel with his prices at auction. In mid-2006 there was a large Warhol show in Moscow and a simultaneous show, curated by film director David Cronenberg, at the Art Gallery of Ontario in Toronto. Two documentary films were released: the widely panned *Factory Girl*, in which Sienna Miller plays Warhol's muse Edie Sedgwick; and a four-hour documentary on his work by Ric Burns. Two new books were published; one, *Andy Warhol Giant Size*, had 2,000 illustrations and weighed 15 lb. No other artist of his era comes even close to this kind of celebrity.

The Warhol Foundation profits by licensing his work for almost any purpose. Snowboard manufacturer Burton produced a limited edition collection of boards, boots and bindings featuring Warhol dollar signs, self-portraits, flower pictures and portraits of Edie Sedgwick. In December 2006, Barney's Department Store in New York offered limited edition Campbell's Tomato Soup cans, containing condensed soup and bearing replica labels in the colours of Warhol's original art. A set of four cans cost \$48, of which \$12 went to the Foundation.

If Warhol is the next Pablo Picasso (a strange comparison but a common auction-house claim), then Jeff Koons is claimed as the successor to Warhol. Koons followed Warhol, and took artist self-marketing to a new level. Koons is a fifty-two-year-old American from York, Pennsylvania, who came to New York in his twenties as an unknown artist, had a breakthrough exhibition in the East Village in 1985, and today lives in a thirteen-room townhouse on Manhattan's Upper East Side. You may have read about or even seen one of his works, a 44 ton, 43ft tall West Highland terrier in long-term residence in downtown Manhattan.

Koons is both an art world brand and legend. He has been called the Ronald Reagan of sculpture; Teflon coated, and bland in the same way a fox is bland. Like Warhol and Hirst, his work is created by technicians under his supervision. Through a career that started with selling memberships at the Museum of Modern Art ('I was the most successful salesman in the Museum's

history – I brought in \$3 million a year'), and continued when he financed his artistic career by working as a Wall Street commodities broker for five years, Koons acquired a great instinct for self-promotion. He has retained the concept of art as a commodity to be promoted. He uses Wall Street phrases which elicit horror in the art community like 'increasing my market share' to describe why he places work in so many gallery shows, and 'the great artists are going to be the great negotiators'.

Most of Koons' work is industrial sculpture and installation. He first became famous for exhibiting manufactured products such as *New Hoover*, *Deluxe Shampoo Polisher* (illustrated), a shampoo polisher in a vitrine. By moving such objects as polishers and vacuum cleaners from the department store to the gallery he recontextualized them, as Warhol did with soup cans.

On 15 May 2001 a sculpture by Koons of pop star Michael Jackson and his pet monkey Bubbles, 3ft tall and 6ft long, was sold at Sotheby's contemporary art auction in New York. Koons claims this is the largest porcelain piece ever produced. *Michael Jackson and Bubbles* was created in 1988 from a publicity photograph. Like all Koons' sculpture, *Michael Jackson* has perfect casting and glowing surfaces. The sculpture was sold to Norwegian shipping owner Hans Rasmus Astrup for \$5.6 million, at the time a record auction price for any living sculptor. That is a higher price than August Rodin, Henry Moore or Constantin Brancusi – the last considered the greatest sculptor of the twentieth century – received for any work during their lifetimes.

Normally the fact that there were two other identical casts of *Michael Jackson and Bubbles* would have limited its price at auction. Sotheby's turned this around by identifying the owners of the other versions as the San Francisco Museum of Modern Art, and Greek collector Dakis Joannou. 'To join such an attractive family warrants a premium', said Sotheby's, and they got one. Astrup donated the sculpture to the Astrup Fearnley Museum of Modern Art in Oslo.

Koons' other work includes a 10ft tall, stainless-steel *Balloon Dog* that weighs 1 ton; basketballs suspended in a fish tank; a vacuum cleaner with fluorescent lamp which mounts on a wall; and *Pink Panther* (illustrated), a

porcelain sculpture of the movie character in the arms of a buxom blonde. When he needed a little media promotion, Koons volunteered that *Panther* was about masturbation: 'I don't know what she would be doing with the *Pink Panther* other than taking it home to masturbate with.' The media raced to report the meaning of the new work, with pictures.

Pink Panther, one of an edition of three plus an artist's proof, was sold at Christie's in 1998 for \$1.8 million. To generate publicity, the auction house offered actors strutting around in Pink Panther costumes, accompanied by rock music. The auction price was four times that of any previous Koons work.

In 1991 Koons married Ilona Staller, known as La Cicciolina, a Hungarianborn pornography star and member of the Italian parliament. He said, 'Ilona and I were born for each other. She's a media woman, I'm a media man.' Koons turned their relationship into a sculpture and painting series depicting them in a variety of lovemaking positions – as poodle and sheepdog and as Adam and Eve.

One work, titled *Red Butt*, is a 90 \times 60in (230 \times 154cm) silkscreen depicting the artist having anal sex with La Cicciolina. In 2003, Christie's sold one of the four versions of *Red Butt* for \$369,000; there were nine bidders. The sale catalogue continued the marketing hype that accompanies Koons, by placing the illustration behind a fold-out panel with a warning label: 'The Following Image Contains Graphic Sexual Content'.

Staller left Koons in 1993, taking their son Ludwig to Italy after a long and expensive legal battle. Koons then created the *Celebration* series; seventy-five artisans worked on the 1996 show at the Guggenheim. Koons said: 'I'm basically the idea person. I'm not physically involved in the production. I don't have the necessary abilities, so I go to the top people, whether I'm working with my foundry – Tallix – or in physics.' The series showed toys and childhood themes such as *Balloon Dog*, enlarged to huge proportions.

While Koons is generally regarded as doing his best work in three dimensions, he also produces paintings. Produces is the right term; like Warhol, he seldom touches a paint brush, but he controls each step in the industrial process of producing computer-based images. As with Warhol and later Hirst, many artisans work on each painting.

Some critics praise Koons' work, some ridicule it. Koons has claimed that his work treats profound issues of conscience, to which critic Robert Hughes responds: 'If Jeff Koons' work is about class struggle, I am Maria of Romania.' Historian Robert Pincus-Witten said, 'Jeff recognizes that works of art in a capitalist culture inevitably are reduced to the condition of commodity. What Jeff did was say, "Let's short-circuit the process. Let's begin with the commodity."'

Koons has had an enormous influence on other artists. Damien Hirst put objects in vitrines after Koons did, and had technicians make photorealist paintings as Koons had.

Dealers admire Koons, in part because he is so good at reaching his target market, which he defines as 'really rich collectors'. Auction specialists in contemporary art love his work and want one piece in every major contemporary art auction, because the work attracts media attention. Koons' astronomical prices make other auction items appear pretty reasonable.

The first work in each of his series is placed with a museum or with a branded collector, often at a discount. The sale is usually negotiated before the work is completed. Subsequent work in the series is marketed with the announcement that 'Saatchi, or Broad, or Pinault, or the Museum' has one.

Koons tirelessly promotes himself as a celebrity. Ads for his gallery exhibitions feature photos of himself posing like a teenage rock star, surrounded by bikini-clad girls. He is probably the only artist other than Andy Warhol and Salvador Dali to have held autograph signings. Articles about his work and his life have appeared in *Vanity Fair, People, Time, Vogue, Cosmopolitan* and *Playboy*. Koons produces wonderful quotes: 'Debasement is what gives the bourgeois freedom' and 'Abstraction and luxury are the guard dogs of the upper class.'

Puppy (illustrated), the giant West Highland terrier sculpture mentioned earlier, was first installed outside the Guggenheim Bilbao in Spain, where Basque terrorists threatened to blow it up. In 2006 it was moved to the front of the General Electric building in New York. It is made from stainless steel, with 70,000 petunias, marigolds and begonias in 23 tons of soil. New Yorkers have turned it into a weekend destination trip. Critic Jerry Saltz says, 'It is the rare work of art that laymen can talk about with the same degree of confidence and

authority that those in the art world bring to it.' Why a West Highland terrier? Saltz says that it is a Koons self-portrait; the breed 'wants to be loved, is spunky, extremely intelligent, affectionate, independent, barks a lot, and was bred to hunt and kill small creatures. Except for that last bit, it sounds a lot like Koons.'

Today Koons works in a studio in Chelsea in New York, where he employs eighty-two people. Like Warhol, he runs what is essentially an industrial process. He seldom contributes to painting or casting, but controls each step of his technicians' work. His next project is a full-size reproduction of a Baldwin locomotive to be suspended above the entrance to the Los Angeles County Museum of Art. The Baldwin locomotive has a unique history in the USA. In 1831, jeweller Matthias Baldwin built a miniature locomotive for exhibition at the Philadelphia Museum. The design was so popular that a few months after the model went on display, he received an order from a railway company for an actual locomotive, built to look like the model. Baldwin found partners, and opened the Baldwin locomotive works.

The most recognizable living British artist is not Damien Hirst, but rather Tracey Emin, a very attractive woman who enhanced her branding through self-promotion and bad-girl packaging. Emin first became known for the frank sexual revelation of her confessional works. *My Bed* (illustrated), shown in 1999, has as its themes fertility, copulation and death. Her art brand was reinforced when she appeared in television interviews, apparently drunk. She then posed for Bombay Gin advertisements. Emin's face was shown next to a bottle of Bombay Gin, with the caption 'Bad Girls Like Bombay Gin'. In 2000 she posed nude for Beck's Beer. Neither ad had to identify Emin. How many contemporary artists can the reader identify by their pictures – even fully clothed? Andy Warhol, but who else?

These ads featuring Emin associate her with a commercial product, as an endorsement by a football star would. The advertising and promotion of the product reinforce the artist's brand. A more recent example is *International Woman*, a limited edition of bags produced for Paris luggage label Longchamp. The bags are a take-off on Emin's best-known work, *Everyone I Have Ever Slept With*, a tent embroidered with names of her past lovers. The tent was illustrated and discussed in the press after being destroyed in a

London art warehouse fire in the spring of 2004. Longchamp seized on this fame with catchy Emin phrases – *Me Every Time, You Said You Love Me*, and *Moments of Love* – sewn on each special-edition bag (illustrated). Longchamp sells the bag only in England, and promotes it not because it sells well (it is priced at four times the price of an equivalent leather bag), but to add an element of cool to the rest of the Longchamp line.

Tracey Emin is a serious artist. In August 2006 she was chosen to represent Britain at the 2007 Venice Biennale. The Biennale is the pinnacle of the art exhibition world, the most important of about sixty biennales and triennales held around the world each year. For Venice, ninety countries nominate individual artists to create exhibitions. Being selected is a little like a soprano being offered a lead role at La Scala. Emin's choice was vindicated by the great critical reception she received at the Biennale – although she almost lost her audience when curator Andrea Rosen introduced her work as 'ladylike'.

True, her in-your-face bad-girl sexuality had been replaced by more subtle and intimate confessions, including a work at Venice titled *Abortion: How It Feels Now*, which combined her own writing and a series of watercolours revealing her vulnerability. But in the spirit of the old Tracey Emin, there were also a series of small drawings showing a female with a variety of phallic assailants. In one, a nude female body is suspended upside down. The inscription reads 'studio', which is crossed out and replaced with 'stupid girl'. One work is called *Hades, Hades, Hades,* another *Dark, Dark, Dark.* The *Observer* reported that Emin had produced sixty of the drawings in five hours. No one thought this of much significance, in particular the Museum of Modern Art; Emin's publicist announced that MoMA had put a reserve on thirty of the drawings. Emin and the Venice Biennale are both big brands.

Warhol, Koons and Emin are great examples of 'You are nobody in contemporary art until somebody brands you'. Or until you brand yourself, at which time the world's major newspapers and art magazines will feature your *Pink Panther* sculpture and promote it as something to be taken home to masturbate with, a bargain at only \$1.8 million.

Charles Saatchi: branded collector

There are no rules about investment. Sharks can be good. Artist's dung can be good. Oil on canvas can be good. There's a squad of conservators out there to look after anything an artist decides is art. Charles Saatchi

able to have their interest in an artist move the market for that artist's work, each of the best-known collectors of contemporary art seems to be unique. Most are American, a few European, some Russian, Asian or Middle Eastern. Some are well known, some secretive. Some are stocking villas with art, some are stocking museums, others are storing art in a warehouse for later resale. Probably the best recognized name on any list of branded collectors, and certainly the most interesting, is Charles Saatchi.

Saatchi is a central figure in contemporary art. He is the prototype of the modern branded collector. His purchases are publicized and create an instant reputation for an artist. He fills other roles. Saatchi was curator, financial backer and owner of the art shown in the Royal Academy's 2006 *USA Today* exhibition. He financed the creation of Damien Hirst's stuffed shark. Some claim that Saatchi invented Hirst's art-world persona.

Saatchi has been described as the greatest art patron of his time, as a secondary-art dealer disguised as a patron, and as the only modern collector credited with creating an art movement. His affinity for 'shock art' (think of the work in *USA Today*) helped establish his collector brand. Media articles,

auction houses and collectors may describe a piece of art or an artist as 'collected by Saatchi' or 'owned by Saatchi' or 'coveted by Saatchi'. Each description is likely to drive up prices for the artist's work. Less fortunate is an artist labelled as 'rejected by Saatchi' or 'sold off by Saatchi'.

Saatchi has another current claim to fame. After divorcing his second wife, he married Nigella Lawson, an author and BBC cookery presenter known as the Domestic Goddess, who accompanies Saatchi on his art-purchasing forays. Ms Lawson is stunning. Her role as his partner has further burnished the Saatchi brand.

Saatchi first came to public attention in 1970 when with his brother Maurice, he founded the advertising agency Saatchi & Saatchi. Saatchi is credited with creating the wildly successful 'Labour isn't working' slogan for the Conservative Party's 1979 general election campaign, together with the famous poster image of a long queue of unemployed workers winding across a barren landscape. Earlier he had created a pregnant-man poster for the Health Education Authority, with the slogan 'Would you be more careful if it was you that got pregnant?' By 1986 Saatchi & Saatchi was the largest advertising agency group in the world.

Art commentators like to point out that Saatchi was born in Iraq to Sephardic Jewish parents and that in Arabic, the word *sa'atchi* means trader. His brother Maurice said that the name is actually an acronym for 'Simple and Arresting Truths Create High Impact'. That may describe Charles Saatchi's advertising approach, but not his collecting strategy.

In 1988 Saatchi visited the *Freeze* student exhibition curated by Damien Hirst. He did not buy anything then, but in 1990 purchased two of Hirst's medicine cabinets. Later that year he purchased *A Thousand Years*, the flies which migrated to the cow's rotting head. The following year he advanced Hirst £25,000 to buy, transport, preserve and mount the tiger shark which became *The Physical Impossibility of Death in the Mind of Someone Living*. After the shark purchase, Saatchi began to visit student shows, art schools, artists' studios and gallery openings. He bought work by new artists in bulk and at low prices, sometimes purchasing whole shows. Jay Jopling emerged as his favourite dealer. White Cube, Jopling's London gallery, represented Hirst and some of the other artists that Saatchi collected and showed.

For twenty years from 1985 Saatchi displayed his art in a gallery created from a former paint factory in Boundary Road, St John's Wood, in London. It pioneered the now-common stark white setting for contemporary art spaces. Saatchi did little advertising for the gallery, promoting it instead by hosting extravagant parties for celebrities who viewed and later talked about his collection. Many young British artists grew up visiting the gallery, with their sense of art shaped by what was shown there. About the time he opened his gallery, Saatchi published *Art in Our Times: the Saatchi Collection*, an £80, four-volume catalogue of his collection, which was followed over the next fifteen years by five other such books.

In 2001, Saatchi moved his art to new premises in the former home of the Greater London Council at County Hall, halfway between Tate Modern and Tate Britain. The 40,000sq ft Saatchi Gallery had at its entrance a heart-shaped light sculpture by Tim Noble and Sue Webster, with a bloody dagger plunged into the centre. On the stairs inside the gallery was a Mini car painted by Damien Hirst with coloured dots. One room was devoted to Richard Wilson's 20:50, a chamber filled shoulder-high with engine oil. Viewers walked on an elevated walkway above the chamber, disoriented by the mirror image of the ceiling reflected on the oil. On opening night there was a formal reception for 900 guests. Artist Spencer Tunick offered performance art involving eighty naked volunteers lying down on the stairs in front of the gallery to greet those arriving. The nudity and the celebrity guests guaranteed that the opening was reported on the front page of every UK newspaper.

The first show held in the new gallery was a Damien Hirst retrospective. Later Saatchi showed the work of artists just graduated from art school, which he had purchased in quantity. The décor of the new gallery was not stark white, but restored oak panelling in the corridors and the old Council Hall. In this setting everything began to look like mainstream art: Hirst's shark; Tracey Emin's *My Bed* (illustrated), an unmade bed complete with underwear and condom wrappers where she spent four days contemplating suicide; and a Chris Ofili depiction of the Virgin Mary which incorporated elephant dung.

The Saatchi show effectively pre-empted a Hirst retrospective being planned by Tate Modern. Hirst thought that a first show at Saatchi would be

more valuable than one at the Tate, but assumed that a Tate show with different art would follow later. The Tate disagreed, not wanting to be associated with a follow-on show.

Saatchi has always been generous in lending art to museums for exhibitions, but often on the condition that additional pieces be accepted and shown. He exhibited a portion of his collection in a September 1997 show at the Royal Academy in London, the previously mentioned *Sensation*. The show included 122 works by forty young British artists, selected from the 3,000 works that Saatchi was then thought to own. Saatchi supplied the £2 million installation cost and was given a free hand in curating and installing the work.

Saatchi's participation in *Sensation* had its origin in an act of considerable generosity. Norman Rosenthal, exhibitions secretary at the Royal Academy, had wanted to hang the Berlin show *Art of the 20th Century*, but given the contemporary and conceptual nature of the work ('Is this a portable fire extinguisher or a sculpture?'), no British sponsor would become involved. Rosenthal had to cancel at the last minute. *Sensation* was the replacement.

The Sensation show was one of the first to focus on shock art. The work and the promotion surrounding the show had the single purpose of provoking a public response, much like a Saatchi & Saatchi advertising campaign. Publicity for the show spread through word of mouth, in a way that no conventional exhibition could have achieved. Two hundred and eighty-five thousand people attended Sensation, 80 per cent of them under the age of thirty. Both these figures were higher than for any other British art exhibition in 1997.

The most discussed work at Sensation and the most extreme example of shock art was Myra, Marcus Harvey's 11×9 ft (340×270 cm) portrait of child murderer Myra Hindley. The image was copied from a police mug shot, and the picture was created by reproducing paint-covered images of a child's hands on the canvas. When the show opened, relatives of the murder victims protested at the inclusion of the painting and demanded that those waiting in line leave. Two men threw eggs and ink at the portrait, which had to be removed for cleaning. It was returned to the show with a clear plastic shield. Guards were posted. The buzz over Myra was such that London taxi drivers were said to need no more instruction from tourists than 'Take me to that art show'.

The collection moved to the Brooklyn Museum in 1999. At that show, the central shock piece was another Chris Ofili depiction of *The Holy Virgin Mary*. One of the Virgin's breasts featured a clump of elephant dung, with photos of female genitalia representing angel's wings. New York mayor Rudolph Giuliani threatened reprisals against the museum. This produced newspaper editorials about free speech and guaranteed large crowds. Damien Hirst said of Giuliani's response: 'He's done me a fucking favour; he's put another nought on the end of all my prices' – even though the mayor had never mentioned a Hirst work.

When a branded collector like Saatchi purchases an artist's work, displays the work in his gallery, loans the work for display in other museums, or exhibits it in *USA Today*, the cumulative effect is to validate both the work and the artist. Each stage serves to increase the value of Saatchi's own art holdings. Over time Saatchi has sold many of his pieces, sometimes in quantity, often at huge profit. A Jenny Saville painting purchased in 1992 for £15,000 was sold in 2001 for £334,000. A Rachel Whiteread plaster sculpture of the underside of a domestic sink, purchased for £5,000, was sold at Christie's London in December 1998 for £133,500. Chris Ofili's *Afrodizia*, a tribute to Afro-American hairstyles and also highlighted with elephant dung, was purchased in 1996 for £40,000 and sold to New York art advisor Todd Levin in 2005 for \$1 million.

Saatchi's most famous sale after Damien Hirst's shark, and his most dramatic profit, came with Marc Quinn's *Self*, a cast of the artist's head made from nine pints of his own frozen blood. Saatchi purchased *Self* in 1992 for £13,000 and sold it to an American collector in 2005 for £1.5 million. *Self* was the subject of the art-world urban legend (but untrue) that Quinn's frozen head had melted when the freezer was unplugged in Saatchi's kitchen during renovations.

A Saatchi charity art sale at Christie's London in December 1998 offered 130 items by ninety-seven yBas. The sale realized £1.6 million; 90 per cent of the work sold, half at above the highest estimate provided by the auction house. Many of the artists represented had never before been sold at any public auction; the event was of huge benefit to them, especially in the dozen cases where work was purchased by a public institution. Profits from the sale were used for scholarships at four London art institutions: Goldsmiths, Chelsea College of Art, the Slade School and the Royal College of Art. Patricia

Bickers, an editor of *Art Monthly*, pointed out that this generosity would give Saatchi the pick of the work of new London art graduates for years to come.

Saatchi also accumulated work by Martin Kippenberger, a maverick German artist who made paintings, sculptures and installations, the best of them while drunk. Kippenberger died of liver cancer in 1997. He was considered only a middle-level artist during most of his artistic lifetime, but both his reputation and prices skyrocketed after his death. Buying Kippenberger represented one of the few times Saatchi entered the art market part way through a trend, rather than starting it. The same 'collected by Saatchi' effect took hold. When it was known that Saatchi was buying, other collectors followed, and prices escalated.

Saatchi's brand and purchasing clout have always given him power. When he buys direct from artists' studios or from a gallery, he is said to ask for quantity discounts. In June 2007 he visited the Royal Academy School graduate art show, and purchased the entire output – forty-six digital prints – of student James Howard, for £4,500. Saatchi's publicist forwarded the information to every UK news outlet, and most ran the story. Howard achieved some fame, and was approached by dealers wanting to represent him. The publicity probably tripled the value of Saatchi's purchase.

When Saatchi buys the work of a new artist through a dealer, the commission may be waived. This means Saatchi pays half or less of the gallery asking price. The value added by Saatchi's ownership is such that neither artist nor dealer complains, or feels exploited.

On at least one occasion Saatchi has gone beyond a simple purchase. He offered the young artist Jenny Saville a monthly stipend from August 1992 to January 1994, in return for first refusal rights on any work she created during that period. This is precisely what patrons in Renaissance Italy did – supporting an artist over a period of time in anticipation of later acquiring their work.

On at least two occasions, Saatchi's sales in the secondary market have infuriated artists, who say they were under the impression that their work would remain part of his permanent collection, or be donated to public institutions. Saatchi purchased ten early works by American artist Julian Schnabel in 1978, for \$2,000 each. One of these, *Accatone* (1978), was among the

nine works Saatchi loaned the Tate Gallery for an eleven-work solo exhibition of Schnabel in 1982. The Tate show was criticized at the time on the basis that it was unfair that an inexperienced American painter should be given a one-man show, when so many British artists had to wait years for such a chance.

Far from being grateful, Schnabel reacted angrily when Saatchi sold several of his works a few years later for \$200,000 each. Schnabel said, 'If this is pruning [his collection], then Saatchi was doing it while wearing a blindfold.' Schnabel described the *Art In Our Times* volumes as 'a mail order catalogue'. In 1993, two more Schnabels from Saatchi's collection were sold at auction in New York for \$319,000 each. In 2007 each would have brought \$2–3 million.

In 1985, after a dispute with the Italian artist Sandro Chia, Saatchi sold at a loss the seven works by Chia he owned, proclaiming to the press that he was 'purging' his collection. Chia claimed he had asked to buy back the paintings but was ignored. What appears to have happened was that Saatchi returned three Chia paintings to New York dealer Sperone Westwater and four to Zurich's Galerie Bruno Bischofberger, from whom he had purchased them. All seven were resold quickly. Saatchi's ability to punish was established, and every artist since Chia has known that what Saatchi gives in validation and reputation, Saatchi can take away. Demand for Chia's work declined, and neither of the two galleries represents him today.

Saatchi seems to have little problem ensuring that work he consigns for auction is placed in major evening events, rather than in the less prestigious day sale. Perhaps his taste is extremely good, perhaps his ownership makes the art 'major', or perhaps auction houses do not want to risk the loss of his continuing patronage by rejecting a consignment.

In April 2006, Saatchi established an internet site called Your Gallery (www.saatchigallery.com/yourgallery), a kind of MySpace for unknown artists. By the end of the first month the site had 1,800 registered artists showing work, and was drawing 1.4 million hits a day. By autumn of 2007, 38,000 artists had registered and Your Gallery was receiving 54 million hits a day. Saatchi has a companion site, Stuart, for student art. Although most work listed on Your Gallery is in the £500–£3,000 range, sales of £100,000 and gallery signings of 250 new artists have been reported. Your Gallery is the

world's most important internet route for young artists trying to reach buyers and have their work recognized.

Saatchi's advertising firm takes the same approach to clients' art promotion as Saatchi does with his own collection. M&C Saatchi (his current company) was hired by the J. Paul Getty Trust in Los Angeles to rebrand the Getty museum. The firm's first poster read 'Rampaging Pig Tramples Man, A Caped Hero Delivers Death Blow!' The copy is an innovative interpretation of Rubens' painting *The Calydonian Boar Hunt*, acquired by the museum in May 2006.

Charles Saatchi has been an important patron of the visual arts. The success of the yBas, the first internationally recognized art movement in postwar Britain, was in large part due to his acquisitions. He has donated art and been generous in lending to galleries. The Your Gallery internet site may be the most important innovation for collectors and new artists in years. Sales from his collection have produced first-auction exposure for many artists, and some of this work has entered public galleries for the first time. The publicity given to his resales has reaffirmed the idea that contemporary art can be a great investment.

So what does the saga of Saatchi as a collector tell us? That the reputation and brand of the owner may be as important in the market as the work being sold? That a collector such as Saatchi can increase the value of an individual work, or of work by the artist, just by adding that work to his collection – or even by expressing interest in it? Or that when other collectors and investors are prepared to buy with their ears rather than their eyes, investing in art can be very profitable for a branded collector? The term 'buying with your ears' is used several times in this book, and I flinch each time I write it. It is an artworld term that means buying art by reputation. Dealers use it to describe collectors who, if presented with an unknown artist with talent and promise, will refuse to look at the work with any degree of interest. The term has made the transition from insight to cliché.

If Saatchi is the best recognized of the elite collectors, who else is on the list? In 2007, *ARTnews* identified the world's most sought after collectors based on dealer opinion and auction records. I have created the list of twenty collectors that follows from discussions in *ARTnews* and elsewhere. Beware, it

is very US-centric. Auction houses say their lists include additional French investors, a German advertising executive, a Korean retailer and twelve Russians. The list changes constantly, because most individuals go through a collecting cycle. They establish an emotional connection with art, fall in love with contemporary art, build a collection, donate some art to museums, and after a few years move on to other passions. At that point some or all of the collection gets sold.

THE WORLD'S TOP TWENTY ACTIVE COLLECTORS OF CONTEMPORARY ART (IN ALPHABETICAL ORDER)

Hélène and Bernard Arnault, Paris, luxury goods

Debra and Leon Black, New York, investment banking

Edythe and Eli Broad, Los Angeles, financial services

Cherryl and Frank Cohen, Manchester, retail

Steve Cohen, Greenwich, Connecticut, hedge funds

Dakis Joannou, Athens, construction

Joseph Lewis, London, financier

George L. Lindemann, New York, investments

Vicki and Kent Logan, Vail, Colorado, investment banking

Samuel Newhouse Jr, New York, magazines

Ronald O. Perelman, New York, venture capitalist

François Pinault, Paris, luxury goods

Mitchell Rales, Washington, DC, tool industry

Charles Saatchi, London, advertising

David Sainsbury, London, supermarkets

Helen and Charles Schwab, Atherton, California, stockbroking

Adam D. Sender, New York, financial services

Abigail and Leslie H. Wexner, Columbus, Ohio, retail

Reinhold Wurth, Stuttgart, industrialist

Elaine and Stephen A. Wynn, Incline Village, Nevada and New York, casinos

Christie's and Sotheby's

There is more similarity in the marketing challenge of selling a precious painting by Degas and a frosted mug of root beer than you ever thought possible.

A. Alfred Taubman, former controlling shareholder of Sotheby's

houses. Their evening auctions create the headline-producing prices that distinguish the work of a very few contemporary artists. Inclusion of an artist's work in such auctions confers final legitimacy on that artist. Christie's and Sotheby's form a duopoly, the name an economist gives a competitive pairing that dominates a market: Coke and Pepsi, McDonald's and Burger King, or Boeing and Airbus. Christie's and Sotheby's share 80 per cent of the world auction market in high-value art, and an almost absolute monopoly on works selling for over \$1 million. In 2006, 810 works of art – all art, not just contemporary art – were auctioned for more than \$1 million; of these, 801 were sold at one or other of the two auction houses. Two other auction houses, Phillips de Pury and Bonhams, compete for major consignments, but they lack the brand cachet of the first two. Other auction houses handle important work from national markets, and many local houses handle lower-value art.

An auction defines both value and ownership. Auctions exist for several reasons, the main one being that more conventional ways of establishing prices are inadequate for one-of-a-kind items like contemporary art. Rather than using some kind of consensual process to value artistic endeavour, an

auction uses competition and ego to pursue the highest possible price. Auctions also have the virtue of providing easy access to the purchase of work by a hot artist. Buying the work of a hot artist from a dealer may require connections, previous purchases and a long time spent on a waiting list. A bidder at auction achieves success based on the ultimate in meritocracy; the collector holding the paddle that stays in the air longest and who comes bearing the thickest wallet takes home the art.

Branding of the two major auction houses has been so successful that most passers-by on New York's Fifth Avenue or London's Oxford Street could probably name both. Far fewer could name two contemporary art dealers or two contemporary artists. Media attention focuses on auctions as events, rather than on the items being sold. The *New York Times* reports London auctions in its arts section, New York auctions in its Metro section, auction previews in the art section, record-breaking auction prices in the first section, and profiles auction personalities in Carol Vogel's 'Notebook' in the arts section. The business section of the newspaper carries almost no auction news.

No dealer or museum garners anywhere near as much coverage as the big auctions. While important paintings hanging in a dealer's gallery are given no media coverage, the same paintings offered in an evening auction are reproduced and discussed in newspapers and magazines, and their sale prices and the identity of their buyers are reported. Auctions at Christie's and Sotheby's are one of only two commercial enterprises in the world whose sales results are reported in the major news media regardless of the importance or interest of the items in those sales. The other enterprise is the stock exchange.

Almost any evening sale of Impressionist, modern or contemporary art fills sale rooms to capacity. In London or New York, evening sales are a place to be seen, an indicator of social distinction – whether or not you have any intention of bidding. Tickets are required to attend the most important auctions. VIPs get to sit in the main sale room; VOPs (very ordinary people – and yes, auction houses use that term privately) watch screens in adjoining rooms.

All art auctions use what is called an 'English' or 'ascending price' system. Bidding starts low and the auctioneer asks for higher and higher prices; when the bidding stops the item is 'knocked down' at the hammer price. A buyer's

premium is added to the bid price to produce the invoice price. The English auction is really Roman in origin. The word auction has its root in the Latin auctio, meaning to ascend, or augere, to increase.

Christie's was founded in 1766 by James Christie, who resigned a navy commission to practise the auctioning of 'houshould' property from important personages. Sotheby's had been founded twenty-two years earlier, by book dealer Samuel Baker. Beginning in 1750 Baker advertised his sales with catalogues, which carried the explanation 'He who bids most is the Buyer'.

The two houses brought the beginning of legitimacy to what has been referred to as the world's second oldest profession – but only a beginning. The auctioneer's social status did not improve dramatically until Montague Barlow purchased Sotheby's in 1908. The two English houses operated for many decades on the basis of the old school tie, with Old Harrovians going to Sotheby's while Old Etonians favoured Christie's. At least the two English houses did not bear the stigma carried by early American auction houses, which for many years allowed collectors to purchase paintings and slaves in the same session.

The histories are of little significance to twenty-first-century consignors or buyers. To understand the current position of the auction houses, only events since 2000 are relevant. That year marked the settlement of US and European Union lawsuits against Christie's and Sotheby's for colluding on consignor fees, and the settlement shaped what each house has become. Sotheby's chairman Alfred Taubman and Christie's chairman Sir Anthony Tennant were said to have met a dozen times between 1993 and 1996 in London and New York, to agree not to negotiate the seller commissions they charged their clients. In a class-action antitrust suit, the firms jointly agreed to pay \$512 million in penalties to those who had consigned or purchased art during the price-fixing period.

Sotheby's agreed to cooperate with investigators on the civil side, but chose to contest the criminal charges. They lost. Taubman was found guilty of organizing the price-fixing scheme, and went to jail for a year, while president Diana (Dede) Brooks served six months of house arrest. Sotheby's paid an additional \$140 million in criminal penalties. Christie's escaped criminal

sanctions by turning over documentary evidence of the price-fixing conspiracy. Chief executive Christopher Davidge avoided the possibility of prosecution by refusing to go to the USA to face trial.

Following the settlement, Sotheby's financial status was so bad that its future viability was in doubt. Bill Ruprecht, now chief executive, said, 'We were in a bunker and there were bombs going off everywhere. I wanted to stay alive, get out of the bunker and be able to pay for my kids to go to school.' The settlement was followed by the events of 9/11 and its impact on the art market. Christie's and Sotheby's postponed their New York auctions, and their travelling sales previews were curtailed.

The battle for consignments intensified with new competition from Phillips, de Pury and Luxembourg. Today Phillips is a weak number three in the contemporary art auction world, but in 2002 it was briefly number two and played a major role in shaping current auction practice. How Phillips fell to number three provides a cautionary tale for Christie's and Sotheby's.

The story of the modern Phillips begins with fifty-seven-year-old Bernard Arnault of fashion conglomerate Louis Vuitton Moet Hennessy, whose private fortune of €14.5 billion makes him the richest person in France. In early 1999, Arnault wanted to purchase Sotheby's. Deterred by the financial threat Sotheby's was facing from pending lawsuits and government fines, Arnault decided instead to acquire an auction brand more cheaply by buying and building Phillips. In November of the same year he purchased the conservative auction house for \$121 million. That turned out to be a really bad decision.

Arnault merged Phillips with an art dealership owned jointly by Simon de Pury, former chairman of Sotheby's Europe, and Daniella Luxembourg, former deputy chairman of Sotheby's Switzerland. The merged firm became Phillips, de Pury and Luxembourg. Arnault's goal was to turn Phillips into a brand and break the Christie's—Sotheby's duopoly, turning the top two into the top three. Phillips spent lavishly on upgrading its auction facilities and luring staff away from Christie's and Sotheby's. It bought collections for resale, and by offering consignors high guarantees. That led to their gaining consignment of two important collections, Heinz Berggruen, and the American art collection of Marion and Nathan Smooke. In each case Christie's and Sotheby's backed off

because the guarantees Phillips had offered were at levels Christie's and Sotheby's thought were excessive.

They really were excessive. The major disaster was the Smooke consignment which Phillips won with the biggest auction guarantee in history, \$180 million for the entire collection. At auction two months later, the major works in the collection brought \$86 million. A few private sales followed, but the loss against the guarantee was between \$40 and \$50 million.

Phillips accumulated losses of almost \$400 million. To put that in context, that amount plus the original purchase price would in 2001 have purchased a controlling interest in either Christie's or Sotheby's. Arnault concluded that being a distant third-ranked auction house in the Christie's–Sotheby's battle guaranteed losses for a very long time. In 2002 he sold majority control to de Pury and Luxembourg for \$30 million, with LMVH retaining a 27.5 per cent stake. Luxembourg left the company shortly afterwards.

Now called Phillips de Pury, the company focuses on four categories: ultra contemporary art, design, jewellery and photographs. The company is again profitable, earning a modest under-\$10 million in each of 2005 and 2006.

Phillips pursues consignment of 'wet-paint art', so new the paint is barely dry on the canvas. This sometimes puts the house in direct competition with dealers for primary art. From 2002 to 2006, Phillips sold more twenty-first-century art than Christie's and Sotheby's combined: \$9 million worth, compared with \$2.4 million for Christie's and \$6.1 million for Sotheby's. Phillips now focuses on first-time buyers in their twenties and thirties, from hedge-fund millionaires to rookie collectors. It wants to avoid being seen as number three to Christie's and Sotheby's, instead positioning itself as number one in its own blue-chip, emerging, super-Modernism segment. As part of the change, Phillips auction catalogues were redesigned to resemble fashion magazines. Simon de Pury was portrayed in press releases as a sort of rock-star auctioneer.

The fourth auction house is Bonhams, with 400 employees, a \$400 million turnover and modest profitability. Howard Rutkowski, director of its contemporary and modern art operation in London, describes its strategy as: 'Mostly we chip away at the lower end of the market that Christie's and Sotheby's don't

care that much about, and we devote tender, loving care to it.' The company has run full-page advertisements in the *Financial Times*, trying to reposition itself as a branded auction destination for investment bankers and the financial world – just like Christie's and Sotheby's. One ad reads: 'Hostile takeover bids can take months to reach a conclusion. How tedious. Far better to take part in a Bonhams sale, where the biggest bid quickly secures the prize.' Another says, 'No commodity or utility assets to dispose of? Sell canvas.' The company then switched to full-page ads in which it called itself Bonhams 1793, just in case potential bidders did not appreciate its long history.

Christie's was purchased for just over \$1 billion in May 1998 by François Pinault. Seventy years old, Pinault is the fourth richest man in France, with assets estimated at €7.8 billion. He controls PPR, the luxury goods group whose brands include Gucci, Yves Saint Laurent, Bottega Veneta and Alexander McQueen. Pinault also competes with Bernard Arnault for the titles of world's top luxury brand owner and leading art collector in Paris. In 2004, he tried to open a private art foundation in Paris, and complained that he had been thwarted by the French government. He took his museum to the Palazzo Grassi in Venice. Arnault countered with plans for a cultural centre in the Bois de Boulogne, designed by Frank Gehry and bearing the name of the Louis Vuitton brand, to showcase his 2,500 artworks and offer design shows of LVMH brands.

Alfred Taubman sold his controlling share in Sotheby's in 2005; it is now a public company without a controlling shareholder.

Christie's and Sotheby's now follow quite different strategies. Sotheby's places less emphasis on market share, focuses on the high end of the market, and no longer pursues low-value consignments. Between 2002 and 2007, it reduced the number of its auction transactions from 160,000 to 85,000 and shrank its number of employees. The average value of work sold increased from \$35,000 to \$50,000 over the same period. Christie's says it concentrates on both high-end and middle-market sales to reduce its fixed costs per sale. The average value of work sold in 2007 was \$35,000.

Bill Ruprecht, chief executive of Sotheby's, describes his strategy as a Porsche, and Christie's as a more mass-market Volkswagen. Ed Dolman of

Christie's says the real difference is not market size but Christie's speed and flexibility: 'We are a private company, the owner Monsieur Pinault is one of the world's great collectors, we are able to access the risk factor and take quick decisions.'

The strategic changes allowed Christie's to lower its break-even sales level (at which it covers fixed costs and begins to make a profit) to between \$1.8 and \$1.9 billion per year. Sotheby's break-even dropped to \$1.7 billion. Each auction house increased its buyer's premium in several steps, from 10 per cent to 20 per cent on the first £250,000 or \$500,000 and 12 per cent above. At the higher rate, a successful bidder on a \$1 million painting would pay an additional \$60,000 plus VAT.

Now move to 2007. Christie's and Sotheby's are both setting sales records and are very profitable, owing to the higher buyer's premium and rising sales. In 2006 Christie's auctioned \$4.3 billion worth of art, up 36 per cent from the previous year, and with 425 lots sold for more than \$1 million. Sotheby's auctioned art worth \$3.7 billion, up 29 per cent, with 376 lots selling for over \$1 million. When Bill Ruprecht of Sotheby's escaped the bunker, he received \$8.8 million for the year in salary and bonuses. Christie's continues to lead Sotheby's in contemporary art sales, not because it has better art judgement or more money, but because it has been better at evaluating the lust level of potential bidders and the prices they are willing to pay. Christie's failure to match Sotheby's guarantee on Rothko's *White Center* was the major exception.

The terminology used by auction houses is interesting. The percentage fee that is charged a seller of art is called a commission, the term reflecting the auction house's fiduciary duty to the seller. The fee that is charged the buyer (also as a percentage of the sales price) is called a premium, the term implying that the auction house has no duty to the buyer. The terminology mirrors the legal reality that the auction house's fiduciary duty is only to the seller; otherwise there would be a conflict of interest.

Seller commissions have existed since the inception of auctions. When buyer premiums were introduced in the 1980s, trade publications referred to them as 'morally unacceptable', and 'a charge for performing no service whatsoever – except perhaps, shelter if it is rainy or cold and the opportunity to use

the toilet'. The underbidder, who takes advantage of the same auction house services as the successful bidder, is not charged.

When it was first introduced, a few dealers laughed at the premium and said it would trigger a buyer revolt. Neither European nor North American buyers revolted. Each accepted the auction houses' argument that what mattered was the final purchase price, not how it was calculated. Auction houses pointed out that no one requires art dealers to divulge their commission rates alongside their selling prices. More perceptive dealers recognized that selling at auction had just become much more financially appealing for consignors, that auction houses had gained another advantage over dealers in the competition to find goods for sale. They also realized that the premium threatened their highly profitable business of advising clients and bidding for them at auction in return for a 10 per cent fee. Buyers were unlikely to be happy paying two fees, one to the dealer and one to the auction house.

From the perspective of the auction house, the virtue of the buyer's premium is that it cannot be negotiated. Neither auction house nor buyer knows who the successful bidder will be until the hammer falls. There is one exception to this rule. To build their brands and create an inducement to consign, both Christie's and Sotheby's offer lower buyer premiums to those whose combined consignments and purchases in a year exceed a predetermined level – the best guess seems to be a 20 per cent rebate of buyer premiums for sales above £5 million, or \$8 million. The details are closely guarded, probably because different buyers have negotiated different discounts.

While sellers nominally pay a commission that starts at 20 per cent, it is often negotiated down to zero for high-value art, as it was for Rockefeller's Rothko, *White Center*, or to 2 per cent for a high-value collection of lower-value work. For star consignments, the auction house sometimes agrees to return to the consignor 80 per cent of the buyer's premium – or in a few cases 100 per cent. Compared with guaranteeing the price to the seller, this practice has the advantage to the auction house that it has no exposure if the work fails to sell.

The auction house performs a great many other functions in return for its seller's commission and buyer's premium. After obtaining the consignment, it stores and transports the art, researches authenticity and provenance,

catalogues, photographs and exhibits, and conducts credit checks on potential bidders. After the auction it collects payment and arranges delivery. These functions are taken for granted by consignors, who assume that such prestigious firms will perform them competently. Services provided to bidders include condition reports, specialist advice, telephone bidding, receptions, boardroom lunches, VIP events, seminars, transporting paintings to visit collectors in other cities, and support of foreign and regional offices.

Christie's and Sotheby's have returned to joint dominance. But while conventional economics would suggest that two dominant firms will quickly learn to collude, tacitly or overtly, Christie's and Sotheby's have instead invented new and expensive ways to compete with each other and with private dealers for choice consignments. Common sense might suggest the companies would put their energies into attracting upmarket customers with a lot of money to spend. What they actually compete over are consignments; buyers are expected to follow the art.

Choosing an auction hammer

This is business, it ain't art history.

Brett Gorvy, deputy chairman, Christie's Contemporary Art

The top auction houses resort to wining, dining, hand-holding, house calls, appraisals, loans, guarantees, single-work catalogues, and providing employment for consignor's children.

Kelly Devine Thomas, art journalist

ow does the consignor choose an auction hammer; what does each auction house offer? For contemporary and modern art, Christie's has in recent years had the highest total sales and the largest number of high-value artworks, and might be the first place to visit. For Impressionist art, Christie's and Sotheby's are neck and neck. For American art, Sotheby's is the place. For contemporary art less than five years old, add Phillips de Pury in New York to the mix. But with this exception, Christie's and Sotheby's are close enough to each other in contemporary art, and far enough ahead of the others, that the question of which to select poses a challenge.

Every time a major collection or star picture appears, winning the consignment (and keeping it out of the hands of competitors) becomes paramount for each auction house. A prime example was the 2003 consignment, for 2004 auction, of the celebrated forty-painting Whitney collection of Impressionist and modern art, the star of which was Picasso's *Garçon à la pipe*. John Hay Whitney was an American financier and sportsman, and

former Ambassador to Great Britain. The Whitney lawyers negotiated so relentlessly that when Christie's quickly agreed to waive the consignor charge, Sotheby's responded by waiving their own charge, offering to rebate a large part of the buyer's premium and agreeing to insert four-page, full-colour auction announcements in several major world newspapers. The collection sold at Sotheby's for over \$200 million, the Picasso bringing what was then a record \$104 million. Sotheby's probably made little if any profit on the auction, but gained enormous publicity and prestige. The auction house did profit from other items offered at the same time as the Whitney collection because other consignors wanted to piggyback on the publicity and collectors these works attracted.

Sometimes the desire to shut out the opposition takes over. In April 2006 Sotheby's gained consignment of David Hockney's painting *The Splash* from a Los Angeles collector it learned might be selling part of his collection. Thinking it was in competition with Christie's, Gagosian, one Los Angeles dealer and at least one high-profile collector, Sotheby's offered a high guarantee, plus the promise of extensive promotion including the picture on the catalogue cover. Once the work was won, it was heavily promoted and used to attract other consignments. Sotheby's later discovered it had been the only one at the table.

To bring in desirable consignments, the auction houses offer ever more imaginative marketing, not just for contemporary art but for objects as diverse as manuscripts and decorative eggs. In December 1994, Christie's auctioned a handwritten copy of Clement Clarke Moore's famous Christmas poem 'A Visit from St Nicholas' ("Twas the night before Christmas, when all through the house ...'). Christie's had *Star Trek* lead and Shakespearean actor Patrick Stewart read the poem. They provided hot chocolate and 'Merry Christie's' souvenirs to children who brought their parents. Five days later the manuscript sold for \$255,000, double its high estimate, to first-time auction buyer Ralph Gadiel, who had learned of the sale through a Christie's-supplied story that appeared in the *Chicago Sun Times*. A month earlier, Christie's had auctioned a diamond-encrusted Fabergé egg, publicizing the sale with a Russian vodka and caviar reception for journalists. Every paper carried the story; the egg also sold for double its high estimate.

Some promotional promises are hard to keep. In 2000, Philippe Segalot, then head of Christie's contemporary art department, won consignment of Jeff Koons' 1988 *Woman in Tub* with the promise it would be promoted through a full-page advertisement in the *New York Times*. The porcelain sculpture shows a bare-breasted woman taking a bubble bath, while a swimmer with a suggestively placed snorkel is seen below. The *Times* rejected the ad. Segalot then ran another showing the back of the work, with the caption: 'If you want to see the front, come to Christie's.' The night before the sale, Christie's threw a 'Bubble Bash' disco party for 900 invited guests. The work sold to a telephone bidder for \$1.7 million.

How a work is promoted depends on which of two types of consignor is involved. The first, the type auction houses hope for, trusts the process and allows professionals to design and carry out the promotion. The second, unloved but pandered to if necessary to secure a desirable consignment, is the micromanager who wants control over the identity of the auctioneer, the wording of the catalogue, the placement of the work in the catalogue, the location where the work will be hung in the preview, which work is hung beside it, the number of clients the auction house will contact directly before the sale, and where the consigned work will be advertised. Some former auction-house specialists, now acting as dealers or agents, fall into this unloved category. They may even demand the right to withdraw work from auction without penalty if any condition is unmet. The designated auctioneer had better not fall ill on auction day.

Pride of place in tales of micromanagement goes to Christie's 1997 sale of 115 works of Impressionist and modern art from the fabled Ganz collection. Victor Ganz was an American art lover who made his money from costume jewellery, but he was not wealthy – the entire collection had cost less than \$2 million. Nevertheless, the consignment was so desirable that pandering became grovelling. As part of the negotiation, Christie's agreed to purchase the Ganzes' New York apartment, which was then resold at a substantial loss. Such huge promotional and financial guarantees were given to the Ganzes' heirs that Christie's faced losses of tens of millions of dollars if the auction was only moderately successful.

Christie's agreed to extend viewing hours both at its Park Avenue headquarters in New York, and at a brownstone building on East 59th Street that had been rented to display the collection. Twenty-five thousand people viewed the collection, three times the number for any other evening auction. Christie's put on a dozen dinners and receptions for potential bidders.

Christie's agreed to honour Victor and Sally Ganz by holding a symposium on the collection and publishing two separate volumes: one a lavish single-owner catalogue, the second a separate hardcover book on the collection, *A Lifetime of Collecting*, with essays by art scholars.

One way auction houses compete for consignors with dealers and with each other is by emphasizing the marketing potential provided by their glossy sales catalogues, some distributed free, most sold to 20,000 customers. Here the collector finds a description of each work, a list of the collectors and dealers who have previously owned it, a discussion of its historical and cultural importance, and an estimate of what it will bring at auction. The catalogue lists whether the work has been previously auctioned at Christie's and Sotheby's – no other auction house is ever mentioned.

A collector receiving this several-kilogram, all-colour volume cannot but be impressed with the aura of quality. With only a few exceptions – those from London dealer Richard Green, Haunch of Venison and Gagosian are three – the catalogue produced for a dealer show does not come close. The quality of reproduction in the auction catalogue is so good that it is possible for the illustration to inadvertently mask subtle flaws in condition.

The catalogue presents the auction house not as a selling centre, but as an institution of scholarship and expertise. The copy recounts stories and myths to market the art and reinforce the auction house mystique. Glance through the catalogue entries and you will conclude that all the work offered has come from a historic setting and a distinguished owner – or at least 'The collection of a gentleman'. Work is never listed as consigned by a spouse bitter after an acrimonious divorce, or from children who inherited their parents' paintings and hate them, or from a dealer unloading mistakes in judgement or a speculator under pressure from his bank.

The rhetoric in a catalogue description can be breathtaking in its efforts to create the framework for an art purchase. Later in the book is an account of the 2006 auction at Christie's of a Francis Bacon triptych, *Three Studies for a Self-Portrait*, painted in 1982 and which some thought would set an auction price record for the artist. *Three Studies* was the featured work in Christie's May auction; the way it was handled is illustrative. The description of that work in the catalogue is a rewording of T.S. Eliot: 'Gone are the rainbow colours and the provocative, swaggering postures of the 1960s and 1970s; and in their place, under the artist's implacable gaze, the subject is pinned "like a patient etherised upon a table" – against a stark black background to be X-rayed and analysed.' The catalogue description came complete with reproductions of self-portraits by van Gogh and Rembrandt.

My own favourite catalogue description came with a May 2007 auction at Sotheby's New York; it compared a Damien Hirst butterfly painting to the work of, again, poet T.S. Eliot. (Eliot seems a favourite with writers of catalogues!) The most famous flight of catalogue-entry fancy was Sotheby's comparison of a Warhol to a Renaissance painting of the martyrdom of St Sebastian. The painting being auctioned was a copy of an advertisement, *Where Is Your Rupture?*, a chart of a human body with numbered arrows pointing towards spots where a hernia might occur. Are potential bidders expected to believe that the contemporary art being auctioned has any relationship to Old Masters? Do bidders actually think 'Wow, this is comparable to the Rembrandt in the Metropolitan'? The important caveat to every catalogue description, ignored by consignors and overlooked by collectors, is that it is not a scholarly essay, but rather a subtle advertisement for the artwork.

Sometimes to win a consignment, and as happened with the Ganz collection, the auction house offers the consignor a single-owner dedicated catalogue, the early pages of which extol the life of the consignor and the virtues of the collection. Catalogues for evening auctions frequently devote a section to art consigned from one collection, with several pages praising the consignor. The auction house may also offer a vanity art book. Sometimes this is produced as an inducement, before negotiations even begin. In 1979, Christie's produced a book extolling the collection of John and Frances Loeb;

the Loeb estate was finally consigned in 1997. The book then formed the basis of the single-owner sales catalogue.

Catalogue production is a miracle of last-minute effort. The catalogue goes to the printer a month before a major sale, to be distributed a week later. Works are still being consigned a day before the catalogue is finalized. Some catalogue descriptions are written while consignment negotiations are still going on; the mock-up of the page is shown to the consignor as part of the negotiation. The catalogue would seem to be a costly marketing device. It is not. With charges to some consignors for their colour illustrations, plus revenue from catalogue sales, auction specialists estimate that contemporary art catalogues break even.

Auction houses also compete for consignors by emphasizing the role of their specialists. The potential bidder's next step after seeing the catalogue is likely to be a meeting with the auction house specialist, who tries to play up the historical and cultural importance of a work, the distinction of its provenance, its iconic nature, how well this artist (or period) is doing in the resale market, other famous collectors known to own the artist's work, or the investment potential. Tobias Meyer has been quoted as saying: 'What I love to do is put people in front of art and make them feel it, make them stop everything else they are doing and experience it, deeply. That's how I make art expensive.'

The next pre-auction competition comes with the preview. The expertly hung show, combined with the scholarly catalogue and an embossed invitation to the private reception, is designed to mimic a museum opening rather than a commercial sale. The layout of the preview is important; placing the right works next to each other is thought to make the total of what is hanging on a wall appear greater than the sum of the individual works. Paintings achieve status both by where they are hung, and what is hung beside them – auction houses argue that the inclusion of great pictures in their auction increases the value of less great ones. At Christie's preview for its June 2006 London contemporary auction, a Francis Bacon triptych occupied a place of honour, alone on the end wall facing the gallery entrance. To the right of the Bacon in a recessed alcove was one of Warhol's six *Orange Marilyn*, to be auctioned five months later in New York. The reason the Warhol was hung

with work from the June auction was its high estimate of \$10–15 million, which provided context and a reference price beside which the Bacon triptych, at two-thirds that amount, seemed pretty reasonable. A Damien Hirst dot painting is hung in a prominent position, with less well-known works flanking it to achieve status by proximity.

The specialist will arrange a private showing for an important bidder. This provides not only uninterrupted time with the work but, more important, a longer period of interaction with the specialist. The first private showings are in a travelling road show for foreign collectors. The Bacon and other major auction works were flown to New York, Hong Kong and Monaco for by-invitation private viewing. When a bidder purchases a lot on the telephone and the auction house later announces it is going to Asia, a common reaction is amazement that someone would spend millions on a painting they have not seen. In many cases the painting has visited the buyer.

Auction houses will agree to fly the art to major cities in pursuit of ultra high net worth collectors. Ultra High Net Worth (UHNW) is a wonderful term created to describe what everyone else calls multi-millionaires. Before its record sale of Picasso's Dora Maar au chat, Sotheby's created a list of fifteen UHNW potential bidders, then flew the painting to London, New York, Chicago, Moscow, Bahrain and Tokyo to visit them. Its final stop was Las Vegas, so that casino owner Steve Wynn could see how it looked on his wall beside Picasso, Matisse and Gauguin. Wynn liked it; he was second underbidder behind Leslie Wexner, owner of retail fashion chain The Limited. The winning bid was \$95.2 million (plus buyer premium) and came from a Russian agent believed to be representing Roustam Tariko, a forty-four-yearold banking and vodka entrepreneur who had seen the painting when Sotheby's displayed it in Moscow. Tariko later denied that he was the buyer and complained that 'Art dealers are now calling, calling, asking me to buy paintings ... only my friends in Russia have my mobile number, but twenty art dealers have managed to get it.' Art-world wisdom says the painting has not surfaced since the auction because it is crated and stored in a Zurich warehouse. That would also suggest a politically cautious Russian buyer (or one from a former Soviet Far-East republic).

Whoever the purchaser was, his agent appears to have been a low-level employee (and auction neophyte) sent to bid for him. Art dealer Laszlo von Vertes, sitting directly behind the agent, described him as an unlikely bidder, looking more like a bodyguard and with a boxer's nose. 'If he walked into my gallery, I wouldn't have sold him a picture.' The agent later said he was instructed to go as high as \$140 million, 50 per cent and ten bids above the actual final hammer price.

All an auction house's pre-auction planning sometimes does not anticipate the outcome. The agent-bidder for *Dora Maar* was unknown to Sotheby's prior to the auction, and was nowhere in its list of fifteen potential buyers. At the end of bidding, amid the applause, Tobias Meyer had to ask for the paddle number, a certain sign that the bidder was not expected. Paddle number 1340 now hangs, as a trophy and a reminder to expect the unexpected, in the office of auction director David Norman.

If pressed, an auction house might compete by permitting the consignor's teenage children to accompany a painting on its promotional tour, receiving their first experience of world travel and foreign cuisine with the compliments of the specialists from Christie's or Sotheby's. If pushed further, the auction house may reluctantly offer a job to the consignor's offspring. There is some debate about whether it is better to have your client's children work for you or for your competitor. Employee gossip at each auction house focuses on mishaps, and employment might discourage further family consignments. The inside joke is 'Consign to Christie's, and we will recommend your daughter for a great position at Sotheby's.'

A large part of 'which paddle' is the process of negotiation between consignor and auction house over a price guarantee. The guarantee ensures that the auction house will pay out to the consignor, even if the bidding does not reach the guarantee price. Normally the auction house asks for a fee of from 10 to 50 per cent of any price realized above the guarantee, most commonly 25 per cent. This is the auction house's compensation for assuming risk. If the amount guaranteed is low, the fee becomes compensation for good negotiating.

At the top of the guarantee boom in 2004–5, most multi-million dollar contemporary consignments were guaranteed. In 2006–7, guarantees were

less frequent, probably because the market was so strong that consignors thought they could obtain their price without having to pay a guarantee fee.

The history of the guarantee as a practice rather than an occasional offer goes back to the late 1970s when Sotheby's offered a guarantee to gain consignment of the Goldschmidt collection. Jacob Goldschmidt was a German Jew who came to the USA as a refugee and found success as a banker. Christie's insisted that guarantees were improper and refused to offer them. The house changed its position in March 1990 after Diana Brooks, then Sotheby's chief executive, used a guarantee of \$110 million to win consignment of the estate of Campbell's Soup heir John Dorrance Jr. Brooks acted after William Acquavella, a New York dealer, offered a guarantee of \$100 million for the collection – the first and probably the last time a single dealer has bid on this scale.

The Dorrance family had first spoken with Christie's, of whom they had long been clients, about consigning their collection of Impressionist paintings and French furniture. The impact of the family's switch to Sotheby's in return for a guarantee was immediate. The collection brought \$135 million at auction and earned Sotheby's a large guarantee fee. Christie's responded by abandoning its principled position and offering a guarantee on Robert Lehman's collection of five paintings, to be auctioned in May 1990.

Based on her experience with the Dorrance sale, Diana Brooks put forward another advantage for offering a block guarantee on an entire collection. When some of the early Dorrance lots sold above estimate, Sotheby's was able to decrease the reserves on those remaining. Had each item in the Dorrance collection been given an individual reserve, some lots would have been bought-in, and there would have been a loss of credibility about the other estimates.

Once Christie's accepted guarantees they embraced them fully. For the Ganz collection, insiders reported a \$170 million guarantee, with \$120 million as a non-repayable advance to four family members. The collection brought \$206 million at auction, so the guarantee was not triggered.

When Sotheby's lost the Ganz collection to Christie's, they made a preemptive offer of a \$54 million guarantee to win consignment of the Evelyn Sharp collection of Impressionist and modern art, to be auctioned two nights after the Ganz collection. Against a pre-sale estimate of \$59–78 million, the Sharp collection brought \$41.2 million.

A failure to meet the guarantee always appears to represent a financial loss for the auction house, but the loss may just be a cost of competing. For example, Christie's November 2005 Impressionist sales in New York featured two masterpieces from the estate of Nelson Harris of Chicago. These were not contemporary, but are good examples of the economics of offering guarantees. One work was an 1886 Toulouse-Lautrec portrait of a young laundress and prostitute with a laundry board. The second was a Monet landscape, *La Route à Luveciennes*. There were two other important works in the consignment, a Matisse still life and a Monet garden scene, but the first two were the stars. Needing the paintings to feature in their November sale, Christie's secured consignment with a block guarantee in the vicinity of \$40 million.

At auction the Toulouse-Lautrec sold at its reserve for \$22.4 million. *La Route à Luveciennes* had no bidders, while the Matisse and the second Monet did not reach their reserves. On paper Christie's had lost money, but in the long run the guarantee was probably good business economics. The Toulouse-Lautrec and the Monet were necessary to bring in other consignments, and attracted bidders. The remainder of the sale went well, due in large part to the presence of the two star works. The Monet was not considered 'burned' (rejected or unwanted, having failed to sell at auction) because it had been 'sold' to the auction house for the guarantee price. The Monet and the other two works were later resold by Christie's to a third party without any stigma from their recent history. At the end, Christie's realized a small loss on the guarantee, but this has to be measured against the role of the two star works in driving a major evening sale. If other works attracted bids even 5 per cent higher because the star works attracted more bidders or greater excitement, Christie's ended up ahead.

Negotiations for a consignment can go through several stages. In the summer of 2004 there was spirited competition for the collection of American paintings and drawings from the New York estate of Rita and Daniel Fraad. Fraad owned an aircraft maintenance company, and was well

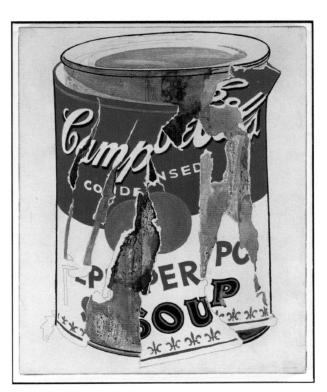

Andy Warhol

Small Torn Campbell's Soup Can (Pepper Pot)(1962) Silkscreen ink and polymer paint on canvas 16" x 20" (41 x 51 cm)

Andy Warhol

Advertisement appearing in Drexel Burnham Lambert Commercial in New York Times Magazine, November 23, 1986.

9" x 5 ?" (23 x 14 cm)

9" x 5 ?" (23 x 14 cm) as printed

Francis Bacon
Post War (Eve) (1933)
Gouache, pastel, pen and ink on paper
21" x 15 1/2"
(54 x 40 cm)

Francis Bacon Study from Innocent X (1962) Oil on canvas 78" x 56" (198 x 142 cm)

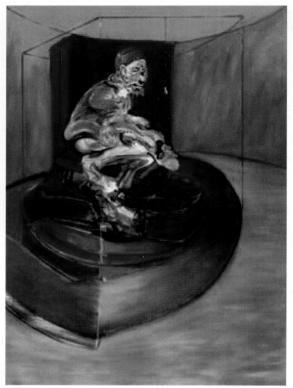

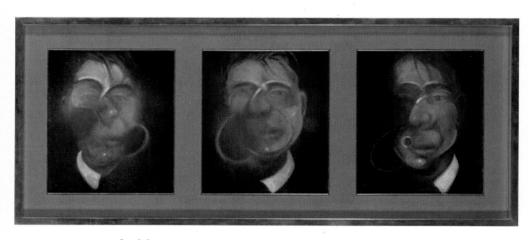

Francis Bacon
Three Studies for a SelfPortrait (1980)
Triptych, oil on canvas
Each panel 14" x 12"
(36 x 31 cm)

Tracey Emin My Bed (1996) Mattress, pillows, stained sheets, liquor bottles, cigarette butts, condoms, other items 31" x 83" x 92" (79 x 211 x 234 cm)

Tracy Emin Me Every Time Limited Edition Bag for Longchamp Paris Approx. 7" x 7" x 41/2" (18 x 18 x 11 cm)

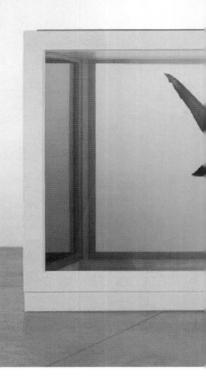

Damien Hirst For the Love of God (2007) Platinum, diamonds and human teeth 63/4 x 5 x 71/2 in. (17.1 x 12.7 x 19.1 cm)

Damien Hirst Instrument Calibration for Beagle Lander (2001) Dimensions unknown

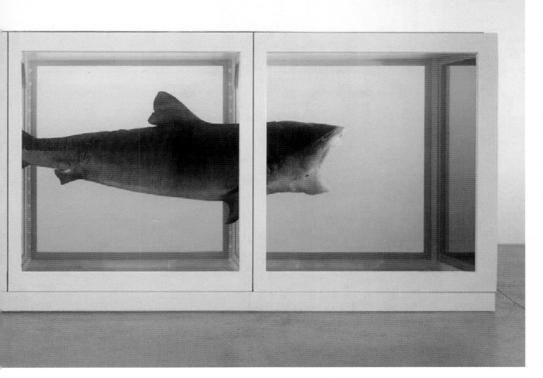

Damien Hirst Detail of Lullaby Winter (2002) Glass, stainless steel and painted pills 78" x 108" x 4" (198 x 274 x 10 cm)

Damien Hirst

The Physical Impossibility of Death in the Mind of Someone Living (1991)
Glass, steel, silicone, shark and 5% formaldehyde solution 84 x 252 x 84 in. (213.4 x 640.1 x 213.4 cm)

Christopher Wool

Untitled W17 (Rundogrundogrun) (1990) Alkyd and enamel on aluminum 108" x 72" (274 x 183 cm)

RUND OGRU NDOG RUN

Jean-Michele Basquiat Untitled (1981) Acrylic, oilstick and spray paint on canvas 781/2" x 72" (199 x 183 cm

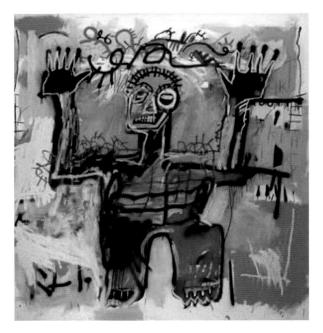

Mark Rothko
White Center (Yellow,
Pink and Lavender on
Rose) (1950)
Oil on board
81" x 55"
(205 x 141 cm)

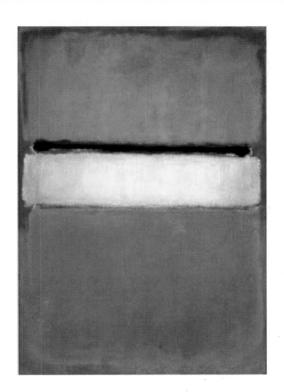

Huma Bhabha Untitled (2005) Clay, wire, plastic, paint 5' x 8' x 45" (152 x 243 x 114 cm)

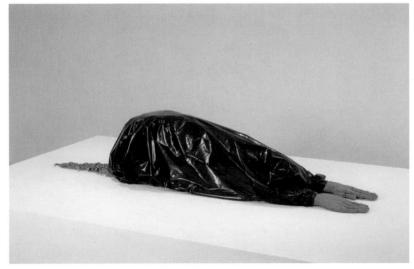

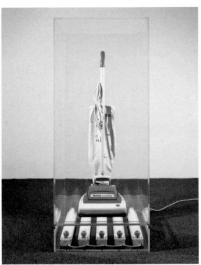

Jeff Koons

New Hoover, Deluxe Shampoo Polisher (1980) Shampoo polisher, Plexiglas, fluorescent lights 56" x 15" x 10" (142 x 38 x 25 cm)

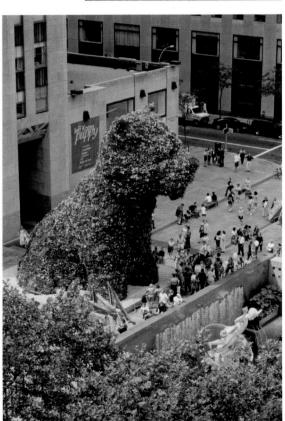

Jeff Koons

Puppy (1992) Stainless steel, soil, geotextile fabric, internal irrigation system and live flowering plants Installed in Rockefeller Center, New York 485" x 486" x 256" (1231 x 1234 x 653 cm)

Jeff Koons

Pink Panther (1988)
Porcelain cast
41 x 20.5 x 19 inches
(104 x 52 x 48 cm)

known as a philanthropist. The collection featured paintings by Winslow Homer, George Bellows and John Singer Sargent – none of them contemporary, but the negotiations involved were a great example of the many stages and parties that can be involved. A dealer opened with an offer to buy the collection outright for \$50 million. Sotheby's offered a \$35 million, nofee guarantee, and immediately raised it to \$50 million. Christie's and another dealer jointly offered a \$60 million guarantee with a small guarantee fee but a lower commission. Each auction house promised a dedicated, one-owner catalogue.

Sotheby's then negotiated a private sale of the two best paintings, Sargent's *Venetian Street* and Bellows' *Shore House*, for a total of \$33.5 million, reportedly to Microsoft's Bill Gates. This selling price was twice the estimate for the two works, and encouraged the Fraad daughters to consign the remaining work to Sotheby's with no guarantee but with a 2 per cent consignor commission.

Even after a decade of offering guarantees, the two auction houses have different philosophies about them. Sotheby's treats them as a profit opportunity; Christie's views them more as a necessary evil that places the auction house at financial risk. This reflects historic prejudices, because over the last decade both houses have profited from offering guarantees, and Christie's probably more so than Sotheby's.

The auction house may also advance money to the consignor, or to a dealer, to purchase a work intended for auction. Generally the advance or loan is no more than 40–50 per cent of the low estimate for the work and carries an interest rate of 2 or 3 per cent above the bank's prime rate (charged to its best customers). Again, all is negotiable. To hold a work for a future auction or to avoid a guarantee, a consignor may be given a higher percentage loan at no interest.

Loans to consignors are now more often advanced by Christie's than by Sotheby's. The latter suffered a substantial loss in 2001 through an \$8.4 million advance paid to private dealer and long-time customer, Michel Cohen, to fund the purchase of three Picassos and two Chagalls. These were to be sold privately, with the profits divided with Sotheby's; if not sold, they

were to be offered at auction. Such transactions are common in the art world, where private dealers who claim to have a seller and buyer but insufficient funds are advanced money by an auction house or another dealer who become silent partners.

Sotheby's was offered ten paintings as collateral against the loans, but took possession of only three. It is still searching for the others. At the same time, Cohen was reported to have sold a single Monet, *Resting in the Garden at Argenteuil*, to three different buyers – while the painting was actually on display at the Museum of Modern Art. In 2003 Cohen was apprehended in Rio de Janeiro, and held on charges of wire fraud and transporting stolen goods across state lines. He escaped custody by feigning illness and escaping from the ambulance on the way to hospital. He has never been tried or convicted. The greater loss may be the damage he inflicted on the culture of trust that had existed between dealers and auction houses. Each is now less willing to transfer possession of an artwork or write a cheque without a signed contract to back up the transaction.

As financial arrangements increase in complexity, auction house staff now find art expertise less valuable than the skills of investment bankers. Dominique Levy, former head of Christie's private sales and now a dealer in New York, says: 'In the past [specialists] had to learn their trade, to really know how to look at the painting and price it in the current market ... today specialists have to know about guarantees and financials and interest rates and the cost of every step of marketing.' Customer-contact persons are now called specialists, rather than experts. When a visitor asks an exhibition attendant about a work, the attendant is instructed to answer, 'Just a moment, I will call our specialist-in-charge.'

The first line of pre-auction contact with potential consignors is the public relations department of each of the auction houses. At the end of each auction, press releases set the stage for future consignments by announcing how well the auction has done, how many works sold above high estimate, and which sold for record-breaking prices. Art world commentators such as Souren Melikian of the *International Herald Tribune* and *Art & Auction Magazine* are given off-the-record briefings on which countries the buyers

came from, and on the extraordinary marketing efforts that produced the results. This information is not targeted at the public; it is aimed at conveying a brand image of success to future consignors.

The second line of contact is the client services representative. These provide publications on an artist. For investors treating art as part of their financial portfolio and requiring information to support a decision to buy, they can offer sales records and trend projections for every auction result attained by that artist. They will transport the client to the art, if necessary bring the art to the client, and after a successful bid, help hang the art on the client's wall. If money is needed, whether for an art purchase or an unexpected tax bill, the client-services representative puts on her private banking hat and writes a cheque, using an art collection as collateral.

Most consignments from individuals reach the auction room through one or more of the four Ds: death, divorce, debt and discretion. The last of these refers to a change in collecting focus, redecorating, or profit-taking. For death, debt and discretion, it is hoped that the consignor has decided which hammer to approach well before the event. In the event of divorce, consignments are almost always made through lawyers, who are bound by due diligence to request a proposal from several auction houses.

Auction specialists spend a lot of time building relationships with potential consignors. They invite them to luncheons and exclusive previews and provide authentication, appraisals and advice on resale. Representatives try to keep in touch with previous buyers, because every buyer is a potential seller. Auction houses have an ongoing struggle to motivate specialists to keep up these efforts; the focus of most is on art rather than customers – that is why they joined an auction house.

Dealers consign one-third of the contemporary art offered at auction, and usually ask for bids from both auction houses. One dealer said that when he consigned, he went first to whatever auction house had the smaller market share of contemporary art sales the previous year. 'I ask for everything when I consign, and I'm more likely to get it from the house that did less well last time. The leading house works to increase their profit; the trailing house tries to build market share.'

Another basis for choosing an auction hammer is the identity of the auctioneer. When Simon de Pury was director of Christie's Europe, he said: 'If you had the same lot sold four times over by four different auctioneers, you would get four different prices.' At Christie's, auctioneers Christopher Burge and Jussi Pylkkanen, and at Sotheby's, Tobias Meyer and rising star Oliver Barker, are held in such high regard that consignors may stipulate that the auction be conducted by one of them. Christie's privately suggest to consignors that having Burge or Pylkkanen hold the hammer is worth an additional 10 per cent in the final price achieved.

The pursuit of potential consignors can be relentless, a great illustration being the case of Don Luis Ferre and *Flaming June*. Ferre was a Puerto Rican cement magnate, later governor of the Commonwealth of Puerto Rico, and later still an ambassador. He was a major art collector, owning work by van Dyck, Rubens and Gainsborough. The most coveted work in his collection was *Flaming June* (1895) by the obscure English classicist painter and sculptor Baron Frederic Leighton. The picture is a depiction of a young woman asleep on an Aegean terrace. Purchased in a Fulham antique shop in London in 1963 for £50, and resold to Ferre a year later by London dealer Jeremy Maas for £2,000, it was exhibited at the Royal Academy in 2003 with an insured value of £10 million. Ferre claimed he received fifty purchase offers a year from collectors and museums.

For twenty years, Christie's and Sotheby's sent representatives to Puerto Rico to visit Ferre and enquire whether any art from his collection was available for auction. In October 2003 Ferre died at the age of ninety-nine, and auction houses' attention turned to his family. Stephen Lash, chairman of Christie's North and South America, attended Ferre's funeral. Two months later Sotheby's director Christopher Apostle attended the family foundation's Christmas party. Further visits followed, all unsuccessful. Flaming June and the other pictures were given to the Museo de Arte de Ponce in San Juan, which Ferre had founded in 1957. In late 2007 it was announced that Flaming June would go on loan to Tate Britain. The Museo de Arte immediately received a call from an auction specialist, again asking if it might be available.

Every day, clerks at Christie's and Sotheby's clip the obituary pages of *The Times*, and forward the clippings to the appropriate directors. After the death of a major collector, both auction and dealer representatives offer condolences and assistance to the estate. One former auction house specialist tells of taking a call concerning a death late in the evening and flying overnight to call on the heirs at noon the next day. He found a representative of the other auction house sitting in the reception room. Three dealers arrived after lunch. Auction house humour about death is such that an auction specialist in New York is reported to have once told a stunned audience that he was a partner in Murder, Incorporated, a subsidiary of Sotheby's active during slow sales periods.

Occasionally auction houses compete by purchasing art outright, and some direct purchases by auction houses are phenomenally profitable. In 2006 Sotheby's specialist Francis Outred, a long-time supporter of painter Peter Doig, persuaded the auction house to purchase seven of the artist's paintings from Charles Saatchi for \$11 million. Doig is a Canadian and lives in Trinidad but is considered in London to be British. His art has wide acceptance.

Why Saatchi wanted to unload his Doig paintings, or sell them rather than auction them, was never revealed. In February 2007, Sotheby's auctioned the best of the seven, *White Canoe*, for £5.8 million (\$11.4 million), making Doig at the time the second most expensive living artist at auction after Jasper Johns. The price was higher than any achieved by British artists Lucian Freud or David Hockney. The work had been purchased in 1990 for £2,000; Sotheby's had put an estimate of £800,000–£1.2 million on it, probably because of the Saatchi provenance. The successful bidder was thought to be Georgian banker Boris Ivanishvili, owner of Imperxbank. In May 2007 Sotheby's auctioned a second Doig work, *The Architect's Home in the Ravine* (1991), for \$3.6 million. This sale upped Sotheby's profit to \$3.9 million on the sale of two works, with five remaining.

When each auction house matches the other's offer, consignors find new ways of choosing a hammer. One undecided seller was Takashi Hashiyama, president of Japanese electronics company Maspro Denkoh. His \$20 million art collection included canvases by Cezanne, Picasso and van Gogh. Hashiyama proposed that Christie's and Sotheby's should decide themselves

which house would get his consignment, with one round of the children's game 'Rock, Paper, Scissors'. In Japan the game is popular and is called *Janken*; when played over many sessions it trains the player to recognize and exploit the non-random behaviour of an opponent.

There is a best strategy for the game if you can predict your opponent's opening move. To help in choosing a sophisticated strategy, and with \$4 million in gross profit at stake, Kanae Ishibashi, president of Christie's in Japan, enlisted experts Flora and Alice, the eleven-year-old twin daughters of Nicholas Maclean, at that time the international director of Christie's Impressionist and modern art department. The twins agreed, 'Everyone knows you start with scissors because the other guys choose paper.' Sotheby's later admitted they had no strategy; they opened with paper. Scissors cut paper, and Christie's won. Apparently neither twin received the standard 1 per cent auction introductory commission.

Auction psychology

Auctions are a bizarre combination of slave market, trading floor, theatre and brothel. They are rarefied entertainments where speculation, spin and trophy hunting merge as an insular caste enacts a highly structured ritual in which the codes of consumption and peerage are manipulated in plain sight.

Jerry Saltz, art critic

God help us if we ever take the theatre out of the auction business or anything else, it would be an awfully boring world.

Alfred Taubman, former controlling shareholder of Sotheby's

N THE RESERVED seats at a Christie's or Sotheby's contemporary art auction you find officials from major museums, plus hopeful bidders from a dozen public museums with acquisition budgets sufficient for one minor painting. There are agents bidding on behalf of collectors such as Charles Saatchi, and curators of the Deutsche Bank corporate collection, which with 50,000 works is the largest in the world. Sitting in adjacent rows are wealthy foreign buyers, often from Russia or China, knowledgeable collectors who make one or two major purchases a year, and new-to-the-field, affluent young buyers. Some are described as in heat, others as only a bit horny. Inexperienced buyers find the auction process itself to be reassuring: the catalogue entries written with great authority, references to auction house 'specialists', and the fact that other sophisticated people are lusting after the same works.

Private collectors account for almost two-thirds of contemporary art purchases in the salesroom. Many of these collectors are uncomfortable with their own judgement. They want advice about which lots to bid on, and how much to bid. Most of all they want reassurance that when they hang the art, their friends will not ridicule their purchase. Some potential bidders consult other collectors, some rely on dealers. Many rely on auction specialists, who come to be perceived as art consultants rather than salespeople.

Auction specialists, like all marketing professionals, understand that buying behaviour is determined in part by the group to which an individual aspires. A bidder may hope to attain visible membership in the group 'owners of important art', or may seek membership on a museum board through donation of an important painting. A hedge-fund manager may bid for a work that will assure he is seen by his own reference group as both cultured and wealthy. A foreign bidder may covet a highly recognizable work that conveys status in her own country because it is coveted in the West. A local buyer may care little about historical importance or aesthetic value, but focus on whether a work is recognizable from across the room as a Warhol.

A dealer purchasing at auction may be buying as agent for a client, for assured resale, or because a glamorous work is needed to front his stand at a major art fair. Even when buying for a client, a dealer may get caught up in the bidding. Prominent New York art dealer Richard Feigen says he often exceeds clients' limits when bidding for them – whether it is a museum or an individual. 'My job is not to be a robot but to use my knowledge and instincts for my client.' Feigen says that in forty-seven years only one client has objected to his exceeding their limit. He is willing to take the work himself if the client is unhappy.

A public museum bids with different criteria. The museum looks to purchase a first-class example of an artist's work, then considers whether it is aesthetically pleasing, and finally whether it is within budget. MoMA may bid against the Guggenheim for a Kippenberger because a curator believes possession will give MoMA the definitive collection of the artist in New York – and losing a work you covet to a local competitor is unthinkable. So the museum, the dealer and the private buyer bid against one another deep into an auction, even though they have valued the work on very different grounds.

For the auction house the challenge is to carry over the excitement of the preview and catalogue to the evening auction. Each house does this differently. Admission to Christie's June 2006 contemporary auction was by ticket only, emphasizing the event's exclusivity. A well-dressed audience of 350 was spread over two rooms of reserved seats in the King Street auction house. Sotheby's contemporary auction the evening before was open to all comers. Six hundred people turned out, filling every seat and standing ten deep at the back of the room, known as auction room Siberia. Many of those standing were tourists in sports shirts and sandals. Dealers and important collectors had up-front, reserved seats.

The packed to overflowing room produced a palpable sense of anticipation and energy. The number present does not matter to the bidding – at each auction house there were no more than thirty active bidders in the auction hall and forty on the telephones.

The auctioneer is now central to the choreography and psychology of the auction. He is never identified by name, either in the catalogue or during the auction. To do so would position him (for a major evening auction, virtually always a male) as a salesperson rather than as part of the community, there to help determine the correct value for each work of art. He is of course already known to many in the auction room.

Once he has taken his place, preliminary announcements are made, and Lot 1 is brought forward. In New York, traditional auction humour holds that lots are carried in by the only black person in the room. In London they are carried in by the only impoverished person.

Typically the auctioneer will select a modest starting price for Lot 1, and bids mount quickly to the reserve price. The bids are usually real but can be fake or 'chandelier' bids (non-existent bids taken 'off the chandelier') on behalf of the consignor, or bids left with the auctioneer in advance. Lots always start with very few bidders involved; dealers and experienced bidders enter towards the end of the process. When Christopher Burge played an auctioneer in the film *Wall Street*, 400 extras raised their paddles at the opening of the bidding. Once he stopped laughing, Burge had to inform them that in an auction no more than two or three paddles are in the air at one time.

If no real bid materializes at the reserve price, the auctioneer stops, looks around, asks 'Are we all done?', announces 'Passed' and moves on. Passed means 'was not purchased'. When the bids keep coming, he keeps going. Every auctioneer tries to get into a rhythm, with a bid spacing of one and a half to two seconds, enough for a bidder to raise his hand but not long enough to think about it. The quick bidding cadence encourages buyers to join in this ensemble performance. There is muted chatter in the room at the beginning of bidding for each lot, but silence and tension as bidding mounts well above the high estimate.

If a lot elicits no interest the auctioneer maintains the flow by pulling a few more fake bids off the chandelier. If these are not followed by real bids, he quickly passes the lot and the work is 'burned'. The term applied to a work used to mean that it had failed at auction within the previous two years, and was unsaleable – all the knowledgeable collectors had seen it, and if neither they nor anyone else thought it worth buying, it was unlikely anyone would buy it in the near future. Today failure at auction seems to matter less – perhaps a wait of six months before the work is offered again, rather than two years.

The cadence always slows as bidders drop out. Dealers or agents bidding for clients via mobile phone create a longer delay than the auctioneer likes. Jussi Pylkkanen, president of Christie's Europe and contemporary art auctioneer at Christie's London, says no lot should take more than sixty seconds, but he cannot always hold to that. His quickest lot is twenty seconds – this happens when he takes chandelier bids to the one real bid he has been told is coming, looks around the room once, and says 'Sold'. The longest lot takes about three and a half minutes and typically involves bidders both in the room and on the telephone.

A bidder is thus forced to re-evaluate the aesthetic value of a work of art, its investment potential and the commitment of other bidders, all in a few seconds. Should he go one bid higher because a competitor who outbid him a few lots earlier wants to take this one away as well? Will an internet entrepreneur who never willingly loses a battle in the business world permit defeat by an unknown bidder on the telephone?

Ego considerations drive the bidding for many lots. The assumption that the auction process produces fair value for a painting through interacting bids from many potential buyers is simply wrong. From the moment that two people want to possess the same item, the auctioneer's role is to play these buyers off against each other, to encourage each not to back down. Comments like Pylkkanen's 'Last bid ... are you sure ... no regrets?' play directly to this. The longer the bidding, the less significant the aesthetic value and the more important rivalry and competition.

The auctioneer introduces each lot in the same way: 'Number 41, the Kippenberger.' He may say 'consigned by the Museum of Contemporary Art, Chicago'. Or he may point out, 'There is a request that this work be loaned to an exhibition at MoMA [or Tate or the Pompidou Centre] this September ...' The request has probably come about because the auction house knew of the forthcoming show and offered the work, subject to the purchaser's agreement. The request has also been noted in the notes posted at the preview.

The reference to a request by MoMA suggests that the work has great credibility. If MoMA wants the work, it must be important. The promise of a forthcoming major museum appearance will boost the auction price more than would a past appearance of the same painting at the same museum, because the successful bidder's name can now be listed as 'From the collection of ...' With these exceptions, the auctioneer almost never mentions attributes of the work. Extravagant description of the painting is confined to the catalogue and the preview. Further comment from the auctioneer would cast doubt on what has been said before and break the rhythm of the auction.

The auctioneer's contribution to the process is central. For between two and three hours, he must be persuasive, without repeating the same gestures or phrases too frequently. He must keep a restless audience engaged, particularly bidders who are uninvolved in the performance until their target painting comes up. He will vary his pitch and tone, implying excitement for an item in which there may be none. He lets the audience know if a bid is in the room, left in advance ('to my book') or on the phone.

His persona is part of the psychology of the auction. Pylkkanen, aged fortyfour, comes from a background that fits the public image of Christie's. He was introduced to art as a boarder at King's College School in Wimbledon, where his father, a metals trader, had him picked up in a chauffeur-driven limousine to visit the National Gallery. He studied English literature at Lady Margaret Hall at Oxford. He is certainly one of the top four art auctioneers in the world.

Every auctioneer seems to be superstitious. On auction day, Pylkkanen has lunch alone at the same restaurant. German-born Tobias Meyer at Sotheby's New York takes a forty-five-minute afternoon nap, drinks tea and eats a yellow apple before each auction. Christopher Burge, British-born but a long-time US resident, is both auctioneer and honorary chairman at Christie's. Burge paces the streets around the auction house before an evening auction, repeating increments and memorizing the names of staff who will be manning the phones. He has a small Scotch before an evening sale but not, he insists, before a morning sale.

At auction, Pylkkanen uses a special, custom-made gavel. He stands behind a lectern that is described as Chippendale, dating to about 1765. Privately, Christie's officials chuckle that Thomas Chippendale died a long time before the tree that became the lectern.

Every good auctioneer strives to create a personal relationship with bidders. Pylkkanen leans to one side then the other, reaching to pull in bids. He uses his hands like a symphony conductor. He calls known bidders by first names: 'David, will you give me three two [£3.2 million]?' He uses end-of-bidding terms like 'Do you like it ... then give me four fifty', and 'Will you let him have it?' To a dropped bidder he says 'Would you like to come back in?' They often do. Christopher Burge leans over the rostrum, checking out the room through his glasses, much more easy-going and welcoming than Pylkkanen, with a soft west of England accent. He has been described as having the persona of a croupier in a Mayfair casino. Tobias Meyer is best known for his movie-star looks and media friendliness. His auction presentation is polished, delivered with a moderate Swiss-German accent. After the Sotheby's price-fixing trial and the departure of president Dede Brooks, Meyer became the public face of the auction house.

Pylkkanen will pause and squint into the bright lights, while searching the audience for a bid. Christopher Burge says that people display characteristic

body language before they bid – they straighten up, they adjust their tie. This is what the auctioneer is looking for. Burge reads body language to sense what increments to accept as bidding for an item nears the end. He will accept a smaller increment if it keeps a potential bidder in the game, or to recreate energy in the bidding if it wanes.

Pylkkanen's favourite closing terms are the famous 'No regrets', but also 'Shall we try one more?', 'Are you sure?', 'and 'Selling, I'm afraid'. These comments are not addressed to all bidders. Pylkkanen has a mental list of individuals who insist on not being acknowledged in any way. If he speaks or gestures to them, they will immediately stop bidding.

Hugh Hildesley offers further insights into the auctioneering process. Hildesley was head of the Old Masters painting department at Sotheby's New York before leaving in 1983 to become Episcopal rector at the Church of the Heavenly Rest on Fifth Avenue. Twelve years later he returned to Sotheby's New York, this time as executive vice-president and senior auctioneer.

Hildesley says that auctioneering is all about entertaining the 90 per cent of the people in the auction room who have no intention of bidding, while eliciting bids from the lustful 10 per cent. He says if you take more than two minutes per auction lot you lose the 90 per cent, and this drop in energy affects the 10 per cent. He points out that his two careers have strong similarities; the dress code is different, but you pray in both places. He also points out that the old auction currency converter at Sotheby's had a note at the bottom that read 'All conversions are approximate', and that this applies to both his worlds.

Hildesley says the most common mistake of inexperienced auction bidders is that they bid and declare their interest too soon. For a desirable painting, serious bidders do not raise their paddles early on, especially before the reserve is met. Sometimes the inexperienced do this from a fear that the auctioneer won't see them. This never happens; four or five spotters, along with the auctioneer search for bidding signals.

Experienced bidders like Larry Gagosian sit back until only two paddles are still in play. When one bidder is about to fold and the other is starting to relax, and the auctioneer says 'Fair warning', only then does the experienced bidder

get involved. The lower bidder is knocked out, and the almost-winner is thrown off balance.

The technical role of auctioneering can be daunting. The reserve price for each lot is marked in his catalogue in code, as are bids left in advance, where potential bidders will be sitting, and who will bid by phone. Bidders signal from the floor, ideally by raising a paddle but sometimes by other prearranged signal, a nod of the head or removal of glasses. Some bidders reverse the process and remain in the auction until they signal they are out. The auctioneer must remember whether a dealer is bidding when his arms are crossed or when they are not.

Part of auction legend is that when famed collector Norton Simon was interested in a work, he would bid by standing up and leaving the auction room. He was considered still to be bidding until he returned to his seat. Simon assumed that the perception he was uninterested would signal to others that the work was not worthy of their interest either. There are a couple of New York dealers famous for bidding by mobile phone while sitting in the first few rows of the auction room – probably to slow the pace and give them more time to respond. The auctioneer takes their bid increments from a telephone clerk while looking directly at the dealer, hoping to encourage one more bid from their client.

Mobile-phone bidding offers a separate set of problems. Approaching the end of bidding for Picasso's *Garçon à la pipe* at Sotheby's, Larry Gagosian, whose bid on behalf of a collector had just been topped, closed his phone and, according to auctioneer Tobias Meyer, turned white and stared. Meyer asked: 'Sir, do you need more time?' Gagosian grabbed his neighbour's mobile phone – his own turned out to have a dead battery – and redialled the client. Meyer waited, Gagosian re-entered at \$77 million, and the bidding increased \$20 million from where it had been when his phone went dead. Gagosian's client ended up as the underbidder.

A third of all bids come by telephone to the auction desk. The are thirty phones in the salesroom, staffed for the most part by comely young women projecting expensively tailored energy – dealers call them auction babes – and by a few auction house employees and part-timers brought in because they

speak languages such as Russian or Cantonese. Bidders who indicate interest in a lot are phoned just before their item comes up. The staff member on the phone tries to convey to the auctioneer the bidder's nationality and level of commitment, while conveying to the bidder the excitement of the salesroom.

Telephone bidders raise the tension level so much they would have to be invented if they did not exist. The existence and anonymity of foreign bidders reinforces the importance of a lot. Is the salesroom bidder up against a Russian oil magnate, a Japanese banker, a New York dealer or a Paris museum?

Every bidder comes to the salesroom with a maximum price in mind: 'this high and no higher'. Few stick to this once bidding starts. A bidder will say to himself 'Just one bid over.' A dealer bidding for a client via mobile phone says: 'We have reached your limit but this is a great work, I think we should go higher.' The 'we' in this case is real. The dealer often earns a commission only if the client makes the purchase.

Regret is a feeling that auctioneers understand and exploit; the 'no regrets' comment is not just a figure of speech. During the auction process, the bidder's previously held values are subject to change. The underbidder feels regret at losing an artwork he might have possessed. A reference point of 'almost having the painting and losing it' is different from having the money, and deciding to bid.

Each bidder starts with a top price in mind. When he becomes the high bidder, there is an 'endowment effect'. He will pay more not to give up the painting, not to lose. Amid the tension of the auction, his reference point has changed to 'I should win, this painting should be mine'. He is aware of the regret he would feel at losing what has become 'his'.

Regret is more complex when a couple is involved. The male is always the bidder, but it is the woman who allows the man to bid. This can be seen in their body language; the man turns to the woman for unspoken permission to bid again. Tobias Meyer says that the male cannot bid without the female's permission 'because it is a pseudo-orgasmic experience'. The auctioneer takes bids from the man, but looks at the woman and directs any comments about regret to her.

The loss of something one has almost owned outweighs the relief of not having overspent. A simple MBA classroom experiment is used to illustrate how the endowment effect functions, how losses have a greater impact than gains. A small group of people is offered something of tangible value, say a three-day, long-weekend trip for two to Bermuda, and asked what they would be willing to pay. The average answer is, say, \$500, and each person receives a voucher redeemable for the trip. An hour later, when asked how much they would sell the voucher back for, values range from \$600 to about \$800.

Economic theory suggests that the amount of money in each case should be the same. Value is value, whether you are buying or selling, and whatever the starting point. Intuition says the amounts will differ; more money will be demanded to give up the trip (or a painting) than was paid for it, because the reference point has changed. Now that the trip is in hand, and possession is real, there is regret in giving it up.

The logic of auction buyers who bid way over their limit is 'I do not want to wake up tomorrow thinking that for one more bid it could have been mine'. This is another kind of 'regret' that Pylkkanen invokes. Of course the 'one more bid' logic may be a rationalization. One more bid may simply trigger a counter-bid.

Bidders understand the tension involved. Robert Lehrman, former chairman of the board of trustees of the Smithsonian Institution's Hirshhorn Museum, said, 'There is more money in the world than great art so if you want a great piece of art you need to be ready to stretch to get it.' When he was interested in a lot, Lehrman would first create his own estimate of the work's value, starting with the auction house's high estimate then adding a premium reflecting the expected salesroom interest. His one-over bid came when his own estimate had been reached. Whenever he bid over his estimate, he admitted to thinking 'Please, somebody, bid and get me off the hook.' Usually somebody did, and Lehrman would sigh and bid again, or drop out and suffer remorse the next morning.

This idea of regret at missing out applies to individuals, but not to museums or dealers – one reason why collectors rather than institutions are almost always high bidders at an evening auction. A curator who bids 50 per

cent over what she has told her trustees a painting is worth might be considered irresponsible. The auction house would like her to keep bidding, if only to motivate other bidders who recognize her – 'If the Guggenheim wants this it must be good.' Christie's or Sotheby's will always allow an institution sixty or ninety days to go back to patrons for more money. Or the auction house will accept a deaccessioned work as part payment. Every museum curator, nominally with a fixed acquisition budget, will admit to thinking 'I have a patron who might top up the additional \$500,000 to purchase this piece', but usually does not act on the impulse.

The most dramatic auction prices are achieved when two collectors decide to 'bid to get', which means telling your agent to just keep bidding until you win. One auction house specialist says, 'Heaven is two Russian oligarchs bidding against each other.' In 2006, the successful bidder for Picasso's *Dora Maar* at Sotheby's New York simply raised his paddle and kept waving it until everyone else quit at \$95.2 million – the second highest price ever achieved at auction. Because of this the bidding raced along, never slowing as it usually does above \$25 million. London dealer Rory Howard said he knew someone who had planned to go as high as \$60 million, but never got to raise his paddle. Most bidders are more subtle; moving the paddle, touching the tie, removing the glasses. Waving and gesturing would be described as intimidation at lower bidding levels – at the *Dora Maar* bidding level it was unheard of.

The idea of regret is also a factor at an art fair, particularly at the opening session, where crowds of buyers induce something like the excitement of an auction. Regret does not apply to buying in galleries, where there is usually no rush and no point at which a painting is the buyer's to defend. If there are no other buyers in the gallery, the painting will almost certainly still be there the next day, and in any case a collector can put a reserved sticker on it.

Not surprisingly, whether the bidder avoids regret by offering 'one bid over' is related to income level. For the rich, the meaning of the painting and their immediate possession of it are more important than the meaning of money. Regret, as measured by bidding over, changes with age. The results-driven thirty-year-old hedge fund manager is willing to pay a higher price to possess a brand-name work right away.

The influx of Russian bidders to the art market has affected auctions in two ways. First, the addition of three or four serious bidders for any work completely changes the dynamic of an auction. The second factor is that Russian bidders, often richer but less experienced than their Western counterparts, seem to have a greater fear of regret. Competitiveness between Russian bidders causes each to go a great many bids-over to avoid losing to anyone. The bidding behaviour for *Dora Maar* is the perfect example.

In February 2006 Christie's London auctioned a Frank Auerbach oil, *Julia Sleeping*, part of the estate of Francis Bacon's friend Valerie Beston. The painting was estimated at £70–90,000 but sold for four times that, and five times what a comparable Auerbach had ever sold for at auction. At triple the estimate, there were still five active bidders. The fear of regret must be powerful if an individual who probably had a mental reserve of £125,000 was still bidding at £290,000. Two comparable Auerbachs were available from London dealers' for under £125,000, but of course they lacked the Christie's/Beston provenance.

Work often sells at auction for amounts well above current dealer prices. In May 1998, two enthusiastic bidders at Sotheby's New York took the Warhol *Orange Marilyn* mentioned earlier to \$17.3 million – against an auction estimate of \$4–6 million. The price was four times the auction record for a Warhol at the time. The work is one of a series of five slightly different *Orange Marilyns* of the same size. There was another of this size available through a New York gallery at one-third the auction-winning price. Underbidders included MoMA, the Tate, the Warhol Museum in Pittsburgh, S.I. Newhouse and Steve Wynn, but they were all out at \$7 million. A few days later Wynn purchased a slightly smaller *Orange Marilyn* for \$3 million. Only two bidders have to be swept away by the bidding. The other thirteen bidders in that auction comprised a community whose role was to reassure the two final bidders that the lot was valuable and desirable.

In fairness, while Warhol works are multiples they are not exact copies. Usually in the most expensive work the silk screening is precise, the red aligns exactly with the subject's lips. Does this account for the price difference? Warhol intended each version to be different; some buyers prefer one version, others a

second. This *Orange Marilyn* had the provenance of having spent thirty years in two German museums, the Landesmuseum in Darmstadt from 1970 to 1981, and the Frankfurt Museum für Moderne Kunst from 1981 to 1997.

Another of the underbidders for *Orange Marilyn* was London diamond merchant Laurence Graff. In 2006 he had purchased a rarer Warhol *Red Liz* after every other bidder but one, a Zurich dealer, had dropped out by \$7 million. Graff and the dealer took Liz from that level to \$12.6 million. There was at least one other version of *Red Liz* available at the time, at 'just under \$6 million'.

Another statistic illustrates the 'carried away' aspect of the auction process. About one successful bidder in eight says when they stop at the payment desk: 'I don't think I bid that high.' All bidding is taped and recorded to protect the auction house from just this misunderstanding. A variant of this is the successful bidder, often Middle Eastern, who arrives at the payment desk saying, 'Yes, I know I bid \$200,000, but might you accept \$175,000?'

Just as failure to make 'one more bid' and dropping out may produce post-auction regret, the successful bidder (who may have gone many bids over his intended maximum) may suffer post-purchase regret. This concept is familiar to anyone who has purchased their first home, and awakened the next morning in a panic: 'I committed to how much?' The auction house tries to provide reassurance, without being asked. The buyer may receive a congratulatory call from the auction specialist the next day. He is reassured that he has acted wisely, that the work of art will meet his expectations. But post-purchase regret is minor; the most dedicated collectors remember only what they missed. Amy Cappellazzo of Christie's says very few successful bidders call her the next day to ask 'Did I overpay?'

Buying at Christie's or Sotheby's mitigates post-purchase regret. Simply saying 'I bought this Bacon at a Christie's evening sale' reduces the possibility of criticism of the painting, or its cost. If the buyer is truly unhappy with the purchase, the auction specialist will agree to resell it, although he will suggest a delay of a year or two so the item will again be 'fresh'.

Post-purchase regret is sometimes eased when it comes to paying for the purchase. When California collector Eli Broad bought Roy Lichtenstein's *I ... I'm Sorry* (1965), a rendering of a tearful blonde, for \$2.47 million, it

occurred to him that he could pay with his American Express card. Billionaires have extremely high card limits. Broad picked up 2.47 million air miles, which he donated to local art students, and Sotheby's had to pay a 1 per cent handling charge, which cost it \$24,700 of its \$227,000 commission. Sotheby's almost immediately changed its policy to accept cards only to a \$25,000 limit – still enough points for an upgrade on a flight from New York to Los Angeles.

Economists design games in order to illustrate auction-like situations that require self-interested participants to take into consideration how others will act. An example is the centipede game, part of the economic field of game theory and so called because of the appearance of its game tree when sketched out.

The basic centipede game has two players, A and B, who sit across from each other at a table. A referee, who we can call the auctioneer, puts \$1 on the table between them. Player A can take the dollar and the game is over. If A does not take the dollar, the auctioneer adds another dollar and gives B the choice: either take the \$2 and end the game, or pass. If B passes, the auctioneer adds another dollar and gives A the same choice. The pot of money is allowed to grow until it reaches a prearranged limit known to both players, say \$50.

Since B would always take the \$50 at the end of the game, a rational player A would always take the pot one move earlier, at \$49. Knowing this, B, who assumes A is rational, would always take the pot at \$48 – and so on back to the original play, where A should take the first dollar and end the game.

There is another rational (but optimistic) outcome, where the game goes to \$50 because A thinks that B will share the pot, even though there is no prior agreement. For sharing to happen each player must assume that the other will make the same calculation and, more importantly, have a sense of fair play that will overcome greed. This is like assuming that if your competitor wins one auction item, he will refrain from bidding and allow you to win the next.

What actually happens when the game is played with students or business people is that players almost never stop with the initial play. By behaving 'irrationally' the players think they will do better than if they played rationally and selfishly. No player sees themselves as irrational, because the satisfaction of bluffing successfully and 'winning' a competitive game are part of the reward.

If the 'auctioneer' quietly encourages A or B not to pick up the money, both players go more deeply into the game. 'Look, if your opponent were rational he would have picked up the money earlier – play on and see how much more you can get before your opponent becomes rational!' And each player plays on, because there is more at stake than the object to be won, just as there is greater reward in winning a Francis Bacon triptych or an *Orange Marilyn* silkscreen at auction than in a quiet and anonymous purchase from the art dealer down the street.

The secret world of auctions

At auctions new values are assigned and desire is fetishized. Jerry Saltz, art critic

It is sobering to think that purchasing at auction means that you have just paid more than any of hundreds of other people in the room thought the work was worth.

Auction room attendee (sitting beside me) during a Sotheby's New York auction

HE FIRST TIME I attended an art auction, registration completed and paddle in hand, I was immediately assailed by doubt. Could prices really be as high as the estimates suggested? Was the Armani-clad man beside me an auction house employee, bidding to drive up prices? If I scratched my nose or adjusted my glasses at the wrong moment, would I end up buying an unaffordable painting? What I have learned is that these were naïve questions; there were many more interesting ones that could have been asked. Much of what I thought I knew about auctions when I began writing this book was incomplete, or just wrong.

A few things about an auction are completely transparent – the number of people bidding in the room, the hammer price, the auctioneer's performance. Almost everything else is opaque: who is actually bidding, how estimates and reserve prices are set, which bids are real and which artificial. Does the auction house itself own the painting being shown? Has it guaranteed the price to the consignor, and thus have a financial interest in the outcome? How is it that dealers – and sometimes collectors – who refuse to

bid, sometimes end up owning the painting? The answers are part of the secret world of auctions.

The physical presence of a bidder in the auction room means very little. He or she may be representing anyone. The auction house will have seen identification as part of the registration process, and required some assurance that bids will be honoured, but this might only involve seeing a passport or a letter of introduction from a bank. Once handed a paddle, the bidder can compete for the least or most expensive work on offer. Because the bidder may be a dealer or agent acting for someone else, the future owner of the work is invisible and unknown.

The extreme case is the Russian or Asian buyer who for personal, political or tax reasons bids through a local dealer, who then bids through a western agent. Anonymity might not be the only motive. A consequence of this multilayered structure is that anyone wanting to bid up the work of an artist to increase the value of their own collection can do so with little risk of being identified. Is this ever done? Dealers say 'Of course'; auction houses say they do not know of any cases. It could happen.

Prior to 1975, it was never even certain whether an item announced as auctioned had actually sold. Lots that did not meet their reserve and were bought-in were nevertheless listed as having been sold, on the logic that the reserve price was close to the true value, and that unsold work should not be stigmatized by being identified. Fictitious names were produced for non-existent buyers. Buy-ins were listed, under 'Sales Prices', as having sold at the reserve price, plus commission.

Reporting buy-ins as sales gave a dealer or collector with five works by Robert Rauschenberg the motivation to consign one of them with a very high reserve. The auctioneer would take chandelier bids to the reserve price and hammer down a fictitious sale. Newspapers reported a record price for a Rauschenberg, and gallery prices were marked up the next morning. The consignor took the painting back, paid a 5 per cent commission (reduced to 3 per cent and sometimes to zero for a dealer), and auctioned a different Rauschenberg at the next round of auctions, and one at the round after that.

This was a particular problem with contemporary art. While the practice of reporting everything as sold existed, probably one-third to one-half of the auction records for modern and contemporary art were false. Saying that art had been sold when it was really bought-in created a different problem. On more than one occasion, Christie's and Sotheby's were faced with a consignor who, thinking his painting had sold early in the auction for a high price, went on to bid for later items with his auction 'credit'.

In 1975 auction houses started to purge buy-ins from the list of reported sales prices. The sale that changed the practice was an Andy Warhol *Soup Can With Peeling Label*, which received a lot of newspaper coverage in New York for selling at a record \$60,000 when in fact it had been bought-in. This turned out to be an innocuous example; the actual high bid was \$55,000, which would also have been a record. Following the change to reporting only real sales, the auction house's list of prices achieved would read Lot 1, 2, 3, 6, 7, 9, and readers knew that Lots 4, 5 and 8 had not reached their reserve and had not sold.

Bidders in the auction room know nothing of the identity of telephone bidders, or of those who leave advance bids with the auctioneer. Half or more of the bidding on some contemporary lots is by these methods. Advance bids left with the auctioneer create a conflict of interest; the auctioneer now represents both the buyer and the seller. If an absentee bidder says 'I'm willing to bid up to £50,000', then the auctioneer may take bids 'from his book' up to that level on his behalf. Was there an actual underbidder at one bid below £50,000? Was the reserve set at that level simply because of the advance bid, with chandelier bids taken to that bid amount? The auctioneer may have bid on behalf of the absentee buyer, but his legal and real obligation was to the consignor.

What of the pre-sales estimates printed in the catalogue? Sotheby's says those in its catalogues are intended 'as a guide for prospective buyers ... any bid between the high and low pre-sale estimates would, in our opinion, offer a chance of success.' This is a pretty safe statement, given that 'chance' means anything from 1 per cent to 100 per cent. According to Christie's catalogue: 'Estimates of the selling price should not be relied on as a statement that this

is the price at which the item will sell or its value for any other purpose.' If an estimate does not reflect value, what should it be taken to reflect?

A rule of thumb is that the low estimate will be set at 60–70 per cent of the best auction price achieved by a similar work of the artist, and the high estimate at 80 per cent. But averages are always misleading. Auction house specialists say that estimates are initially set by examining recent work sold by that artist at auction, and the trend of prices. They then add expert opinion as to whether that trend will continue. The size, date, composition and provenance of the piece are important, as is the historical importance of the work and its rarity. The identity of a previous owner is significant when a prestigious private collection comes up at auction, or where a work is deaccessioned by an important museum. Coming from MoMA or a similar branded museum adds as much as 50 per cent to the price.

Recent or pending major museum shows for an artist add further value. The inclusion of the artist in a group show in a major museum may raise a piece's estimate by 10–20 per cent. A group show in a secondary museum may make a 10 per cent difference. A single-artist show at a major museum increases value by 50–100 per cent.

Any formula is just a starting point. There are two very different philosophies of estimating. One, called in the trade a 'come-hither' estimate, involves setting as low an estimate as the consignor will accept, to encourage bidding. Once collectors are attracted by the low estimate, they begin bidding and become committed to a work; regret becomes involved. It is hoped that they will continue past the estimate. The extreme practitioner of this is the 'third' auction house, Phillips de Pury, which on occasion sets both estimate and reserve price below the price already guaranteed to the consignor – the price that Phillips has itself agreed to pay for the work. This is done to attract new bidders, and to produce a spirited bidding environment to attract future consignments. The second approach, referred to as 'kiss-my-ass-if-you-want-this-great-work' estimating, involves setting the low estimate at or above the dealer's retail price.

The two approaches to estimate-setting were tested in Christie's and Sotheby's contemporary sales in February 2007. Each house offered a Frank

Auerbach oil from the same year, of the same size, and of comparable subject matter and quality. Both Christie's and Sotheby's had first sought consignment of Auerbach's *To The Studio II* (1977–8), owned by two American brothers whose father had bought it at Marlborough Fine Arts in 1981 for £15,000. Sotheby's proposed a modest estimate of £500–£700,000. Auerbach's auction record at the time was £450,000, although private sales had brought amounts over £1 million. Christie's won consignment of *Studio* with an estimate of £800,000–1.2 million, and a guarantee reported as £1 million.

Sotheby's then acquired Auerbach's *Camden Theatre in the Rain* (1977), depicting a scene close to his London studio, from a European collector who was a longstanding Sotheby's client and who did not offer the work to Christie's. Sotheby's proposed the same £500–700,000 estimate as they had for *Studio*, a level which was not challenged by the consignor. Dealers considered *Camden* as superior in quality, but less interesting in subject matter.

Sotheby's auctioned *Camden* for a record £1,925,000, more than double its high estimate, with fifteen bidders in the salesroom or on the telephone. Christie's sold *Studio*, with its higher estimate, for £1.25 million, with seven bidders involved.

The 'modest estimate' approach sometimes produces absurd results, as with Rothko's *White Center* from the Rockefeller collection, where the pre-sale estimate of \$40 million was \$32.8 million below the final selling price. What experts cannot do is anticipate the level of lust and competitiveness exhibited by oligarchs for whom winning is more important than value.

Estimate-setting is part of the negotiation process. Auction house specialists try to convince consignors that a low estimate will produce more bidding, but in the end they do what they must – which explains why catalogues have such marvellous disclaimers. Winning the consignment comes first and some consignors find it hard to resist the auction house that offers the highest estimate. One auction house specialist said: 'If a consignor wants you to estimate a Jean-Michel Basquiat at \$1.5 million, are we going to say "No"? You can't afford to let it go to the competition.' The estimate then ends up reflecting the seller's firm belief that a high estimate will bring a higher price.

The 'Kiss my ass, I want a high estimate' consignor is sometimes right, though not for the reason he thinks. Even a lot with an unreasonably high estimate may sell, because risk-averse non-professionals will bid to the lowend estimate, or to the halfway point between low and high estimates, without consideration of how realistic these are. A high estimate that scares off dealers and informed collectors may still attract bids from more casual collectors.

Consignors who demand a high estimate sometimes end up with a catalogue notation that cites no amounts but rather states 'Refer Department'. The stated reason for a 'Refer Department' estimate is that the object is unique, and impossible to value. The auction house then sets a tentative estimate. If the first caller becomes excited at a quoted estimate of \$3–4 million, the next caller is told \$3.5–4.5 million. More excitement, and the next is told \$4–5 million. If the \$3–4 million estimate brings a succession of 'too much' responses, the auction house pressurizes the consignor to lower the estimate.

There is a strong preference for the first few lots in an auction to be given low estimates. Christie's February 2006 London sale opened with the six works from the Valerie Beston estate. The estate did not object, so each of the six carried a wildly low estimate. Prices increased so fast that many bidders who were willing to go well above the high estimate never got a chance to raise a paddle. Total estimates on the six were £2.05 million, the total selling price £6.3 million.

Fewer lots sell above the high estimate as you go deeper into the auction. A consignor who insists on a high estimate may be rewarded with a late position in the catalogue.

Then there is the reserve price set by the auction house on most auctioned work – the confidential amount below which the auction house will not sell. Reserves are so common that the auction house has a special catalogue marking for any work without a reserve. Why are reserves secret? Auction house specialists say there are two reasons. One is that the work would otherwise have to open at the reserve price, resulting in fewer bids, fewer bidders and less excitement. The second is that if bidders knew the reserve, they might refuse to bid, wait for the painting to be passed, and approach the auction house or the consignor after the auction to negotiate a private sale.

The reserve is most often set at 80 per cent of the low estimate; it is occasionally as low as 60 per cent but never higher than 100 per cent. The auctioneer will often signal that he has reached the reserve by openly seeking real bids from the audience rather than pulling them off the chandelier. If he is already taking real bids, he may say, as Jussi Pylkkanen does, 'I'm selling'.

The ability to lower reserves a few hours before an auction is one of the great advantages of 'going second' in the Christie's–Sotheby's alternating two-day sale sequence. In May 2005, Sotheby's Impressionist and modern sale in New York stuttered, with hesitant bidding and unsold lots. The next morning, Christie's specialists got on the phones and persuaded a number of consigners to lower their reserves. (They could not lower the estimates, which were printed in the catalogue.) The strategy worked. In a weak market the auction house whose sale comes second usually has fewer unsold lots than the house whose sale took place the first day.

It hardly ever works the other way. In June 2006, Sotheby's held the first auction with great success, setting ten artist records. At least one Christie's consignor who had a lot in the following day's sale expressed concern that its reserve price was too low, but he was talked out of increasing the reserve. At the Christie's auction six lots failed to sell. Had all reserves been raised to the low estimate, three times as many would have failed.

Each auction house will have up to \$250 million in price guarantees to consignors on their books at any one time. As insurance against a market downturn, or to limit their total exposure, Christie's and Sotheby's sometimes bring in third parties to co-insure part or all of the risk. The third-party guarantor can be a collector, a dealer or a financial institution. Publicly identified guarantors include dealers Acquavella Galleries, L&M Arts and Mitchell, Innes & Nash in New York, and collectors Peter Brant, Steve Wynn and Steve Cohen.

The third-party guarantor enters the scene after the guarantee has been negotiated with the consignor, and the auction house decides how much risk it wants taken off its books. Both the existence and the identity of the outside guarantor are normally confidential; the consignor may not know a third party is involved unless he reads about it after the auction. The guarantor earns a

commission that differs from what the auction house negotiated with the consignor. Guarantees are 'auctioned off' among possible guarantors. The commission will be higher if the market is weak closer to the auction date or if the auction house has provided too high a guarantee.

The existence of a market for third-party guarantees gives the auction house the potential to 'hedge' its minimum profit from an auction lot. Imagine that an auction house guarantees a painting to a consignor for what it considers a very conservative price, say \$5 million, and then is able to sell a third-party guarantee to an investor for \$7 million. If the painting sold above \$7 million the auction house would receive a guarantee fee from the consignor, would pay a fee for the third party's \$7 million guarantee, and would earn a full buyer's premium on the sale price.

If the actual high bid were to come below \$5 million, the painting would be passed. The third-party guarantor would now have 'bought' it for \$7 million, the consignor would get \$5 million from her guarantee, and the auction house would earn a guarantee fee and the \$2 million differential, less the cost of the third-party guarantee. The third-party guarantee fee is the cost of the hedge against a failed auction result, the additional \$2 million profit is the reward for good negotiating.

If the high bid were to come between \$5 million and \$7 million, the bidder would get the painting, the auction house would waive the \$7 million guarantee requirement, and the guarantor at that amount would keep the fee. The outside guarantor would not be disadvantaged; if he had wanted to own the work, he would have bid the price up to \$7 million.

Is this ever done? One dealer said he thinks so, others that it is so potentially lucrative that it must have been considered. Auction specialists say little; third-party guarantees and fees are the most carefully guarded of auction house secrets.

In documents filed with US regulators, Sotheby's revealed in April 2007 that it had outstanding guarantees of \$295 million, one-third offset by third parties. As a privately held company, Christie's does not make such financial disclosures, but it is fair to assume its guarantees are at the same level. This suggests that at least for the peak period of April (before the

major May and June auctions), total guarantees for the two houses are in the neighbourhood of half a billion dollars, with about \$170 million covered by third parties.

The only indication that a third-party guarantee may be involved comes immediately before an auction, when the auctioneer states that someone with a financial interest in the art offered may be bidding on a particular lot. The auctioneer never says whether this involves a third-party guarantee, a prior debt to the auction house, or a party to a divorce who is bidding on family art.

Some of the collectors mentioned earlier also act as guarantors. For Sotheby's 2004 sale of Picasso's *Garçon à la pipe* for \$104 million, a third party said to be Steve Wynn guaranteed \$80 million, and earned about \$1.2 million for providing the guarantee. In May 2003, Wynn had paid \$17.3 million at Christie's for a self-portrait by Cézanne. This was guaranteed for \$13 million by Steve Cohen, who earned about \$400,000.

The existence of third-party guarantees would be only an interesting footnote to the auction story were it not for the concern that a guarantor might manipulate the auction process by bidding directly, or by advising clients to bid. A dealer bidding for one or more clients earns a risk-free commission by guaranteeing a price below what he knows his client will offer. If the guarantor bids on his own, he will buy the work at a lower net price than anyone else can because a portion of the purchase price is returned as commission.

Guarantees blur the distinction between dealing and auctioneering; the auction house is now a selling partner with the consignor. This leads to the suspicion that the auction house might devote more effort to marketing a lot on which it bears a financial risk as guarantor, at the expense of consignors of non-guaranteed work. If there are three Warhols in an auction, one with a guarantee and two without, and a collector asks the specialist 'Which work do you think is the best investment?', is the response biased by the existence of a guarantee? The consignors with the guarantee certainly hope that this is the case. The auction house argument is that guarantees add depth to the market by bringing in work for auction that might otherwise go to a dealer.

The one thing that might have changed my bidding behaviour on those few occasions I wanted to speculate would have been knowing that auction houses will sometimes lend part of the purchase price to buyers – although generally only for major purchases. It is not that easy to find out. There is no mention in an auction catalogue of the availability of loans. At the eighth-floor reception at Sotheby's New York there is a small sign that says 'Art Financing Available'. There is no equivalent sign at Sotheby's New Bond Street in London.

The best-known story of an auction house loaning money to a bidder dates to November 1987, with Australian entrepreneur Alan Bond's purchase of van Gogh's *Irises* at Sotheby's. Consigned from the Whitney Payson collection, the Impressionist painting had been purchased in 1947 for \$80,000 and sold for \$53.9 million, the highest price achieved to that date for any work of art at auction. *Irises* was painted a week after van Gogh entered the lunatic asylum at St Remy. It is considered a good work but certainly not his best. Two weeks after the sale the Yves Saint-Laurent fashion house used the picture's flowered pattern for a summer dress.

Bond, the successful bidder for *Irises*, was a classic example of the art buyer chasing cultural status. An Australian businessman often described as a cowboy, he is famous both for his business ventures and for criminal convictions stemming from the collapse of his companies. He was a national hero after winning the America's Cup yacht race for Australia in 1983, and was named Man of the Year in 1987. Australia's first private university bears his name. He was jailed in 1996 for trying to conceal an Edouard Manet painting, *La Promenade*, from his creditors. He thought owning the Manet was more prestigious than owning *Irises*.

The sale price for *Irises* was startling – the far superior van Gogh *Sunflowers* had sold at Christie's six months earlier for under \$40 million. The bidding pace was also startling. The work opened at \$15 million and sold in under two minutes.

The price was so unexpected that Christie's challenged Sotheby's to prove that there had been a real underbidder – a challenge motivated in part by Bond, who raised the issue of whether the only underbidder had been the

famous 'Mr Chandelier'. Sotheby's was incensed at having its veracity challenged. After a few weeks of duelling press releases, Sotheby's showed the auction clerk's bid sheet identifying the underbidders to Christie's chairman Lord Carrington, who apologized and declared himself satisfied.

Two years after the sale it was revealed that Sotheby's had loaned Bond half the value of the work, but after two extensions had not been repaid. This led to criticism from art dealers. An article in the *New York Times* asked whether the loan had encouraged higher bids. It obviously had, in the same way that brokers do when they loan money to a client to buy stock on margin (where part of the purchase price is borrowed from the broker), or when a bank provides a mortgage to purchase a home.

Christie's says it does not offer loans to potential buyers, though it will assist them in locating financing. Sotheby's says that it now provides secured loans against collections, or as advances to consignors. When Sotheby's Financial Services does lend money to a collector, the terms restrict the collector from selling the work anywhere but Sotheby's, even for a period after the loan is repaid. This makes it harder for the consignor to negotiate a lower commission, providing Sotheby's an additional return.

You would assume that consignors would not be allowed to bid on art they have themselves consigned. They would have no reason to do so, except to bid up the price. There is at least one hidden exception to this rule. Called the 'divorcing couple' rule, it comes into play when art is consigned as part of a divorce settlement. The work can then be repurchased by the divorcing individuals, or by agents bidding for them. Invoking the divorcing couple rule involves an honour system; the dealer through whom the work is consigned need not reveal the actual owners.

In 2005, Christie's New York offered forty-three lots consigned by a New York finance company 'on behalf of a divorcing couple', described in the catalogue as from a private collection. Each of the lots indicated that a party with a financial interest might bid, which most bidders would have interpreted to mean that third-party guarantees were involved. Christie's had been told that the spouses would bid, one through the finance company and one through a dealer. At the auction, twenty-one lots were sold to persons associated with

the finance company or the dealer, sixteen went to other buyers and six were unsold. After questions were raised about whether some bids were real, Christie's investigated and concluded that there was no divorcing couple, that the real consignor was the company. Christie's offered each of the sixteen purchasers the option of cancelling the sale.

The auction house may actually own the lot being auctioned. It may have purchased the art rather than offering a guarantee, or it may have bought a dealer's inventory. Ownership may also come about when a guaranteed work fails to sell, when a previously sold work is not paid for, or when art is given to the auction house as part payment for a purchase. Ownership raises the same problem as a guarantee – does the auction house exert greater effort, or provide more enthusiastic recommendation, for a work that it owns than for a consigned work?

One perplexing question is why dealers or collectors who do not bid at auction sometimes end up owning the lot. When an auction reserve price is not met and the auctioneer says 'passed', it is not the end of the story. Often 20–30 per cent of lots at auction don't sell, usually because of optimistic reserve prices. Sometimes an auction house has become carried away with negotiating for a star consignment, overvalues lesser work in the collection, and offers a global guarantee. This can result in disaster. Dealers and sophisticated collectors become aware of the situation, and refrain from bidding on items from the collection in the hope that bargains will be available after the auction.

A classic example came in August 2004, when New York collector Hester Diamond asked Christie's and Sotheby's to make proposals to auction her collection of modern art. Sotheby's offered a huge \$65 million pre-emptive guarantee for the whole collection so it could use Piet Mondrian's 1941 *New York/Boogie Woogie* as the feature work in its forthcoming auction. The offer was accepted without waiting for Christie's counter-bid. The art trade concluded that value of the lesser artworks had been overestimated. The Mondrian sold for \$21 million, a record for the artist at auction. The other featured work, Brancusi's 1908 sculpture *The Kiss*, sold for \$8.9 million, well above expectations. Bidding on everything else in the collection dried up.

Kandinsky's *Sketch for Deluge II* (1912), estimated at \$20–30 million, and Picasso's 1912 *Baigneur et baigneuses*, estimated at \$8 million, both failed to sell. The collection brought only \$39 million. Dealers and collectors submitted a stack of after-auction bids.

More than half of all failed auction lots are later sold through a negotiated private sale, a kind of silent auction after the public auction. If the best 'silent' bid is above the reserve, it is accepted, otherwise the consignor decides. This gives the individual buyer the same opportunity as dealers, and it gives museums a chance to seek trustee approval and acquisition funds.

Knowledge of the after-auction process encourages dealers and individual buyers to gamble that an item they are interested in won't reach its reserve. They keep their bidding paddles down at least until the reserve is met, in the hope of obtaining the lot at a lower price. Dealers prefer the after-auction process; the negotiated price is private, so the client or future buyer never knows how much the dealer paid for the work.

Competitive juices still flow, and the after-auction sale sometimes brings a higher price than auction bidding. In May 2003, an Andy Warhol 1962 *One Dollar Bills* had an estimate of \$400–600,000 and a reserve of \$320,000. It was bought-in when auction bidding stopped at \$280,000. Eleven after-auction bids were submitted and it sold for \$400,000.

Sometimes the collector ends up with both the art and a profit. San Francisco collector Thomas Weisel consigned a collection to Sotheby's New York for sale in November 2002, with a reported guarantee of \$44 million for the entire collection. One painting, de Kooning's *Orestes*, sold above the reserve, but eight were bought-in, six nowhere close to the reserve. After the auction, Weisel repurchased four of his own works, most notably Franz Kline's *Provincetown II*, at well below the guarantee price.

In 1991 a New York State Committee held hearings on auction house practices. Their proposed remedies included requiring auction houses to disclose reserve prices. Guarantees and loans to prospective buyers would be forbidden, as would chandelier bidding. New York would have banned almost every practice discussed in this chapter. Auction houses argued that this would destroy the balance between auction house and consignor. Nothing

came of the proposed legislation, leaving the auction market, as one commentator described it, as a place 'where consenting adults can indulge in irrational private acts'.

In the late nineteenth and early twentieth centuries there were several famous 'knockout ring' auction scandals in the UK. Dealers would agree not to bid against each other in the auction room – and this was at a time when dealers comprised 80–90 per cent of bidders. After the regular auction there would be a 'knockout auction' among the dealers in the ring. The difference between the price at the regular auction and at the knockout auction would be divided among members of the ring.

Knockouts were thought to be an artefact of ancient auction history, and in any case only a British practice, because supposedly there were too many individual collectors in New York auctions to organize a ring there. However, in 1997 the United States Department of Justice launched an investigation of what appeared to be a modern knockout ring, subpoenaing auction and phone records, and personal diaries from high-profile dealers including Leo Castelli and PaceWildenstein, and from Christie's and Sotheby's. This was apparently initiated by a consignor suspicious of a sudden absence of dealer bidding.

It turned out the Department of Justice was concerned about the common practice of bid-pooling among dealers. This occurs when two or more dealers bid together at auction, either because they do not have the resources to bid individually or because they want to share risk. Dealers argue that the practice increases competition by enabling the partnership to bid when the individuals could not. Dealers were concerned that the Justice Department would conclude that because bid-pooling took one bidder out of the market, it was an illegal restraint of trade. The investigation went on for months. In the end the case was not pursued, and the issues have never been resolved.

A final auction question is why, ten lots from the end of any evening auction, a group of women in the first few rows, individually or collectively, and unrelated to the quality of the work remaining, stand up and slowly depart the auction hall, husbands in tow. Perhaps their departure, like their arrival, is

intended to make sure the crowd knows they were present, and what they were wearing.

Does knowledge of all this change anything about the way we use auctions? If auction houses really deal in glamour and theatre as well as art, then many auction house secrets may, as much as anything, simply contribute to the production of better theatre.

Francis Bacon's perfect portrait

The job of the artist is always to deepen the mystery.

Even within the most beautiful landscape, in the trees, under the leaves the insects are eating each other; violence is a part of life. Francis Bacon, artist

o see More of the auction process in action, I followed the fortunes of the highly anticipated and promoted 2006 sale, at Christie's London, of a painting by Francis Bacon expected to set an auction record for the artist. Following this work through the auction process provided insights into how an important work by a major artist was priced and sold, and why it might or might not be worth £5 million.

Francis Bacon (1909–92) was an Anglo-Irish figurative painter. The name is familiar outside the context of art because there was a more famous Francis Bacon (no relation), who was England's Solicitor-General, Attorney-General and Lord Chancellor. The first Bacon was neither artist nor collector; he died in 1626 at the age of forty-five.

Bacon the painter is generally considered the greatest post-war British artist, probably the greatest since Turner. Considered contemporary because so much of his important work was done after 1970, he is one of a handful of modern artists whose role in art history is unchallenged. Bacon's work will certainly be considered important fifty years from now. David Sylvester, the great English art critic of the latter half of the twentieth century, thought Bacon's importance comparable to that of Picasso. While that is a major stretch, no one leapt up to dissent.

In May 2006, Christie's London announced that its post-war and contemporary auction in June would feature a Bacon triptych, *Three Studies for a Self-Portrait*, painted in 1982 (illustrated). This is the work described in its auction setting in the chapter 'Choosing an Auction Hammer'. Like most of Bacon's work, *Three Studies* is difficult, but it is undeniably important. Biographer Michael Peppiatt said Bacon considered *Three Studies* the closest he would come to creating the ultimate portrait and perfect representation. Bacon's idea of the perfect portrait was not a realistic painting, but one that distorted the face and features to capture the subject's personality. The works are psychologically powerful and honest, much like those by Rembrandt. The theme is often decay and death.

Bacon said that the triptych format corresponded to the idea of a succession of images on film. He started at the photo booth in a railway station. Here, often while drunk, he could adopt different poses and use the three-photo strip to produce a triptych, with different views of his head. The triptych form had originally been used for Renaissance altarpieces showing the virtues of Christ. In an interesting example of how contemporary art can draw on the past, Bacon reversed this by using the form to show the distortions of man.

Bacon was contemptuous of portraiture where the goal was to reproduce the sitter as he wanted to be seen. His portraits and self-portraits were faithful to reality as he saw it. He often painted from a photo rather than using a live model, because he did not want to embarrass his subjects by distorting their features while they watched.

The uncertainty that hovered over the Bacon auction at Christie's since its announcement was not about the quality of the work, but about the price. Christie's estimated the portrait at £3.5–5.5 million. The upper limit (\$10.2 million) would have been a world auction record for the artist. At the Impressionist and modern art auction held at Christie's two nights earlier, that sum would have purchased two oils by Claude Monet, *Pêches* and *Oliviers et palmiers, vallée de Sasso*; a Camille Pissarro, *La vallée de la Seine aux Damps, jardin d'Octave Mirbeau*, and a gorgeous and large Paul Cézanne, *Maisons dans la venture*. That is the sort of comparison that many observers

of the contemporary art market find incredible. What is it about contemporary art and the auction process that equates a difficult-to-live-with Francis Bacon to two Monets, a Pissarro and a Cézanne?

Three Studies came to Christie's via a telephone enquiry from an artist's family in the north of England. The artist had purchased the work directly from Bacon in 1982. The consignor wanted to remain anonymous; let us call him Hunter. Hunter chose Christie's because it had a long history of auctioning Bacon's work and, four months earlier, had achieved an outstanding price for a Bacon from the Valerie Beston estate.

Christie's believed that the work was also being offered to Sotheby's, putting the auction houses in competition for the consignment. As it turned out, this was not the case – Sotheby's was never approached. Five weeks prior to its major June auction, Christie's had no really important and valuable work as a focus, and was willing to be aggressive in the offer made to the consignor. Sotheby's would certainly have bid for the Bacon if approached, but already had an important painting by David Hockney as its feature work and promised catalogue cover.

Hunter negotiated with Christie's contemporary art specialist Pilar Ordovas for a high reserve price, a promotion package that included a featured position in the auction catalogue, extensive UK media promotion, a European promotional tour, and a catalogue entry authored by Bacon's biographer, Michael Peppiatt. The high negotiated reserve price resulted in the high price estimate. Aware of the good price achieved for a Bacon painting at Christie's the previous February, the consignor thought he could get his price without paying a guarantee fee, and no discussion of a guarantee ever took place.

The first step in marketing *Three Studies* was to decide its positioning in the sales catalogue. The sequence in which work is listed and sold in the catalogue is part of the psychology of the auction. *Three Studies* was intended as the star lot of seventy-nine offered. The ideal contemporary art evening sale is thought to be sixty-two to sixty-four lots, which implies an auction time of under two hours. In the past, the major auction houses offered more lots, but the dwindling supply of top-quality Impressionist and older work led to shorter lists, the scarcity masked with longer descriptions and fatter catalogues. The

norm of shorter lists then spread to contemporary art. The Bacon auction was larger because nine sought-after consignments were finalized on the two days before the catalogue went to press.

Christie's and Sotheby's each close their catalogue when the number of lots passes seventy and no highly sought work remains outstanding. One of Phillips de Pury's strategies is to try to keep its catalogue open for at least two days later than the other auction houses, hoping to pick up a few works that just missed the other closings.

The Bacon was listed as Lot 37, which was unusual; normally the featured lot would come up about ten places earlier. The late placement indicated that there was no strong second-featured work. The positioning was an attempt to hold bidders in their seats deep into the auction.

A more typical auction has the most expensive works interspersed between Lots 12 and 45, with the feature lot between 25 and 30. If there are three or four strong lots, the feature work can come as early as Lot 10 – this happened with the Hockney sale at Sotheby's the same week. If a feature lot is placed this early, other strong lots are spaced between 25 and 45. An expensive work is followed by three or four with lower estimates. The spacing builds peaks of interest and provides reference prices to make the works between seem more reasonable.

If there is more than one work by the same artist, as there was at Christie's with a second Bacon available, the best is offered first so unsuccessful bidders can try for another later. The auction house tries not to offer multiple works by the same artist that would compete with each other. For example, it would not include more than two similarly valued late 1960s photo-paintings by Gerhard Richter. If more were offered for consignment, the house would try to move one from a New York to a London auction or vice versa. Or they will postpone one to the next contemporary evening auction — perhaps with a price guarantee and an interest-free loan to the consignor, to compensate for the delay and to deter the consignor from taking the work to a competitor. The current exception to this selectivity is works by Andy Warhol. In their June 2006 London sales, Christie's offered six Warhols and Sotheby's nine. Both the Warhol estate and collectors want to consign work, and neither Christie's

nor Sotheby's wants to offend anyone by asking them to wait in line for a year or more. Neither auction house wants to offer long-term guarantees in an inflated and uncertain Warhol market.

The way the price estimate for *Three Studies* was produced offers a good illustration of how close estimation comes to fortune telling. I talked to one dealer who, before the auction, projected the triptych as worth £2 million on the basis of its quality (which meant it would have failed without a bid at auction), and to another who forecast a sale price record of £6 million on the basis of its subject matter and scarcity.

Christie's put its faith in the quality of the work and its rarity. During his lifetime Bacon completed thirty-three large triptychs. He later destroyed three of these. Many of his best works are in museums and will never reappear on the market. His work has been exhibited extensively, including retrospectives at the Tate, the Guggenheim, the Museum of Modern Art and the Centre Georges Pompidou in Paris. But this triptych had never been shown publicly, and had no distinguished prior ownership to flaunt.

One problem with the high reserve was that the market for Bacon's work is 'thin', meaning that at expected price levels, there are relatively few collectors willing to raise a paddle. In a thin market the auctioneer would prefer a low reserve and estimate, and hope new collectors are tempted to bid.

MoMA had purchased a Bacon a few months earlier from London's Faggionato Fine Arts, which was managing the Bacon estate, so MoMA was thought to be out of the market. The Tate had a large number of Bacons and was not seeking more. The Metropolitan Museum in New York had only one, but was not known to be interested in a second. There were two or three American museums which might bid, but given the brief two-month lead time between the announcement of the Bacon and the auction, it was doubtful that one of these could raise sufficient funds for a bid.

Three Studies has an interesting history. Bacon kept the work in his studio for two years and, bypassing his dealer Marlborough, sold it privately for a figure variously reported as £25,000 and £100,000. It was the family of this buyer who consigned it to Christie's. The period of time it spent in the studio was unusual because Valerie Beston, a director of Bacon's Marlborough

gallery who spent most of her time as Bacon's personal assistant, hardly ever allowed him to keep work in his studio after the paint dried. Bacon was so self-critical that he destroyed any work he later decided he did not like, or asked his lover John Edwards to cut it with a knife. Edwards said that on one occasion he destroyed twenty finished canvases. Fragments of different cut-up canvases were found in Bacon's studio after his death. Bacon cited the precedent set by Jasper Johns, one of the greatest of American contemporary artists, who in 1954, at the age of twenty-four, decided to destroy most of his paintings because they were too derivative of the work of other artists.

In 1958 Bacon joined the Marlborough Fine Arts gallery, and from then until 1992, Marlborough was his sole dealer. Without seeking legal advice, Bacon signed what must be one of the most unusual contracts ever between artist and gallery. Marlborough agreed to acquire paintings from him at a set price, based on the size of the canvas – £165 for a 24 \times 20in work, and £420 for one measuring 6½ \times 5½ft. The agreement limited Marlborough's obligation to £3,500 (\$9,800 at the time) per year. Marlborough could offer more, at their option. There was no provision for price increases over the first ten years. The low income this gave Bacon is one reason he sold some of his paintings privately.

In the final ten years of the agreement, Bacon's total income from Marlborough was just £123,000 although a single 1983 painting, *Study from the Human Body*, was sold by Marlborough Liechtenstein to the DeMenil Foundation in Texas for \$250,000. His eccentric lifestyle and lack of interest in money nevertheless seemed to work against any attempt to change galleries.

Marlborough also provided Bacon with Valerie Beston's services. 'Miss B', as he referred to her, was his link to the gallery. As well as saving canvases from destruction and collecting new work from his Kensington studio, she organized his private life, had his laundry picked up, paid his Harrods bills, had his taxes prepared, bailed him out from gambling creditors (one of whom had threatened to cut off his hands), and consoled his discarded male lovers.

Following Bacon's death in 1992, his estate sued Marlborough, alleging missing paintings, fraud and undue influence, and seeking £10–80 million in

damages. The allegation of undue influence involved accusations that Marlborough had underpaid him while selling his work for a large profit. Marlborough disputed each claim, and defended the lawsuit claiming it was only the purchaser of Bacon's paintings, not his agent, and had no fiduciary responsibility to him. Bacon's estate unilaterally abandoned the court proceedings in early 2002, because the trustee said the estate's sole beneficiary, John Edwards, was in Thailand and dying from lung cancer. All claims against Marlborough Galleries were dismissed.

Bacon's work had done well at auction. A 1976 triptych also titled *Three Studies for a Self-Portrait* sold for \$5.8 million at Sotheby's New York in November 2005. His 1967 portrait of his lover, *George Dyer Staring into a Mirror*, sold for £4.9 million in June 2005. The previous Bacon record of \$10.1 million was set in November 2005 for the 1961 *Study for a Pope I.* In February 2006 at Christie's London, the small but high-quality *Self-Portrait* which he had given to Valerie Beston sold for £4.8 million. It was this sale result that prompted consignment of *Three Studies*. These prices were all considered in the discussion of the estimate and reserve for the painting.

Somewhat ominously, however, a month earlier at Christie's contemporary art sale in New York, a good 1956 Bacon oil on canvas, *Man Carrying a Child*, had been estimated at \$8–12 million and was passed at \$7.5 million. It was one of the few failures in an otherwise highly successful auction that saw twelve records achieved for individual artists.

All considered, Christie's setting the high estimate above Bacon's previous record price seemed optimistic. Pricing a painting through comparison with a work sold earlier is always chancy, because size, quality, rarity and period differ. Hunter was warned that the painting might fail to reach its reserve and be bought in. The consignor chose to proceed, and his wishes prevailed.

Two days before the Christie's sale, Larry Gagosian's London gallery opened a six-week exhibition of Bacon's work, including five triptychs, shown together with paintings and sculpture by Damien Hirst. Hirst was inspired by and in awe of Bacon, as Bacon had been inspired by Picasso. Although intended as a non-selling show, three of the works at Gagosian were made available for purchase. One sold in advance of the opening to Steve Cohen, a

second on the opening evening, the third later in the first week. One of the three was a triptych which reportedly brought £2.7 million.

Christie's provided a great deal of marketing support for their Bacon. The six underbidders on the Bacon sold by Christie's four months earlier were contacted, as well as every major collector and museum curator who might be interested. One curator was reminded that he could extend the payment period while purchase funds were sought. Full-page ads illustrating the triptych were run in newspapers and art magazines. It was taken on tour to New York, Hong Kong and Switzerland, and presented to celebrities attending the Formula 1 Grand Prix in Monaco, where it also featured at a dinner attended by Prince Albert at Karl Lagerfeld's estate. Monaco was chosen because many collectors have second homes and art collections there. (It was at the dinner that the work was seen by the Italian buyer who ultimately purchased it at auction.)

The Christie's catalogue featured a fold-out illustration of the triptych and a four-page essay on the work and artist, written (as agreed with the consignor) by Michael Peppiatt. Titled 'All the Pulsations of a Person', and with formal academic footnotes, the essay compared Bacon's self-portrait to those of Vincent van Gogh and Rembrandt, illustrating work by each.

At the private auction preview in London, auctioneer Jussi Pylkkanen spent much of his time promoting the Bacon. He claimed to know exactly how many people would bid seriously, and who the final two or three bidders would be. He was willing to tell those interested the numbers, but not identities.

In addition to previous prices achieved for Bacon paintings, the catalogue estimate for the triptych factored in both the economy and buyer optimism; these are as important to auction results as the art on offer. There had been a run of good omens just before the auction, but also two negative ones. Four days prior, Switzerland's Art Basel fair had closed with \$300 million in sales, 20 per cent above expectations. The day before the sale, it was reported that New York cosmetics heir Ron Lauder had paid \$135 million for Gustav Klimt's *Portrait of Adele Bloch-Bauer I* for his private Neue Galerie in New York City, eclipsing the previous auction record for a painting – \$104 million for a 1905 Picasso – and setting a new price standard against which works of art could

be measured. There was a feeling that the best work of the late nineteenth and early twentieth centuries had suddenly increased in value. Whether this would spill over to contemporary work was uncertain.

The first sobering omen was a fall in world stock markets two weeks before the sale, with related setbacks for US hedge funds. A drop in asset prices produces the reverse of the economist's 'wealth effect' – if stocks are down or business is not doing well, people feel less wealthy and are less likely to indulge in a new car, or an expensive painting. The second omen was the realization that Christie's had set reserve prices for their modern and Impressionist sale two days earlier that were far too aggressive. Eight lots had failed to sell after reaching one or two bids below the reserve price. There was concern that this might dampen bidder enthusiasm at the contemporary sale.

Results for the first thirty-six auction lots were encouraging. Thirty had equalled or exceeded their low estimates, sixteen of these exceeding their high estimate. Three lots sold just below the low estimate, two failed to reach the reserve price and were passed, and one was withdrawn.

The Bacon triptych came up as Lot 37. Pylkkanen paused after Lot 36 to consult his 'book', which included a compilation of information from auction staff, assembled during the pre-auction, afternoon meeting. For each lot it indicated who was expected to bid, where they would be sitting or standing, and through which staff member foreign collectors would bid by phone. If necessary, the first few off-the-chandelier bids would be taken from an area of the room with no real bidders.

Pylkkanen opened bidding by saying 'l'II start at £2,200,000,' well below the published estimate of £3.5–5.5 million. Bidding went to £2.5 million, then to £2.7 million. Then Pylkkanen said 'I have £3 million to my right.' And then it stopped. There was a pause and some auctioneer urging. Larry Gagosian, bidding on behalf of a client, offered £3.2 million. The currency converter flipped once. Pylkkanen said 'I'm selling then,' indicating that this had been the reserve price. After a ten-second delay with no comment from the auctioneer, a bidder on the telephone – a well-known Italian collector – offered £3.5 million. The telephone lady on the Christie's end thrust her hand in the air to signify the bid. Gagosian nodded no. Pylkkanen waited three seconds,

repeated 'Are you sure?' and brought the gavel down at £3.5 million to telephone bidder 892. With auction house charges, the final price was £3.8 million. There were four bidders in the room and two on the phone; only one of the four in the room bid at or above the reserve. Elapsed time to the gavel was 1 minute 20 seconds, of which a third was spent with the last two bidders. The bidding never reached the low estimate, and the triptych was two bids past failing to meet the reserve and going unsold.

Three lots after *Three Studies for a Self-Portrait* came the only other Francis Bacon at either Christie's or Sotheby's sales. This was his *Post War (Eve)* (illustrated), painted in 1933. This is a rarer work than *Three Studies* because so little of Bacon's work from this period survived destruction. It had an estimate of £350–550,000, one-tenth the price of the triptych.

Unlike *Three Studies*, which had never been exhibited in public until the Christie's auction, *Post War (Eve)* was discussed and illustrated in three books about Bacon, and had been shown at the Hayward Gallery, the Centre Georges Pompidou and the Marlborough Gallery in New York. It is an oil on paper, a work that would look at home beside a Picasso or a fauvist painting – and ended up being purchased by a collector who had both.

There was hope that interest in *Three Studies* would spill over to bidding for *Post War (Eve)*. The first bid was £280,000. Three more slow and unenthusiastic bids followed. Only one of the three bidders had been an underbidder on *Three Studies*. *Post War (Eve)* sold in twenty-five seconds for £350,000 to a European collector, bidder 885, also on the telephone. There was almost no press reporting of the *Post War (Eve)* sales result, which was a disappointment to Christie's; the selling price represented an auction record for any work on paper by Bacon.

The most important factor in the hammer price achieved by *Three Studies* was not promotion or the economic conditions, but that it had not come from a branded collection. The consignor, Hunter, had not wanted to be identified, but in any case he and his collection were not well known. Because it was known that the consignor also owned another work purchased directly from Bacon, Christie's was happy not to have other dealers or Sotheby's learn his identity.

Five months later, at Sotheby's New York November contemporary evening sale, a 1968 Bacon, the almost Expressionist *Version No. 2 of Lying Figure with Hypodermic Syringe*, came up for auction estimated at \$9–12 million. The painting is of a heroin addict, the model thought to be Henrietta Moraes, former wife of Indian poet Dom Moraes. She was an artist's model (and not a heroin addict), painted by Bacon at least a dozen times in different contexts. The work shows parts of a human body on a Perspex table, with a syringe projecting from the flesh. This was one of twenty-seven works consigned from the internationally recognized and branded collection of Belgians Josette and Roger Vanthourout after the death of the latter.

Many critics thought *Lying Figure* inferior to *Three Studies*. Two-and-a-half minutes and twelve bidders into the Sotheby's auction, the painting was hammered down at \$15 million, beating the previous Bacon record by 50 per cent. The Vanthourout provenance gave added respectability and value to all the work in the consignment. The collection brought a total of \$42 million, exceeding the high estimate by \$7 million. The lack of this kind of distinguished provenance was probably the difference between the prices attained by *Lying Figure* and *Three Studies*.

In February 2007, Christie's finally achieved its Bacon record with *Study for Portrait II*. This is one of a series of Bacon works inspired by Diego Velasquez's 1650 *Portrait of Pope Innocent X*, and considered the most important of his Pope series ever to appear on the market. It sold at Christie's London for £14 million (\$27.6 million). How the work was marketed is as interesting as the record price.

The painting was consigned by Sophia Loren from the collection of her late husband Carlo Ponti, producer of *Dr Zhivago* and other well-known movies. It carried a reserve price, and likely a guarantee, of £10 million. The problem was that Ms Loren did not want to be identified as the consignor, and without any indication of the painting's celebrity provenance, it was unlikely that a price well above the *Lying Figure* record could be achieved. The estimate was not published, but was indicated in the catalogue as 'Available on Request'.

Someone tipped several reporters, including Colin Gleadell of the *Telegraph*, that the work, indicated as last shown in public in 1963, had in fact

been exhibited in 1983 at the Brera Art Gallery in Milan. This fact made it fairly certain to have come from Ponti's collection, which included ten Bacons. Gleadell published the information, other art reporters picked up the story, and Christie's brought the story to the attention of potential bidders.

The Loren/Ponti provenance probably added £2–3 million to the value of the painting. On the morning of the auction, Christie's was quoting an estimate of £12 million and auction house specialists were saying privately that it might bring £14 million. The successful bidder was Andrew Fabricant of the Richard Gray Gallery in Chicago, on behalf of an unnamed American client.

In May 2007, Sotheby's won back the record with *Study from Innocent X* (1962; illustrated). Probably the most important Bacon ever to come to auction, this was promoted and expected to achieve a high price solely on the basis of that characteristic. Bacon started the fifty-work Pope series in 1946 but later destroyed all those done between that year and 1949. *Study from Innocent X* sold for \$52.7 million, almost doubling the Christie's record. In the end, at least for the greatest post-war British painter, quality trumped marketing and provenance.

Auction houses versus dealers

All the world's a stage
And all the men and women merely players
They have their exits and their entrances
And one man in his time plays many parts.
William Shakespeare, As You Like It II.vii

HERE IS INTENSE competition for consignments between dealers and auction houses. There is also a great deal of tension: dislike and resentment on the part of dealers, condescension and a sense of 'we always win' on the part of auction houses. Nevertheless, there is a symbiotic relationship between the two. Auction houses obtain a third of their contemporary art consignments from dealers, while dealers are dependent on auction houses for the disposal of surplus art and ill-considered acquisitions. It is the existence of major auctions that permits dealers to obtain lines of credit and to risk purchasing expensive work. Bankers know there is a place where dealers' errors can be quickly liquidated.

Dealers get most of the secondary-market art they resell on consignment, but some fill out their inventory by purchasing at auction. One reason dealers buy at auction is that they need high-quality work to anchor a booth at an art fair such as Maastricht, both to gain admission and for the reflected status for their other art. A dealer may purchase a picture at auction for a client (in lieu of commission) that the dealer can display the work at a fair, putting a 'sold' sticker on it after the first few hours.

In their search for consignments, auction houses compete with each other, with dealers and directly with collectors. The competition means that everyone's profits are squeezed, and mainstream dealers are outspent and bypassed. It is not that dealers are targeted by auction houses; it is the artworld version of the truism that when the elephants wrestle, the ants take a terrible beating. Arne Glimcher of PaceWildenstein in New York calls auction houses the single most damaging element of the art eco-structure in fifty years. All dealers complain that auction houses are overly rich promoters who care only about sales figures and pleasing consignors, not about developing artists. Auction houses respond that their role is to match buyers and sellers, and that in doing so they produce recognition for the artists involved. They also point out that whenever a record price is achieved at auction, dealers happily return to their galleries and mark up prices.

Direct competition between Christie's and Sotheby's is as old as the auction houses. Direct competition between auction houses and dealers is more recent. Some date it to the tenure of Peter Wilson, chairman of Sotheby's in the 1970s, or to the aggressive tactics of Sotheby's president Diana Brooks following the art world crash of 1990. Others date the auction houses' invasion of dealers' turf to Charles Saatchi's consignment of 130 lots of recent contemporary art at Christie's London for sale in December 1998. There were ninety-seven artists involved; some – Damien Hirst and Rachel Whiteread – had auction track records, but the majority were unknown. Dealers viewed the sale as unfair and disruptive. Many of the artists were then unrepresented; a few had mainstream dealer representation. The works sold, because Saatchi's ownership validated the art and artists. The event's success validated the idea of offering art on which the paint was barely dry at evening auction.

Private treaty sale is the term auction houses use for all secondary art sales carried out by means other than direct consignment for auction. Their private treaty departments sell art privately; they earn a profit the same way that secondary-market dealers do. They know what price the consignor wants to achieve, they sell for whatever they can, and the difference is their commission. Occasionally they agree to sell at the best price and take a percentage commission – or they may take a commission

from both parties. What makes private treaty sales so profitable for auction houses is that there are almost none of the catalogue, promotion and physical overhead costs associated with auctions. Private treaty departments can offer sellers intangibles like access to lists of auction bidders and collector contacts.

For Sotheby's, private treaty sales include a five-week annual display and sale of sculpture at Chatsworth, the Duke of Devonshire's seventeenth-century estate in Derbyshire, two hours north of London. In 2006, sculpture worth £15 million was offered, 36,000 people came, and most work sold. Ten thousand catalogues, illustrating work by Henry Moore, Jean Dubuffet and Damien Hirst, were sent to collectors. Some work, for example a Damien Hirst sculpture, was consigned for sale at a non-negotiable price, exactly as if placed with a dealer. Sotheby's also exhibits up to forty sculptures each year, between January and April, at the Isleworth Country Club near Orlando, Florida. In 2007 these had a total value of \$40 million, and most sold.

In 2006, Christie's did \$260 million and Sotheby's \$300 million in private treaty sales. If each private treaty department were considered a dealership, they would rank sixth or seventh in their respective cities – and they are growing quickly.

One great advantage of private treaty sales is confidentiality. At auction, the work being sold is public, even if the identity of the consignor is not. With a private deal through an auction house, neither is revealed – of great value to those with financial problems or involved in a divorce.

Another advantage is timing. It is sometimes difficult for a museum to respond as quickly as the auction process requires. Private treaty sales provide price certainty, and as much time as the museum requires to raise the funds.

A work offered by private treaty that fails to sell will not be publicly branded as being burned. Private treaty also offers a means of reselling newly purchased art quickly. A speculator who has been on a waiting list for a hot artist can immediately resell the work to Japan or Russia, with minimal chance that the artist or gallery will find out.

The dealer may try to compete with the auction house's private treaty sales by suggesting a higher selling price. If Sotheby's says a work will fetch £400,000, the dealer may say 'Half a million for sure'. Such overestimation is often self-defeating. The specialist at Christie's or Sotheby's will say to the consignor, 'Try them at that price. If it doesn't sell in two months, bring it here.' When a dealer promises a quick sale and does not deliver, subsequent consignments may go the private treaty route.

If a collector is looking for a specific artist and period, using a private treaty facility allows the auction house to approach other collectors and propose a transaction. Even if the original deal falls through, the owner of the work has started to think about selling. The specialist can propose putting the work up for auction, perhaps guaranteeing the same price the collector was offering. Or the specialist may call a collector to inform him of upcoming consignments, and point out that a private buyer exists for one of the collector's existing works to help pay for a new acquisition.

Some private treaty activity is initiated by dealers, who are forced to partner with auction houses to gain access to their client lists. Only Christie's can identify the underbidders at most recent Francis Bacon auctions – and in a thin market, a seller needs access to this information. A dealer may agree to sell a Bacon for a client to net £5 million; the dealer then gives it to an auction house to deal by private treaty. The dealer is guaranteed £5.5 million, incorporating his commission. The auction house places it privately, probably asking £8 million and negotiating to £7 million. The auction house has the financial clout to offer a collector a large advance payment. If the consignor of the Bacon wants an advance of £4 million, the dealer may have to take the auction-house partnership route to find the money.

Sometimes a dealer almost drives the collector into the hands of an auction house. Collectors regularly sell off their existing art to pay for new passions. But trading in a collection of Eric Fischl paintings is not easily done through Fischl's dealer, who will see any disposal of his work as a threat to the value of the dealer's inventory. Knowing he faces antagonism or hostility from the dealer, the collector may go to the auction house's private dealing

department, which can keep dealers or collectors from noticing that Fischl's work is being disposed of in bulk.

Private dealing is even more attractive where there are only a few possible buyers. There are only three Raphaels left in private hands. Every auction specialist and every dealer in Old Masters knows where they are and who might bid on each should it become available: some combination of the National Gallery in London, the Getty Museum in Los Angeles, one or two other American galleries, and two or three Russian oligarchs. There is no particular advantage in exposing the work to a larger group through auction.

Another form of private treaty dealing was demonstrated in Ron Lauder's purchase for his Neue Galerie of Gustav Klimt's *Portrait of Adele Bloch-Bauer I* in 2006. The Klimt shows the face of a Viennese aristocrat, executed in gold, silver and oil. It is highly recognizable because it reminds the viewer of Klimt's more famous work *The Kiss*, also painted in 1907, also oil and gold on canvas, and reproduced on millions of prints hung in women's college rooms.

The painting was seized by Germany in 1938 and ended up after the war in the Austrian National Gallery. A long and highly publicized recovery fight was led by Randol Schoenberg, lawyer for Bloch-Bauer's heiress, Maria Altmann, in Austrian and US courts. At the end of the battle the Austrian government dismissed a suggestion that it retain ownership in return for a compensation payment of €60 million, calling the amount extortionate. Austrian culture minister Elisabeth Gehrer said it was four times the annual acquisition budget for all Austrian national museums.

Negotiation for the painting began in February 2006 and eventually involved offers from four museums and six private collectors. The most serious offer came from Eli Broad. He offered \$150 million for *Adele Bloch-Bauer* plus four other Klimts, for loan to the Los Angeles County Museum of Modern Art. The Klimt sale came about at least in part because Schoenberg had worked on a contingency fee of 40 per cent of the sale proceeds, to be paid if the paintings were found to have been illegally confiscated by the Third Reich and were reclaimed from the Austrian National Gallery. Having recovered five of the six works he sought, Schoenberg was due \$54 million from the sale of *Adele Bloch-Bauer*, and an estimated \$55 million on the other four.

Christie's became involved when Maria Altmann consulted Stephen Lash, chairman of Christie's Americas, as an advisor on the arbitration and legal cases. Ron Lauder asked Mark Porter of Christie's New York, rather than a dealer, to assist in his negotiations. The auction house thus had the relationship sewn up. Sotheby's made a proposal, thought to be similar to that from Christie's, but Altmann's relationship with Stephen Lash proved decisive.

Porter arranged for Christie's to provide a loan to Lauder, reportedly of \$100 million, to facilitate the purchase. Someone then leaked the \$135 million price to the *New York Times*, producing the desired publicity for Lauder and his museum. Neither Lash nor Porter received a commission; what Christie's obtained for their efforts was far more valuable. They were given a consignment of works from the Neue Galerie collection valued at \$100 million, to be sold at auction or privately, against a guarantee from Christie's which was not disclosed but was estimated at \$80 million. One of the consigned paintings, a two-sided work by Egon Schiele, *Houses (With Mountains)* on one side and *Monk I* on the other, realized \$22.4 million, a record for the artist.

Christie's also obtained an option on the four other Klimts the Bloch-Bauer heirs had reclaimed, to be auctioned in November 2006. At auction the portrait *Adele Bloch-Bauer II* sold for \$87.9 million, a record for a Klimt at auction – its presale estimate was \$40–60 million. Klimt's *Birch Forest* went for \$40.3 million; it had been estimated at \$30 million. *Apple Tree* brought \$33 million against an estimate of \$25 million. *Houses in Unterach on the Attersee* brought \$31.3 million against a \$25 million estimate. One factor in the price levels was the extensive media coverage of the restitution claim and subsequent record sale to Ron Lauder. Christie's earned about \$23 million in gross commissions on the four works, bringing its total gross profit from facilitating the original *Bloch-Bauer* transaction to about \$27 million.

Another activity with direct impact on dealers is the occasional auction house practice of selling contemporary art consigned directly by the artist. Several years ago, New York artist David Hammons consigned *Basketball Lamp*, a work fresh from his studio, to Phillips de Pury. It sold for \$370,000, three times what a dealer would have asked. When asked why they would sell a primary-market work, a spokesman for Phillips said, 'Hammons has

not been active at auction, and we wanted to introduce him to an international audience.' In other words, Phillips would serve as Hammons' primary-market dealer.

Auction houses also purchase dealerships. In 1990 both Sotheby's and Christie's made offers for the Pierre Matisse Gallery when the owner retired. In what was then the largest single transaction in the modern history of the art trade, Sotheby's and New York dealer William Acquavella made a joint offer of \$143 million for 2,300 works by sixty-one twentieth-century artists. These were resold over several years at auction through Acquavella, the Lefevre Gallery of London, and Galerie Beyeler of Basel.

In 1996 Sotheby's purchased New York's Andre Emmerich Gallery and set up a short-lived division called Emmerich Sotheby's. Sotheby's later bought the Old Masters collection of Dutch businessman Joost Ritman in partnership with Noortman Fine Arts. In June 2006, Sotheby's acquired Noortman Master Paintings. Noortman is one of the world's two major dealers in Old Masters. Robert Noortman said the purchase provided him with enough capital backing to guarantee continued success – and capital demands in the Old Masters market are even lower than those for contemporary art. There are fewer works, bank financing is easier to obtain, and – because it is all secondary-market resale – there are no new artists to finance. For the Noortman purchase, Sotheby's exchanged \$56 million of its stock for 100 per cent of Noortman and took over \$26 million of Noortman's debt. Noortman was to continue to exhibit at Maastricht and other art fairs under his own name.

When the Noortman purchase was announced, Christie's approached the board of the Maastricht art fair, demanding to be provided a booth at the fair and reportedly threatening to take the case to the European Court if it was turned down. The executive committee agreed to admit Christie's without having them go through normal admission procedures. Christie's agreed to show only art which was being sold though private treaty and would not be auctioned later. Christie's considered that provision unenforceable, a sop to current exhibitors. To enforce it, Maastricht would have to get all its dealers to agree to the 'no subsequent auction' provision, and that would never

happen. Christie's set up a wholly owned subsidiary called King Street Fine Art Limited. The result is that both auction houses now have the precedent to apply for admission to other fairs. In gaining admissions to fairs, Christie's and Sotheby's have overcome the dealer's last major defence to auction house inroads.

In February 2007 came the blockbuster deal. Christie's purchased Haunch of Venison, the gallery established in 2002 by dealers Harry Blain and Graham Southern. Haunch is a major player, with galleries in London, Zurich and Berlin. It represents a number of very hot artists, including Keith Tyson and Bill Viola, and competes with Gagosian, White Cube and other superstar galleries. The purchase price was reported as £65 million, although this is a meaningless figure without knowing the value of the art inventory and debt that came with the gallery. This was not a forced sale through financial difficulty; chief executive Ed Dolman announced it was part of Christie's long-term expansion, and that Haunch would open a New York branch on the twentieth floor of Rockefeller Center, in space that Christie's had been using for special exhibitions. Christie's is now firmly ensconced in the primary market for contemporary art.

Will the auction houses' dual roles collide? Would a dealer-turned-auction-house-representative such as Harry Blain be welcome at one of the 'must-see' fairs if it was thought that his inventory was offered on behalf of Christie's private treaty sales? Would Blain have an unfair advantage in buying or selling at auction? Dolman defused that by saying that Haunch would not be permitted to sell or buy at Christie's auctions. Is that enough to reassure other dealers and collectors?

The sealed-bid auction, used for very high-value work, is another direct threat to dealers. A sealed-bid auction is like a public auction but with a by-invitation-only audience, with each bidder allowed a single written bid that must be made without knowledge of what anyone else has offered. These auctions were used from the 1950s to the early 1970s by the Museum of Modern Art to deaccession work through dealers. Ten dealers would be chosen to visit MoMA at intervals during the same day, view the pictures to be deaccessioned, and sign a bid for the price they would offer. Starting in the

mid-1970s, deaccessioned work was offered through auction houses instead, in the hope that it would bring higher prices.

Today, Christie's and Sotheby's use the sealed-bid process in a way that is part-auction, part-private treaty. Institutions and collectors who express interest in a work are given an information package listing details of the works and the minimum acceptable bid. In May 2005, Sotheby's offered Asher Durand's 1849 *Kindred Spirits* in a sealed-bid auction that they recommended in lieu of a private treaty sale or public auction. The painting, Durand's most famous work, shows journalist William Cullen Bryant and Thomas Cole, founder of the Hudson River art movement, in the Catskill Mountains. It had been in the collection of the New York Public Library, and was the most valuable of nineteen works being deaccessioned by the library. The remaining art was auctioned at Sotheby's American paintings sale a few months later.

Sotheby's recommended a sealed-bid auction because it thought there were only twelve likely buyers. Forty-seven enquiries were actually received; twenty-one potential bidders asked for an information package, and eight bid. *Kindred Spirits* was purchased on a bid of \$35 million by Wal-Mart heiress Alice Walton, for the Walton-sponsored Crystal Bridges Museum which opens in Bentonville, Arkansas, in 2009. Ms Walton was not on Sotheby's initial prospect list but learned of the picture through an advisor. The only underbid made public was a joint offer of \$25 million by the Metropolitan Museum in New York and the National Gallery of Art in Washington. The museums would have shared the work, offered works already owned in trade, or would later have conducted their own internal auction to determine which was willing to pay more for the other's share.

Dealers criticize sealed-bid auctions as unfair, on the ground that each bidder does not know how much competitors are bidding, and the winning bidder may end up paying far more than the next highest bid. That is true, as Ms Walton learned, but it is an odd argument because it is exactly what happens when art is consigned and sold through a dealer.

Auction houses further complicate relationships by offering a commission to dealers and advisors to refer consignments and buyers to them. The introductory commission may be 1–3 per cent of the final selling price, but

frequently it is offered as a percentage of the seller's commission. The dealer is then less motivated to tell his client that the seller's commission is negotiable. The dealer or advisor also has an incentive to direct consignments to one preferred auction house. That gives him leverage in getting the house to accept future, more marginal, work, and he may receive an end-of-year volume-based bonus. Referring business to an auction house is a dangerous path for a dealer, who trades a short-term commission for the longer-term possibility that the next time the client will take her consignment directly to the auction house or to its private treaty service.

When a star work is offered to both auction houses and also to one or two branded dealers, the auction house submits a proposal extolling the strength of its team – the specialists, financial and legal advisors and the auctioneer – and suggesting a price, loans, promotion and, often most important, a financial guarantee. Dealers have generally had to focus on their expertise and personal contacts with collectors. A very few dealers, occasionally and reluctantly, offer their own financial guarantees. Robert Mnuchin of L&M Arts in New York describes a deal whereby the gallery guarantees and advances a consignor \$5 million for a painting, then takes 10 per cent of the difference between the guarantee and the sales price, with the consignor and gallery splitting the other 90 per cent. If the selling price is \$10 million, the consignor receives \$7.25 million (the \$5 million guarantee plus \$2.25 million on the balance), and L&M earns \$2.75 million. This is a slightly worse outcome for the consignor than an auction house guaranteeing \$10 million, but superior to a lower auction house guarantee of, say, \$8 million (from which commission and fees would be deducted). If the dealer really does have greater expertise, this is one way to exploit it.

The other approach is for the dealer to offer to buy the work outright at a higher price than that guaranteed by the auction house. Christie's or Sotheby's occasionally do offer to purchase a work or a collection outright, but for many reasons, mostly precedent, they prefer to offer a cash advance and a price guarantee.

Both auction houses, two dealers and at least one private buyer were in head-to-head competition in March 2005 when each made offers to Los Angeles dealer Irving Blum for one of Andy Warhol's 1963 *Liz* series, which

was expected to sell for \$8.5–9 million at auction. One dealer reportedly offered \$8 million, a private collector offered \$8.7 million, and Christie's then submitted a guarantee of \$9 million. Christie's had reportedly arranged to sell the guarantee to a third-party guarantor, thought to be the same collector who was bidding. After a quick board meeting, Sotheby's executives upped their final guarantee offer to \$10 million. Christie's was offered the chance to top that but could not resell the guarantee at that level, and so declined. The work sold at auction for \$12.6 million, including the buyer's premium.

Very wealthy collectors sometimes bid successfully against both auction houses and dealers. In 1995, Steve Wynn purchased van Gogh's 1890 *Peasant Woman Against a Background of Wheat* for \$47.5 million. At the same time he purchased Gauguin's 1902 Tahitian painting *Bathers* for \$35 million, and two Paul Cézanne paintings, *Rideau, cruchon et copotier* (1894) and an 1895 self-portrait. The star piece of the four was *Peasant Woman*.

Wynn received regular enquiries from auction house specialists, dealers and other collectors enquiring about art that might be available for sale, and specifically about *Peasant Woman*: 'If you ever think of selling that work, please call me first.' In 2004 a great offer from Chicago hedge-fund manager Kenneth Griffin led to the private sale of the two Cézannes. In 2005, Steve Cohen offered a reported \$80 million for *Peasant Woman* and, to seal the deal, agreed to take *Bathers* for an additional \$40 million. Dealers and auction houses were shut out. The four paintings would have yielded Christie's or Sotheby's at least \$26 million in gross commissions.

The same cast of dealers, auction house specialists and private collectors pursue Michael Ovitz, who has an extensive collection, the most lusted-after painting being Jasper Johns' 1958 White Flag. Pursued with equal keenness is Jackson Pollock's 1947 Lucifer, a drip painting in the Anderson Collection in San Francisco. The most coveted modern painting anywhere may be Paul Cézanne's 1893 The Cardplayers, which is reported to have attracted a private offer of \$135 million. It is staggering to think what Cardplayers might bring if it were offered at auction.

Dealers benefit or suffer from auction house competition in another way. The health of the entire art market is judged by how well the two major auction

houses do in their twice-yearly major evening sales. Is there cause for optimism or for caution? Are price levels attractive or frightening? All are judged by the statistics on auction records set, or works bought in.

Dealers are always frustrated at how hard it is to compete with the glamour of auctions. Almost every dealer I talked to had a story of a collector overpaying at auction for one version of a multi-edition work, where other versions were available at a gallery for a fraction of the price. A particularly expensive example is Jeff Koons' 1988 kitsch sculpture of a pink pig titled *Ushering in Banality*, sold at Sotheby's New York in November 2006 for \$4 million. The pig is one of an edition of four. A second version was available ten blocks from the auction house at an asking price of \$2.25 million.

Dealers needed some other competitive advantage to set against the glamour of auctions and the wealth of auction houses. Some have found this with the attractions of high-level art fairs.

Art fairs, the final frontier

Art fairs have surpassed auctions as the premier events for buyers in the market's upper tiers.

Souren Melikian, art journalist

In reality art fairs are adrenaline-addled spectacles for a kind of buying and selling where intimacy, conviction, patience and focused looking, not to mention looking again, are essentially nonexistent.

Jerry Saltz, art critic

Basel art fair, a wealthy home-improvement retailer from Manchester named Frank Cohen got into a bidding war with Charles Saatchi and Bernard Arnault for a sculpture by Terence Koh. Koh's work had attracted attention when Saatchi promised to feature it in *USA Today*. The Koh installation consisted of glass boxes containing bronze casts of human excrement, covered in 24-carat gold. Arnault said he wanted it, Saatchi raised his bid, then Cohen upped his bid to £68,000 and won. Javier Peres, the American dealer who sold it, said the sculpture represented an anticonsumerist statement.

Fairs such as Art Basel are industry trade shows where dealers come together for several days to offer specialized works. The work offered at the best contemporary fairs equals in quality and quantity that offered by auction houses in an entire selling season. In their ongoing battle against Christie's and Sotheby's branding, money and private dealing, art dealers needed a

slingshot to combat Goliath. They needed some relative competitive advantage. The weapon they found was not mergers or blockbuster gallery shows but branded and heavily marketed art fairs. The start of the twenty-first century was also the beginning of the decade of the art fair.

Commercial art fairs have existed for a long time. The earliest may have been Pand in Antwerp, in the mid-fifteenth century. This took place in the cloisters of the cathedral for six weeks at a time. There were stalls for picture-sellers, frame-makers and colour-grinders. Three hundred years later, at the end of the nineteenth century, Paris had grand expositions, and the Royal Academy in London held a fair where artists exhibited. The first twentieth-century art fair was the 1913 Armory exhibition in New York City, open to 'progressive painters usually neglected', which included Braque, Duchamp and Kandinsky. Various art biennales served as covert art fairs; the Venice Biennale discontinued selling the art it exhibited only in 1968. (In 2007 a collector could still 'reserve' a work shown at Venice, but the word 'purchase' was never to be uttered.)

Today there are four international fairs whose branding is such that they add provenance and value to contemporary art. They are to art what Cannes is to movie festivals. One is TEFAF, the European Fine Art Foundation fair, held each March and known as 'Maastricht'. Another is Art Basel, which every June draws collectors, curators and dealers to the Swiss city. A third is Art Basel's spin-off, Art Basel Miami Beach, which is held each December and has achieved fame for its blend of art, money and fashion. A fourth, the most recent addition, is London's Frieze, held each October. The art fair season actually runs year round. There are a hundred lesser international fairs; mixed in are art biennales and hotel fairs. In February 2007 there were eight art fairs running concurrently in New York. This epidemic of fairs has created the art world malady of 'fair fatigue'; Munich's Michaela Neumeister, a partner in Phillips de Pury, says: 'Whenever I hear about a new art fair starting, it is almost physically painful to me. The art world has become a gypsy circus.'

Maastricht, the two Basel fairs and Frieze are the 'must-see' fairs, where dealers match auction houses in quality and speed of sale and payment. These attract consignments that might have gone to evening sales at Christie's

or Sotheby's. They feature the superstar dealers who come because the best fairs draw the best collectors. The collectors visit because superstar dealers are showing. It is what economists call a virtuous circle or network effect; it leads to a self-perpetuating oligopoly among a few top fairs. Each of the four fairs attracts the same collection of dealers, art advisors, curators, museum directors and artists, along with the accompanying public relations people and journalists, all asking each other which artist and work is hot.

Below these four are twenty 'nice-to-see' fairs, which substitute for main-stream dealers; the others are even more minor. The nice-to-see fairs understand the distinction. One Chicago fair official said they must 'stop chasing jet-setters and concentrate on the pool of collectors closer to home, those who spend \$5,000 to \$50,000 at a time ... every fair needs to know what its niche is.'

Collectors love fairs because they are convenient. UHNW individuals are time-poor. They like to consolidate research, search and purchase in a single location. Comparison shopping at fairs is easy; a single dealer might with difficulty assemble three Gerhard Richters to show a client. Dealers at Art Basel 2007 offered a total of twelve.

Fairs represent a culture change in art-buying. They replace quiet discussions held in the gallery with an experience akin to the shopping mall, blending art, fashion and parties in one place. Collectors become shoppers who acquire impulsively, usually purchasing only one work by an artist. They may never visit the gallery of the dealer from whom they buy at a fair. With each fair, collectors become more accustomed to purchasing art in a shopping-mall setting.

Fairs offer collectors a high level of comfort. Just as the presence of underbidders reassures an auction bidder that he is not bidding foolishly, the sheer number of people and 'sold' stickers at a fair alleviates the collector's uncertainty. The psychology at a fair is referred to as herding: when a buyer does not have sufficient information to make a reasoned decision, reassurance comes from mimicking the behaviour of the herd.

Dealers reap great publicity if they handle their appearance at a fair properly. A gallery may bring one or two good works that have already been

sold-or have been borrowed for the occasion – in order to impress collectors and gain media coverage saying that the works sprouted 'sold' stickers within five minutes of the fair opening. These featured works are placed at the front of the booth, drawing collectors to see the lesser works that are really on offer.

Fairs allow a dealer with limited capital to compete for top-quality consignments, because the work is expected to resell quickly. A collector who wants to sell a painting might have the promise of a guarantee and advance from an auction house, but confirmation is slow if the agreement has to be approved by a committee of the auction house's board. A dealer can offer the consignor immediate payment, financing this through bank credit against the expectation of reselling at a fair within weeks.

The downside for the dealer is that attending fairs is time-consuming and expensive. A dealer who goes to five fairs a year – the top four plus one in her home city – will spend seven or eight weeks away from the gallery, including travel, set-up and take-down time. The month before a major fair consists of a phone and internet-based pre-fair, during which dealers contact collectors and collectors check in with dealers. Five fairs cost the dealer £200–300,000, sometimes more – often more than the rent on her home gallery. Booths at Maastricht range up to €50,000; the total cost of an average 80sq m booth, including shipping, accommodation, food and entertainment, reaches €80,000. But dealers queue to take part, because other dealers do. One dealer described his thinking, 'If I don't go, people will think the fair would not accept me.' To ensure that collectors perceive a gallery as important, attendance at the most prestigious fairs is a necessity. It is also necessary in order to keep happy those gallery artists who insist on being featured at the best fairs.

Fairs present a terrible environment in which to view art; they have been described as 'the best example of seeing art in the worst way'. The setting and crowds are not conducive to contemplating work. The work is random and juxtaposed, with no sense of curatorial involvement. The lighting is always excessively bright, designed for crowd safety rather than art viewing. But every gallery lives with the same conditions and collectors accept them because at least once every fair, one rounds a corner and spots a powerful work by an heretofore unknown artist.

The Maastricht fair is held in southern Holland on the river Meuse. In 2007, 610 dealers applied to show and 219 were accepted, 40 of those dealing in modern and contemporary art. No important art dealer, collector or curator wants to miss Maastricht. In 2006 the Wildenstein gallery and its contemporary art joint-venture PaceWildenstein attended – the first time in five generations that Wildenstein had taken part in any fair.

In 2007, sales arranged at Maastricht had a value of about €790 million. Many dealers say that 40 per cent of their annual sales are made in the eleven days of Maastricht; some claim 70 per cent. Because of high Dutch taxes, including 17.5 per cent VAT and *droit de suite* (a European Union levy on art sales, paid to a living artist or estate), few sales are actually finalized at Maastricht. The fair is a venue where collectors and dealers agree to later transactions. The dealer returns to a more friendly tax environment – usually the USA, Canada or Switzerland – to formalize the sale and ship to a location of the buyer's choice.

Contemporary art is a relatively new offering at Maastricht. The fair first specialized in Dutch and Flemish art, and evolved to sell modern art, Asian and Russian fine arts, silver and porcelain. Maastricht is important not for its role in contemporary art – although that increases each year – but as the best strategic example of how dealers can band together to compete with auction houses. Some €1.25 million is spent advertising Maastricht; the fair attracts 80,000 visitors.

At the best fairs, and particularly at Maastricht, both dealers and the work to be shown are vetted in advance and again at the opening of the fair. Two days before the opening, dealers leave their stands as the vettors inspect each object. The important factor in assessing contemporary art is 'show worthiness', which involves the status and quality of the artist and the gallery rather than the work itself. Vetting adds value in the same way as expert appraisal and acceptance by a major auction house.

Vettors at Maastricht can be staff, dealers, auction house specialists or academics. There are concerns over the use of dealers, that competitiveness may lead to a rival's good pieces being 'vetted off', or that friendships may result in items of lesser quality being accepted. Three out of four members of

the vetting committee must agree before a work is removed. The process is time-consuming and rigorous, but it gives a collector the confidence to purchase and, later, to boast 'I bought this at Maastricht', as he might say 'at Christie's' or 'at Gagosian'.

Opening night at fairs is by invitation only, to dealers, press, and selected major buyers and agents. The atmosphere is more like that at an auction than a gallery, which may explain the bidding between Arnault, Saatchi and Cohen for Terence Koh's sculpture. Half the most important works will sell in the first hour, half of those in the first fifteen minutes. Buyers race from booth to booth, committing to a purchase or asking for a 'hold' – and the dealer may say 'Ten minutes only, and give me your mobile number.' There is none of the gallery approach of: 'I will come back and look on the weekend', or 'Can I hang it in my home for thirty days?'

The opening period is so critical that most fairs exploit it with tiered-ticket pricing. The Armory Show in New York is the most extreme: tickets to enter the show at 5 pm cost \$1,000, entry at 5.30 pm costs \$500 and 7 pm entry \$250. You get less than you might think for \$1,000, because dealers can invite their own clients in at noon; the best works are sold or on reserve long before the holders of \$1,000 tickets arrive. On opening day at London's Frieze Art Fair, VIPs are allowed in at 2 pm and VOPs at 5 pm, but the VVIPs specially invited by sponsor Deutsche Bank gain entry at 11 am to check out the best work.

Maastricht, the two Basel fairs and Frieze have a different impact on the collector than an auction showroom or a gallery do. When an auction specialist talks to collectors before an evening auction, she emphasizes the uniqueness and rarity of what is on offer. A gallery does this too, though the absence of other collectors removes the element of now-or-never found with the auction process. In contrast, walking through Maastricht surrounded by thousands of artworks shown by hundreds of dealers offers the perception of abundance, but crowds and frenzied buying also produce a 'last chance' atmosphere. One dealer says, 'With crowds like this, I can present work to a collector with the unspoken admonition that if they don't grab it, that guy over there, the one looking this way, will beat him out.'

The prices achieved at these fairs are remarkable; it is not uncommon to see a work offered at 50 per cent more than what the dealer paid at public auction a few months earlier – and have it sell in the first half-hour.

Art Basel is held each June in the medieval city on the Rhine. Nine hundred galleries apply for 290 spaces, \$2 million is spent on advertising, and 50,000 people attend. NetJets, a shared-ownership jet aircraft company, provided 198 flights to Basel for the 2007 fair. Dealer fees for the smallest stand start at €17,000, and total costs are about €40,000. The selection committee is made up of six art dealers. Galleries that are rejected go to an appeal process with a different jury. Those accepted keep their best work for the fair, as they do for Maastricht. Five to ten per cent of galleries are dropped each year, usually for not showing their best work.

By way of comparison with the works at a major auction, in 2007 New York's Tony Shafrazi Gallery offered five paintings with a total asking price of just under \$100 million: two Francis Bacons at \$25 million each; two Jean-Michel Basquiats at \$20 million and \$15 million; and an Ed Ruscha at \$13 million. All sold.

Only exhibitors can enter Art Basel's exhibition area before the fair's opening at 11 am on the first day. An exception seems to exist for supercollectors like Eli Broad and Charles Saatchi, who are permitted to wander around earlier, but not to purchase until opening. It is commonly believed that other collectors sneak in, disguised as workers. In 2005, a French dealer was caught doing this and banned from the 2006 fair. Apparently he found a new disguise and attended anyway.

Art Basel Miami Beach, known as Basel Miami, is now the largest contemporary art fair in the world, a five-day carnival each December of partying, sports and entertainment celebrities, and conspicuous consumption, with art-viewing almost secondary. Columnists call this the 'all singing, all dancing art fair'. It accepts 200 exhibitors from 650 applicants, galleries from Moscow to Los Angeles. The all-in cost of mounting an 80sq m booth is about \$110,000. The media campaign mentions only the names of star artists being shown, not the galleries exhibiting them. Miami Basel promises its exhibitors that it will attract 'two thousand Very High Net Worth individuals' – and it does. It

provides a snapshot of the future of fairs, and perhaps of the marketing of contemporary art.

Miami Basel was created to provide access to North and South American wealth; money not being tapped by other fairs. The principal sponsor is the Swiss bank UBS, which ranks the fair equal in importance for sponsorship with the 2007 America's Cup yacht race. It is the only sponsorship event UBS undertakes that is so obviously beneficial that it does not have to be approved at board-committee level. UBS has been so successful in using contemporary art to lure rich clients that one of its competitors. HSBC, now hosts a huge refreshment tent behind a Miami hotel. Deutsche Bank has responded by sponsoring the Frieze and Cologne fairs, and ING Bank by sponsoring Art Brussels. The other sponsors of Miami Basel are luxury goods purveyors Swarovski crystal; BMW, which offers chauffeured 7-Series cars to VIPs; and NetJets, which sent 216 flights to Miami for the 2006 fair. That number exceeds what the company provides for American football's Super Bowl, and is second only to the 240 flights it sent to the 2006 Academy Awards. Curators moan about how much sponsorship money is being spent by UBS and others, and fantasize about what their museum could accomplish, given the same amount.

To accommodate some of the hundreds of galleries unable to gain entry to Miami Basel, there are ten satellite fairs in warehouses and boutique hotels, with exhibitions named Pulse, Flow, Aqua, Nada and Scope. These feature young artists, digital and video art, prints and photography. Many dealers come to these satellite fairs not just to sell, but to be able to return home and tell their collectors 'We showed at Miami Basel'. In December 2005, ninety museums, including New York MoMA, the Guggenheim, Tate Modern, the Reina Sofia and Sao Paulo MoMA, organized trips to Basel Miami for their trustees and patrons in the hope that some of the art purchased would eventually be donated to their museum.

The fourth must-attend fair, quickly gaining a place equal with the first three, is Frieze, held in London during October. Only four years old, the fair was created by Matthew Slotover and Amanda Sharp, owners of *Frieze* magazine. The name, both for the magazine and the fair, came from a

searching a thesaurus for synonyms for 'art'. Frieze is defined as a horizontal band of carved reliefs. In 2006, 470 galleries from Europe, the USA, Russia and Japan applied for 152 spots at the fair. Frieze best illustrates the divide between art-industry insiders and outsiders. Favoured collectors and agents get in early, eat and drink free in sponsored VIP lounges, and have dealers whisper, 'For you, my friend, a special price'. VOPs wearing sneakers queue for the opening, drink £7 white wine from plastic glasses, and if they manage to corner a dealer, ask, 'Please, if it is permissible to ask – and please tell me if it isn't – how much is this painting?' Often they learn it is not permissible, usually by being told the work is 'not available'.

Dealer Roland Augustine of New York gallery Luhring & Augustine points out that when a gallery sells at four fairs in three months, artists are inevitably required to churn out repetitive work. One of the reasons that dealers space major shows for an artist at intervals of eighteen to twenty-four months is that it takes that long for the artist to develop the next stage in his body of work. With a demand for new work every few months, the evolution may not happen; the work remains cookie-cutter. Augustine asks how much of 'turn out more this month' can possibly be first rate, and how much is 'same-as' previous work?

Art and money

Are we liking certain things because we know that other people are liking them? How is the market affecting the ways we see art? How does it affect the way curators and editors see art? Does the market create a competitive atmosphere that drives artists to produce better work, or does it foster empty product?

Jerry Saltz, art critic

Money complicates everything. I have a genuine belief that art is a more powerful currency than money – that's the romantic feeling that an artist has. But you start to have this sneaking feeling that money is more powerful.

Damien Hirst, artist

oney complicates everything in contemporary art, and affects every observer. It is impossible to look at a work in an auction preview without glancing at the estimate, and having that influence how the work is interpreted. Only a few people seriously ask why a leather jacket tossed in the corner of the auction gallery is being sold as art; it must be art if it appears at a Sotheby's evening auction, or if the auction estimate for the jacket equals the value of an average suburban house, or ten cars.

When, after a long bidding battle, the auctioneer hammered down Mark Rothko's painting *White Center (Yellow, Pink and Lavender on Rose)* at \$72.8 million, there was sustained audience applause. What was being celebrated?

The buyer's oil wealth? The triumph of his ego? His aesthetic taste? A new record price, often well above that asked for a similar work earlier that day by the gallery down the street? When the auction hammer falls, price becomes equated with value, and this is written into art history.

Collectors walking through a museum are likely to discuss the art in terms like 'This work is worth five million; that over there is worth ten'. As I was told at the permanent Rothko display at Tate Modern, 'The art in this room [nine colour field paintings] is now worth a third of a billion pounds.' New York dealer Arne Glimcher calls this the *American Idol* approach, art appreciation as a trivia contest. Robert Storr, dean of Yale's art school and director of the 2007 Venice Biennale, says one of the challenges facing museums is 'getting the public to forget the economic history of the object once it leaves the market; the more stress on how much a museum or donor paid ... the more likely people will miss seeing the work of art because of preoccupation about the price tag.' Seeing Damien Hirst's diamond-encrusted skull, *For The Love of God*, at White Cube and knowing it is priced at £50 million creates a huge wow factor – and the price is how you report the sculpture to friends.

Or a collector enters a friend's home, views with disbelief a Warhol torn-label Campbell's soup can silkscreen on the wall and thinks, not 'You have cutting-edge taste', but 'You have a lot of money'. It is easier to appreciate art when what is required is not an understanding of art history, just your memory of a recent article about high auction prices.

Art critics and curators also follow the dictates of art prices. Expensive work becomes meaningful in part because it is expensive. Critics write essays interpreting the work of Jeff Koons or Tracey Emin – and many articles about Damien Hirst – but never admit that the reason the work has meaning is because so much money has been paid for it. Crowds line up to see *Portrait of Adele Bloch-Bauer* 1, and Hirst's sculptures, in part because of what they cost. The history of contemporary art would be different if there were no reported auction results, and no record of a Klimt selling for \$135 million or Hirst's *Lullaby Spring* for £9.6 million.

Artists have held negative views of the relationship between art and money since the mid-eighteenth century, when the aristocracy and monarchy ceased

to be the main sources of art patronage. Artists today resent the market economy and the degree to which artworks are acquired not just on merit but because art has become an expression of status. Unfortunately for artists' concerns, the contemporary art world must have an inflow of money from somewhere. Unless government becomes the sole purchaser of art, it is dealers, collectors and speculators who must come up with the cash. Artists have to accept art choices driven by status or investment, with the importance of a work of art often based on the size of the collector's bank account.

Does a market economy discourage artistic diversity? This does not appear to happen with books or music. Any stroll through a music or book superstore reveals products created to satisfy hundreds of niche tastes in music and literature. A developing artist may have trouble finding immediate representation with Gagosian or any other dealer who demands a prior track record, but there are many ways to attract collectors to his studio show. An artist who believes he can lead fashion by indulging his own taste can produce a shark, and sometimes he will be rewarded by a Charles Saatchi.

If the market economy does not always succeed in rewarding merit, should the government fill the gap by subsidizing artists? Those who have studied the economics of culture agree it should, because the arts offer economic externalities – benefits that accrue to the public at large, not just to people who own art. Art museums attract tourists, and help produce desirable cities that attract investment. But then who should be paid, and for what?

Both economists and members of the public suggest that subsidies are reasonable at two points in an artist's career: at the beginning, in the form of tuition grants, scholarships and one-time grants to new artists; and later, when the artist is producing mature work, as prizes or commissions for public art. Most artists have a dramatically different view, that occasional subsidies are inadequate, and that there must be grants and subsidies all through their careers – irrespective of whether the market accepts or respects their work. They claim the market will always under-reward contemporary art because buyers are not sophisticated enough to understand it. The extreme position is that government should offer a living-wage stipend to all who say they want to create art, a guaranteed annual income that rewards effort rather than output.

Robert Storr expresses this expectation well. When asked 'What have we a right to expect from art right now?', his response was 'What does art have a right to expect from us right now?'

A guaranteed income has actually been tried. For many years the Dutch government subsidized artists by purchasing their work. The price paid reflected both the amount asked by the artist, and the amount thought necessary to provide a living wage. Many artists sold only to the government, never on the open market. Those who sold on both markets received about three times as much for a work sold to the government. The scheme ended in 1987, and led to prolonged disputes between artists and their dealers over pricing. Dealers complained that artists refused to accept that the free market would not pay government prices. When the government later sold off some of the art it had accumulated, average resale prices were about one-fifth of what had originally been paid.

After all the subsidies, can you name a single contemporary Dutch artist from the 1980s? The only name that may come to mind is Marlene Dumas. She does not count; she moved to the Netherlands from South Africa, and was never part of the subsidy system.

If there are to be grants, who chooses the recipients? The public? But most people's taste in art is, as artists claim, undeveloped. An elected elite? Do politicians have any better taste in art than the general public? Art administrators? They are seen as having a vested interest in the art they supported in the past. Art critics, art historians, gallery owners and prominent collectors? All are suspected of having a bias towards the traditional, because their area of competence would be diminished if a new art form were to evolve.

How about a panel of artists deciding? Then there is the necessity of defining who is an artist. Must it be someone who has graduated from a prestigious art school?

We actually know a fair amount about the relationship between subsidies and motivation. There is a well-developed psychological literature on the effect known as the 'hidden cost of rewards'. The theory says that rewarding highly motivated persons to undertake a task actually reduces their intrinsic motivation. It suggests that rewards related to output – for example, selling a

painting – motivate more output, while subsidies that simply reward effort may decrease output. This implies that some government grants to artists might have the perverse effect of limiting creativity rather than promoting it.

Governments do subsidize artists differently than they would cabinet-makers or jewellery manufacturers. The methods often reflect political expediency rather than any sensible economic analysis. In the UK, the Arts Council – through an initiative called *Own Art* – created a marvellous scheme for artists and galleries. The *Own Art* programme allows any subscribing UK gallery to sell contemporary art priced up to £2,000, the buyer taking the work home without payment. The purchase price is covered by an interest-free loan from the Arts Council, and the Council guarantees the loan. The loan is supposed to be repaid over ten months. The buyer can also use the loan as a down payment towards a more expensive art purchase. The scheme is of great benefit to galleries offering inexpensive art, because more people buy, and buyers accepting an *Own Art* loan almost never try to negotiate the price. A few mainstream galleries like Whitechapel use the scheme, but for the most part it is High Street galleries with emerging artists that support it.

It is interesting to compare the direct funding of contemporary art by the French and US governments. The French Culture Ministry gives the visual arts about twenty times as much relative to the number of artists as does the National Endowment for the Arts in the USA. The reader may recall that there were no French contemporary artists in the consensus top twenty-five list earlier in the book. The New York contemporary art market has an annual sales volume about eleven times the size of that in Paris. The French results have been so disappointing that the Ministry itself funded *La Force de l'Art*, a 2006 exhibition in Paris of 200 grant-recipient contemporary artists. Attendance was far below expectations.

The very large number of art prizes constitute another subsidy, but one which goes to relatively few artists. At one extreme is the £25,000 Turner Prize, known as the world's most notorious art award, given to a British artist (or one who works in Britain) under the age of fifty for an exhibition of their work during the previous twelve months. Most Turner Prize candidates produce work that few collectors would want to purchase or exhibit. Four artists are shortlisted by

a jury of four judges chosen by Tate director Sir Nicholas Serota, in a process again reminiscent of *The X Factor*. The four finalists in 2004 included Kutlug Ataman with a film on Turkish transsexuals, and Ben Langland and Nikki Bell with a digital and video virtual tour of Osama bin Laden's house. Martin Creed won in 2001 for *Work No. 227: The Lights Going on and Off*, which was just that – the lights switch on and off in an empty gallery.

The 2006 winner was Simon Starling, for a work called *Shedboatshed* (*Mobile Architecture No. 2*), an old board shed which he found while cycling along the Rhine. He disassembled the shed and converted it into a boat that he paddled to Basel. He then rebuilt it as a shed and put it in a gallery. Starling said his £25,000 prize would be used to build a replica of Henry Moore's sculpture *Warrior with a Shield*. This would be submerged in Canada's Lake Ontario for six months where it would become encrusted with zebra mussels. He would then exhibit the result.

The 1993 Turner Prize, then worth £20,000, was won by Rachel Whiteread for *House*, a full-sized concrete cast of a derelict house which was to be torn down by her local council. To round out Whiteread's year, the K Foundation then awarded her its £40,000 first prize as 'Worst Artist of the Year'. The Turner Prize is presented inside Tate Britain; the K Foundation award on the street outside. Prior to presenting the award, the K Foundation held an exhibition of artworks entitled *Money: A Major Body of Cash*.

It is hard to discern what criteria the Turner Prize judges use in choosing 'best'. The art-world claim for many years was that 'Turner' meant 'Must never go to a painter'. However, the 2007 prize was won by serious abstract painter Tomma Abts, a German-born artist who lives in London. The favourite, and thought to be runner-up, was Phil Collins, whose submission was a film called *The Return of the Real*, in which people whose lives had been ruined by reality television were given a chance to tell their stories, unedited.

Most artists welcome the wide interest and debate that the Turner Prize generates as an indirect subsidy to contemporary art. One hundred thousand visitors each year attend Tate Britain to view the finalists' work. But some think that putting the Tate's power and status behind very avant-garde art skews the development of young artists.

What does being a Turner Prize winner do for the artist? There are as many stories as there are winners. Consensus opinion among dealers I asked was that winning the Turner guarantees at least mainstream dealer representation, and raises the artist's prices about 40 per cent. Winning does not produce more sales, just representation and higher prices for the work that does sell.

But that is only the Turner. There are 4,500 other contemporary art prizes around the world, worth in total – remarkably – about \$100 million a year. Candidates for most of these are chosen by committee rather than public nomination. Many competitions have the same group of collectors, curators, writers and other art professionals as judges.

Not surprisingly, curators and collectors often support artists whose work they own. Thus Albanian video artist Anri Sala was nominated by the same collector for the Young Artist Prize at the Venice Biennale, the Hugo Boss Prize, the Marcel Duchamp Award, the Beck's Futures Award and the National Gallery Prize for Young Art in Germany. He won in Venice.

The major subsidy goes neither to students nor to working artists but to museums, which get three-quarters or more of their operating funds from public sources. The money is not for art acquisition, but to cover the salaries of curators, ticket sellers and the guards who sit comatose in the corner of each gallery, answering no questions but expected to spring into action if someone skulks off with a Jeff Koons sculpture. There is a much-repeated statistic that, fuelled by grants, the average museum guard in the USA or UK earns a higher yearly income than the average working artist. A depressing idea but, fortunately, absolutely wrong.

That statistic is typical of a lot of analysis in the art world; the comparison is usually of guards' total yearly income with artists' income from selling art. It ignores artists' other income, whether from teaching or table-waiting. The figure also pools the incomes of young apprentice artists with those of mature artists – and most apprentices earn little or nothing. Most will soon enter another profession. If you compare apples with apples, full-time artists over thirty-five have double or triple the total income of full-time guards over thirty-five.

The interlocking themes of art, money and power sometimes become the subject of artists' efforts. In 1997 Russian artist Aleksandr Brener went to the

Stedelijk Museum in Amsterdam and spray-painted a green dollar sign on Kazimir Malevich's white canvas painting *Suprematism*. When arrested, Brener explained that the paint was a political act protesting the role of money in the art world. Media coverage focused on the €6 million value of the painting, which Brener said proved his point. Curators were outraged, while many artists were sympathetic and contributed to Brener's legal expenses. He was sentenced to ten months' imprisonment and fined €8,000, which he refused to pay.

No one was more committed to money than Andy Warhol, who said, 'A lady friend of mine asked me "Well, what do you love most?" That's how I started painting money.' In his book *The Philosophy of Andy Warhol: from A to B and Back Again*, Warhol famously wrote: 'Say you were going to buy a \$200,000 painting. I think you should take that money, tie it up, and hang it on the wall. Then when someone visited you, the first thing they would see is the money on the wall.'

Damien Hirst quotes his manager Frank Dunphy as saying that 'art should chase life while the art world chases money; if you start chasing money with art the whole thing is fucked'. Hirst is also known for a quote from his 1996 show at the Gagosian Gallery in New York, where his most-discussed work consisted of two cows cut into pieces and suspended in twelve formaldehyde-filled tanks. The show was delayed for six months, until Gagosian could satisfy concerns from the New York Sanitation Department that rotting meat within their jurisdiction might accidentally be consumed. The title of the work was *Some Comfort Gained from the Acceptance of the Inherent Lies in Everything*. When asked to explain the title, Hirst said it meant 'the work is worth a lot of money'.

Santiago Sierra, a Spanish/Mexican artist whose most famous work involved offering heroin-addicted Spanish prostitutes the cost of one dose for permission to tattoo a straight line across their backs, then displaying the prostitutes as art, sometimes used his shows to demonstrate the relationship between art, money and privilege. He proposed a show at the Kunsthalle in Vienna where the museum staff (male and female) would line up, stripped to the waist, in order of salary, to show the progression of skin tones from lighter at the executive end to darker for museum guards.

In 1997, given the freedom to mount an installation, Sierra set fire to the gallery to demonstrate his hostility towards its commercial orientation. In his second most famous show (nothing tops tattooing prostitutes) he barricaded the entrances of the Lisson Gallery in London with metal grates, to prevent those invited from attending the opening. He said he wanted the cultural elite to experience the sensation of being excluded.

Many paintings belonging to art museums are stored and never exhibited to the public, but are never offered for sale either. The reasons deaccession and resale do not happen more frequently provide another illustration of the complex relationship between money and art.

Some stored art gains exposure by being loaned to other museums for exhibitions, but museum directors say that half or more of the pieces their institutions have in storage will never be shown. Some are important works of art that should be hung somewhere. The numbers of stored works are substantial. The Public Catalogue Foundation in the UK estimates that there are 150,000 paintings in public collections in the UK, of which 120,000 are not on view to the public at any one time. Projected to the USA, the equivalent figure would be about 900,000 paintings, with 720,000 not on display.

Why store work that will never be seen, rather than sell it? Logic says the museum should focus on what is important to its field of collecting, and divest what will not be shown. The freed-up funds could be invested in new art or the restoration of paintings in the collection.

One argument for not selling stored art is that it has 'low value' (because the stored works are not as good as those being shown). This is not persuasive, given the current high level of art prices and the added value that comes from the provenance of being in a museum collection. Another argument holds that if sold, the work will be lost to the public. This does not explain why worthy paintings could not be sold to another museum. In 2006 the Centraal Museum in Utrecht deaccessioned 1,400 works by first offering them to other Dutch museums. Any works not taken were auctioned by Sotheby's. The museum's argument was that if a work is not worth showing, and no other museum wants to acquire it, it is not worth keeping.

The real problem is the psychologically asymmetric way that the value of art and the value of money are viewed. A painting that is deaccessioned and sold from the museum's holdings is considered a loss. Members of the public and the art press bemoan that loss, while not viewing new acquisition funds from the sale as a gain.

There are two different conventions for deaccessioning. The first is the Association of Art Museum Directors' Code, which says that art can be sold only to buy more art. The second is an unwritten rule that when a museum deaccessions a picture, the money should be used to purchase art only of the same period. This ignores market opportunities, but heads off the internal battles that would occur if the contemporary art department recommended selling a Rembrandt to raise money to purchase a cow in formaldehyde.

The 'same period' rule is sometimes ignored, but that requires a confident museum director with a supportive board. Thomas Krens of the Guggenheim has several times deaccessioned major work, most controversially in 1990 with Kandinsky's *Fugue*, Modigliani's *Blue Jacket* and Chagall's *L'Anniversaire*. These were sold at Sotheby's for \$30 million to pay for the art collection of Count Giuseppe Panza di Biumo – 200 works by American conceptual artists Dan Flavin, Donald Judd and Richard Serra. This collection was intended to be sent to the Guggenheim in Bilbao as the first art loan from the Guggenheim in New York. It was rejected by Bilbao.

If a museum's excess paintings cannot be sold, why not lease them to someone else? Art is a large part of a museum's capital. The value of this capital is the amount the art would bring on the market. At an interest rate of 5 per cent, a \$2 million painting stored in the basement has an opportunity cost (what you could earn investing elsewhere) of \$100,000 a year. This could be converted to an income of \$100,000 per year by renting the work to another museum or private collection. Any major art museum's work in storage has a value of hundreds of millions of dollars, and many new museums – particularly new foreign museums – are willing to lease art while they build their own collections.

Rentals of museum art do happen, usually with as little publicity as possible. One exception to 'little publicity' was the 2006 three-year agreement

between the Louvre and the High Museum in Atlanta, Georgia, to provide 180 works for a series of exhibitions, in return for \$6.4 million – an incredible bargain for Atlanta in terms of additional attendance and entrance fees. Another was the 2007 Louvre agreement to loan its brand and 300 works of art to a new Louvre Abu Dhabi Museum – the Louvre name for a twenty-year period, the art for five years. Abu Dhabi paid €400 million for the name, €25 million to fund renovations in the Paris museum, and a further €575 million for the art loan, some special exhibitions and for advice on future art acquisitions. What is fascinating about the Abu Dhabi venture is that while the name cost so much, the actual building itself was budgeted at only \$115 million. Such is the economics of art branding. A more philosophical commentary on the deal came from Jean-Rene Gaborit, a former head curator of the Louvre: 'You can export Disneyland by building lots of Disneylands in different cities around the world, but the Louvre can't be reproduced. Is the Louvre a museum or a franchiseable brand name?'

The very substantial untapped value of locked-away art is a museum secret. For years, accounting bodies in the USA and UK have urged museums to list the value of their collections on their balance sheets. Museum directors always refuse, on the grounds that revealing the true value of the collection would signal to donors that the museum has no need of philanthropy; they could simply sell or lease art to finance new acquisitions.

A final value-of-art issue is how a museum maintains contemporary art. Is it authenticity or the artist's original intention that matters? If Jeff Koons' vacuum cleaner or Damien Hirst's pills change with age, can the collector or museum go to the nearest store and replace them, as Hirst replaced the decaying shark? Does the collector have to divulge what has been replaced? What does a museum curator do with the 1974 *TV Buddha* by Korean-born artist Nam June Paik, which consists of Buddha gazing at a television monitor that shows his own image? The monitor requires a cathode-ray tube that is no longer manufactured anywhere in the world. Can it be replaced with a flat-screen plasma TV?

If it is only intention that matters, is it necessary to put artworks at risk by transporting them? Curators for the Guggenheim's 2007 Art in America show

at the Shanghai Museum of Contemporary Art showed Felix Gonzales-Torres' 1991 *Untitled (Public Opinion)*, another of his sculptures of black liquorice candies. This one consisted of 700 lb of individual pieces wrapped in cellophane and piled in a corner of the gallery, for the audience to pick up and eat. Gonzales-Torres had always used 'authentic' liquorice sourced from the Peerless Confection Company in Chicago. For the Shanghai show, the Guggenheim substituted liquorice purchased locally; the original sculpture remained in the USA.

Burton and Emily Tremaine discovered another relationship between art and money after donating a large part of their collection to museums. When they simply gave a work to a museum, it often ended up in long-term storage. When they sold a work to the museum, even at below the market price, it was hung and promoted. Emily Tremaine decided that curators most appreciated items for which they had to give up a large part of their acquisition funds. A high price also made the painting easier to promote, because like the \$135 million Klimt, purchase price is presented to museum patrons as equal to value.

Pricing contemporary art

Art prices are determined by the meeting of real or induced scarcity with pure, irrational desire, and nothing is more manipulable than desire ... A fair price is the highest one a collector can be induced to pay.

Robert Hughes, art critic

Trates some of the factors an auction house takes into consideration when producing a price estimate. But how do dealers price art? Most dealers are reluctant to talk about the process of price-setting. Just like use of the word 'dealer', a discussion of pricing makes the art trade sound a lot like everyday commerce. Whenever I raised the topic of pricing during an interview, the discussion would turn to dealers' other roles: enabling clients to acquire contemporary art, assisting artists to become known, providing the artist financial and emotional support. Money changes hands in performing these roles, but the dealer treats the payment as unimportant. The price is simply part of a necessary process to compensate artist and dealer.

Superstar dealers go further, discussing their function not as sellers but as patrons, curators of a semi-commercial museum. Dealers expose the artist's work to real museums and collectors, sometimes mount non-selling shows – as Gagosian did with Francis Bacon's work – and publish catalogues. The layout of every gallery reflects this distinction between art and commerce. The front display area is a museum-like space where artwork is exhibited. There are no posted prices, although a list may be available at the

desk. Negotiations take place in a separate room at the back or upstairs; that is where sales are finalized.

But each sale comes at a price. How is that number chosen? Clearly it has nothing to do with cost. The value of the canvas and oil that goes into a painting would not exceed £50. Nor is it based on the artist's time. Some paintings take three hours, some three months.

After the more formal part of dealer interviews, often later over a glass of wine, tales would be told of how the dealer does cope with pricing decisions, how other dealers are thought to set prices, and the pricing problems that result when evil collectors flip new paintings at auction. What emerges is that the dealer's profit really is not the first consideration. What is more important is what an economist calls signalling. In a market where information is scarce and not trustworthy, the first rule is that the price level signals the reputation of the artist, and the status of the dealer and that of the intended purchaser. Prices reflect the size of a work, not its quality or artistic merit. That sounds simplistic, but it isn't. Different pricing levels would imply that an artist's output is not consistent, so all work must be presented as of equal merit. Where judging quality is uncertain, prices are set according to image size, to offer the buyer reassurance. On the rare occasion where same-sized works by a mature artist are priced differently, this is explained as reflecting importance or difficulty rather than quality.

The starting point in setting a price for the work of a new artist is the *dealer's* reputation. For a mainstream gallery, and for an oil painting on canvas by an artist with no gallery history, £3–6,000 (\$5,400-10,800) is about right. This is high enough to convey the status of the gallery and not cast doubt on the work or the artist, but low enough that if the work is promising, it will sell.

If the first show sells out quickly, the dealer will say the pricing was correct. The artist may be underwhelmed, because even selling out one show a year at new-artist prices means she is still living below the poverty line. She is told to view today's low prices as an investment in her artistic future. She also learns that in the primary-art market, price creates value and buyer satisfaction rather than reflecting it. This is what economists call the Veblen effect: the satisfaction derived by the buyer comes from the art, but also from the list

price or conspicuous price paid for it. If the real price reflects a discount the satisfaction is greater, because friends assume you paid the higher list price. The same principle holds with a designer handbag or a diamond engagement ring. The higher the perceived price, the more valuable the object is seen to be and the greater the buyer satisfaction.

As an artist becomes better known, the price of her work is based on reputation and history. If the artist's first show sold out at £4,000, work in the second show might be priced at £6,000, and in a third at £10–12,000. Successive shows will come eighteen to twenty-four months apart. Publications, exhibitions or other forms of recognition for the artist produce faster price escalation.

Because the initial price reflects the dealer's reputation, a superstar dealer multiplies each price level by a factor of three or four, with larger increments. If a mainstream dealer charges £4,000 for a modestly sized work in an artist's first show, Larry Gagosian's gallery might charge £12–15,000 for work of comparable size and quality. Gagosian's reputation for showing promising artists makes work from that gallery more valuable. On resale the Gagosian provenance will bring a higher price.

There are exceptional cases of artists whose first shows start at much higher prices; this is called 'live or die pricing'. British artist Jenny Saville, who may turn out to be the most enduring of the yBas, had her first show of six large Rubenesque nudes at Gagosian New York in 1999, each work priced around \$100,000. The prices were criticized by other dealers as too crazily high to be in anyone's interest and, in any case, so high as to put too much pressure on the artist at too young an age (she was twenty-nine). In three weeks, Gagosian's pricing was going to make Saville either a star or just another emerging artist. The show sold out, and her prices have continued to increase, although not as fast as demand for her work would support. Nor do prices for any artist. It is always considered better to sell out a show than to try to achieve maximum prices for a few works.

A second rule is that the dealer must never reduce an artist's list price. Never. This applies to all artists, beginning and mature. Each successive show must be priced higher than the last. In an art world where the illusion of success is everything, a price decrease for an artist would signal that she was out of favour. Demand for her work would fall instead of rise. With a second price decrease, demand might disappear. The single exception to this norm is a show where the artist experiments with new media or styles. Decreases also cause collectors to feel uncertain about the judgement and instincts of the dealer in choosing artists.

Both dealers and collectors believe there is an implicit promise – and sometimes an explicit one – that the next show's pricing for an artist will be higher than that of the current show. Think of Gagosian selling out a show over the phone, prior to opening. Why does a collector buy art sight unseen? One reason is the expectation that prices will increase over time – not just because of a work's artistic merit, but because the price level is managed. The buyer expects to receive satisfaction and status from ownership, but also expects a profit on resale.

Even when an art market collapses, galleries generally do not drop prices for their own artists. After the 1990 market crash, New York dealer Leo Castelli said that under no circumstances would his list prices be lowered. However, his artists were told that it would be necessary to offer more generous discounts to museums and collectors. Discounts permit dealers to maintain high list prices as a sign of an artist's success, while generating sales and gaining the gratitude of collectors.

Rather than be forced to decrease list prices, the dealer will almost always drop an artist. Prices can restart at a lower level if the artist finds representation at a new gallery; the new dealer does not have to worry about lower prices betraying former buyers.

Those are the norms for beginning artists. How do dealers set prices for secondary-market work by mature gallery artists? The best description came from Andre Emmerich, founder of the legendary Madison Avenue gallery in New York, who passed away in September 2007. Emmerich represented a diverse list of contemporary artists, including David Hockney, Sam Francis and Morris Louis.

Emmerich said he only priced a work once it was in the gallery, in front of him. It was only when a piece was seen beside other work that a justifiable

price could be determined. The key word is 'justifiable'. The test was whether the price could be justified to a client against other work hanging on the same wall – a Sam Francis against a Morris Louis, the Louis also having been priced in comparison to work hung earlier. What Emmerich had paid for the painting was never part of the equation. Neither Emmerich nor any dealer I talked with ever discussed this process with a client. A collector either wants a work or he does not.

There are problems in maintaining a coherent price structure for an artist when pricing is based on 'justified'. Marc Glimcher, president of PaceWildenstein in New York, years ago offered the example of selling a small Frank Stella for \$250,000. Glimcher then acquired a more important Stella of the same size on consignment. Should he price this work higher, but revert to the old price for future Stella sales? If he priced the next one lower, would his customers think the Stella market had weakened? Would there be a decline in the value of previously sold Stellas, and of his own inventory?

Emmerich's other consideration in pricing was the body language of the collector. He likened the pricing process to sailing, where one gets speed by hauling in the sail close to the wind but not so much as to tip the boat. If he was challenged on a price, Emmerich would ignore the question and launch into a narrative on the historical importance of the artist, and the names of other collectors who owned the work.

Emmerich disliked discounts, but since competing galleries offered them, he did too. If his artists and estates refused to allow discounts, Emmerich would sell at full price and offer the buyer another work free or at a discount. His standard discount was 10 per cent, graciously offered because the purchaser was a good customer or might become one, was a promising young collector, might leave the work to a museum, paid promptly, or – as a last resort – had opposable thumbs. The 10 per cent discount was built into the price. Higher discounts, when offered, went to genuinely good customers or to buyers who might really donate to a museum. Emmerich said that if others offered a discount much above 10 per cent it might be because the purchaser was buying a 'difficult' work: a picture of lesser quality or one from the wrong period of an artist's career.

When Emmerich knew a buyer would demand a higher discount, as did his major Japanese collectors, he simply increased the quoted price by 50 per cent. He then offered a one-third discount, which would be bargained up to 40 per cent to produce the same 10 per cent off list price that everyone else received. Emmerich's standard discount was modest because he was a branded dealer with branded artists. Lesser galleries are more flexible with discounts, but the process is the same. Emmerich's approach required that prices never be publicly posted or discussed at the desk. The buyer had to enquire of him personally.

It is this non-transparent pricing that makes it possible to charge customers dramatically different prices for similar work. Dealers say that offering price transparency would cause problems. In 1988, New York City tried to enforce 'truth in pricing' regulations against art galleries that refused to display prices. Major galleries refused to comply, many paying small fines. They argued that posting prices would interfere with customers' enjoyment of art, and would treat galleries as ordinary retail stores. New York stopped enforcing the regulation.

Many galleries do not reveal prices even during a show. During the Bacon exhibition at Gagosian London, his gallery girls even refused to tell me which three works were available for sale. When I pointed out that I knew which ones they were, I was told that 'they have not been priced as yet'. I thought this meant Gagosian was waiting to see how much Bacon's *Three Studies for a Self-Portrait* would bring at the Christie's auction, and would set a price based on that. It turned out that two of the three Bacons had already been sold.

Auction prices establish a ceiling for dealer pricing. Except for really rare work – a Jasper Johns coming to market for the first time in years – dealers never price above comparable published auction results. However, when new price records are set at auction, dealers immediately mark up their own prices.

Contemporary art seems to be priced more 'solidly' (which in the art trade means realistically) in North American dealerships and fairs, and more 'aggressively' (overpriced) in their European equivalents. Art writer Marc Spiegler said of the pricing at Basel Miami: 'At Gagosian, where the numbers are usually known to be aggressive, the prices for once are actually in line with

the market ... he has a Warhol *Double Jackie* at \$600,000, that's a solid price, but in Basel it would be at \$850,000 to \$900,000. Or look at Cologne's Jablonka Galerie and its Warhol *Dollar Sign*. The one they had in Basel was \$750,000; here [in Miami] it is \$575,000.'

Pricing becomes a lot more challenging when a hot artist is involved. A collector who covets the artist's work and can afford it may be denied the opportunity to buy because there is a long waiting list and a pecking order that favours museums, important collectors and the gallery's best customers. For the novice collector there is a ritual to be performed before gaining a place in the artist queue. The gallery wants your CV, a statement of what you will do with the art, and your pledge to be patient for a year until a painting might become available. Buying has nothing to do with offering to pay full price; you might still get a discount. It is not unlike a woman wanting to purchase a Hermès Birken bag being asked what sort of social events she attends, before being assigned an appropriate place in the Birken queue.

Waiting lists serve the function of getting art to the right people, and trying to control what happens to the art after it has been purchased – in particular trying to ensure that it will not be flipped at auction. Working with an art advisor may help the collector move up the list, because keeping the advisor happy may produce future referrals for the gallery. An advisor may also have a negative influence, especially if he demands an additional commission from the gallery without telling the collector he is doing so.

The recent history of waiting lists goes back to New York dealer Mary Boone, who in the late 1980s succeeded in increasing demand for neo-Expressionist painters Jean-Michel Basquiat, Julian Schnabel and Eric Fischl by pricing realistically, then refusing to sell. Boone not only cited a waiting list, but required collectors who wanted a place on the list to pay for the art before it was created. The practice drew criticism for encouraging artists to release lower-quality work, and for inducing buyers unhappy with their seen-for-the-first-time purchase to flip the work at auction. Waiting lists also mean the artist is 'caged-in'; collectors want something in the same style they have seen, and the artist's move to the next stage of evolution of his work is delayed. But waiting lists can be irresistible; Boone's artists were sought

after for being hard to purchase, and the gallery flourished until the market crash of the early 1990s.

The story of French-Swiss collector Jean-Pierre Lehmann illustrates how far one might go to obtain a painting. Lehmann has been collecting for three decades and has art-filled homes in New York City and Gstaad. His wife, Rachel Lehmann, is a partner in the Lehmann-Maupin Gallery in Chelsea. He is an important collector by any standard.

Lehmann lusted after the work of Julie Mehretu, a thirty-five-year-old Ethiopian-born, Harlem-based artist whose *The Empirical Construction* is displayed at MoMA beside Barnett Newman's *Obelisk*. Mehretu is high on any list of artists who might still be important a generation hence. Stuck low on a very long waiting list, Lehmann thought he had found a way to move up. He invested \$75,000 in New York's Project Gallery, which represents Mehretu. The contract said Lehmann would receive a 30 per cent discount on his purchases from Project until total discounts equalled \$100,000. The discount did not matter to him; he normally received a 10 to 20 per cent discount just by asking. What did matter was that Lehmann would also have first right of refusal on any work sold by the gallery – including, he thought, paintings by Julie Mehretu.

It turned out that Lehmann had acquired first right to anyone except Mehretu. As long as there was more demand than supply, the gallery was selling to preferred clients, museums and some foreign galleries. Over a three-year period, the Project Gallery sold forty works by Mehretu to Jay Jopling of White Cube, to New York dealer Jeanne Greenberg Rohatyn, who was lending work to a Mehretu one-woman show at the Walker Art Center in Minneapolis, and to Michael Ovitz, who is on the MoMA board, among others. Only one buyer ever paid full list price. Discounts for others ranged up to 40 per cent.

Lehmann learned that the gallery had apparently promised half of Mehretu's future production to White Cube, a third to Berlin dealer Carlier Gebauer, a third to Jeanne Greenberg Rohatyn, and had sold four other rights of first refusal to collectors. Lehmann sued, and his case, Lehmann v. The Project Worldwide, became the first lawsuit to try to enforce a right to buy contemporary art. Lehmann won the right to purchase for \$17,500 a small

Mehretu painting, *Excerpt Regimen*. He also won \$1.73 million in damages when dealer Christian Heye was found guilty of violating his contract with Lehmann by refusing to sell to him. Lehmann reached an amicable agreement with Heye which involved compensation for his legal costs with no damages, but presumably the right to acquire many future Mehretus.

Many 'waiting lists' reflect gallery hype – a more sophisticated form of putting red 'sold' dots on work that has not actually sold. Gallery owners are happy to announce there is a waiting list, but not how many collectors might be on it (or who they are). Some lists are just for 'first right to view', and some names on the list represent people who simply want to look like they are players. Lists for artists such as Mehretu, John Currin, Cecily Brown, Damien Hirst and Matthias Weischer are certainly genuine, 'I will buy sight unseen when a work becomes available'. Some lists arise because of the very limited production of market-savvy artists. When Charles Saatchi acted as patron to Jenny Saville early in her career, he reportedly limited her production-for-sale to six paintings per year. In selling out her 1999 show at Gagosian, Saville ended up with a waiting list of two dozen names, potentially four years of artistic output.

Waiting lists have a huge impact on the level and complexity of art pricing. Consider the case of German contemporary artist Matthias Weischer, a member of the 'Leipzig Academy' (*Hochschule für Grafik und Buchkunst*) group of artists, and one of the major beneficiaries of the extensive self-hype of that group. Weischer is represented by Galerie Eigen + Art in Berlin, owned by dealer Gert Harry 'Judy' Lybke, who is known for controlling how many canvases his artists produce each year and who is allowed to purchase them.

Weischer's large paintings were priced at €22–25,000 in 2004, when his new work *Ohne Titel* (2003) was purchased by a private collector. The buyer almost immediately consigned it to Christie's London for an October 2005 auction. The 29 × 35in (75 × 90cm) oil on canvas view of a room interior was estimated by Christie's at £18–22,000, reflecting its gallery pricing. After frantic bidding by two German collectors, it sold for £210,000, ten times the Galerie Eigen + Art price.

What should Gert Lybke then have done? If he increased prices to match the auction market there would be very few collectors willing to purchase, because collectors expect small-step price increases, never jumps of ten times magnitude. But a dealer selling work for a fraction of what it might bring at auction is inviting speculators to buy and immediately consign the work.

Dealers hate this situation. New York dealer Andrea Rosen and London's Haunch of Venison, among others, discourage speculation with invoices or resale contracts specifying that a purchaser who resells the work must offer it first to the gallery. In theory this is to prevent work going to auction at a price that disrupts the dealer's pricing scheme, and to allow the gallery to educate the new buyer on the artist and his work. It is also intended to give galleries a percentage of the proceeds of resale, which they sometimes share with theartist. Resale contracts are normally used only with hot artists, but occasionally also with harder-to-sell artists because use of a contract implies that demand exceeds supply. The result is that buyers are unable to get the best possible price on resale, because they only have one place to sell.

No one thinks resale clauses are enforceable. In any case the buyer could return to the gallery, demanding an outrageous repurchase price that 'Christie's said I would net'. If the gallery refused, the buyer could consign to auction.

Most dealers do not use resale agreements, but assume the buyer will do the right thing. Larry Gagosian talks about a protocol whereby if the purchaser later wants to sell, he will respect the fragility of the artist's career, respect his relationship with Gagosian, and call the gallery first. Some galleries are more explicit about punishment. Lawrence Augustine of New York art dealership Luhring Augustine has said publicly that he informs his clients that if they consign a work from his gallery through an auction house without checking with him first, Luhring Augustine will never do business with them again. Mr Augustine estimates he has dropped 20 per cent of his 500 collectors for flipping works at auction. Other dealers say they would go further and circulate blacklists.

Owners of a Weischer still have a huge motivation to cash in on the new values, through the dealer or at auction. But because Galerie Eigen + Art is unlikely to pay €200,000 to buy back a painting, that leaves only the auction

route. However – and this is the problem – if a lot of paintings by Weischer are simultaneously consigned to auction houses with high estimates, most of them will not sell, and Weischer will be perceived as out-of-favour.

Auction houses do not like to sell new work of artists such as Weischer, and they certainly do not want to offer more than one or two Weischers at a time. But they will not reject a consignment if they think the painting will then go to a competitor. They compromise by listing a modest estimate when they do accept a Weischer – well below the auction record. The consignor understands the game, thinks bidders will also, and assumes that the work will sell far above the high estimate.

The pricing of an artist such as Weischer gets even more complicated when collectors consign to other dealers, who then take the work to an art fair. Prices at a fair for a hot artist with a waiting list start at the gallery price plus one-third of the difference between gallery price and auction price, and increase from there. Buyers will pay this to jump the queue at the home gallery, and because with an art fair purchase, there is no restriction on immediately flipping the work at auction.

In October 2006, a large Weischer oil on canvas at Galerie Eigen + Art was listed at €65,000. You could not buy it, merely admire it and ask to be placed on the waiting list. On 11 October, fifteen minutes into opening day of the Frieze Art Fair in London, another German gallery sold a Weischer of that size with an asking price of €120,000. Four days later a similar 2003 Weischer was offered as Lot 65 at Christie's London contemporary sale, estimated at £80–120,000 (€120–180,000). Fourteen bidders and twenty-one bids later it was hammered down at £180,000 – or £209,600 (€309,000) after adding the buyer's premium. Two days later, Galerie Eigen + Art increased its list price to €80,000.

These sales may not be entirely what they seem. One way Weischer's gallery can cut the artist in on the huge auction and art fair prices is to consign the work themselves, and share the proceeds. This is what some think may have happened at Frieze.

The dealer might consign a new work directly to auction under a different circumstance. A buyer does not want to be placed on a waiting list, and offers

€150,000 for immediate purchase of a work listed at €80,000, but unavailable. The dealer suggests the following: the work will be consigned to Christie's or Sotheby's with a reserve above the current gallery list price, and the buyer will agree to bid up to €150,000. If the work goes to another bidder at a higher price, the gallery will supply the original bidder an equivalent work at €150,000. There is no issue of a rigged sale because in either case, the bid is real. The higher auction price is shared with the artist, and the apparent value of the artist's work increases, so gallery list prices can be increased a little.

Julie Mehretu and Matthias Weischer illustrate one of the key antagonisms between dealers and auction houses. Should market price be managed and increased only slowly and systematically by dealers, in a system designed to protect artist and dealer? Should auction houses be forbidden to sell a work of art for say, ten years after its creation, as galleries have argued? For Mehretu and Weischer, this would mean that their art could only be purchased by someone deemed by the dealer 'a suitable collector' – both rich and a taste maker. Or should price be set in a free auction market, as proposed by the auction houses, where demand is determined by the two top bidders?

Fakes

What few art professionals seem to want to admit is that the art world we are living in today is a new, highly active, unprincipled one of art fakery.

Thomas Hoving, former director of the Metropolitan Museum of Art

Some counterfeiters try to enter the 'soul and mind of the artist'. Some delight in the chemistry of baking paint and creating wormholes. Some start with real pictures and then 'restore' them until they look as if they're by a different artist.

Milton Esterow, editor of ARTnews

RT FAKES ARE rife throughout the art market, but are particularly problematic for modern art. A well-known example involved Paul Gauguin's 1885 *Vase de fleurs (Lilas)*, a 'middle market' Gauguin — which means not one of his better works. This is one of those routine paintings by a great artist that changes hands for a few hundred thousand dollars and attracts little attention. In May 2000, after Christie's and Sotheby's had finalized their auction catalogues, they discovered that each was offering the same *Vase de fleurs* — and each thought it had the original. The auction houses showed both works to Sylvie Crussard, a Gauguin expert at the Wildenstein Institute in Paris, who determined that Christie's version was, in the language of the art trade, 'not right'. She called it the best fake Gauguin she had ever seen. Christie's recalled its printed catalogue and reissued it without the Gauguin. Sotheby's sold the

genuine painting for \$310,000, the money going to the consignor, New York dealer Ely Sakhai.

Art fakes are another aspect of the curious value of art. Tom Hoving, former director of MoMA, estimates that up to 40 per cent of the high-end art market is made up of forged art. There were at one time 600 Rembrandts hung in major museums around the world and another 350 in private collections. This aroused suspicion, because Rembrandt scholars say the master only created 320 paintings. Forgery is not restricted to Old Masters. They are an increasing problem for contemporary art as prices leap into the millions of pounds. There are fake Damien Hirst spot and spin paintings out there, certainly in the UK and USA but also in Japan or Russia. Sotheby's withdrew three Damien Hirst prints from a London auction in October 2006, when it was determined the paper, the ink and the colours of the dots were wrong and the signatures were not Hirst's. There are probably piles of non-authentic Felix Gonzalez-Torres candy or fortune cookies with fake letters of attribution.

The story of the newly discovered Jackson Pollock drip paintings illustrates some of the issues surrounding forgeries. In 2003, Alex Matter, son of the painter Mercedes Matter and the graphic artist Herbert Matter, was cleaning out a storage locker in East Hampton, New York, and found thirty-two paintings wrapped in brown paper. Twenty-two of these appeared to be signature Jackson Pollock drip paintings. They were stored with other art and a collection of letters and personal effects left by Matter's father, who had passed away in 1984. The Matters had close ties to Pollock and his wife, the artist Lee Krasner, and had both purchased and been given small works by Pollock. A hand-written letter found with the personal effects indicated that the works had been painted by Pollock in New York City in 1948 and 1949.

The circumstances of their discovery suggested that the drip paintings might be authentic, but there were also reasons for caution. The board and paints Pollock used can still be purchased, and faking a drip painting is a lot easier than faking a Picasso. There are thought to be ten 'Pollocks' in existence for each one that spent time in his studio.

A dispute immediately broke out among Pollock scholars. Ellen Landau, author of a 1989 biography of Pollock, initially said the newly discovered

works were authentic, and finding them was 'the scholarly thrill of a lifetime'. Later she tempered her enthusiasm a little but said that 'If I draw a line down the page and point to all the things that point to Pollock on the left and things that point away on the right, what points away does not explain all the things that point to.' Mark Borghi, an art dealer who had dealt in Pollock drip paintings, agreed. Landau, Borghi and Alex Matter exhibited the paintings at the McMullen Museum of Art at Boston College in September 2007, with an exhibition catalogue by Landau.

On the other side of the argument was Eugene Thaw, an elderly and highly respected art dealer and co-author of Pollock's catalogue raisonné, the official listing of the artist's work. Thaw's expertise on Pollock is probably second to that of Ellen Landau, but his opinion was important because of his involvement in a future update of the artist's catalogue. Listing in a catalogue raisonné is essential, because auction houses and dealers rely on the entry to support the authenticity of any work they sell. Thaw was asked by the Pollock-Krasner Foundation to inspect the works. After the viewing he said he had serious doubts, and would not support showing them.

The owners of a work of art rejected for listing in a catalogue sometimes resort to lawsuits. The Pollock-Krasner Authentication Board, appointed by the Foundation, has been sued three times over rejected work. All three were successfully defended, but at substantial cost in time and money. The Board's position on the new Pollocks continues to be that there are scientific and other reasons for doubt about the works. There is concern about future suits with these Pollocks because they have solid professional support.

If the Matter paintings are accepted as authentic, they might be worth as much as \$8–15 million each – in 2004 a small 1974 drip painting on paper deaccessioned by MoMA sold at Christie's for \$11.6 million. In 2007, two buyers ignored the uncertainty and each purchased one painting, for \$1 million each. One sale was later rescinded. If the conclusion is that the paintings are very good but not by Pollock's hand, the value of each will be in the low thousands. So the stakes are as much as \$275 million, versus \$100,000.

In another incident, in 1991 a retired female truck driver from Newport Beach, California, named Terry Horton, who had never heard of Jackson

Pollock, purchased a drip painting in a California junk shop for \$5. She bargained the price down from the asking price of \$7. Ten years later an art professor friend saw it and told her it might be a Pollock. Authentication was inconclusive, although Tom Hoving said he thought the colours were wrong.

Then Peter Paul Biro, an art restorer, matched a fingerprint on the painting to one on Pollock's *Naked Man With A Knife*, on display at Tate Modern in London. If Pollock produced the fingerprint, does that confirm that he produced the painting? Or was the Tate Modern painting faked by the same person who produced Horton's? If Horton's drip painting is authentic, it is worth up to \$40 million; if not, it is worth a few hundred dollars. Horton was reported as having been offered \$9 million by a collector from Dubai willing to bet on its authenticity. She turned it down.

Should Horton have rejected the offer? Another question, of greater interest to an economist, is why Tom Hoving's disagreement on the authenticity of its colour should make such a huge price difference to Horton's Pollock. Is the low price for a forgery that almost no one can discern conclusive evidence that the value of art is not entirely about aesthetics and beauty, but also about investment and status? If a buyer loves the work, why not a higher price? A buyer does not worry about friends with little art background saying 'That is really unattractive'. Why should there be any concern about the same friends saying 'Are you sure that is authentic?'

In the case of Gauguin's Vase de fleurs (Lilas), the FBI found that dealer Ely Sakhai had been purchasing middle-market work and having it copied, most likely in China. Sakhai had sold the Gauguin copy to a Japanese collector, together with the original letter of authenticity and a provenance which cited previous auction transactions. The purchaser could more easily check out the letter and the transactions than the art, and would discover that these were genuine. Sakhai did not need the letter to resell the original in New York because that work was real. Selling the copy in Japan was safe because Japanese buyers feel shamed when they discover they have been defrauded, and are unlikely to go to the police.

Unfortunately, the buyer of the Gauguin copy consigned the work to Christie's at the same time Sakhai consigned the original to Sotheby's. Sakhai

pleaded guilty to fraud and agreed to repay \$12.5 million to purchasers of copies of works by Marc Chagall, Paul Klee, Marie Laurencin, Gustave Moreau and Pierre-Auguste Renoir, all of which he had sold over a fifteen-year period. Japanese purchasers got to keep the copies, and Sakhai avoided going to jail.

The scam illustrated one of the quiet secrets of the art world; many dealers and auction house officials accept the existence of art fraud so long as it only affects someone else. A few dealers seemed to have been aware that works sold by Sakhai had 'twins' somewhere, usually in Asia, but because the paintings sold in Europe or North America were originals – and were only middle-market works – no one commented.

On a rare occasion a fake makes it past auction house scrutiny and is exhibited and auctioned. Christie's New York accepted and auctioned for \$450,000 a Sakhai copy of Marc Chagall's *Les Mariés au bouquet*. Well after the auction Christie's realized it was a fake and rescinded the sale. Many dealers claimed to have spotted the fake when it hung at the auction preview, and warned clients and each other, but no one was willing to endanger their relationship with the auction house or risk a libel suit by issuing a public warning. With many suspected forgeries, the auction house does not turn the work over to the police art fraud squad, but returns it to the consignor. Returned work sometimes appears later on dealers' walls.

Art historians have always held that an original painting has a special 'aura', invisible but real, which a fake lacks. But if it is not possible for an auction specialist to distinguish the reproduction from the original, or detect the aura, then there must be something besides the aesthetic aspect which makes the original more valuable. Economic theory cannot easily explain why a perfect copy with a different history is so much less valuable than the original. If Sotheby's Gauguin sold for \$310,000, how much would you pay to hang the Christie's version? What is the value of a 'Damien Hirst' spin painting created after hours by his technician Rachel, with Hirst's knowledge but without his inspection or signature?

The concept of authenticity has been very flexible over the centuries. An Old Master painter such as Rembrandt had many apprentice artists at work in his studio. The apprentices prepared the canvas and painted much of the

picture, with Rembrandt doing the face, hands and other difficult features. As long as Rembrandt's hand was responsible for a portion of the total, the work was considered authentic.

The number of Rembrandts accepted as authentic can go up as well as down. A 1632 oil *Portrait of a Young Woman with a Black Cap*, attributed to Rembrandt, was in 1972 rejected by the Rembrandt Project (an authentication group) as the work of an imitator. Its value with that attribution was \$40,000 or less. The painting was cleaned and reanalysed, and in 1995 the Project reinstated it as a Rembrandt. In 2007, *Young Woman* was auctioned at Sotheby's for \$9 million.

Beginning in 1917, Marcel Duchamp reinterpreted the notion of authenticity with the manufactured objects he purchased and signed. The most famous example was *Fountain*, a commercial urinal which was accepted as art when signed 'R. Mutt 1917' by the artist. There are at least three copies of *Fountain*, commissioned by various museums but manufactured by other firms than produced the original. None of the three is an exact copy of the original; art-world legend is that it was thrown out as garbage. Duchamp accepted each of the three copies and signed it. Are the copies authentic because Duchamp signed them, or because of his concept, followed by Damien Hirst eighty years later, that authenticity could be created?

It is often very hard to tell a fake from an original, even when you know it must be fake. Think about the opening scenes of the movie version of Dan Brown's *The Da Vinci Code*. Some scenes were shot in the galleries of the Louvre. The museum would not allow actors Tom Hanks or Audrey Tautou to remove Leonardos from the wall, so those scenes were shot in London. One hundred and fifty paintings from the Louvre were reproduced for the London set, using digital photography. Artist James Gemmill overpainted and glazed each, even copying the craquelure and the wormholes in the frames. When *Madonna of the Rocks* is removed from the wall, the back of the painting shows the correct stretcher placement and Louvre identification codes.

Dealers in Old Masters who saw the movie and were familiar with the originals in the Louvre confess to not being sure which paintings are copies – although they certainly would have known had they been able to see the

copies in person, if only because the paint would have been too obviously 'fresh'. The answer is that every painting in the movie that is touched by Hanks or Tautou is a copy. Paintings that appear only as background in the Louvre are real. What happened to James Gemmill's copies after the scenes were shot? No one will say.

What about the value of a painting being the subject and not the artist? The first picture ever acquired by London's National Portrait Gallery was in terrible condition. It was overpainted, the artist was unknown, and the work had been completed after the subject's death. At any local auction it might today bring £50, yet it is valued for insurance purposes at £10 million. It was for a long time thought to be the only existing portrait of William Shakespeare. It is now believed that the newly discovered Sanders portrait, named after its reputed painter John Sanders, a Shakespeare-era actor, is of Shakespeare – in which case the National Gallery's is not. If that is established, the National Gallery's painting returns to £50, plus a premium for its National Gallery provenance.

Like fake art, stolen art is not always what it seems. The value of stolen art may be greater for the victim than for the thief – if the victim is perceptive or lucky. In 1994 two Turner paintings owned by the Tate Gallery in London were stolen while on loan to the Schirn Kunsthalle in Frankfurt. They were insured for £12 million each. In 1996 the insurance company offered a £24 million settlement. Acceptance of the offer would have meant title to the paintings passed to the insurance company. The Tate hoped the paintings would be recovered, and offered £8 million of the payment to the insurance company to retain title. The insurer accepted, and paid the Tate £16 million net. The Tate next asked permission of the High Court to offer a £3.5 million reward for the return of the art. The High Court agreed; this protected the Tate against later being charged with paying an illegal ransom. The Tate then publicized the reward.

One painting was returned in 2000, the other in 2002, and a reward was paid. Four participants in the theft were sentenced in Germany prior to recovery of the second painting, but the mastermind was never found. The Tate now has its Turners back on the wall, with £12.5 million in its art purchase fund to compensate for the eight years it was without them.

How do you tell a fake from an original? Not by relying on its provenance, which is a very different thing from authenticity. Provenance is the list of a painting's previous owners and the places where it has been displayed, although even that can also be faked. Authenticity – who painted it and when – is determined by expert opinion, physical examination, and sometimes by scientific analysis.

For an older painting, there are two kinds of experts: the connoisseur and the conservator. A connoisseur has long experience with the artist's work, and a highly developed sense of when a painting is 'right'. He looks at colours, texture, and how ears, eyes and fingernails are rendered. The conservator uses black-light examination, and X-ray and pigment analysis, to reveal whether the canvas and paint are consistent with the artist's period. Neither the skills of the connoisseur nor those of the conservator are very useful for contemporary art. The best contemporary forgeries are not stroke-by-stroke transcriptions of a real work, but new compositions, painted with elements of form and content used by the original artist. A Damien Hirst spot painting with the right dot composition, canvas and paints, but new colour combinations, would be hard for either a connoisseur or a conservator to detect.

From art fakes we move to art critics. There is no suggestion that critics are fakes; most are well educated, thoughtful and articulate. But you would expect critics to be important in the overall scheme of contemporary art, and they are not. Why?

Art critics

When I entered the art world, critics had an aura of power; now they are more like philosophers, respected but not as powerful as collectors, dealers or curators.

Samuel Keller, director of Art Basel

One gets tired of the role critics are supposed to have in this culture. It's like being the piano player in a whorehouse, you don't have any control over the action going on upstairs.

Robert Hughes, art critic

drives demand and prices for contemporary art. Critics are closely associated with the world of artists, dealers and art fairs, and might be expected to be major art-world players. They are not. Dealers, auction house specialists and collectors insist that critics have little influence on the contemporary art world – not on artists' success, and certainly not on prices. Why should critics have so little clout, and what role do they play?

There are two very different kinds of art writers. Journalists write for the mass media, while traditional critics write for a specialized audience in small-circulation journals. Art journalists are sometimes employed full time, while critics almost always write freelance, for minimal payment. Glossy art publications like *Art in America*, *Frieze* and *Art Forum* pay as little as \$200 for a freelance review.

Some art journalists have a background in art history, or are working artists. Critics may be university professors, museum curators, former artists, or spouses of artists. While journalists try to remain at arm's length from the art community, critics are often personally involved with the artists they write about. Critics argue that their role is to explain the artist's work – and without personal contact, how could they understand its context and meaning?

You might think that either kind of journalist could make or break the career of an artist. Make, never; break, only rarely. Jerry Saltz, senior art critic of New York's *Village Voice* and three times nominated for the Pulitzer Prize in criticism, states it nicely: 'At no time in the last fifty years has what an art critic writes had less of an effect on the market than now. I can write that work is bad and it has little-to-no effect, and I can write it is good and the same thing will happen. Ditto if I don't write about it at all.'

Other critics who, along with Saltz, are considered influential – Roberta Smith and Michael Kimmelman at the *New York Times*, Richard Dorment of the *Daily Telegraph* and Adrian Searle of the *Guardian* – seem to have the same view of their own impact. It is true that simultaneous support from a critic such as Kimmelman, a museum curator and a branded collector, can jump-start an artist's career, as happened with photographer Richard Prince. But the key part of that consensus is the collector, not the critic.

There is probably one exception to the 'reviews do not matter' rule. In New York it is gospel in the art community that a highly favourable review in the New York Times will sell out a show, and a picture will sell the illustrated painting quickly, over the telephone.

The last make-or-break critic was American Clement Greenberg (1909–94). In the 1950s and 60s he was thought able to single-handedly determine the fate of an artist. Greenberg was most famous for championing Jackson Pollock, after seeing Pollock's first show at the Guggenheim Gallery. He did not discover Pollock – Peggy Guggenheim did – but Greenberg was the first to write praising Pollock's work. His writing was probably responsible for the early success of Willem de Kooning, Helen Frankenthaler and Morris Louis. As a side activity, he organized and curated exhibitions, sometimes for museums, sometimes for dealers, but including only artists of whom he approved.

By the late 1960s the power to influence trends and collector choice had shifted to dealers such as Leo Castelli and Andre Emmerich, and to the branded American collectors who followed them: Victor and Sally Ganz, and Burton and Emily Tremaine. No current art critic has anything like the clout of a Clement Greenberg. The major influence of today's critics is in urging audiences to visit gallery shows of new or developing artists. Even this influence is blunted by readers' recognition that critics are usually unwilling to be critical of new work.

Readers understand that what today's critic is judging is not what they need to know. The public, and most art collectors, equate aesthetic desirability with technical quality. Critics equate desirability with originality or vision. The different approaches exist because critics compete to be hired full time by editors, to have their freelance writing published, or to win approval from university tenure committees. There are a hundred candidates for any critic position at the *New York Times*, the *Daily Telegraph* or a major art monthly. The critic discusses the abstract importance of an artist's work and its uniqueness because she seeks the editor's continued approval, not because she is serving as a guide for art buyers.

Critics can focus readers' attention. It is hard to imagine a more favourable review than the four-page piece on Cecily Brown which appeared in the *Sunday Times* 'Culture' magazine of 16 April 2006, the ultimate in 'happy criticism'. Accompanied by a two-page colour reproduction of one of Brown's paintings, Waldemar Januszczak's review of a show at the Gagosian Gallery began, 'Cecily Brown could be the best British painter around.' With a cohort that includes Damien Hirst, Lucian Freud and Jenny Saville, that is impressive praise for an artist who was previously little known to most readers of the newspaper. Januszczak went on to compare Brown to Monet in that 'the paint ... appears to be moving', and to discuss how well she paints sex.

Did this praise draw thousands of visitors to Gagosian? Hundreds? From this four-page review in a quality newspaper, one gallery official guessed 'Maybe a hundred visitors over the six-week run of the show, three a day. Maybe.' Did it sell any paintings? The show was sold out well before the opening, at £70,000 and up, and the review did not add a single name to the

hundred-strong waiting list. Cecily Brown, and collectors who already owned her work, were no doubt enthused with Gagosian's ability to generate this kind of media coverage from such a prestigious newspaper.

The *Sunday Times* review may have contributed to a separate Brown record. Encouraged by the Gagosian show, its publicity and long waiting list, Charles Saatchi put her 1997 work *High Society* in Sotheby's May 2006 contemporary evening sale in New York. Her work is better known in New York; while born in London, she has lived in the USA for twelve years. Originally purchased by Saatchi for about \$25,000, *High Society* sold to an English buyer for \$968,000, nine times Brown's previous auction record.

The art critic has another function, to help generate advertising revenue for the publication for which he writes. Many art publications will not review a gallery that does not advertise with them. It is common to read a critic's review of Jane Doe's latest show, and a few pages later find a full-page ad for the gallery, often saying simply 'Jane Doe Is Represented By Smith Gallery', with an address, website and phone number. The name of the gallery will already have been mentioned in the review.

Critics' writing fees are sometimes paid in part or in whole by an artist's dealer. The dealer in effect commissions the review, and chooses a critic who is likely to offer favourable comments. The dealer may send payment to the magazine, but more often it is done by purchasing – or overpaying for – an advertisement. The critic may never learn of the dealer's role. Is anyone influenced by these reviews? Again, the artist and current owners of her work would be high on the list.

Critics also write catalogue essays for galleries or second-level auction houses. Christie's and Sotheby's do most of their writing in-house, or commission a signed catalogue essay by an art historian. In writing essays the critic becomes a hired gun, because what he writes must be approved before publication. For many critics, curating exhibitions or advising collectors may produce more influence and generate more income than their critical reviews. These activities also say something about how the role of the critic is viewed. Would any newspaper hire a film critic who organized film festivals, consulted for distributors, or acted as an agent for film producers on the side?

It is not uncommon for a critic to accept a work of art as a token of thanks from an artist he has covered. I asked several critics about this – on the basis that I did not expect a motoring writer to accept a BMW from the manufacturer, or a music critic a trip to La Scala from a concert promoter. Even critics who say they have never accepted a gift defend the practice on economic grounds, and because it is traditional. Most art critics earn less than a movie, theatre or book critic writing for the same publications. And gifts have a long history in the art field. Clement Greenberg not only accepted paintings, most of which he later sold, but took them on the condition that if he later saw one in the artist's studio that he liked better, he could trade in the original gift.

The British critic David Sylvester, Francis Bacon's promoter and biographer, was known for accepting art from those he wrote about – notably from Willem de Kooning. He received one painting from Bacon, which years later he sold. With the proceeds from the Bacon sale, he purchased a furnished home in London's Notting Hill.

The most valuable gift went to an amateur and first-time critic, a writer who never asked for or expected any reward. Jasper Johns gave Michael Crichton, author of *Jurassic Park* and *The Andromeda Strain*, a small painting as a token of thanks for writing the catalogue essay for Johns' retrospective at the Whitney Museum of Modern Art in New York. Crichton's essay may be the most read of all time; it has been republished at least three times, and is available on Crichton's website. Years later, Larry Gagosian offered Crichton \$5 million for the Johns painting and was turned down.

The most shameless artist of all when it came to self-promotion was probably Pablo Picasso. His first show at Ambroise Vollard's gallery in Paris featured portraits of the exhibition's three financial backers, while he gave paintings to the two critics who attended the show and wrote laudatory reviews. After he achieved fame, Picasso wrote cheques to art editors and critics for even the smallest amount, knowing that they would never be cashed, that the recipient would keep the cheque for its signature.

So do critics or auction prices best predict the long-term importance of an artist's work? The answer, as regards modern art, is that the market is a much better predictor than the critic. There are several good studies by David

Galenson, listed at the end of this book, which rank artists by their single highest-priced work. The highest prices go to great artists such as Jasper Johns, Robert Rauschenberg, Cy Twombly and Gerhard Richter, none of whom received uniformly favourable critical reviews for their early work.

Museums

A museum can either be modern or it can be a museum, but it cannot be both.

Gertrude Stein, author

The museum has largely supplanted the church as the emblematic focus of the American city.

Robert Hughes, art critic

artists succeed, museums and their curators matter more – but in ways that are opaque to observers of the art world. The obvious role of museums is as gatekeepers an artist must pass to achieve the highest level of branding. Museums are independent of the market process, so their judgement is seldom questioned. Both the work shown in a museum and the artist are seen as 'museum quality'.

Most collectors of contemporary art would barely recognize the names of those museum officials who influence their collecting and the prices they pay. Norman Rosenthal, Rudi Fuchs, David Elliott, Hans-Ulrich Obrist and Christos Joachimides are five. Who are these people? They are contemporary art curators, who create the high-profile exhibitions that travel to foreign museums. Rosenthal has been mentioned already; he is exhibitions secretary of the Royal Academy of Arts in London. Fuchs is director of Amsterdam's Stedelijk Museum of Modern Art, Elliott is director of the Mori Art Museum in Tokyo. Obrist is co-director of exhibitions at London's Serpentine Gallery, while

Joachimides is a curator at the Athens Art Gallery. These gentlemen select what will be seen – influenced in part by what dealers and artists say about the art, what is written in the *New York Times*, and by the crowds who visit dealer shows and those at minor museums. Or Charles Saatchi curates an exhibition of his newly acquired art at the Royal Academy, and the importance of the art is judged by his attendance figures and press coverage.

The most important museums are the few that are internationally branded, the ones guide books tell you not to miss. In New York there is the Museum of Modern Art and the Metropolitan Museum of Art, in Washington the National Gallery, in Los Angeles the Getty. Paris has the Louvre, Madrid the Prado, London the National Gallery and the two Tates, and Amsterdam the Rijksmuseum. Each features one or more paintings that are world famous – *Mona Lisa* in the Louvre, *Las Meninas* in the Prado, *Nightwatch* in the Rijksmuseum. Each museum has thousands of paintings in its collection, but each is defined by one or two that are essential viewing. The Louvre has found that of the 20,000 people a day who pass by *Mona Lisa*, more than half have come to the museum to see nothing else. The Louvre has now constructed a separate entrance for visitors who want to see only *Mona Lisa*.

Its potential blockbuster status is why Ron Lauder was willing to pay a reported \$135 million in 2006 for Gustav Klimt's 1907 *Portrait of Adele Bloch-Bauer I*, to display in his Neue Galerie in New York. Lauder described his new painting as 'This is our Mona Lisa', a phrase no one else had ever thought of inserting in the same sentence as 'Gustav Klimt'. The purchase price is best described as reported, because it has not been confirmed and a confidentiality agreement included in the sales agreement prevents Lauder from disclosing it. He says there was no negotiation about the price: 'It was just a question of how much it would take to buy it without it going to auction; it took about three seconds.' Lauder also said the price was a record, meaning it beat the \$104 million paid at auction in 2004 for Picasso's *Garçon à la pipe*. Steven Thomas, the lawyer who handled the transaction, says the true price might be higher or lower. It is like Saatchi's sale of the shark; once a high price is reported, no one is motivated to contradict it.

To put \$135 million in context, that is the price of a fully equipped Boeing 787 Dreamliner, an aircraft capable of holding 300 passengers. Does a masterpiece have the same value as a Dreamliner? Or, if you want, should a Dreamliner be compared to an outstanding Gustav Klimt?

Located on Fifth Avenue and 86th Street in Manhattan, in a mansion formerly owned by Grace Vanderbilt, the Neue Galerie shows works of Austrian and German modernism from 1890 to 1940. Opened in November 2001, Neue Galerie needed a blockbuster work to become a guidebook gallery. When Portrait of Adele Bloch-Bauer was on display in Vienna's Österreichische Galeri Belvedere, it was one of many great works, but not the premier attraction. What draws crowds in New York is the painting's status as - if only for a few weeks - the most expensive artwork in history. In the year before Adele went on display, the museum averaged 800 visitors a day. In the three months following the arrival, it averaged 6,000 - and given its capacity of 350 people at a time, that meant frequent forty-five-minute lineups. The gallery tried to capitalize by announcing a special \$50 entry fee on Wednesdays, a ticket that would permit wealthier patrons to avoid crowds. They withdrew the idea in the face of media criticism. The publicity around Adele did succeed in making the Neue Galerie a first-date destination for couples.

Who is the Ron Lauder who finances a museum and pays a record price so it can have a star work? Lauder, sixty-two, is one of two brothers who control 88 per cent of the Estée Lauder Companies, a cosmetic company built by their mother, with \$6 billion in annual sales. Lauder's personal fortune is estimated at \$2 billion. He is a major donor to MoMA, where he was chairman from 1995 to 2005, and a former American ambassador to Austria, where he was prominent in the local art scene. He was also a candidate for mayor of New York; he lost the 2001 Republican primary to Rudolph Giuliani. Coming from a wealthy family permits an early start in the art world; Lauder bought his first Expressionist works by Egon Schiele and Gustave Klimt at the age of fifteen, during his first trip to Vienna. At sixteen he purchased his first van Gogh drawing. His brother, Leonard, is chairman of New York's Whitney Museum of Modern Art, to which he donated \$200 million of modern art in 2002.

Lauder exemplifies the rich, committed collector. Glenn Lowry, director of MoMA, has said: 'Ronald's interest in art is central to his understanding of the world. He collects art 24 hours a day, 364 days a year. He does it with an intensity and intellect that is probably unmatched in the world.' According to Lauder there are three categories of art: 'Oh', 'Oh my', and 'Oh, my God'. He says he collects only the last.

The best example of the successful purchase of iconic works to put a museum on the map was probably the Art Institute of Chicago's acquisition of three famous works: Georges Seurat's *A Sunday on La Grande Jatte;* Grant Wood's *American Gothic,* a portrait of a farmer holding a pitchfork, with his wife beside him; and Edward Hopper's *Nighthawks.* These were acquired between 1926 and 1942, at a time when the Art Institute was at a stage of development similar to that of the Neue Galerie when *Adele Bloch-Bauer* was purchased.

Other blockbuster acquisitions have been much less successful; witness the Huntington Art Museum, which opened in 1928 featuring Thomas Gainsborough's *The Blue Boy*, at the time one of the best recognized paintings in the world. Having trouble placing the Huntington? It is in San Marino, California. Having trouble with San Marino? The Huntington and *The Blue Boy* were not very successful in putting it on the map.

The alternative to purchasing a blockbuster painting, and one preferred by many trustees, is to try and create a branded museum through memorable architecture. This often attracts tourists to view the outside of the museum rather than the collection. The best example is the Guggenheim in Bilbao; another is the Walker Art Center in Minneapolis, designed by Swiss architects Herzog & de Meuron. *Adele Bloch-Bauer* received greater and more sustained publicity than either of these two buildings, but then it cost more than either of them.

Buying the 'Oh, my God' Klimt painting as a museum star mimics the branding ethic found throughout entertainment and culture. Audiences for two decades paid premium prices to hear branded superstars Luciano Pavarotti, Placido Domingo and Jose Carreras sing. Who were numbers four, five and six on the list of great tenors? How much less would you have paid to

hear them? Consumers purchase branded Estée Lauder cosmetics rather than a store brand of comparable quality for one-half the price.

Being branded means a museum must have in its collection the major artists of a particular era, rather than interesting but perhaps more obscure artists from the same period. Branded artists define the branded museum, which in return is obliged to hang branded artists.

What should be the focus of the branded museum? Is it tourists and oncea-year visitors, is it the museum-building role, or is it the task of increasing understanding of modern and contemporary art? Should MoMA focus on tourist-friendly but bland blockbuster shows like 2006's summer show, *Cézanne and Pissarro: 1865–1885*, or should it show the sort of work that Charles Saatchi did in *USA Today*? Glenn Lowry became the best-known museum official in the world by helping choreograph an economic miracle; with New York in a cultural trough after 9/11, he raised \$850 million to move MoMA's collection to Queens, while building what is essentially a new structure over the old. Much of that money was raised by positioning MoMA as a tourist magnet. Could it have been raised by positioning the museum as a site for cutting-edge art, for shows like *USA Today*? Who will show art like that of *USA Today* in the future, if not MoMA or the Neue Galerie? That question provides better understanding of the important role of Charles Saatchi.

Fundraisers for MoMA and other public museums find that donors hardly ever offer a grant towards operations. Rather they give works of art, sponsor travelling exhibitions, or fund a new wing to which their name is appended in gold block letters. Every time a patron donates a work of art with the condition that it must always be on display (never stored), there is one less wall space available for non-donated work. Money rather than curatorial preference dictates some of what you see on a museum wall.

The logic that drives provision of public monies to museums sometimes has little to do with art. The art museum competes for funding with the natural history museum, the zoo, and the municipally owned football stadium. In 1999 Charles Saatchi suggested that part of his collection might be donated to a new British public museum. Tory politician Lord Archer, who is also an art collector, asked publicly whether money could be found to house it. Ken

Livingstone, later mayor of London, said that an aquarium in the East End of London would be preferable because it would have much more impact on tourism. Author Rita Hatton then suggested that Damien Hirst's shark would fill both needs.

The traditional process of building a museum collection was to allow one generation to select the best works of the preceding generation and donate them for the benefit of generations to come. The underlying idea was that collecting art less than thirty or forty years old would reflect fads rather than convey historical significance. When MoMA was founded in New York in 1929, the concepts of 'museum' and 'modern' were still thought to be incompatible.

Today's contemporary art museum purchases avant-garde art shortly after its creation, while it is still affordable, and often shows the same artists as are being sold by dealers down the street. The museum purchasing and showing the work provides the artist with legitimacy – the forty-year test is replaced by the opinion of a curator or a committee. When Alfred Barr purchased three paintings by Jasper Johns for MoMA at Johns' first one-man show and immediately put them on display, the museum created the reputation it was supposed to record – and put a stamp of approval both on Johns' work and on his prices. More recently and dramatically, the Guggenheim purchased the work of painter Alison Fox while she was still a graduate student at Hunter College in New York. Who recommended the purchase? Charles Saatchi, who had just purchased three of Fox's paintings for his own collection.

Many new museums are opened by billionaires to reflect their own taste in art, or to immortalize the family name. This is not a new phenomenon; early museums reflected the collections of Renaissance dukes and popes. More recently the J. Paul Getty collection, the Frick collection and the Barnes collection became the basis for named museums. But for sheer numbers, what is happening in the first decade of the twenty-first century is unmatched. Besides Ron Lauder and Neue Galerie in New York, Bernard Arnault is opening the Louis Vuitton Foundation in Paris, Eli Broad the Broad Contemporary Art Museum at the Los Angeles County Museum of Art, and Alice Walton the Crystal Bridges Museum of American Art in Bentonville, Arkansas. Outside the USA, Joe Bernardo founded the

Bernardo Museum in Lisbon, Bulent and Oya Eczcibasi financed the Istanbul Museum of Modern Art, Joaquin Rivero the Bodegas Tradicion Gallery in Jerez de la Frontera, Spain, Lee Kun-Hee the Leeum Samsung Museum in Seoul, Korea, Victor Pinchuk the Pinchuk Art Centre in Kiev, and Peter Aven the Aven Art Museum in Moscow. These eleven new museums will ultimately account for 8–9,000 works of art, representing the individual passion of billionaires and their advisors rather than the selection criteria of a museum curator.

The museum can influence an artist's career path by accepting a nostrings-attached painting as a donation and immediately flipping it at auction – and yes, it does happen. The painting commands a higher auction price because part of its provenance is 'Consigned by the Chicago Museum of Modern Art'. The donor gets a higher charitable donation, because valuation for tax purposes is based on the gross auction value – hammer price plus commission. The donor may also benefit from higher values for other of the artist's works in her collection. The auction house's other lots benefit from being associated with a work deaccessioned by a branded museum. The museum acquires funds for future acquisitions. If everybody gains, what is the harm? I will leave that question to the reader.

A museum show casts a vote for the artist in another way. The identity of an artist selected for a mid-career retrospective is one of the most sought-after morsels of art-world gossip. If the best thing that can happen to the value of an artist's work is a huge price at auction, the second best thing is a retrospective at MoMA, Whitney, Tate or the Pompidou Centre – which in turn leads to high prices at auction. Museum shows are never announced immediately after the board's decision is made, and – in the hope that the work will be donated later – most museums do not proscribe their directors from buying an artist's work prior to the formal announcement of a show. Directors do buy, and a dealer may offer a substantial discount to a buyer who confides news of a forthcoming museum show. The information can then be passed on to the gallery's best clients. This would be considered illegal insider trading, called 'front-running' in a commodities market, but in the art market it is considered beneficial to all concerned. The artist benefits

from the retrospective, and has her work sanctified by its appearance in a dozen well-known collections.

There is a suspicion that another factor may be at work in the selection of artists for a retrospective. Many public museums ask dealers to contribute to the cost of their artists' exhibitions. Dealers traditionally paid for activities like an opening reception, but now they are often asked to pay for the catalogue, to produce advertising, or to help choose and assemble the art. Curators say that the selection process is so rigorous that deserving artists will always prevail, and that branded dealers are so wealthy it is unrealistic not to permit underfunded institutions to partner with them. But the suspicion remains that the artist with a branded and wealthy gallery is more likely to have his work appear in a museum retrospective.

Now it is easier to understand the total influence of a branded gallery like Gagosian. The gallery has a public relations department to create a positive buzz around an artist, and to generate long articles in the media – think of the Cecily Brown piece in the *Sunday Times*. The publicity causes contemporary art curators to become interested in the artist, and Gagosian offers to sell the best work at a museum discount, with favourable payment terms, or sometimes to present it as a gift. Now the artist is represented in a museum, with no historical test ever having been applied. Later, if a retrospective is a possibility, the gallery may offer to choose and locate art, and supply funding. Ten or twenty years after its first purchase, if the artist has achieved no further critical recognition, the museum can deaccession and sell the work.

Gagosian also tries to control the context in which his artists appear. For each of the artworks illustrated in this book, permission was sought to reproduce both the photograph and the image. Every copyright owner said yes, with one exception. I asked the Gagosian Gallery for permission to use an image by Takashi Murakami. It wanted to know which other artists would be discussed in the same chapter, the size and prominence of the picture, the publisher, the size of the press run – and when I provided answers, it rejected my request.

Should it be considered questionable, or even a form of insider trading, for a museum to use donor funds to purchase art created by one of its own

trustees? In 2006 Tate Modern paid £600,000 for thirteen paintings by Chris Ofili, who at the time was a trustee of the Tate. Ofili is a winner of the Turner Prize who achieved early fame for his paintings, several of which featured elephant dung. The price is a substantial discount from what his dealer, Victoria Miro, would ask from a collector. Both Ofili and the Victoria Miro gallery benefit financially from the status conferred by a Tate acquisition. The purchase details were never made public by the Tate; they were disclosed some time later by the Charities Commission. Sir Nicholas Serota, director of the Tate, argues that secrecy about the Tate's purchases of contemporary art is necessary if dealers are to be encouraged to offer below-list prices. But the question remains: bargain or not, should a museum use donor funds to undertake non-publicized purchases of work created by one of its own trustees?

Do artists or collectors ever exploit the museum exhibition process? In 2006, *The Doomsday*, a work by Huang Yong Ping, was loaned to a retrospective of his work at the Walker Art Museum in Minneapolis, then withdrawn from exhibition prior to going on tour to several other museums. It was immediately consigned to an auction house, the catalogue listing noting its appearance at the Walker. It sold for \$168,000, almost three times its estimate. In the same year, a Milan dealer promised Renoir's *Village Street* for a 2007 travelling exhibition at London's National Gallery, the Philadelphia Museum of Art and the National Gallery of Canada. Prior to any of the museum shows, it was consigned to Christie's London for auction in June 2007. The Christie's catalogue included in its provenance that that the work had been 'promised' to the Philadelphia Museum.

Contrast the \$135 million paid for *Adele Bloch-Bauer* with the \$150 million annual budget of the Museum of Modern Art in New York. In MoMA's budget, only \$25 million is for acquisitions. Of the rest, \$43 million is for curatorial expenses, \$44 million for building expenses and insurance, \$16 million for administration, \$12 million to pay for special exhibitions, and \$10 million for security. The cost of each MoMA visitor is \$50; the admission fee is \$20. Only half the visitors actually pay \$20; half pay less. The \$30 or more shortfall per visitor is covered by profit from the bookstore and gift shop and restaurants,

and by income from MOMA's \$700 million endowment. In a bad month (usually February), MOMA draws 150,000 visitors. In a really good month, when it has a blockbuster exhibition, it draws 420,000. That is why branded museums focus on blockbuster exhibitions.

There is another reason, relating to the economics of their new buildings, why museums seek out touring shows. Museum building may have become a competitive sport among cities, but every new museum brings higher security, insurance and staffing costs. These are not usually covered by increased attendance and admission charges. The ratio of costs related to the building and those related to programs and acquisitions changes. Museums have less money for their own exhibitions, and a greater need for visiting shows.

All art museums face an acquisition crisis as budgets fail to keep pace with escalating prices on the international art market. The National Portrait Gallery in London has often expressed interest in acquiring a Francis Bacon self-portrait, but has little chance because more historically important portraits compete for its limited funding. Museums rely on an acquisition strategy which involves asking for donations of art – and accepting donations from artists. The examples of the artist's work shown are those that the artist wants to have seen. The arbiter of which of an artist's work is important becomes the artist.

Another aspect of the tangled relationship between the museum and contemporary art is the globalization of galleries, in particular the Guggenheim. Of New York's three major art museums, the Guggenheim has the smallest endowment, and no room to expand – it is bordered by Central Park. The Guggenheim has 6,500 works of art, but space to show only one-third of these at a time. One solution was to sponsor seven or eight touring shows each year, to host institutions that paid a fee. But travelling shows are labour-intensive, not very profitable, and risk damage to fragile artwork.

Under director Thomas Krens, the Guggenheim decided instead to expand internationally to leverage its name, art and capital. Krens came to the Guggenheim as an art professor and curator at Williams College in Massachusetts. Of more significance to the Guggenheim board he came with

a Yale MBA. What Krens then did is called franchising – and in his case is sometimes called McGuggenheimization. In 1991 he negotiated a fabulous agreement with the Basque regional government in Spain to build a Frank Gehry-designed Bilbao Guggenheim, in that tourist-forsaken industrial town. In return for a payment of €18 million for licensing and consulting services, the Guggenheim lent Bilbao its name, its administrative experience and art it was currently not showing. The Bilbao government agreed to invest €45 million a year to acquire new art, with purchases to be approved by Guggenheim officials. When Gehry's spectacular Bilbao Guggenheim building opened in 1997 it was an immediate success, drawing a million admissions a year. Eighty per cent of tourists interviewed at Bilbao airport say one reason they have come is to visit the Guggenheim. The success of the Bilbao Guggenheim triggered a craze for global art tourism, with museum architecture suddenly as important as museum content.

Krens has since opened a small Deutsche Guggenheim Berlin in partnership with Deutsche Bank. In June 2006 he signed an agreement for another Frank Gehry-designed Guggenheim Museum in the Saadiyat cultural district of Abu Dhabi, capital of the United Arab Emirates, to open in 2010. At 300,000sq m, it will be larger than the Guggenheim in New York. Abu Dhabi's leaders talk of using the museum to 'brand' the city, of duplicating the 'Bilbao Effect'. As with the other museums, the Guggenheim will receive a one-time fee for the name and an annual licensing fee, and will exercise some control over art purchased by the franchised partner.

Krens has also negotiated to place new Guggenheim franchises in the port area of Rio de Janeiro, in an urban renewal area of Guadalajara, Mexico, and in the centre of Taichung, Taiwan. Each of these projects is currently on hold because of financial constraints. There is a more promising proposal to build in downtown Singapore a museum bigger than that planned for Abu Dhabi.

When the Guggenheim does a show with a living artist, it requests an art donation from the artist – sometimes several pieces – 'so that [the artist] can now have a permanent presence in Bilbao and Berlin'. Every museum anticipates that an artist might offer one of the works that has appeared in a show, but no other museum asks for multiple works, and in advance.

Superstar museums are ever more involved in branding contemporary art and artists; there is a symbiosis in their actions. Branding art is part of the process of branding themselves, which is necessary for their economic survival. As the number of museums increases and they take more contemporary work off the market, the stakes of branding go up.

End game

You're seeing the same kind of consolidation in a number of areas – entertainment, conglomerates, utilities. This is consolidation in art dealing. The auction houses could take over the whole game.

Allan Stone, New York art dealer

The market is a perfect storm of hocus-pocus, spin, and speculation, a combination slave market, trading floor, disco, theater, and brothel where an insular ever-growing caste enacts rituals in which the codes of consumption and peerage are manipulated in plain sight.

Jerry Saltz, art critic

wo QUESTIONS PUZZLED me as I began this journey in the world of contemporary art. Who determines what makes the work of a particular artist sought after? And by what alchemy is a shark sculpture or a contemporary painting worth \$12 million or \$140 million, rather than \$250,000? Why is an easily reproduced stuffed shark, produced by technicians, seen as a good investment by a really smart and experienced collector? A third question arose as I talked to dealers and auction specialists: where are the contemporary art market and its runaway prices going?

The first question turns out to have a straightforward answer, the second a more complex one. The answer to the third is still open, although all trends are unfavourable to dealers.

First, how does a hot artist obtain that distinction? A sought-after artist is one who has already passed several gatekeepers. The artist has been

accepted and shown by a mainstream dealer, and usually moved to representation by a superstar dealer. The artist's work has been cleverly marketed, placed in branded collections and with branded art museums. The work has appeared in evening auctions at Christie's or Sotheby's. It is this process, not aesthetic judgement and certainly not critical acclaim, that defines the hot artist. Damien Hirst obtained his distinction rather differently: first the shock work, the shark, then the branded collector, Charles Saatchi. Then came the branded dealers, White Cube and Gagosian, then the museum show with Saatchi, then the evening auctions.

How does an artist other than Hirst get past these gatekeepers? Most often with work which is big on creativity, innovation or shock value, rather than through traditional skill in draughtsmanship or use of colour. The first stuffed shark attracted more attention and much more money than the thousandth great colour field painting. Marc Quinn's cast of his own head made from his frozen blood, or Marcus Harvey's portrait of child murderer Myra Hindley made with tiny images of a child's hands, attracted more publicity than more conventional art.

How does a work then come to be worth \$12 million, or \$140 million? This has more to do with the way the contemporary art market has become a competitive high-stakes game, fuelled by great amounts of money and ego. The value of art often has more to do with artist, dealer or auction-house branding, and with collector ego, than it does with art. The value of one work of art compared to another is in no way related to the time or skill that went into producing it, or even whether anyone else considers it to be great art. The market is driven by high-status auctions and art fairs that become events in their own right, entertainment and public display for the ultra-rich.

Perceived scarcity also produces inflated prices. It does not have to be real scarcity; it can occur when an artist's primary dealer withholds her work and announces the existence of a queue of high-status buyers. It isn't that anyone believes the artist's work might never again be available, it is a combination of fear that prices will go up, plus the 'I will pay to have it now' approach of the wealthy young collector.

The value of contemporary art also reflects the reality that art history can be rewritten by a buyer wielding a heavy wallet. If a buyer pays \$140 million

for a Jackson Pollock, the work is by definition a masterpiece and the artist belongs on the wall of every status-seeking collector. The next major Jackson Pollock is more desirable if priced at \$141 million than at \$125 million, because its new museum or private owner acquires bragging rights.

Art prices are propelled by what is known in economics as a ratchet effect. A ratchet turns in only one direction, and then locks in place. A price ratchet means that prices are sticky in a downward direction but free to move up. The ratchet concept is easily understood when applied to labour markets – think of what would happen if the board of directors of every art museum required that their chief executive's pay level be in the top quarter of his peer group. The ratchet effect in art occurs when two collectors bid up the auction price of a Matthias Weischer oil to ten times the gallery's list price, and this becomes a new reference price below which no collector wants to sell.

In an auction, a form of ratchet is at work when the first five items sell for double their estimate. The higher-quality items that follow must be worth more, because these lesser works sold for so much more than their estimates. The ratchet also works for the most expensive lots. If the record price for a Mark Rothko has always been twice that for the best Klimt, and a Klimt suddenly sells for more than any Rothko, how much will be paid for the next great Rothko? The answer may be \$73 million – the three-times the previous auction record achieved at Sotheby's in May 2007.

Prices for an individual artist never ratchet down. A Klimt at auction will never sell for much less than comparable Klimts. If there are no bidders at the reserve asked, the auctioneer will chandelier-bid it to the reserve and pass the lot, or it will go to the guarantor. Work by an artist who consistently fails to meet his reserve is no longer accepted for consignment. Ed Ruscha, whose work was in great demand during the 1980s, almost disappeared from major auctions in the 1990s – and disappeared from art price indices. Price collapses aren't recorded in any price indices.

The ratchet effect also holds for dealers, who will not lower list prices for a gallery artist. If the artist's work does not sell at the new, higher price at which it is offered, the artist is dropped. If secondary-market work is sold by a dealer at a low price, neither the sale nor the price is ever publicized.

If the ratchet, perceived scarcity and too much money consistently push prices up, is the entire contemporary art market just a bubble, a form of Dutch tulip craze? Art dealers and auction specialists never use the word crash, and hate the word bubble. The immutable rule in a buoyant art market is that the participants suspend all doubt. The art market is simply referred to as being in an extended boom period. Art writer Marc Spiegler compares this approach to teenagers having unprotected sex in the belief they can never get pregnant.

Bubble or not, every auction specialist warns of a market correction. The question is how hard the landing will be: whether the bubble will burst like a birthday balloon, or just lose a little air and become flabby, like the discarded balloon a month after the party.

There are several good reasons why the contemporary market may not suffer a really disastrous crash. Both economic and artistic trends are favourable. The number of wealthy collectors is probably twenty times larger today than it was before the 1990 crash. At that time, one-third of auction buyers were from Japan, and the Japanese yakuza were buying with money borrowed against highly leveraged property. When the Nikkei share index collapsed and Tokyo property values tumbled, warehouses full of western art emptied onto a market that was not buying. Japanese buyers disappeared, New York buyers were very nervous, and few others remained.

Compare that to the present market, where the boom in trophy art prices reflects both the buoyancy of the financial markets and the concentration of income that has occurred all around the world in the past twenty years. In the UK and USA, the share of income held by the top 1 per cent of the population has doubled since the start of the 1980s. In Italy and France, where the collection of tax from the very rich is more a concept than a practice, the income share of the top 1 per cent has tripled. In Russia, China and India, the share may be fifty times higher.

There are a lot more wealthy collectors around, and since the supply of prestige art is more or less constant, there is steady upward ratchet on prices. In 2007, *Forbes* magazine reported a record 946 billionaires, 415 of those in the United States. There were 176 newcomers including 19 Russians, 14 Indians and 13 Chinese. These are the same people who are buying football

teams and penthouse apartments in London and New York. They are also people for whom alternative investments like art are another form of currency, and will not be dumped. The newcomers pay cash. It would take a sharp drop in both financial and commodity markets worldwide to deter those who pursue property, luxury goods and contemporary art.

First-time art buyers usually begin with modest purchases, but many Russian and Far Eastern buyers now enter the contemporary art market at the very top. The new buyers turn first to auctions, reassured by the reputations of branded auction houses. Foreign buyers entering the western art market are also buying artists with their ears rather than their eyes, and overpaying if others have. Asian and Russian collectors buy a Hirst spin painting or a Warhol silkscreen, because these artists are sought after and confer status in London and New York.

A concern with foreign buyers is their long-term staying power. Will they keep buying if western buyers stop? Will they continue to collect, and stock private museums in their own countries as American and British collectors have?

Another factor is the boom in museum purchases. Four new museums in the United Arab Emirates – the Louvre and Guggenheim in Abu Dhabi, one in Dubai and one in Sharjah, plus a new contemporary museum in Qatar, will between them absorb 400 to 500 works each year for the next ten to fifteen years. Each museum will focus on branded artists, expensive but needing less justification to boards of directors and the news media than work by unbranded artists. Auction houses and dealers are drooling – and opening new offices in the Emirates.

The art market has become very international; after Christie's New York sales in May 2007, auctioneer Christopher Burge said 30 per cent of buyers were Americans, 50 per cent were from the UK, Europe and Russia, and 20 per cent from the Middle East, Latin America and China. This kind of internationalization of the market should protect against a crash. If the dollar is down, the ruble, yen or euro may be up. If the UK economy slows, India and the Emirates may be booming. If contemporary art is seen as an investment category, it will benefit when other investments falter. At the end of the 1990s, when the dotcom bubble burst and share prices fell, everyone assumed that

contemporary art would crash. Instead, prices increased as people shifted money from the stock market into art.

A greater danger than economic reversal may be a rejection of the practice of emulating popular taste that underlies contemporary art buying. Tobias Meyer famously claimed that 'The best art is the most expensive because the market is so smart.' Jerry Saltz responds, 'This is exactly wrong. The market isn't "smart", it's like a camera – so dumb it'll believe anything you put in front of it ... everyone says the market is "about quality", the market merely assigns value, fetishizes desire, charts hits, and creates ambience.' What happens then if group cultural intelligence and connoisseurship go into reverse, and the market realizes all at once that Jim Hodges' *No-One Ever Leaves*, the crumpled leather jacket in the corner of the gallery, might not actually be worth hundreds of thousands of dollars – or even thousands? Is it all a deck of cards that will come crashing down when lots of collectors try to dump work because a few others have?

But so long as popular taste rules, supercollectors drive the contemporary art market as never before. Fifteen years ago it was Charles Saatchi who could make or break an artist. Now, along with Saatchi, it is David Geffen and Steve Cohen and Adam Sender and fifty others. One fear relates to the psychology of so many contemporary art collectors whose fortunes originated in finance and hedge funds. Will people who as traders try to outguess the market do the same when it comes to art? If they anticipate a culture shift or a market decline, will they dump art before the market catches on? When Japanese markets crashed in the late 1980s, banks seized art from about twenty major borrowers who had pledged their collections against bank loans. The first Japanese bank soon dumped art on the international auction market; others tried to follow, but it was soon too late.

There was a sense of foreboding in October 2005 when Steve Cohen paid more than \$100 million for two paintings by Paul Gauguin and one by Vincent van Gogh, purchased privately from Steve Wynn. The concern was not that Wynn was dumping Impressionists; there is no uncertainty about that market. But was Cohen switching into Impressionism and dumping the 1,200 works in his contemporary collection? If Cohen was selling contemporary art, every

other investor wanted to sell right now, not next month. Cohen could have produced a market decline by his own actions – possibly just by offering Damien Hirst's shark for sale.

Similar fears arose when Daniel Loeb, a New York hedge-fund operator who owns about twenty Martin Kippenbergers, was thought to be selling. Market fears were calmed only by the news that Charles Saatchi was buying Kippenberger. If Saatchi had also been thought to be selling, the Kippenberger market might have collapsed. As long-time collectors remember, one contributing factor to the 1990 art-market crash was that Saatchi was going through a divorce and giving up control of his advertising agency, and was selling off art from his personal and corporate collections.

Sales are not a concern as long as the seller's motive is known and believed. In October 2006, David Geffen sold a Jasper Johns painting and another by Willem de Kooning, for a combined \$143 million. A month later he sold Jackson Pollock's *No. 5 1948* for a record-breaking \$140 million. A month after that he sold Willem de Kooning's *Women III* for \$137.5 million. Geffen was seen not as dumping his art collection but as raising funds to bid for the *Los Angeles Times*. The market was unconcerned about the sales, but impressed that four paintings might equal a substantial down payment for a major newspaper.

There is further hope that a crash will be avoided, because high prices for contemporary art do reflect a generational shift. The new generation of collectors want to decorate their homes with postmodern furniture and contemporary art, to establish their own taste rather than following their parents' collecting preferences. 'People just want to own the signs of our times,' says Tobias Meyer. 'Icons are highly visible and recognizable and therefore have the most impact on a new audience that is starting to buy.' People also want their collections to shape how they are seen by their peers, and contemporary art is a lot more, well, contemporary, than are Old Masters.

After offering these arguments with conviction, dealers and auction specialists roll their eyes and shrug when discussing auction prices for individual artists – Warhol or Emin or Kippenberger. There is a sense that much contemporary art – think of the work in the *USA Today* show – is being sold to

a trend-driven market that really will one day dump it, maybe for Chinese contemporary, maybe for nineteenth-century weather vanes. Every dealer seems to have a contingency plan for this eventuality: close the gallery and deal out of an apartment, switch to Old Masters, or enter a monastery.

How will we know if the art bubble bursts? The conventional answer is that the first signal would be disastrous back-to-back sales at Christie's and Sotheby's. One auction failure might reflect mediocre consignments or overly aggressive reserves, a second means a deflating bubble. Auctions are the first and best indicator of what the market is doing because auction prices are transparent and widely reported. The dealer and art fair markets are opaque, and dealers have every incentive to hide low prices.

As soon as buyers think the bubble has burst they pull back. In mid-1990, paintings by Julian Schnabel and Sandro Chia had a long waiting list. By October the list had evaporated and their art was being discounted. By Christmas there were no buyers even at discounted prices. Speculators and most private collectors are the first to disappear from the buying side. Dealers appease their bankers by paring inventory, consigning art to auction houses and offering favoured collectors large discounts on the promise of secrecy. In three months, as leases expire, the first galleries close and inventory from other galleries starts to appear at auction.

The correction process after the 1990 crash was interesting. Galleries remained resistant to lowering list prices on artists they represented, because it meant that the prices charged a few months earlier were not justifiable. Lower prices might have signalled that an artist was out of favour. Faced with a dearth of sales, many artists switched galleries, with tacit agreement from former dealers who understood the logic. Having no previous buyers to appease, the new gallery was able to price their work in line with new market realities.

So where is the art market going? What will the marketing process for contemporary art look like in 2012? One clue comes with the increasing success of auction houses. Amy Cappellazzo, international co-head of Christie's post-war and contemporary art, was reported in 2006 to have described auction houses as 'big box retailers putting the mom-and-pops out of business'. She later claimed to have said 'One can see how auction houses

look like big box retailers trying to put mom-and-pops out of business.' She also marvellously described her job as hostage negotiation, trying to free property for Christie's from its captors.

The dominance of auction houses has forced many dealers to rely on art fairs. Fairs now both drive the market and restructure it. Two hundred and fifty dealers in one place generate a huge crowd and great excitement. Dealers supported art fairs as a way to compete with auction houses, but now they find their gallery sales cannibalized by the same fairs. This is a problem for a dealer who has to absorb the high cost of attending fairs. It is much worse for a dealer outside the charmed 250 who win admission to a major fair. Mainstream dealers who two decades ago might have had ten walk-in visitors a day, today get three or four. They may go a month without a walk-in sale. A few have closed their galleries and now rely on middle-level art fairs and some private dealing.

The change in marketing is changing the process of collecting. First auction houses and then fairs encouraged collectors to bypass dealers. New collectors do not develop the breadth of knowledge that used to be a prerequisite of connoisseurship. They buy what the art consultant or the auction specialist at Christie's or the writer at *Frieze* magazine tells them is hot. Art fairs create more buyers but fewer collectors. Buyers are more detached from the art market, acquire impulsively, and only infrequently set foot in a gallery. Contemporary art becomes a commodity acquired in a shopping centre. Dealers lose more of their traditional role.

The social structure of the collecting community is also changing. Museum groups from Toronto and Milan go to Miami Basel, meet collectors from Beijing, and are exposed to new dealers from London and Berlin – but few from Toronto or Milan. Fairs become the place to find, discuss and purchase art.

Meanwhile, the contemporary art world watches the continued rise of auction houses relative to dealerships. The advances and guarantees offered by auction houses are higher than ever, raising the capital required for a major dealership to compete. A new American dealer who wanted to maintain a back-room selection of work by Stella, Johns and Lichtenstein would today require starting capital well in excess of \$250 million.

For a collector wanting to dispose of a painting, what advantage is there now in giving it to a dealer on consignment rather than taking a guarantee and advance from an auction house, or having the auction house offer it for private treaty sale? Veteran Los Angeles dealer Irving Blum said at Art Basel in 2007, 'If you're a collector and you have something to sell, your first impulse is to go to the auction houses not the dealers because the prices they're getting are unimaginable. The dealers ... hardly get to smell the material.' Dealers' best chance is to put up a lot of capital to purchase a work, or else become resigned to dropping back to handle work on which auction houses do not make offers. Art dealing is ever more a money game.

The scale of capital required to compete at the highest level of the art world was illustrated in 2006 when the Donald Judd Foundation, which oversees the artist's estate, offered twenty-seven Judd sculptures for sale and asked for bids. The foundation wanted a guarantee in the range of \$20-24 million. Six dealers tried unsuccessfully to form a consortium to buy the work. Several others asked to purchase individual sculptures, but were turned down. In the end, no dealer bid. Both Christie's and Sotheby's thought the guarantee level unreasonable; both wanted the consignment and neither wanted to see the other win - which is probably what the foundation was hoping. Christie's offered a reported \$21 million guarantee, marginally more than Sotheby's, and agreed to display the works for five weeks in rented space in New York's Rockefeller Center, complete with an audio tour. They produced an auction catalogue with three new essays, plus previously unpublished texts by Judd. At auction, Christie's sold twenty-four works for \$24.5 million, and made a small profit when the remaining three sold privately. Dealers were shut out.

Auction houses' access to art makes their private dealing even more attractive to consignors. What now happens to the dealers' role of developing artists' careers? Do they focus on their best-selling artists and drop any who do not sell well for two consecutive shows? Does the pressure on mainstream galleries lead to more of these being absorbed by auction houses, as Haunch of Venison was, or to more dealer joint ventures, or to defensive mergers among dealers, resulting in fewer options for new artists? Have auction

houses' guarantees and loans, and now their access to art fairs, completely shifted art dealing from an expert game to a money game?

The next seismic shift may be for Christie's and Sotheby's to follow Phillips and Bonhams and solicit consignment of brand new art that would normally have gone through a dealer. Sotheby's recently sold Barnaby Furnas' Blown to Bits for \$400,000, and said it agreed to take the consignment because had it not, Phillips or Christie's would have. Furnas is represented in New York by Marianne Boesky and in London by Stuart Shave. Could Sotheby's contract to offer all new work by Furnas, or by more established artists like Jeff Koons or Jenny Saville, at biannual auctions, at one-third of the commission asked by their current dealers? An auction house offering to sell the whole output of a hot artist is a scenario that terrifies dealers; the artist would lose some promotion and mentoring, but might find the offer tempting: 'My work sells out, why give my dealer 40 or 50 per cent when an auction house will take 15 per cent or less, and might achieve higher prices?' If the two major auction houses expand their sale of primarymarket art, that would speed the demise of a great many dealers, and signal a permanent change in the ecology of the art market.

The party of the state of the s

Contemporary art as an investment

There are more people collecting for the wrong reasons, basically as the latest get-rich-quick scheme. They buy art like lottery tickets. Mary Boone, art dealer

HY DO COLLECTORS now show such a pronounced interest in contemporary art? In part it is because they respond to the energy of the art of their own generation, as they respond to its music. It is also because so much of earlier art has disappeared into collections and museums, unlikely to be available again for a very long time. The collector's focus on contemporary art and the examples of huge price increases will have led the reader to conclude that contemporary art represents a great investment, whether the collector loves the work, likes it, or does not care.

Even collectors of contemporary art who have acquired works because they love them believe the value of those works will appreciate. They follow auction results as they would stock-market listings. Is a \$12 million shark a good investment? What are the rules for art as an investment? This seems a good question to end the book on.

The answer may not be what you expected. In the overwhelming majority of cases, art is neither a good investment nor an efficient investment vehicle. Most art will not appreciate, and there are high transaction costs, including dealer markups, auction house commissions, insurance and storage costs, value added tax, and capital gains tax when work is sold. Like the stock or bond market, the art market is made up of many separate parts. The value of

Old Masters, as a group, has increased only moderately. There has been falling demand for Victorian pictures and English watercolours over several decades, as there has for antique furniture and silver. Some contemporary art has increased in value since 2000, some has declined.

All art markets are cyclical. In the 1980s, the Impressionist and modern art market seemed unstoppable. Japanese paper mogul Ryoei Saito came to symbolize the boom when he paid record auction prices in 1990 for two Impressionist works. The first, van Gogh's *Portrait of Dr Gachet*, cost \$82.5 million. In inflation-corrected dollars that was until 2006 the most expensive work ever sold. The second most expensive, a week later, was Renoir's *Au moulin de la galette*, for which Saito paid \$78.1 million. Everyone concluded that the market could only go up. A few months later the art bubble didn't deflate, it exploded, as economic uncertainty and the pending war with Iraq paralysed buyers. At Sotheby's Impressionist sale in May 1991, 41 per cent of the lots went unsold. London dealer Ivor Braka said, 'It was not a question of how low the price was pitched; for many works there were no buyers at any price.'

Christie's and Sotheby's launched public relations campaigns, publicizing the benefits of buying in a depressed market. Nothing helped. London dealer Desmond Corcoran described buyer psychology in these terms: 'People have money but they don't want to look stupid by getting back in before prices drop all the way.' New York art critic David d'Arcy said: 'If the news isn't that a gallery has shut down or announced that it will close, one hears that a dealer ... is sitting atop dozens of unsaleable Warhols and Basquiats, praying for a bail-out from somewhere.' Dealers searched unsuccessfully for risk-insensitive buyers, then were pressured by banks to sell on the basis that 'You can have this work on your terms, but only on your solemn promise that you never, ever tell anyone how little you paid.'

The market dropped from an index of 100 in July 1990 to 45 in July 1993, and remained at about that level until July 2001, when it started to climb. It was 2005 before the prices of Impressionist, modern and contemporary art returned to 1990 levels. Even in 2005, one-fifth of the top 100 artists in 1990 had seen the value of their work fall over the previous fifteen years, two-fifths were even; and only two-fifths were up.

So is contemporary art now a good investment? In the case of inexpensive art, the answer is definitely no. Eighty per cent of the art bought from local dealers and local art fairs will never resell for as much as the original purchase price. Never, not a decade later, not ever. Buy inexpensive art if you love it and want to live with it, but not in the hope it will appreciate in value.

How about more expensive art? The preceding chapters offer many examples of art that resold for ten, twenty or fifty times its purchase price. Surely those were good investments. Yes they were, but the very few, hugely profitable resales are the ones that make the news. It is like reading about the one drill hole in forty that finds oil. No newspaper reports on the thirty-nine dry wells.

New York collector Adam Sender is manager of Exis Capital Management, a hedge fund in New York – and before that was a trader for Steve Cohen's SAC Capital. In 2002, Sender travelled to Los Angeles to view a John Currin show at Regen Projects Gallery in Los Angeles, where he purchased six works. Two years later, art writers everywhere reported that Sender had sold *The Fishermen*, a painting bought for \$100,000 at Currin's show, to collector S.I. Newhouse for \$1.4 million. But what is Sender's average return on his total art investment over a five-year period? Actually it is almost certainly very good. Sender has been quoted as saying he has made more money on art than through his hedge fund. He has a personal curator, Tod Levin, and great dealer connections. Sender owns 800 works, including pieces by Richard Prince, Mike Kelley and Andreas Gursky, valued at \$125 million. But no art journalist reports Sender's losers.

Art advisors like to cite the example of Picasso's *Garçon à la pipe*, purchased by John Hay Whitney and Betsy Cushing Whitney in 1950 for \$30,000 and sold at Sotheby's in 2004 for \$104 million. To put that price in context, it was twice the previous record for the artist, the \$55 million paid *for La Femme aux bras croisés* at Christie's New York in November 2000. Over the fifty-four years the Whitneys owned the painting, it increased in value at an average annual rate of 16 per cent. After insurance and other costs the net was about 14 per cent. An excellent return, but for one of the best long-term art investments anyone can cite. Much of the rest of the Whitney collection

showed annual gains of less than 10 per cent. About one-fifth of the Whitney works were auctioned at less than the cost of their acquisition. The entire collection averaged a 7 per cent gain each year after expenses.

An even more successful collection was that of Victor and Sally Ganz, mentioned earlier and auctioned by Christie's New York in 1997. The 115 works sold for \$171 million; they had cost the Ganzes about \$2 million in 1997 dollars, adjusted for inflation. The works had been purchased over a period of fifty-six years, with an average gross rate of return of 12 per cent a year and net of 10.5 per cent, about equal to investing in stocks. The Ganzes were considered brilliant collectors; the *Wall Street Journal* coined the term 'Ganzmania' for the excitement that surrounded the sale of their collection. Their profit history is hardly typical.

The most successful work in the Ganz collection was another Picasso, purchased for \$7,000 in 1941 and sold in 1997 for \$48.4 million. This seems a staggering return. To put that gain in perspective, had the Ganzes invested the \$7,000 in a portfolio of small-company stocks in 1941, the stock would have been worth \$46 million in 1997. If we include insurance costs of about \$4.9 million over the period they held the Picasso, the stock investment would have produced a greater profit. Of course there is no emotional or psychological benefit from hanging stock certificates on your wall. The economist John Picard Stein once tried to quantify emotional or psychological returns and concluded that they were equal to a return on investment in art of 1.6 per cent a year. That makes the art-market investment slightly more favourable than owning stock.

No advisor cites Monet's *Le Grand Canal*, sold at Sotheby's in November 1989 for \$12 million and reauctioned by the same auction house sixteen years later for \$10.8 million. Another example is Edgar Degas's 1922 bronze *Petite danseuse de quatorze ans*. It set the record for a Degas bronze in November 1999 when François Pinault paid \$12.4 million at Sotheby's New York. Another cast of the sculpture came up for auction in February 2004, this one with a more distinguished provenance – it had been owned by US ambassadors Pamela and Averell Harriman. Estimated at \$9–12.5 million, it sold to a single bid at \$5.45 million. Picasso's much-reproduced *Le Clown au singe* sold at Sotheby's New York in 1989 for \$2.4 million, and resold in 1995 for \$827,000.

We never read about the four out of five contemporary works that collectors bring in, and Christie's or Sotheby's, or even Phillips or Bonhams, reject for their evening auctions. Even artists whose work makes it to auction can have short-lived popularity. Fewer than half of the modern and contemporary artists listed in a Christie's or Sotheby's modern and contemporary auction catalogue twenty-five years ago are still offered at any major auction.

What about a collector like Charles Saatchi? He makes a great deal of money purchasing and reselling contemporary art. Saatchi, and a few other collectors who can themselves move the market by purchasing an artist's work, are the exception to the rule that art is not generally a good investment. In his role as a collector, Saatchi is a brand, and his involvement brands an artist's work as interest by Gagosian or MoMA can. In lending work to museums, or including it in a show like *USA Today*, Saatchi creates a valuable provenance. He also has the huge advantage of getting first crack at the new work of many artists. Other collectors compete for what Saatchi did not take.

Even with those advantages, the consensus is that Saatchi loses money on two purchases out of five, earns a moderate profit on two, and makes a large profit only on the fifth. If there are 3,000 works in the Saatchi warehouse, this means 600 big winners, so there are many great stories to report. It also means 1.200 unreported losers.

When writers claim that contemporary art as an investment has outperformed the larger art market over the past quarter of a century, or that contemporary art has done better than gold or UK government bonds, they are usually citing a research study called the Mei/Moses Index. Jianping Mei and Michael Moses are researchers at New York University who have developed an index measuring price trends for art. The Index has a few flaws, the main one being that it measures only paintings which have sold at least twice at auction. The Index does not include work that auction houses have refused to accept for resale, which means that only successful artists – those with rising values at auction – are counted. This is analogous to looking only at stocks from the FTSE 100 or S&P 500 that have increased in value and concluding that investment in shares is a good thing. Because the prices of these are opaque, the Mei/Moses Index does not include private sales, dealer sales, or sales at art fairs.

Mei/Moses also includes auctioned art which fails to reach its guarantee as having been 'sold' to the auction house at the guarantee price. This is technically correct, but hardly reflects a work's real market value. The index is at best a measure of the profitability of highly successful artists, and greatly overstates the return from an ordinary art portfolio.

Mei/Moses and most other art-as-investment indexes do not consider taxation when they calculate the returns to be made from art. They disregard it for the very good reason that investment in the most expensive art is skewed by the existence of tax havens. Superstar dealers and auction houses have branches (or nominal head offices) in Liechtenstein or Zurich or Monaco. Transactions negotiated in London or New York can be finalized in centres where the sale is untaxed, and ownership goes unrecorded. Subsequent sale at a profit can also go unrecorded.

There are investment funds that focus on art as an asset class, just as others invest in property. An early example was Paris's La Peau de l'ours, 'The Skin of the Bear' - so named, it is said, because there was a bearskin wallhanging in the room where the fund was negotiated. (Another version says the name comes from La Fontaine's fable L'Ours et les deux compagnons, about two hunters about to skin a bear.) The story is that in 1904, a French financier named André Level convinced twelve other investors to contribute 212 francs each to purchase 100 paintings and drawings, including very early work by Matisse and Picasso. The investors were able to hang the art in their private homes for the duration of the fund. In 1914 the French art market was booming, and the group decided to sell all their work at the Hôtel Drouot auction house in Paris. At sale, the fund returned four times the original investment; some paintings sold for ten times their acquisition price. The group's timing and fortuitous choice of artists has never been duplicated. The profit was so unexpected that the investors donated one-fifth of their profits to be shared among the artists.

A more fanciful idea was the decision in 1974 by the British Rail Pension Fund's manager Christopher Lewin, to invest about £40 million, or 2.5 per cent of its investment portfolio – the equivalent of £200 million (\$375 million) today – in a collection of 2,425 works of art, from Old Masters to Chinese

porcelain. Lewin wanted to decrease the pension fund's reliance on a sluggish London stock market. Sotheby's was contracted to provide investment advice, with a clause that any sale of art from the fund had to be carried out through the auction house. This imposed higher costs by precluding the pension fund from negotiating consignor discounts.

Sotheby's set up an independent company called Lexbourne in an effort to eliminate any concern about conflict of interest. Both the trade and the press questioned whether Sotheby's could act both as agents for the sellers and as unbiased advisors to the pension fund. However, Lewin and the fund said they were comfortable with the arrangement.

The fund sold its art holdings between 1987 and 1999, a large portion through a 1989 sale that Sotheby's described as 'one of the most important single-owner sales for years'. That sale offered an extreme example of the value of provenance. A fund-owned Old Master print of Albrecht Dürer's *The Madonna and Child with a Pear* was estimated at £10–14,000 and sold in June 1987 for £10,450, with five bidders still active at £9,000. An identical Dürer print – same subject, same condition – was offered a week later at Sotheby's for £4–6,000, and sold for £4,400 – less than half the price of the one with the provenance of the British Rail collection.

The fund earned an annual compound return of 13 per cent, less than the 14–16 per cent it would have earned if invested in the FTSE 100 or S&P 500 over the same period, but slightly more than if invested in bonds. The timing of the sale was pure luck; the fund sold many items near the top of the market. A year later the whole art market had dropped. If the collection had been auctioned then, the annual return would have been less than 5 per cent. Three-quarters of the return came from profits on just twenty-five Impressionist paintings. An amount equal to half the total gain was spent over the life of the fund in advisor and auction fees. The fund was regarded as successful because it allowed British Rail to diversify risk. Only one sector of the collection increased dramatically in value, but no one could have predicted at the start of the fund that Impressionist art would be the great success.

In the late 1990s, UBS, Citigroup and Deutsche Bank set up departments to advise high net worth clients on art investment. Most of their recommended

investments are in Old Masters and modern and Impressionist art, though contemporary art is slowly becoming more popular. The firms recommend investing for a minimum term of ten years. Advisors assist in lending clients' artwork to exhibitions, in order to enhance the value of the work and improve the profile of the client.

Ten art-investment funds were launched between 2005 and 2007. Run by former Christie's and Sotheby's auction house directors and by Wall Street money managers, these securitize art; they bundle an art collection and allow investors to purchase shares in the bundle, in a manner analogous to a mutual fund or a private equity fund. Each fund is targeted at high-asset individuals, pension funds and private banks, who can invest a minimum of \$250,000. Several of the funds intend to identify promising young artists, and purchase enough of their work to be able to control the resale market. Others hope to offer immediate cash to acquire art from sellers coping with debt, divorce or death. A couple of funds plan to hedge the risk in their collections by using share derivatives of luxury goods companies such as the Swiss firm Richemont, or Sotheby's itself. If you don't understand the concept of hedging (by purchasing one asset and selling another), don't even consider trying to emulate this.

There have been a number of art-fund disasters that no one discusses. Between 1989 and 1991, the Banque Nationale de Paris invested \$22 million in a portfolio of sixty-eight French and Italian paintings and drawings. They lost \$8 million when the works were sold in 1998. New York's Chase Manhattan Bank with a \$300 million art fund, Morgan Grenfell with a \$25 million fund and the Japanese Itoman Mortgage Corporation, which invested \$500 million in Western paintings, each lost much of its investment. Each said that its model would have worked with a holding period of twenty to twenty-five years, but no investor was willing to commit funds for that long.

One argument supporting investment in an art fund is the Mei/Moses finding that financial markets and the art market do not move together. When equity markets are falling, investors pull money out of the stock market and invest in museum quality art. The qualifier is 'museum quality', not all artwork. This finding is not of great use to art buyers who pursue nice-but-not-very-expensive paintings.

Another interesting Mei/Moses finding is that big-name artists like Monet, Renoir and Picasso underperform the art market as a whole. Mei and Moses claimed in an article in the prestigious *American Economic Review*, 'If you slice the art market into thirds by purchase price, the work in the top third does not appreciate as much as that in the middle third, and work in the middle third does not appreciate as much as those from the bottom third.' Mei/Moses also concluded that during every armed conflict of long duration during the last century, art indexes outperformed major stock indexes.

So what about the work of Picasso, who might be assumed to have the lowest long-term risk of any artist because of his role in shaping twentieth-century art? Picassos combine the best attributes of investment-quality art. They carry the signature of an artist familiar even to those who know little about art. The work is recognizable from across the room ('Wow, ain't that a Picasso?') and advertises the owner's financial and cultural status. What can be wrong?

What is wrong is the already high prices. At higher price levels there are many fewer potential buyers – which is why the top third in the Mei/Moses Index underperforms. When Picasso's *Dora Maar au chat* sold at Sotheby's in May 2006 for \$95.2 million, becoming the second most expensive painting ever sold at auction, it was described by art critics as a great portrait. But if bought as an investment, *Dora Maar* would have to resell, seven years later, for almost \$200 million, assuming the buyer would settle for a modest 10 per cent annual compounded return after expenses.

Even if *Dora Maar* had been resold a few weeks later, the price would have had to be almost \$110 million to compensate for auction house costs and insurance. Would there be another two collectors ready to purchase this painting? It takes two for a bidding war; one bidder from the previous auction is now the owner and the other dropped out one bid earlier. Of course *Dora Maar* is a trophy piece; one art-market theory is that there will always be bidders for trophy pieces – a major Klimt or Bacon or Johns – and that a record-price trophy is a safer bet than a second-most-expensive trophy. But trophy art might be a foolproof investment only if the buyer can guess which works will still be considered trophies seven years later.

Purchasing a non-trophy work from a lesser-known artist or school of art carries the risk that a decade from now the work will appear so rarely that collectors will have lost any interest in the painter or school. This is happening now with second-level fauvist work by Maurice de Vlaminck, André Derain and Louis Valtat. There are far fewer bidders for each work than was true a decade ago.

Then there is the speculator who has read about John Currin and others whose value has skyrocketed. She spends \$10,000 on the work of a twenty-two-year-old just out of art school with the hope of flipping it at double the price in a year. Good luck. And if the speculator is unhappy at the outcome, think of dealers faced with angry collectors trying to cut their losses by returning artwork, as they would an impulse purchase at Prada.

Who knows what might happen to an artwork in the hands of an investor? One Picasso purchaser announced that he would cut the painting into one-inch squares, selling these at a profit so that 'Everyone can own a Picasso'. Just before his death, Ryoei Saito declared that *Portrait of Dr Gachet* would be cremated with his body. The director of the Van Gogh Museum in Amsterdam pleaded with Saito, declaring that 'a work of art remains the possession of the world at large, even if you have paid for it'. Saito ignored the plea. When he died a few months later, the work was saved by being seized by Saito's creditors.

If you do want to invest in contemporary art for profit rather than to cut it up or burn it, what are the guidelines? Dealers and auction house specialists agree that information-gathering is crucial. Starting an art collection involves a significant investment of time. The first stop should be galleries in a major art centre, London or New York or Los Angeles or Paris. Talk to gallery representatives, ask them to explain artists and their work. If you are treated with disdain, move on to another gallery.

Find newsletters from the art-advisory services of Citibank, JP Morgan and UBS Global Asset Management, many available online. Identify artists who look promising – not new artists, but those whose careers seem to be developing, with a second show at a superstar gallery or a third or fourth at a main-stream gallery.

Another approach is to select and evaluate a mainstream dealer (this step isn't necessary for superstar dealers). Does the dealer have a reputation for promoting her stable of artists? Do art critics regularly review her shows of new work? Do curators come to see work in her gallery? Will she sell to you, or just put you on a waiting list?

Look for work costing from £30,000 to £75,000. Avoid the blockbuster, highest-priced work by an artist, not just because of the 'underperformance of masterpieces', but to diversify risk, the same way you purchase a portfolio of shares rather than investing everything in one company. An investor is almost always better off with ten works at £50,000 by developing artists rather than a single work costing half a million. If the investor buys at auction or on the secondary market from a dealer, he may find an artist's early work, where the rarity value will be high.

If you don't want to simply buy and hold the work for twenty or thirty years (which is what most experts would suggest), then watch the artist carefully. If he goes more than a couple of years without a major gallery show, or is dropped by his gallery and not picked up by one of equal status within three months, sell fast.

And watch price trends. This is easy to do on Artnet, a website that permits you to check on previous auction prices. Most successful artists show a slow price increase in the first phase of their work, a steeply upward price trend in the second, and a flat or downward price trend in the third. Decreasing returns set in, then negative returns. It is an S-shaped curve. You can be told that an artist's work has tripled in value over the past ten years, and that may be true. But it masks the reality that prices peaked two years earlier, have now dropped by a quarter, and that the work now only appears sporadically in secondary auctions. Plot prices as best you can, and when the steep rise ends and the flat phase seems to be starting, sell.

An interesting insight comes from David Galenson, a professor of economics at the University of Chicago who has studied the relative value of paintings. Galenson suggests that there is a pattern that holds for the majority of successful artists. Their most valuable work is produced either early in their career, like Andy Warhol, or very late, like Jackson Pollock. The younger

innovators – think Picasso – are conceptual artists who make a breakthrough by innovating new ideas of painting at an early age. The older innovators – think Cézanne – develop their art though a lifetime of work, with their best recognized contributions coming later as the result of trial and error. This also suggests that for investment purposes, you should ignore older artists because the market will have found them first, and mid-career artists because they will already have had increases in value. The greatest return comes from discovering the innovators, the ones who will help shape art for decades to come. Try first to identify trends, and then identify the young innovators. That is how Charles Saatchi collects.

Several investors claim to have had success by simply mimicking Saatchi's investment choices, even buying work he passed over in the hope that placement in the Saatchi collection will trigger appearances by the artist in mainstream galleries and institutional exhibitions in a year rather than a decade. If you do this, the time to sell is during the artist's first or second exhibition, because Saatchi and most other investors will wait longer. The market may go higher, but it may also collapse if interest in the artist wanes, or if too many works are consigned at the same time.

When you visit galleries and auction houses, do not expect to like very much of the contemporary art you see, and don't be put off by disliking everything in a show – everyone dislikes most of what they see. There is an art-world saying that you have to see hundreds of works you don't like before you begin to understand what you do like. This is a good argument for attending art fairs. Look at a thousand works before you buy anything, and expect to see an additional five hundred for every additional purchase. According to MoMA the average patron looks at a work of art for seven seconds. When you enter an art fair or gallery room, try the 'which one as a raffle prize' approach, or else look around and think 'If I were going to steal one, which would it be?' Most people have thought more about imaginary theft than about connoisseurship. Once you have circled the room, come back and spend thirty seconds looking at the object of your criminal lust and try to understand why you chose it. And when you visit a fair or a gallery, don't look at new art for more than half an hour at a time. You cannot absorb that many images and still make judgements.

If you think you really have the eye to recognize good work – and only if you think so – consider contemporary art by young artists from Russia, India and, most important, China. The most dramatic art trend in mid-2007 was the expanding role and popularity of Chinese art, much of it a commentary on that country's huge social changes. In January 2007, Charles Saatchi created a version of his popular website to cover Chinese art, with chat rooms in both English and Chinese. He is due to open his new London gallery in early 2008 with a show of Chinese art that he owns.

Christie's and Sotheby's have for several years held auctions of modern Chinese art in Hong Kong and Shanghai; some prices have tripled in three years. In 2004 the two auction houses auctioned \$22 million worth of Chinese art; in 2006 it was \$190 million. For 2008 they forecast \$400 million. Western biennales and galleries are showing Chinese artists. Larry Gagosian plans to open galleries in Shanghai and Beijing, not only to show western art but also to attract a stable of the best Chinese artists.

As Chinese art becomes more accepted in the West, demand for it grows in China, If Jackson Pollock is worth \$140 million in New York, what is the worth of an artist of equal importance to twentieth-century China? The answer so far is £2.9 million; the Chinese record was at Sotheby's London in October 2007 for a 1995 canvas Execution, by Yue Minjun, showing four naked men laughing as two other men simulate a firing squad. The bestknown contemporary Chinese artists are Cai Guo Qiang, who won the Golden Lion at the 2005 Venice Biennale, and Beijing-based Liu Xiadong, one of the 'cynical realist' school. Cai's work has reached \$650,000 at auction, while a Liu painting brought \$2.7 million at auction in Beijing in 2007. A section on Charles Saatchi's website lists eight Chinese artists whose work he has acquired. Yue, Cai and Liu are not included. Will Cai or one of the artists acquired by Saatchi be the next Damien Hirst or Jeff Koons and the subject of long waiting lists in western galleries? Will Christie's and Sotheby's in London and New York one day feature more of Cai's work and less Warhol?

With the work of western artists, what kind of painting will appreciate most? There are general rules. A portrait of an attractive woman or a child will do

better than that of an older woman or an unattractive man. An Andy Warhol *Orange Marilyn* brings twenty times the price of an equal-sized *Richard Nixon*.

Colours matter. Brett Gorvy, co-head of contemporary art at Christie's International, claims the grading from most saleable to least is red, white, blue, yellow, green and black. When it comes to Andy Warhol, green moves up. Green is the colour of money.

Bright colours do better than pale colours. Horizontal canvases do better than vertical ones. Nudity sells for more than modesty, and female nudes for much more than male. A Boucher female nude sells for ten times the price of a male nude. Figurative works do better than landscapes. A still life with flowers is worth more than one with fruit, and roses are worth more than chrysanthemums. Calm water adds value (think of Monet's *Water Lilies*); rough water brings lower prices (think of maritime pictures). Shipwrecks bring even less.

Pure-bred dogs are worth more than mongrels, and racehorses more than cart horses. For paintings which include game birds, the more expensive it is to hunt the bird, the more the bird adds to the value of the painting; a grouse is worth three times as much as a mallard. There is an even more specific rule, offered by New York private dealer David Nash: paintings with cows never do well. Never.

A final rule was contributed by Sotheby's auctioneer Tobias Meyer. Meyer was auctioning a 1972 Bruce Nauman neon work, *Run from Fear/Fun from Rear*, which referred to an erotic act. When the work was brought in, a voice from the back of the room complained, 'Obscenity'. Meyer, not known for his use of humour on the rostrum, responded 'Obscenity sells'. Often it does not, but for a superstar artist like Jeff Koons or Bruce Nauman, it does. It did.

Postscript

The Person who first introduced me to the intrigue and complexity of the auctioning of art was Peter C. Wilson, a former chairman, director and master auctioneer at Sotheby's London. Some years ago I was a visiting professor at the London School of Economics. Often at lunch I walked over to Sotheby's to look at pre-auction exhibitions. One day I eavesdropped as Wilson described with great enthusiasm a Georges Braque painting to a French client. After the client moved on, and having been discovered, I introduced myself. Wilson invited me back on several occasions, recounting stories of the auction trade, and of how Sotheby's had obtained consignment of some of the Impressionist and modern art being shown. I attended auctions he conducted, and we talked about them later.

Peter Wilson, known to all as PCW, had attended Eton and read history at New College, Oxford. He was an intelligence officer in MI5 during the war, and served in Washington with Donald Maclean and Kim Philby. His Eton and Oxford background would normally have taken him to Christie's, but somehow he ended up at Sotheby's.

Wilson said auctions were half-theatre, half-gambling, and that was how they should be treated. The most famous PCW auction-as-theatre story recounts how in 1978 he secured consignment of the Jakob Goldschmidt collection of seven Impressionist paintings – a Renoir, a van Gogh, three Manets and two Cézannes. He proposed holding the first invitation-only evening sale in Sotheby's history, where all those attending would wear black tie or evening dress. It attracted 1,400 guests, including Somerset Maugham, Kirk Douglas, Dame Margot Fonteyn, and millionaires Paul Mellon, Henry

Ford II and Florence Gould, the widow of Frank Jay Gould and a famous collector of her time. Goldschmidt later said Wilson had offered a guarantee for his collection, and Wilson never denied it. If so it was Peter Wilson, not Dede Brooks twenty years later, who deserves credit for originating today's guarantee system.

The sixth lot at the evening sale was Paul Cézanne's *Garçon au gilet rouge*, with a reserve price of £125,000. Bidding started at £20,000 and quickly became a duel between two New York dealers, Roland Balay of Knoedler's and George Keller of Carstairs, with Keller representing Paul Mellon. Bidding reached £220,000, double the price then achieved for any modern picture at auction. When Keller offered the final bid, Wilson paused for ten seconds before, with an incredulous expression and in an astonished tone, he finally said 'What, will no one offer any more?' The room was silent, and then erupted in applause, with normally staid dealers and collectors standing on their chairs. The *Daily Mail* described it as 'like a Covent Garden great occasion'. Sotheby's became, for a decade, the place to consign Impressionist art.

During his career, Peter Wilson sold 38,000 paintings. He retired from Sotheby's in 1980, and died of leukaemia in June 1984.

The other great motivation for the book was the publication of *Freakonomics*, the 2005 bestseller by Steven Levitt and Stephen Dubner, who used economics to try to explain everyday phenomena that a great many people had wondered about — as they do when they read about multi-million-dollar auction prices for contemporary art. I have tried to use some economic concepts in the examples I give, without referring to much economic theory. The interested reader will find many insights in basic economic literature.

The material in the book comes from personal interviews and secondary sources. It is not footnoted because the book was intended as a journey of discovery in the economics of contemporary art, not as an academic reference. Following this section is a list of useful internet sites and of background reading specific to each chapter.

Much of the anecdotal material and some of the numbers in the book are single-source stories and facts that many I talked to had heard and retold. Sometimes I would hear a story from a dealer or auction house specialist, and

later see a slightly different version in an old publication. Often a source would say that a figure or story 'sounded right', but would be unable to confirm the specifics. In all single-source material, and particularly in that from the art world, tales are embellished in their retelling, or may simply have always been an urban legend. Did Vincent van Gogh sell only one painting during his lifetime? Did the Francis Bacon triptych come from the family of an artist in the north of England and end up in an Italian collection? Did Damien Hirst's stuffed shark actually bring \$12 million? These are accepted as fact because they are repeated as fact. The material in the book should be treated as illustrative, or as legend that closely mirrors reality. I hope that any errors in reporting do not compromise the central themes of the book. Corrections and clarifications for subsequent editions are invited.

I had generous assistance and encouragement from dealers, auction house specialists, other art-world people, and former executives from each group. They tried to answer my questions, let me look at documents, and introduced me to new sources. Many asked not to be quoted directly, others not to be identified by name or position, which has meant that several of the best tales could not be retold because the source would be too readily apparent. Some people I approached were initially suspicious: 'What is this about, and who else have you talked to?' Having previously talked to Pilar Ordovas at Christie's and Oliver Barker at Sotheby's was usually enough to get me through the next door. Wary of smear jobs, or just too busy to talk to a writer, a few dealers would not return repeated calls or emails, but only a few. I thank everyone who was kind enough not to point out the gaps in my understanding, and who helped contribute to the originality of my writing. I use the term originality in the spirit of the famous comment by American Laurence J. Peter (father of The Peter Principle) that originality is the art of remembering what you hear but forgetting where you heard it.

Many of those I talked with did agree to be mentioned. They are, in alphabetical order: Oliver Barker, Head of Contemporary Art, Sotheby's London; Liz Beatty, Francis Bacon Foundation; David Bellingham, Sotheby's Institute of Art, London; Heinz Berggruen, collector and former dealer and critic; Rhiannon Bevan-John, Christie's London; Harry Blain, Haunch of Venison

Gallery; Beverley Buckingham, Sotheby's; Derrick Chong, Royal Holloway College, University of London; Gerard Faggionato, Faggionato Fine Arts; Larry Gagosian, Gagosian Galleries; Sarah Gilmour, Sotheby's Institute of Art; Julia Macmillan, London artist; Catherine Manson, Head of Public Relations, Christie's Europe; Tim Marlow, White Cube; Deborah McLeod, Gagosian Galleries; Duncan Miller, Duncan R. Miller Fine Arts; Pilar Ordovas, Director of Contemporary Art, Christie's London; Frances Outred, Head of Private Sales, Sotheby's London; Robert Noortman, Noortman Master Paintings; Ian Robertson, Sotheby's Institute of Art, London; Howard Rutkowski, Director, Modern and Contemporary Art, Bonhams London; and Poni Ujlacki, Director of Public Relations, Sotheby's London.

During 2006, when the book was being researched I was a visiting professor at University College London and its Centre for Economic Learning and Social Evolution. I thank Professor Mark Armstrong, who invited me to UCL and supported this venture, and Glen Bowness, for his extensive administrative help. Overlapping my stay in London I served as visiting professor in the business school at Bilkent University in Ankara, Turkey. I am grateful to the university, and particularly to Dean Erhan Erkut, for agreeing to a period to do research in London, free of other commitments.

My great debt is to my wife and partner, Kirsten Ward, for her support in the trials and frustrations of the writing enterprise. Kirsten served as an excellent editor and critic. To whatever extent this book is readable and interesting it is largely the result of Kirsten's editorial efforts. Sincere thanks also to my literary agent Kevin Conroy Scott of A.P. Watt Ltd. in London. Kevin spent many hours encouraging me to write for humans rather than academics, to personalize the work and insert what he called passion – both of which the academic world discourages. My sincere thanks to Natasha Martin, my overworked editor at Aurum Press in London, for her suggestions on organizing the book, to a wonderful and patient editor, Celia Hayley, who suggested a marvellous assortment of improvements in presentation, and to Steve Gove, who provided final copy editing plus a lot of important suggestions.

References

The reader with an interest in the business and economics of contemporary art should begin with three periodicals: Art & Auction Magazine, ARTnews and The Art Newspaper. Art & Auction magazine is published monthly by Art & Auction LLC in New York. It covers the type of contemporary art sold in major evening auctions. ARTnews magazine is published eleven times a year by ARTnews LLC in New York. It covers art-market news and gallery openings. The Art Newspaper is a tabloid, published in London eleven times a year, a combination of news and industry gossip. All three are widely available at magazine shops, or by subscription.

In my personal view, the most interesting writer on art and business is Souren Melikian, a columnist for Art & Auction Magazine and Paris-based art editor of the International Herald Tribune, where he has written a column for forty years. Melikian is also an expert in Persian art and culture. He curated the well-reviewed Louvre museum exhibition Le Chant du monde: L'art de l'Iran safavide (The Song of the World: The Art of Safavid Iran, 1501-1736. It was curated under his full name. Assadulah Souren Melikian-Chirvani), and opened in October 2007. Melikian is known in the auction and art dealer world as 'The Phantom', because no one seems to have his email or phone number. He contacts them, they don't contact him. I often saw him striding in and out of evening auctions but I was unable to arrange a meeting, one of my great disappointments in the process of writing.

Always informed and readable is the writing of Kelly Devine Thomas of *ARTnews*, Carol Vogel of the *New York Times*, Jerry

Saltz, art critic for New York's Village Voice, Anthony Haden-Guest of the Financial Times, and Judd Tully of Art & Auction. My two favourite recent books about art dealing are Richard Feigen's Tales from the Art Crypt and Adam Lindemann's Collecting Contemporary.

Richard Caves' book *Creative Industries* offers unique insights on the economics of art. Dick Caves is an internationally recognized and highly creative professor of economics at Harvard. He said he had the idea for the book twenty years earlier, but he waited until after his retirement to write it, when his reputation for professional seriousness could more comfortably be placed at risk. His reputation emerged intact.

One of the most innovative economists writing on twentieth-century painting is David W. Galenson at the University of Chicago, whose studies are mentioned several times in the book. Most of Professor Galenson's work is hard to access – much is available only in working papers published by the National Bureau of Economic Research in Washington. Some of his work is included in a 2006 book, *Artistic Capital*.

The following suggested reading is related to individual chapters of the book.

Branding and insecurity

Minna Hanninen, Branding: An Examination of Auction House Branding Strategies and Management, London: Sotheby's Institute of Art, 2005.

Robert Lacey, Sotheby's: Bidding for Class,

London: Time Warner, 2002.

Brandon Taylor, *Contemporary Art: Art Since*1970, Upper Saddle River, NJ:
Pearson/Prentice Hall, 2005.

Branded dealers

J.H. Duveen, *Secrets of an Art Dealer*, New York: E.P. Dutton, 1938.

Rene Gimpel, *Diary of an Art Dealer* (translated from the French by John Rosenberg), New York: Strauss and Giroux, 1966.

Art of the dealer

Jenny Bruckmann, *How to Promote Art:*Lessons from the Twentieth Century's Most
Successful Dealers, London: Sotheby's
Institute of Art, 2002.
Adam Lindemann, Collecting Contemporary,
New York: Taschen, 2006.

Art and artists

Richard E. Caves, *Creative Industries:* **Contracts Between Art and Commerce**,

Cambridge and London: Harvard University Press, 2000.

Richard Feigen, *Tales from the Art Crypt*, New York: Knopf, 2000.

David W. Galenson, *Artistic Capital*, London: Routledge, 2006.

Julian Stallabrass, *Art Incorporated: The Story of Contemporary Art*, Oxford: Oxford University Press, 2004.

Damien Hirst and the shark

Jonathan Barnbrook, *Damien Hirst: Pictures From the Charles Saatchi Collection*, New York: Harry Abrams/Booth Clibborn, 2001.

Damien Hirst and Robert Violette (eds), *I Want to Spend the Rest of My Life Everywhere, With Everyone, One to One, Always, Forever, Now*, London: Booth Clibborn Editions, 1997.

Jerry Saltz, 'The Emperor's New Paintings', *Artnet Magazine*, 6 April 2005.

Warhol, Koons and Emin

Victor Bockris, *Warhol: The Biography*, London: Muller, 1989.

Jeff Howe, 'The Two Faces of Takashi Murakami', *Wired*, November 2003.
Robert Rosenblum, *The Jeff Koons Handbook*, London: Thames and Hudson/Anthony d'Offay Gallery, 1992.
Michael Shnayerson, 'Judging Andy', *Vanity Fair*, November 2003.
Kelly Devine Thomas, 'The Selling of Jeff Koons'. *ARTnews*, May 2005.

Charles Saatchi: Branded collector

Rita Hatton and John A. Walker, Supercollector: A Critique of Charles Saatchi, Hong Kong: Ellipsis, 2000. Andrea Urban, Manipulation and the Contemporary Art Market: An Examination of Charles Saatchi, London: Sotheby's Institute, 2003.

Choosing an auction hammer

Florence Alexandre, *Exploring Different Ways Branding Is Used in the Art World*, London: Sotheby's Institute, 2000.

Judith Benhamou-Huet, *The Worth of Art: Pricing the Priceless*, New York: Assouline Publishing, 2001.

Helen Kirwan-Taylor, 'Horror of the Hammer', *Financial Times Weekend Magazine*, 8–9 July 2000).

Robert Lacey, *Sotheby's: Bidding for Class*, London: Little, Brown, 1998. Christopher Mason, *The Art of the Steal: Inside the Sotheby's-Christie's Auction House Scandal*, New York: G.P. Putnam's Sons, 2004.

Auction psychology

Hahn Ahlee and Ulricke Malmendier, 'Biases in the Market: The Case of Overbidding In Auctions', Graduate School of Business, Stanford University Working Paper no. 9, 2006. William Grampp, *Pricing the Priceless: Art, Artists and Economics*, New York: Basic Books, 1989.

C. Hugh Hildesley, *The Compete Guide to Buying and Selling at Auction*, New York: W.W. Norton, 1997.

Helen Perkins, *Hammering the Estimate: An Examination of Consumer Behaviour at Auction*, London: Sotheby's Institute of Art, 2000.

Francis Bacon's perfect portrait

Michael Peppiatt, *Francis Bacon: Anatomy of an Enigma*, New York: Farrar, Strauss and Giroux, 1997.

David Sylvester, *Looking Back at Francis Bacon*, London: Thames and Hudson, 2000.

Auction houses versus dealers

Roger Bevan, 'The Changed Contemporary Art Market: Have Auction Houses Tried To Become Dealers Either By Buying Them Or By Behaving Like Them?', *The Art Newspaper* (2002), available at theartnewspaper.com

Art fairs: The final frontier

Morris Hargreaves McIntyre, *Taste Buds: How to Cultivate the Art Market*, London: Arts Council UK, 2004.

Lauren Smith, Fair Trade: Art Fairs as a Competitive Strategy for Dealers, London: Sotheby's Institute, 2005.

Peter Watson, *From Manet to Manhattan: The Rise of the Modern Art Market*, New York: Random House, 1992.

Art and money

Rand Corporation, *Gifts of the Muse: Reframing the Debate About The Benefits of the Arts*, New York: Wallace Foundation, 2005.
Katy Siegel and Paul Mattick, *Money*, London: Thames and Hudson, 2004.

Andy Warhol, *The Philosophy of Andy Warhol:* from A to B and Back Again, New York, 1975.

Pricing contemporary art

Judith Benhamou-Huet, *The Worth of Art: Pricing the Priceless* (translated by Charles Penwarden), New York: Assouline, 2001.

Louisa Buck, *Market Matters*, London: Arts Council England, 2004.
Otto Velthuis, *Talking Prices: Symbolic Meanings of Prices on the Market for Contemporary Art*, Princeton, NJ: Princeton University Press, 2005.

Fakes

Dennis Dutton, *The Forger's Art: Forgery and the Philosophy of Art*, Berkeley: University of California Press, 1983.

Bruno S. Fry, *Art Fakes – What Fakes? An Economic View*, Institute for Empirical Research in Economics, Working Paper Series, University of Zurich, July 1999.

Art critics

David Galenson, *Painting Outside the Lines*, Princeton, NJ: Princeton University Press, 2006.

David Galenson, Who Are The Greatest Living Artists? The View From The Auction Market, Cambridge: National Bureau of Economic Research, September 2005.

Museums

Bruce Altschuler (ed.), *Collecting the New: Museums and Contemporary Art*, Princeton, NJ:
Princeton University Press, 2005.

James Twitchell, *Branded Nation: The Marketing of Megachurch, College Inc. and Museumworld*, New York: Simon & Schuster, 2004.

Contemporary art as an investment

Orley Ashenfelter, Kathryn Graddy and Margaret Stevens, *A Study of Sales Rates and Prices in Impressionist and Contemporary Art Auctions*, Oxford University Working Paper, May 2003.

William Baumol, 'Unnatural Value: Art Investment as a Floating Crap Game', *American Economic Review*, vol. 76, no. 2, 1986.

Walter Galenson, *Old Masters and Young Geniuses: The Two Life Cycles of Artistic Creativity*, Princeton, NJ: Princeton University Press, 2006.

William Goetzmann, 'Accounting for Taste: An Analysis of Art Returns Over Three Centuries,' *American Economic Review*, vol. 83, no. 5, 1993.

William Landes, 'Winning the Art Lottery: The Economic Returns to the Ganz Collection, *Recherches Economiques de Louvain*, vol. 66, 2000.

Michael Moses and Jianping Mei, 'Art as an

Michael Moses and Jianping Mei, 'Art as a Investment and the Underperformance of Masterpieces', *American Economic Review*, vol. 92, no. 5, 1992.

Art websites

Publications

www.artandauction.com The home of **Art + Auction** magazine, with columns and background material on the art market and auction news. It includes a calendar of events

www.artinamericamagazine.com The home of *Art in America* magazine, which covers artist information. columns and news

www.theartnewspaper.com The home of London's *The Art Newspaper*, which reports on art issues and offers updates online on auction house sales and major exhibitions

www.art-review.com A London-based magazine which covers the art market, exhibitions and events

www.artnews.com The website for **ARTnews** magazine, which claims to be the most read art magazine in the world. It covers artmarket news, gallery openings and related topics

www.artforum.com Content and back issues of **Artforum** magazine, with art-market news, columns and reader comment blogs

Auction houses

www.christies.com The home site for Christie's international auction operations

www.sothebys.com The home site for Sotheby's international auction operations

www.phillipsdepury.com The home site for Phillips de Pury international auction operations www.bonhams.com The home site for Bonhams international auction operations

Museums and art fairs

www.moma.com Exhibitions and information for the Museum of Modern Art, New York

www.tate.org.uk Exhibitions and information for the four Tate museums in the UK

www.warhol.org Website of the Andy Warhol Museum in Pittsburgh

www.TEFAF.com Website of the TEFAF Maastricht fair

www.artbasel.com Website for the Art Basel and Art Basel Miami Beach fairs

www.friezeartfair.com Website for London's Frieze Art Fair

Art selling sites

www.saatchi-gallery.co.uk/yourgallery Charles Saatchi's website for artists to post CVs and display and sell art

www.saatchi-gallery.co.uk/stuart Charles Saatchi's website for student artists to post CVs and display and sell art

www.artbank.com An intermediary site bringing buyers and sellers of art together

www.britart.com A selling site for British artists

www.artquest.com A site for the buying and selling of art

www.saffronart.com An online website for galleries on the Indian subcontinent

Databases

www.artnet.com An art price database, an auction house and gallery directory, and an online magazine

www.artprice.com Auction price information, indices and artist information as well as a marketplace for buying and selling art

www.artmarketresearch.com A subscription site with art price indices

www.art-sales-index.com A fee-based database of auction results over a fifty-year period

www.groveart.com A subscription-based site with information on the visual arts. It includes Oxford University Press's 34-volume *Dictionary of Art, and the Oxford Companion to Western Art*

www.meimosesfineartindex.org, A fee-based site offering the family of Mei/Moses art indexes

Art images

www.artres.com An archive of art resources and fine art images, and a site which licenses the reproduction of images on a fee basis

General sites

www.artinfo.com Art news, exhibition information and featured artists

www.artfacts.net Information on artists, exhibitions and galleries

www.artsandbusiness.org Website of the Arts & Business Council, Inc. of New York

www.artscouncil.org.uk/ownart The British Arts Council's *Ownart* purchase scheme

www.bcainc.org Website of the British Council for the Arts, Inc., which works to bring business and the arts closer together

www.chubbcollectors.com/Vacnews/index Articles relating to art, collecting and insurance

Photo credits

Green and wrinkled and twelve million
Damien Hirst, The Physical Impossibility of
Death in the Mind of Someone Living (1991),
copyright Damien Hirst, photo Antony
Oliver, courtesy Jay Jopling/White Cube
(London)

Huma Bhabha, *Untitled* (2006), clay, plastic, wire, wood, courtesy of Saatchi Gallery, London and ATM Gallery, New York

Branding and insecurity

Christopher Wool, *Rundogrundogrun* (1990), copyright Christopher Wool, courtesy of the artist, Luhring Augustine New York, and Christie's Images Limited.

Branded auctions

Mark Rothko, White Center (Yellow, Pink and Lavender on Rose) (1950), courtesy of Sotheby's New York

Jean-Michele Basquiat, *Untitled* (1981), courtesy of Sotheby's New York, copyright ADAGP, Paris and DACS, London 2007*

Francis Bacon, **Study from Innocent X** (1962), courtesy of Sotheby's New York. Copyright Estate of Francis Bacon/DACS 2007

Damien Hirst, *Lullaby Winter* (detail) (2002), copyright Damien Hirst, courtesy of Christie's Images Limited and Jay Jopling/White Cube (London)

Damien Hirst and the shark

Damien Hirst, *Instrument Calibration for Beagle Lander* (2002), copyright Damien
Hirst, courtesy of European Space Agency
and Jay Jopling/White Cube (London)

Damien Hirst, *For The Love of God* (2007), copyright Damien Hirst, photo Prudence Cuming Associates Limited, courtesy of Jay Jopling/White Cube (London)

Warhol, Koons and Emin

Andy Warhol, *Small Torn Campbell's Soup Can* (*Pepper Pot*) (1962), copyright The Andy Warhol Foundation for the Visual Arts, Inc./DACS London 2007. Trademarks licensed by Campbell Soup Company. All rights reserved. Courtesy Christie's Images Limited

Drexel Burnham Lambert Commercial (1986), courtesy of TBWA Chiat New York

Tracey Emin, *Limited Edition Bag for Longchamp Paris*, courtesy of Laure Le
Cainec, Longchamp Paris

Jeff Koons, **New Hoover, Deluxe Shampoo Polisher** (1980), copyright Jeff Koons, courtesy of Jeff Koons LLC

Jeff Koons, *Pink Panther* (1988), copyright Jeff Koons, courtesy of Jeff Koons LLC

Jeff Koons, *Puppy* (1992), copyright Jeff Koons, installed in Rockefeller Center, New York, courtesy of Jeff Koons LLC

^{*}For all DACS credits, the author has paid DACS visual creators for the use of their artistic works.

Charles Saatchi: Branded collector

Tracey Emin, *My Bed* (1998), copyright Tracey Emin, photo Stephen White, courtesy Jay Jopling/White Cube (London)

Francis Bacon's perfect portrait
Francis Bacon, *Three Studies for a Self-Portrait* (1982), courtesy of Christie's Images Limited, Copyright Estate of Francis

Bacon/DACS 2007

Francis Bacon, *Post-War (Eve)* (1933), courtesy of Christie's Images Limited. Copyright Estate of Francis Bacon/DACS 2007

Index

20: 50 (Wilson) 95 1947 White (Warhol) 82

Abortion: How It Feels Now (Emin) 91

Abrahams, Ivor 5 Abts, Tomma 200

Accatone (Schnabel) 98-9

Ackermann, Franz 43

Acquavella Gallery (New York) 84

Adele Bloch-Bauer (Klimt) 177

Adele Bloch-Bauer II (Klimt) 178

Afrodizia (Ofili) 97

Agnew, Julian 30 Albrecht, Lothar 41

Almost (Pierson) 24

Altmann, Maria 177, 178

American Gothic (Wood) 236

Ammann, Thomas 30, 85

Andre, Carl 43

Andre Emmerich Gallery 179, 210

Anthony d'Offay Gallery 46

Antonini, Janine 43

Approach, The 43

Architect's Home in the Ravine, The (Doig)

25, 127

Armory Show 190

Arnault, Bernard 11, 101, 106, 190

Arnault, Hélène 101

Art Basel 53, 168, 185, 186-7, 190, 191

Art Basel Miami Beach 186, 190, 191-2, 212

Art in America (exhibition) 205-6

Astrup, Hans Rasmus 87

Au Moulin da la Galette (Renoir) 258

Auerbach, Frank 140, 148-9

Augustine, Luhring 43, 48, 193, 216

Bacon, Francis 25, 35, 38, 60, 67, 117, 118, 119, 161–72, 176, 191, 207, 212, 231

Baigneur et baigneuses (Picasso) 157

Baker, Samuel 105

Baldessari, John 42

Baldwin, Matthias 90

Balincourt, Jules de 6

Balloon Dog (Koons) 87

Barker, Oliver 73-4, 126

Barney, Matthew 43, 59

Barr, Jaspar 34-5

Basketball (Hammons) 178-9

Basquiat, Jean-Michel 25, 59, 60, 149, 191,

213

Bathers (Gauguin) 183

Beckham, David 72

Beston, Valerie 140, 150, 165-6, 167

Beuys, Joseph 60

Beyond Belief (exhibition) 76

Bhabha, Huma 6

Bickers, Patricia 97-8

Big White Clock (Koh) 6

Bird in Space (Brancusi) 62

Bischofberger, Bruno 99

Bitforms 42

Black, Debra 101

Black, Leon 101

Blain Fine Arts 46

Blain, Harry 30, 42, 46, 74, 180

Bleckner, Ross 48

Blood of Christ, The (Hirst) 70

Blown to Bits (Furnas) 255

Blue Boy (Gainsborough) 32, 236

Blue Jacket (Modigliani) 204

Blum, Irving 35, 80-1, 182-3

Boisvert, Clinton 11-12

Bond, Alan 154

Bonhams 103, 107-8

Boone, Mary 29, 48, 50-1, 213, 257

Braka, Ivor 258

Brancusi, Constantin 14, 62, 87, 156

Brener, Aleksandr 201-2

Broad, Edythe 101

Broad, Eli 81, 101, 141-2, 177-8, 191

Brooks, Diana (Dede) 105, 121, 134, 174, 272

Brown, Cecily 229-30

Brown, Gavin 43

Burden, Chris 37

Burge, Christopher 126, 134-5

Button, Virginia 74

Camden Theatre in the Rain (Auerbach) 149 Dollar Sign (Warhol) 82 Campbell's Soup Cans (exhibition) 80-1 Dolman, Ed 108-9, 180 Cappellazzo, Amy 141, 252-3 Dora Maar au chat (Picasso) 61, 119, 120, Cardplayers, The (Cézanne) 183 139, 140, 265-6 Castelli, Leo 34-6, 38, 46, 48, 80 Dorment, Richard 228 Cattelan, Maurizio 59, 60 Dumas, Marlene 198 Cavalier devant la case (Gauguin) 57 Dunphy, Frank 76, 202 Celebration series (Koons) 88 Durand, Asher 181 Cézanne, Paul 33, 34, 57, 153, 162, 183 Dürer, Albrecht 263 Chagall, Marc 223 Duveen, Joseph Henry 32-3 Chapman, Dinos 76 Chia, Sandro 36, 99, 252 Edelman, Asher 85 Christie's 9, 10, 11, 13, 15, 20-1, 24, 57, Edlis, Stefan 62 58-9, 61, 62, 84, 88, 103-7, 108-11, Electric Chair series (Warhol) 84-5 113-16, 117-19, 121, 122-4, 126-7, Emin, Tracey 39, 42, 90-1, 95 131, 132, 133-5, 140-1, 147-9, 150, Emmerich, Andre 29, 210-12 151, 153, 154-7, 158, 161-72, 174, 175, Esterow, Milton 219 176, 178, 179-80, 181, 182-4, 219-20, Everyone I Have Ever Slept With (Emin) 90-1 252-3, 254, 255, 258 Excerpt Regimen (Mehretu) 215 Cirincione, Janine 49 Close, Chuck 43 F*** the Police (Snow) 6 Cohen, Cherryl 101 FA Projects 41 Cohen, Frank 101 Fabricant, Andrew 172 Cohen, Michel 123, 124 Faggionato, Anne 74 Cohen, Steve 2, 3-4, 61, 62, 69, 70, 84, 101, Faggionato Fine Arts 38 153, 167, 183, 190, 250-1 False Start (Johns) 62 Coles, Sadie 42 Feigen, Richard 130 Collins, Phil 200 Feldman, Ron 30 Cooper, Paula 43 Ferre, Don Luis 126 CRACKHEAD (Koh) 6, 12 Ferus Gallery (Los Angeles) 80 Cubi XXVIII (Smith) 62 Fischl, Eric 48, 176-7, 213 Currin, John 39, 42, 259 Fischli, Peter 60 Fishermen (Currin) 39, 259 Damien Hirst: The Elusive Truth (exhibition) 72 Five Deaths (Warhol) 81-2 Davidge, Christopher 106 Flaming June (Leighton) 126 Dead Shark Isn't Art, A (Saunders) 69-70 Flavin, Dan 3, 204 Death of God, The (exhibition) 70 For the Love of God (Hirst) 75-6, 196 Diamond, Hester 156 Four Race Riots (Warhol) 84 Dick Tracy and Sam Ketchum (Warhol) 84 Fox. Alison 238 Diebenkorn, Richard 60 Fraad, Daniel 122-3 Dine, Jim 34 Fraad, Rita 122-3 d'Offay, Anthony 30, 46 Fragile Truth, The (Hirst) 74 Doig, Peter 25, 42, 43, 127 Frank, Natalie 50

Freedman, Carl 68
Freeze (exhibition) 68, 94
Freud, Lucian 60
Freud, Matthew 73
Frick, Henry Clay 33
Friedman, Tom 37–8, 43
Frieze 186, 190, 192–3
Fright Wig (Warhol) 85
Fuchs, Rudi 233–4
Fugue (Kandinsky) 204
Full of Love (Hirst) 74
Furnas, Barnaby 255

Gaborit, Jean-Rene 205
Gagosian, Larry 2, 3, 13, 20, 29, 31, 36–9, 41, 42, 43, 48, 50, 52, 72, 73, 84, 85, 114, 116, 135, 136, 167–8, 169–70, 202, 207, 212, 216, 231, 269
Gainsborough, Thomas 32, 236
Galenson, David 231–2
Gambler (exhibition) 68–9
Ganz, Sally 260
Ganz, Victor 260

153, 259 Gauguin, Paul 33, 53, 57, 183, 219–20,

Garçon à la pipe (Picasso) 61, 113-14, 136,

222–3 Geffen, David 35, 62, 84, 251 Gehrer, Elisabeth 177

George Dyer Staring into a Mirror (Bacon)

167
Gill, A.A. 75
Gimpel, René 45
Gladstone 43
Gleadell, Colin 171–2
Glimcher, Arne 174, 196
Glimcher, Marc 42, 211
Gober, Robert 59
Goldschmidt, Jacob 121
Gonzalez-Torres, Felix 15–16, 59

Goodman, Marian 43 Gorvy, Brett 113 Graff, Laurence 141 Green Car Crash (Burning Car 1) (Warhol)
25–6, 62, 84
Green, Richard 116
Greenberg, Clement 228, 231
Grider, Logan 50
Griffin, Anne 62
Griffin, Kenneth 62, 183
Guggenheim Museum 11, 13, 16, 53, 88, 204, 205–6, 238, 242–3
Guidecca, La Donna della Salute and San

Guidecca, La Donna della Salute and San Giorgio (Turner) 62 Gursky, Andreas 43, 59, 60

Halley, Peter 50

Hammer and Sickle (Warhol) 82

Hammons, David 42, 50, 59, 178–9

Harris, Nelson 122

Harvey, Marcus 96

Hashiyama, Takashi 127–8

Haunch of Venison 30, 42, 46, 74, 116, 180, 216, 254
Hauser and Wirth 42

Helman, Joseph 35 Hennessy, Louis Vuitton Moet 106 High Society (Brown) 230 Hildesley, Hugh 135

Hirst, Damien 1–4, 11, 12, 13, 17, 26, 36, 37, 39, 42, 43, 48, 59, 60, 67–77, 89, 93, 94, 95–6, 97, 117, 119, 167, 195, 196, 202, 220, 246

Hislop, Vic 69, 70 Hockney, David 60, 114, 163 Hodges, Jim 24

Holy Virgin Mary, The (Ofili) 97

Hope, Ashley 50

Hopefully, I Will Live Through This With a Little Bit of Dignity (Pylpchuk) 6

Hopper, Dennis 80 Hopper, Edward 236 Horan, Vivian 62 *House* (Whiteread) 200

Houses (With Mountains) (Schiele) 178 Hoving, Thomas 57, 219, 222 Howard, James 98 Howard, Rory 139 Hughes, Frederick 83 Hughes, Robert 89, 227 Huntingdon, Arabella 32 Huntingdon, Henry 32

I... I'm Sorry (Lichtenstein) 141–2
IKB 234 (Klein) 58–9
Irises (van Gogh) 154–5
Ishibashi, Kanae 128
Isolated Elements Swimming in the Same Direction for the Purposes of Understanding (Hirst) 72
Ivanishvili, Boris 127

Jack Tilton Gallery 49–50
Janis, Sidney 22
Januszczak, Waldemar 6, 229–30
Joannou, Dakis 101
Johns, Jasper 16–17, 34–5, 48, 60, 61, 62, 71, 166, 183, 231, 238, 251
Jopling, Jay 13, 39–40, 94, 214
Judd, Donald 25, 60, 204, 254
Julia Sleeping (Auerbach) 140

Kallir, Jane 30 Kallir, Otto 30 Kandinsky, Wassily 157, 204 Kapoor, Anish 42 Karp, Ivan 46 Kawara, On 14-15 Keller, Samuel 227 Kelley, Mike 37, 59 Kelly, Ellsworth 11, 43 Kennedy, Jonathan 73 Kimmelman, Michael 12, 228 Kindred Spirits (Durand) 181 Kippenberger, Martin 59, 60, 98, 251 Kiss, The (Brancusi) 156 Kiss, The (Klimt) 177 Klein, Yves 58-9 Klimt, Gustav 61, 62, 168, 177, 178, 234, 247 Kline, Franz 157
Koh, Terence 6, 12, 190
Kooning, Willem de 35, 37, 60, 61, 62, 157, 231, 251
Koons, Jeff 13, 24–5, 37, 42, 43, 59, 60, 86–90, 115, 184
Kravis, Henry 84
Krens, Thomas 242–3

Kunsthaus Museum (Bregenz) 69

L&M Arts 31, 182 La Route à Luveciennes (Monet) 122 La vallée de la Seine aux Damps, jardin d'Octave Mirbeau (Pissarro) 162 Lacev. Robert 13 Lambert, Yvon 41 Lash, Stephen 178 Lauder, Ron 168, 234, 235-6 Le Fils du concierge (Modigliani) 57 Lehman, Robert 121 Lehmann, Jean-Pierre 214-15 Lehrman, Robert 138 Leighton, Frederic 126 Levin, Todd 97 Levy, Dominique 124 Lewis, Joseph 101 Lichtenstein, Roy 35, 60, 85, 141-2 Lindemann, George L. 101 Lisson Gallery 42, 203 Little Electric Chair (Warhol) 83 Liz series (Warhol) 182-3 Loeb, Daniel 251 Logan, Kent 101 Logan, Vicki 101 Loren, Sophia 171 Louckx, Roberta 23 Louis, Morris 210, 211 Louvre 205, 234 Lover Boys (Gonzalez-Torres) 15 Lowry, Glenn 236 Lucas, Sarah 42

Lucifer (Pollock) 183

Lullaby Spring (Hirst) 70-1

Lullaby Winter (Hirst) 26, 71 Luxembourg, Daniella 106 Lybke, Gert 215–16

Maastricht art fair 186, 188, 189-90

Maclean, Alice 128

Maclean, Flora 128

Maclean, Nicholas 24, 128

Madonna and Child with a Pear (Dürer) 263

Madonna of the Pinks (Raphael) 63

Maison dans la venture (Cézanne) 162

Makos, Chris 82

Man Carrying a Child (Bacon) 167

Marden, Brice 36

Marks, Matthew 43

Marlborough Fine Arts 165-7

Marlow, Tim 30

Marx, Karl 19

Matisse, Henri 122

Mehretu, Julie 214-15, 218

Melikian, Souren 79, 124-5

Mellon, Andrew 33

Metropolitan Museum of Art (New York) 33, 69, 91, 165

Meyer, Tobias 22-4, 49-50, 61, 118, 120,

126, 134, 136, 137, 250, 251, 270

Michael Jackson and Bubbles (Koons) 87

Miro, Victoria 42, 65

Mitchell Innes & Nash 31

Mnuchin, Robert 182

Modigliani, Amedeo, 57, 204

Mondrian, Piet 36-7, 156

Monet, Claude 122, 124, 162

Morgan, J.P. 33

Monk I (Schiele) 178

Morosov, Ivan 33

Morrissey, Paul 82

Mother and Child, Divided (Hirst) 75

Murakami, Takashi 43, 59, 60, 240

Musée d'Art Moderne (Paris) 21, 23

Museum of Modern Art (MoMA) 4, 13, 34–5, 80, 86–7, 133, 165, 236, 238, 241–2

My Bed (Emin) 90, 95

My New Home (Grider) 50 Myra (Harvey) 96

National Gallery (Washington) 21, 23, 33

Natural History series (Hirst) 70

Nature morte au melon vert (Cézanne) 57

Nauman, Bruce 60, 270

Neumeister, Michaela 186

New Hoover, Deluxe Shampoo Polisher (Koons)

24-5, 87

New York/Boogie Woogie (Mondrian) 156

Newhouse, S.I. 36-7, 39, 101

Nighthawks (Hopper) 236

No. 5 1948 (Pollock) 61, 62, 251

No-One Ever Leaves (Hodges) 24

Noble, Tim 95

Noortman Master Paintings 179

Noortman, Robert 179

Norman, David 120

Nosei, Annina 36

Ofili, Chris 11, 42, 95, 97, 241

Oldenberg, Claus 34

Oliviers et palmiers, vallée de Sasso (Monet)

162

One Dollar Bills (Warhol) 157

Orange Marilyn (Warhol) 84, 118-19, 140-1

Orestes (de Kooning) 157

Ordovas, Pilar 163

Outred, Francis 127

Ovitz, Michael 17, 50, 183

Oxidation Paintings (Warhol) 85

PaceWildenstein 31, 42, 43, 48, 174, 189, 211

Paik, Nam June 205

Painter, Patrick 41

Paley, Maureen 42

Panter, Matthew 51

Parkinson, Eliza Bliss 21-2

Paumgarten, Nick 67

Peasant Woman Against a Backdrop of Wheat

(van Gogh) 62, 183

Pêches (Monet) 162
Pepper Pot (Warhol) 81
Peppiatt, Michael 162, 163, 168
Perelman, Ronald O. 101
Phillips de Pury 103, 106–7, 148, 164, 178–9
Physical Impossibility of Death in the Mind of
Someone Living, The (Hirst) 1–4, 12, 36, 69–70, 74, 77, 93, 94
Picasso, Pablo 33, 61, 113–14, 119, 136

Picasso, Pablo 33, 61, 113–14, 119, 136, 139, 153, 157, 259, 260, 265–6

Pierson, Jack 24

Pinault, François 74, 101, 108

Pincus-Witten, Robert 89

Pink Panther (Koons) 87-8

Pissarro, Camille 53, 162

Pollock, Jackson 61, 62, 183, 220-2, 228, 251

Ponti, Carlo 171-2

Porter, Mark 61, 178

Portrait of a Young Woman with a Black Cap (Rembrandt) 224

Portrait of Adele Bloch-Bauer I (Klimt) 61, 62, 168, 177, 234, 235

Portrait of Adele Bloch-Bauer II (Klimt) 62 Portrait of Dr Gachet (van Gogh) 61, 258, 266

Post War (Eve) (Bacon) 170

Price, Richard 228

Prince, Richard 42, 43, 59

Provincetown II (Kline) 157

Puppy (Koons) 89-90

Pury, Simon de 106, 107, 126

Pushkin Museum (Moscow) 34

Pylkkanen, Jussi 126, 132, 133–5, 138, 151, 168, 169–70

Pylpchuk, Jonathan 5-6

Quinn, Marc 97

Rales, Mitchell 101

Raphael 63

Rauschenberg, Robert 11, 34, 43, 60, 85, 146

Ray, Charles 59

Re-Object (exhibition) 69

Red Butt (Koons) 88

Red Liz (Warhol) 141

Rembrandt 223-4

Renoir, Pierre-Auguste 258

Resting in the Garden at Argenteuil (Monet)
124

Return of the Real, The (Collins) 200

Richter, Gerhard 10, 43, 60, 164

Ritman, Joost 179

Rockefeller, David 21-3

Rockefeller, John D. 33

Rosen, Andrea 39, 216

Rosenthal, Norman 5, 68, 96

Ross, Clifford 43

Rothko, Mark 21-4, 62, 109, 149, 195-6, 247

Royal Academy of Arts 4, 7, 96

Run from Fear/Fun from Rear (Nauman) 270

Rundogrundogrun (Wool) 11

Ruprecht, Bill 106, 108, 109

Ruscha, Ed 60, 191, 247

Rutkowski, Howard 9, 50, 107-8

Saatchi, Charles 1–2, 3, 4–5, 7, 13, 36, 53, 68, 69, 77, 85, 93–101, 127, 174, 190, 191, 215, 230, 237–8, 246, 251, 261, 269

Saatchi Gallery 2, 3, 95-6

Sacks, Steve 42

Sainsbury, David 101

Sakhai, Ely 222-3

Sala, Anri 201

Salle, David 48

Saltz, Jerry 7, 73, 77, 89–90, 129, 145, 195, 228, 245, 250

Saunders, Eddie 69-70

Saville, Jenny 37, 97, 98, 209, 215

Schiele, Egon 30, 178

Schjeldahl, Peter 57

Schnabel, Julian 48, 98-9, 213, 252

Schoenberg, Randol 177-8

School Days (exhibition) 49-50

Schwab, Charles 101

Schwab, Helen 101

Scull, Ethel 35 Scull, Robert 35 Searle, Adrian 228 Segalot, Philippe 59, 115 Self (Quinn) 97 Sender, Adam 39, 101, 259 Sensation (exhibition) 96-7 Seurat, Georges 236 Serota, Nicholas 2, 3, 200, 241 Serra, Richard 37, 60, 204 Sewell, Brian 5 Sharp, Amanda 192 Shedboatshed (Starling) 200 Sherman, Cindy 10, 59 Shoe (Warhol) 80 Shot Red Marilyn (Warhol) 84 Shrigley, David 43 Shukin, Sergei 33 Sickert, Walter 59 Sierra, Santiago 202-3 Sikkema, Brent 45 Simon, Norton 136 Simon-Whelan, Joe 83 Sketch for Deluge II (Kandinsky) 157 Slotover, Matthew 192 Smith, David 61, 62 Smith, Roberta 228 Smith, Tony 42 Smooke, Marion 106-7 Smooke, Nathan 106-7

Snow, Dash 6
Some Comfort Gained from the Acceptance of
the Inherent Lies in Everything (Hirst) 202

Sonnabend 43
Sotheby's 9–10, 13, 15, 20–1, 22–5, 57, 61, 62, 71, 84, 87, 103–7, 108–11, 113, 114, 117, 119–24, 126–8, 136, 139, 141, 147, 148–9, 151, 152–3, 154–5, 156–7, 158, 164–5, 167, 171, 174, 175, 179, 181, 182–4, 219–20, 255, 258, 262–3, 271–2

Soup Can With Peeling Label (Warhol) 147 Southern, Graham 180 Spector, Nancy 16 Spiegler, Marc 212 Splash, The (Hockney) 114 Staller, Ilona 88 Starling, Simon 200 Stein, Gertrude 233 Stella, Frank 34, 211 Stephen Friedman Gallery 43 Stern, Peter 54-5 Stezaker, John 43 Stone, Allan 245 Storr, Robert 50, 196, 198 Study for a Pope I (Bacon) 167 Study for a Portrait II (Bacon) 171 Study from Innocent X (Bacon) 25, 172 Study from the Human Body (Bacon) 166 Sunday on La Grande Jatte, A (Seurat) 236 Sunflowers (van Gogh) 154 Superman (Warhol) 84 Sylvester, David 161, 231

Tapies, Antoni 60

Target with Plaster Casts (Johns) 35

Tariko, Roustam 119

Taubman, Alfred 105, 108, 129

Taylor, Brabdon 9

Taylor, Timothy 74

Tennant, Anthony 105

Testorf, Helga 52

Thomas, Kelly Devine 79, 113

Thousand Years, A (Hirst) 68–9, 94

Three Studies for a Self-Portrait (Bacon) 117, 162–72, 207, 212

Tilton, Jack 49–50

To The Studio II (Auerbach) 149

Today series (Kawara) 14–15

Tony Shafrazi Gallery 191

Toulouse-Lautrec, Henri de 122

Tremaine, Burton 36, 206

Tremaine, Emily 36, 206

Triple Elvis (Warhol) 85

Tunick, Spencer 95

Turner, J.M.W. 62, 225

Tillmans, Wolfgang 42

Turner Prize 198–201
Turquoise Marilyn (Warhol) 62
Tuymans, Luc 43, 59
TV Buddha (Paik) 205
Twombly, Cy 11, 34, 37, 60
Tyson, Keith 180

Valium (Hirst) 72

Untitled (Basquiat) 25
Untitled, 1977 (77.41) Bernstein (Judd) 25
Untitled (America) 16
Untitled (Fortune Cookie Corner) (Gonzalez-Torres) 15–16
US World Studies II (de Balincourt) 6
USA Today (exhibition) 4–7, 20, 26, 63, 93
Ushering in Banality (Koons) 184

van Gogh, Vincent 33, 61, 62, 154–5, 183, 258
Vanthourout, Josette 171
Vanthourout, Roger 171
Vase de fleurs (Lilas) (Gauguin) 219–20, 222–3
Version No. 2 of Lying Figure with Hypodermic Syringe (Bacon) 171
Vertes, Laszlo von 120
Victoria and Albert Museum 11
Victory Boogie Woogie (Mondrian) 36–7
Viola, Bill 42, 180
Vogel, Carol 22, 49–50, 104
Vollard, 33–4
Vuitton, Louis 11, 13–14

Wall, Jeff 43
Walton, Alice 181
Ward, Kirsten 6
Warhol, Andy 11, 24, 25–6, 30, 35, 37, 60, 61, 62, 80–6, 118–19, 140–1, 147, 157, 164–5, 182–3, 202

Warhola, Paul 85-6 Wearing, Gillian 42 Webb, Gary 43 Webster, Sue 95 Weischer, Matthias 215-17 Weisel, Thomas 157 Weiss, David 60 Wenders, Wim 42 Westwater, Angela 24 Westwater, Sperone 99 Wexner, Abigail 101 Wexner, Leslie H. 101, 119 White Canoe (Doig) 127 White Center (Yellow, Pink and Lavender on Rose) (Rothko) 21-4, 62, 109, 149, White Cube 13, 30, 39-40, 41, 42, 48, 50, 52, 72, 76, 94, 196, 214 White Flag (Johns) 16-17, 183 Whiteread, Rachel 37, 97, 200 Whitney, Batsy 259-60 Whitney, John Hay 113-14, 259-60 Wilson, Peter 174, 271-2 Wilson, Richard 95 Wilson, Robert 43 Woman in Tub (Koons) 115 Women III (de Kooning) 61, 62, 251 Wood, Grant 236 Wool, Christopher 11, 43 Wrath of God. The (exhibition) 70 Wurth, Reinhold 101 Wyeth, Andrew 52 Wynn, Elaine 101 Wynn, Steve 62, 101, 119, 153, 183, 250

Yuskavage, Lisa 43

Zwirner, David 43